PHAIDON

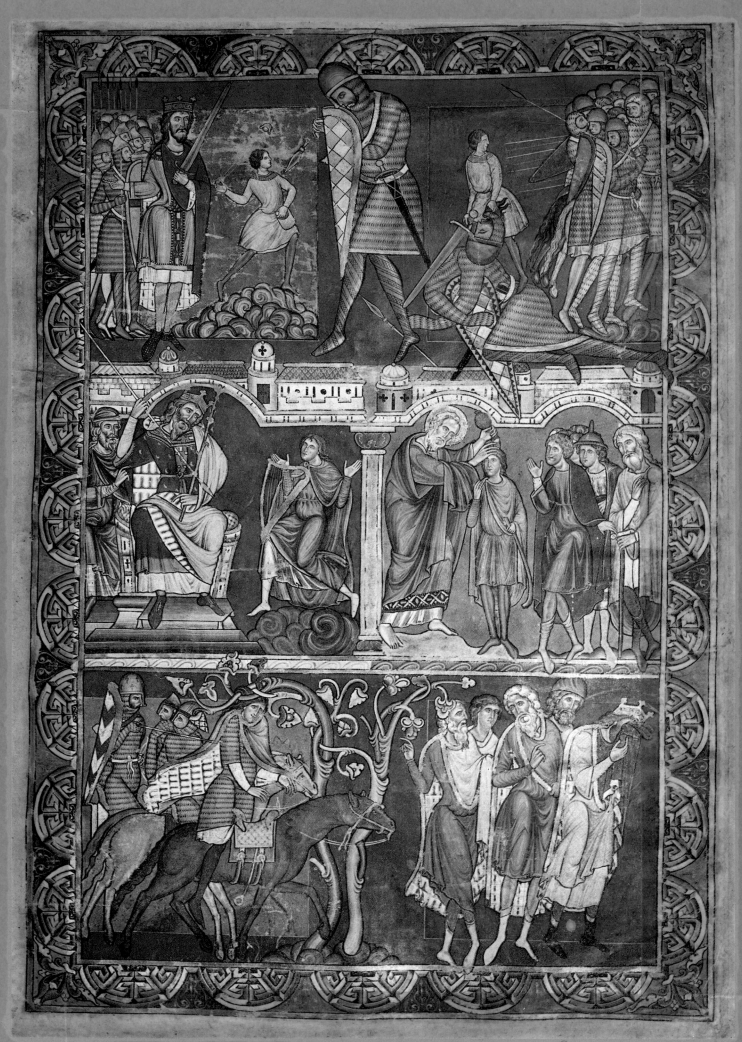

New York, Pierpont Morgan Library, MS. 619, fol. 1v.

THE ART OF ILLUMINATION

AN ANTHOLOGY OF MANUSCRIPTS
FROM THE SIXTH TO THE SIXTEENTH CENTURY

BY P·D'ANCONA & E·AESCHLIMANN

PHAIDON

© 1969 PHAIDON PRESS LTD · 5 CROMWELL PLACE · LONDON SW7

PHAIDON PUBLISHERS INC · NEW YORK
DISTRIBUTORS IN THE UNITED STATES: FREDERICK A. PRAEGER INC
III FOURTH AVENUE · NEW YORK · N.Y. 10003
LIBRARY OF CONGRESS CATALOG CARD NUMBER: 68-27421

TRANSLATED FROM THE ITALIAN
BY ALISON M. BROWN

WITH ADDITIONAL NOTES ON THE PLATES
BY M. ALISON STONES

SBN 7148 1350 8

SELECTION AND DESIGN BY ELLY MILLER

PRINTED BY HUNT BARNARD AND CO LTD · AYLESBURY
COLOUR PLATES PRINTED BY CAVENDISH PRESS · LEICESTER
MADE IN GREAT BRITAIN

CONTENTS

Preface

PAGE 5

An Outline of
the Development of
European Miniature Paintings

PAGE 7

Plates

PAGE 33

Notes on the Plates

PAGE 201

Short Bibliography

PAGE 233

List of Collections

PAGE 235

PREFACE

UNTIL A FEW DECADES AGO, manuscripts used to lie for a long time undisturbed on the wooden bookshelves where they were kept, not infrequently among dust and woodworms. No one had reason to ask for them apart from the odd student, who wanted to look at them in order to amend an ancient text, but practically never to study their decoration.

It was said somewhat disparagingly that miniature painting was only a minor form of art and could contribute little to the knowledge of the 'greater' arts of panel and wall painting. And so long as interest was confined to the aesthetic appreciation of a few treasures venerated by tradition, no one thought of considering miniature painting critically as a subject in itself for historical study.

The present concept of the value of miniature painting is quite different: not only has it taken its rightful place on the same plane as panel painting but it is also used to throw light on and complete whole periods of artistic history rendered obscure either by lack of other pictorial evidence or by the sad changes wrought by successive touching up and restoration, which hide the spirit of the originals.

As soon as it was understood what miniature painting – which nearly always comes down to us fresh and unspoiled – could contribute to a knowledge of past and little known periods of artistic history, a kind of competition began between the most famous centres of culture to study and display their great treasures. Of yesterday are the exhibitions of illuminated manuscripts in Paris, Rome and Munich, to mention only the most important.

This book, which addresses itself both to students of art and to the much wider public of *persone di cultura,* attempts to be a 'Musée Imaginaire' of miniature painting, where each can find what most appeals to his taste.

If this aim has been achieved, we must first of all thank our publisher, who has given us every possible support and assistance, and express our gratitude to all who have so kindly collaborated with us. Above all, we would like to remember with real gratitude Dr. Gemma Villa Guglielmetti, to whose intelligent and enthusiastic work we are especially indepted.

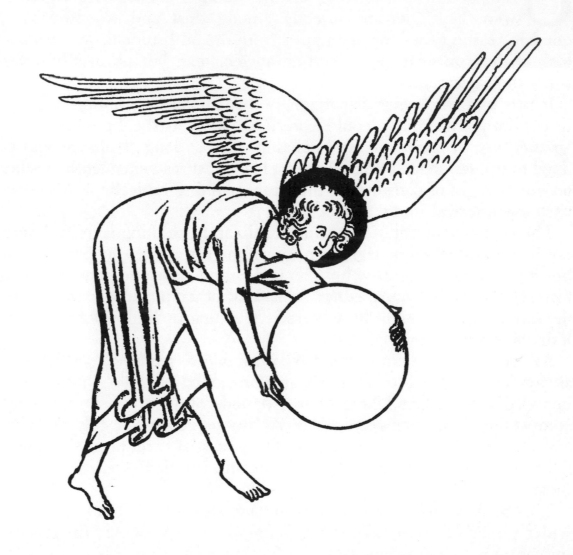

OUTLINE OF
THE DEVELOPMENT OF
EUROPEAN MINIATURE PAINTING

' *"Art thou not Oderisi"* then said I,
"Honour of Gubbio, honour of that art
The illuminators famed in Paris ply?"
"Brother, the pages smile more on the mart
Which Franco of Bologna paints," said he:
"Now the honour is all his, mine only in part".'

Dante, *Purgatorio*, XL, 79-84 transl. Laurence Binyon.

'PIU RIDON LE CARTE': Dante's poetic phrase so well defines the aesthetic appeal of miniature painting, for this is just the impression one gets when turning over the pages of illuminated manuscripts, rich with colour and gold. Manuscripts provide precious evidence for those periods of art history not sufficiently represented by panel or wall paintings (and this is especially true for the early Middle Ages); and since their illuminated pages are well protected by bindings and less easily disfigured by the restorations which have ruined so many paintings, the work executed by artists many centuries ago is preserved intact with only a few exceptions.

So although miniature painting is often unjustly considered a 'minor' form of art because of its dimensions, being sometimes limited to the small space of an initial letter, yet it provides very interesting material for the study of past cultures, and at the same time is aesthetically no less a work of art than the masterpieces of the great panel painters. And if miniatures have sometimes had to model themselves on panel paintings, frescoes or mosaics, at other times the process has been reversed, and it has been the greater arts who have drawn inspiration from the decoration of manuscripts.

Miniature Painting in the Classical Period

THE PRACTICE OF DECORATING MANUSCRIPTS was known to classical antiquity, and although no direct example has come down to us, there is evidence of this in the writings of classical authors. In Martial's *Epigrams*, for instance, reference is made to a Virgil written on vellum, the frontispiece of which was decorated with a portrait of the author; and this custom of portraying the author at the beginning of literary manuscripts must have been common in Rome. We know, too, that the beautiful purple-dyed vellum, inscribed in gold and silver letters, was particularly sought-after by the bibliophiles of Rome.

The world of classical antiquity possibly owed the practice of decorating manuscripts to the distant regions of the East and to Egypt, where this art was extensively developed at the time of the Ptolemies. The Library of Alexandria, famous throughout antiquity, must have possessed a very rich collection of illuminated manuscripts, none of which have unfortunately come down to us.

Thus in order to reconstruct the lost production of classical miniature paintings, if only ideally, one has to examine books of a later period which go back to the fourth and fifth centuries, and which were certainly influenced by, and sometimes even copies of, more ancient exemplars. Of foremost importance in this respect are the *Iliad* of the Ambrosiana in Milan and the Virgil of the Vatican Library, both of which can be ascribed to the fifth century; their decoration, contained within small rectangular spaces in the form of small pictures, is strongly reminiscent, both in technique and in iconography, of the wall paintings at Pompeii. They abound in personifications and allegories, described in a compendiary style with all the freedom and naturalism of Hellenistic and Roman paintings and frescoes.

Plates **2, 3**

Byzantine Miniature Painting

THE HELLENISTIC TRADITION was continued in Byzantine illumination which, as it began to come into contact with different cultural centres, was able in its turn to transmit to the West all that it had received from Islamic, Syriac, Coptic, Armenian and other forms of art in the course of its development.

It is usual to distinguish four periods in the development of Byzantine

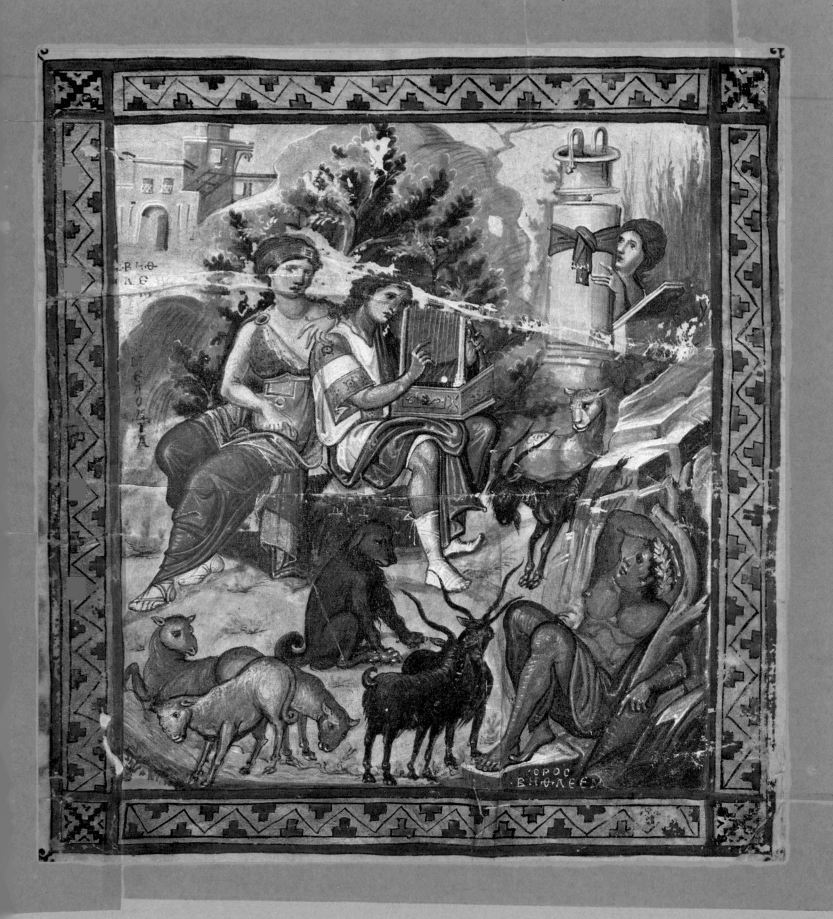

illumination, which altogether lasted from the foundation of Constantinople in A.D. 330 to the fall of the Eastern Empire in 1453.

Belonging to the first period, which can be classified as pre-Byzantine and embraces the fourth and fifth centuries, are the *Iliad* of the Ambrosiana and the Vatican Virgil mentioned above, on account of their strictly classical tone. To these may be added the Joshua Roll of the Vatican Library, a long strip of parchment (rolled round a small stick to form a 'rotulus'), on which the deeds of biblical heroes are unfolded. This manuscript, datable to the sixth century (or later) but probably a copy of a fourth century original, combines Roman and Hellenistic influences with those of the art of Syria and Palestine, and in the iconography of some of its personifications already reveals features which were to become characteristics of a purely Byzantine art. It should also be remembered that many medieval manuscripts, for example the *Comedies* of Terence, have miniatures which are copies of lost originals of this same period. Plates 2, 3

After this, Byzantine illumination enjoyed two great periods of flowering. These correspond to the first golden age of the time of Justinian in the sixth century, and to the second golden age following the iconoclast persecution, which took place during the political and religious struggles which upset the Greek East until 843. During the first golden age – at the very time when the great dome of St. Sophia began to rise at Constantinople and the mosaics flowered at Ravenna – miniature painting showed increasing interest in the decoration of religious manuscripts. Among these, the most outstanding are the Vienna Genesis, the Cotton Genesis in the British Museum, the Greek Gospels of Rossano and the Syriac Rabula Gospels in the Laurenziana, Florence. Nevertheless, there were also secular decorated books of great importance in this period, such as the *Dioscorides* of Vienna and the *Topographia Christiana* of Cosmas Indicopleustes. In all these works, while the traces of classical antiquity are still evident both in iconography and in technique, there are already signs of a purely Byzantine style in the vivid colouring, precious as an enamel, and in the decorative stylisation of the human figure, of nature, and of architecture. Plates 5, 6
Plates 1, 4

In the course of the eighth century miniature painting suffered from the raging of the iconoclastic struggle and underwent a moment of crisis. But when it flowered again under the imperial dynasties of the Macedonians and the Comnene family, during the period lasting from the ninth to the twelfth centuries, it was even more splendid and sumptuous than before.

This was the second golden age of Byzantine art, when miniature painting competed with the mosaics of Daphni, the Sicilian mosaics of Palermo and Monreale, and those of St. Sophia of Kiev in Russia. Especially

popular among the writings of the Old Testament were the Psalms of David, which are handed down to us in many codices whose decoration follows two patterns: there are the sumptuous imperial or aristocratic Psalters, containing full-page miniatures on gold backgrounds, and the more modest monastic Psalters, decorated with marginal vignettes.

Facing
Page 8 There is a magnificent example of an aristocratic Psalter in the Bibliothèque Nationale in Paris containing fourteen full-page miniatures, in which the allegorical representations now reappearing are classical in type, though inspired by the ceremonial of the court of Byzantium in their detail.

The illustrations of the Khloudov Psalter (Moscow, Lenin Library), the most famous of the monastic Psalters, are composed in a vein of popular realism, sometimes with a hint of satire.

The writings of Gregory of Nazianzus, John Chrysostom and the monk Jacobus, which have come down to us in several magnificently-decorated codices, must also have been popular. There are two famous codices of the *Homilies* of Gregory of Nazianzus in the Bibliothèque Nationale in Paris (cod. Parisinus 510) and in the Ambrosiana in Milan, in which the human figure, although still modelled according to classical proportions, is nevertheless more stylised than in earlier works. The decoration also is treated more fully.

The narrative skill of the artists found full scope in the Octateuchs and Menologies, among which the Vatican Menology is famous, with its architectural backgrounds and decorous costumes reminiscent of the splendour of the Court of Byzantium. The writings of John Climacus, on the other hand, offer a pretext for edifying scenes of the lives of monks, and in representations of virtues and vices, encourage the taste of Byzantine artists for allegory. The harmony of forms and colours to be found in the luxury manuscripts, which at this time were kept with care in the large imperial libraries, seems to compete with the contemporary production of enamels and fabrics.

Later, in the course of the thirteenth to the fifteenth centuries, while the art of miniature painting was reaching its apogee in the West, signs of decadence could be detected in Byzantine illumination, which were directly related to the serious disasters then threatening the Eastern Empire and causing the exodus of the monks and artists who had kept alive the art of the illuminated book.

The works of this time show great poverty of invention and err in design and colour, which is now too harsh and now too faint. Portraits, on the other hand, of which there are numerous examples in Byzantine miniature painting of this period, were becoming increasingly interesting.

The Byzantine style of miniature painting was also developed in countries like Armenia and the Slav lands, which were placed outside the confines of the Empire but were joined to the Greek Church. the Key

Miniature Painting in the Early Middle Ages until the end of the Thirteenth Century: Monastic Illumination

IN THE EARLY MIDDLE AGES miniature painting was practised most extensively in the cloisters of monasteries and for this reason can justifiably be described as 'monastic'. In the monasteries, which had become the most active centres of learning, monks dedicated themselves with great religious fervour to the exacting and tiring work of writing sacred texts: 'You do not know what it is to write. It is a killing work' are the words of a monk of St. Aignan of Orléans, and it was also a monk, from the monastery of Corbie, who wrote 'Dear reader, in turning over these pages with your fingers, take care not to damage the writing; no one who is not a calligrapher can have any idea of the labour involved. It is as sweet to the copyist to reach his last line as it is to the sailor to reach his port. Three of his fingers hold the reed for writing, but his whole person has painfully to work.' Generally the scribe, as well as writing the text, also decorated the pages and illuminated the initial letters, but for the historiated initials and the larger illustrations, which comment on the text, an experienced master of miniature painting was usually employed.

The earliest examples of western medieval miniature painting appear in Celtic Ireland. Situated in the north-western part of Europe, this island had been able to escape the Roman Conquest, and had succeeded in preserving its own original form of artistic expression, severed from all contact with classical civilisation. It was her conversion to Christianity in the fourth century which re-joined Ireland to the rest of Europe; she then became one of the most active centres of monastic life, and her monks, fired by an ardent missionary zeal, became responsible for spreading the word of the new faith to the most distant parts of Europe, and along with it the art of book decoration that had flourished in the confines of her monasteries.

However original it may have been, Irish miniature painting is not an isolated phenomenon: it shows contacts with the art of the Christian East, which may well be explained by the presence in Ireland of Egyptian monks

who had come to settle there. Even so, too much importance should not be attributed to these influences, since the type of decoration found in Irish miniatures is common to all forms of primitive and barbarian art. But in Ireland these decorative tendencies were carried to their extreme limits, and the illuminated page became a prodigious tangle of straight or curved lines, interlaces, circles, lozenges and spirals. Human figures and animals are not forgotten, but they are stylised and deformed to such an extent that they become purely ornamental motifs. This is well illustrated in the Plate 10 crucified Christ of the Gospels of St. Gall, in which the human body disappears beneath the confusion of linear interlace. The fascination of this purely abstract and decorative art lies in the vitality with which the most varied forms bend and interweave without ever appearing contrived, and also in the colouring, which, although limited in range to red, yellow and green, achieves great effect through its pure and vivid tone. Two of the most famous illuminated Irish manuscripts are preserved in the Library Plates of Trinity College, Dublin: the Book of Durrow and the Book of Kells, 11, 12 the first of which can be ascribed to the end of the seventh century, the second to the eighth or ninth century.

Closely related to the history of Irish miniature painting is that of the Anglo-Celtic art of Northumberland, where monasteries were founded in close contact with those of Ireland. In Northumberland, however, new motifs derived from Mediterranean art were introduced through the frequent journeys of her monks to Rome: significant in this respect is the Plate 8 eighth-century Codex Amiatinus, a Bible now in the Laurenziana in Florence.

The influence of Irish illumination continued to make itself felt in Anglo-Saxon books as late as the tenth century, although by then they were also being influenced by their close contact with the Carolingian art of the Continent. The centres of the new production were in southern England, at Winchester and at Canterbury. The most outstanding works of the Winchester School are the Benedictional of St. Aethelwold (originally in Plate 31 the Duke of Devonshire's Library at Chatsworth, now in the British Museum), illuminated about 980, and the Missal of Robert of Jumièges (Rouen, Bibliothèque Municipale), dating from the beginning of the eleventh century. Considered as a whole, Anglo-Saxon illumination never Plates 32, achieved the sumptuous effect of continental decoration, but it developed 34, 35 its own original form of expression through rapid, nervous outline-drawing and an amazing richness of invention.

Miniature painting had a much greater efflorescence in France and Germany in the Carolingian period, thanks to the diligent and intelligent patronage of Charlemagne and his successors, among whom the figure of

that famous and enthusiastic bibliophile, Charles the Bald, is prominent.

It was a period of renaissance in all fields of learning: schools and libraries were founded; ancient texts were transcribed with care and accuracy; illuminated manuscripts of great splendour were produced that rivalled those of Byzantium.

The most typical feature of the miniature painting of this period is its tremendously rich ornamentation, always lofty in style and accompanied by an evenly-flowing script. Especially popular was the beautiful purple vellum, inscribed in gold and silver letters according to a custom which, as we have seen, was of long standing in the history of miniature painting. Gold backgrounds were most often used for full-page miniatures and also for initial letters, which sometimes occupy a considerable amount of space with their ornamental motifs. The imagination and inventive genius of the miniaturists and scribes found full scope in the Bibles, Psalters, Gospel Books and Sacramentaries which abound in this period, and reached heights which were never surpassed.

It is possible to distinguish in these manuscripts different stylistic tendencies corresponding to the different schools which were being formed in the vast Carolingian Empire. In the region of the Loire the school of Tours achieved great splendour, especially in the time of Louis the Pious and Charles the Bald, whose precious Bible, offered to him as a gift by Count Vivian, is now in the Bibliothèque Nationale in Paris. With this codex and others equally famous, such as the Sacramentary of the Bibliothèque Municipale of Autun, and the Gospel Book of Lothair (Paris, Bibliothèque Nationale), the school of Tours achieved a clear, simple, and at the same time grandiose style, perfectly balanced in script. Plates 23, 25 Plate 24

In the eastern part of France, at Rheims, another school of miniature painting flourished which drew inspiration from the examples of antique art in which the region was rich, at the same time infusing its figures with an intense dynamism, as can be seen in the Ebbo Gospels (Épernay, Bibliothèque Municipale), or in the Utrecht Psalter, a work of great importance, not least for its influence on English illumination. We find in it the same realism as in Byzantine monastic psalters, as well as a tendency to describe the essential in rapid pen-stroke sketches. The Codex Aureus of Saint Emmeram (preserved in the Staatsbibliothek of Munich) is of a magnificence that recalls the precious work of gold and silversmiths. It was probably executed in the Abbey of Saint Denis, like the Psalter of Charles the Bald (Paris, Bibliothèque Nationale) and the Bible of Charles the Fat or the Bible of San Paolo fuori le Mura in Rome, which is considered to be the most richly decorated of all Carolingian manuscripts. Plate 18 Plate 17 Plates 27, 30 Plates 28, 29

Schools of miniature painting also flourished in other centres, at Corbie

and at Metz, to which may be added the school generally known as the 'Franco-Insular' school for its close contact with the art of the other side of the Channel. Notable are the so-called Gospels of Francis II (Paris, Bibliothèque Nationale) and the Sacramentary of Drogo (Bibliothèque Nationale), executed for the Cathedral of Metz at the time of the episcopate of Drogo, natural son of Charlemagne, and famous for the exceptional splendour of its decorated and historiated initials.

Plate 19

Although it is not easy to classify the numerous manuscripts of this period with any precision – because of the constant movement of artists from one centre of the Empire to another, or because the most valuable manuscripts were often copied or imitated even far away – one should nevertheless not forget to mention, in addition, the flowering of miniature painting in the regions of the Rhine, centring round Charlemagne himself at Trier and Aachen, his favourite residence. At this school – also called the Ada school from the name of Charlemagne's natural sister who commissioned the Gospel Book now in the Library of Trier – was produced the oldest of all Carolingian manuscripts, the Godescalc Gospels, a book containing six full-page miniatures, written by the scribe Godescalc at Charlemagne's request and completed towards 783 (Paris, Bibliothèque Nationale).

Plate 15
Plate 16

Throughout the whole of the ninth century, therefore, it was France who held first place in the art of illumination. Later, political upheavals and the devastation of her monasteries by Norman pirates brought about a decline in miniature painting in France, while in Germany it enjoyed a period of great splendour under the Saxon dynasty of the Ottonians. Bishops as well as sovereigns became patrons of this art, and by their frequent travels were able to establish close contacts with the art of Rome. The Ottonian Renaissance had its home principally in several religious centres in the regions of the Rhine and Danube. Looking at some examples of the school of Reichenau, a Benedictine Abbey situated on Lake Constance, such as the Egbert Codex from the Library of Trier, or the Gospel Book once in Bamberg Cathedral and now in Munich, one can observe in the former its close derivation from models of primitive Christian art, and in the latter its great intensity of expression, both dramatic and comic, achieved through the use of concise gestures and the simplification of scenes. In the Bamberg Apocalypse, attributable to the school of Reichenau about the year 1007, the visions of St. John are translated into a series of illustrations executed without perspective, in which the figures are delineated flatly against their backgrounds with an archaism befitting the mysterious quality of the text itself.

Plates 40, 43

Plate 45

The schools of Trier and Echternach were less rich in inventive genius although more sumptuous in decorative effect, and produced several such

impressive books as the *Registrum Gregorii* (of which only a few illumin-
ated fragments remain at the Musée Condé of Chantilly), the *Codex Aureus*
of Gotha, the Goslar Gospel Book (now at Upsala) and the *Codex Aureus*
of Speyer (now in the Escurial Library).

Belonging to the school of the Middle Rhine is a codex, now lost, which
is of considerable importance for the study of Christian iconography. This
is the famous *Hortus Deliciarum,* composed at the end of the twelfth century
for the edification of the nuns of the convent of Hohenburg. Here the
miniatures can be reconstructed from a series of tracings and sketches, and
they contain many allegorical subjects. A wide repertory of the iconography
of the saints can be found in the Stuttgart Passionary, which is decorated
with flat, two-dimensional figures, freely twisted and contorted to ac-
centuate both expression and movement.

With the two Danubian schools of Ratisbon and Salzburg we are already
in the eleventh and twelfth centuries. The Sacramentary of Henry II and
the Uta Codex (both in Munich) are the two most interesting examples of
the first of these schools; from Salzburg, there is the twelfth-century
Admont Bible, containing a complete iconographical repertory of the whole Plate 64
of the Old Testament in its full and freely-flowing illustrations, which
reveal the hand of an artist used to monumental painting.

The first symptoms of a process of decline in German illumination ap-
peared in the twelfth century; it became increasingly evident until, by the
middle of the thirteenth century, it yielded its primacy to new artistic
centres in France, Italy, England and the Low Countries, and became of
no more than secondary importance.

Miniature painting in Spain is characterised by its clear calligraphic
tendencies and its use of decorative motifs, such as horseshoe-shaped
arcading and exotic animals, derived from Moorish art. In the numerous Plates
tenth to twelfth century manuscripts, which illustrate Beatus' Commentary 46, 47,
on the Apocalypse according to a special Spanish tradition, human beings 48, 50
and monsters can be seen intermingled in imaginary scenes of great
decorative value. A group of manuscripts of Catalan origin is particularly
notable for its purity and accuracy of draughtsmanship, among which the
Bible of Farfa (now in the Vatican Library) and the Bible of San Pedro Plate 49
de Roda, also called the Bible of Noailles (Paris, Bibliothèque Nationale)
are prominent.

The influence of Byzantine art left a deep impression on the miniature
painting of southern Italy. The most important centre for the production of
illuminated books was the Benedictine Abbey of Montecassino, which
passed under the rule of Byzantium at the time of Abbot Desiderius. The
most original work of this Abbey were the parchment Exultet Rolls,

illustrated by small, lightly-coloured drawings, which were painted upside down in relation to the rest of the text so that they could be more easily looked at by the faithful while the deacon read out the hymn of praise. The Exultet Rolls of Bari Cathedral and the Vatican Library, together with other manuscripts such as the eleventh-century *Miracles of St. Benedict* and the *Chronicon Volturnense* dating from the early twelfth century (both in the Vatican Library), illustrate the importance of monastic miniature painting in the Middle Ages. This art was also developed in other centres in Italy – at Bobbio, Polirone (the Gospels of the Countess Mathilda in the Pierpont Morgan Library of New York), Nonantola, and Farfa.

The miniature painting which flourished in France and England during the twelfth and thirteenth centuries was also monastic. From the time of the Norman conquest of England in 1066 until the end of the Hundred Years' War, England and France were joined in close political unity and gave rise to a school of illumination which can justly be called the 'Franco-English Channel School'. In England, its principal centres were at the Plates 62, 63 68–70 abbeys of St. Albans, Canterbury, Bury St. Edmunds and Peterborough, where Bibles, Psalters, Gospel Books, Apocalypses and Bestiaries were written and illuminated. Special fame among English thirteenth-century illuminators belongs to Matthew Paris, a monk of St. Albans and author of Plate 78 the famous *Historia Anglorum* of the British Museum. Considered as a whole, English illumination, by endowing its work with a poetic charm of unusual elegance, achieved a level of refinement equalled only by the French art of the thirteenth century.

Among the different regions in France where miniature painting flourished in the twelfth century, a place of first importance belongs to Burgundy, the centre of intense religious activity. It was here that the Cîteaux Bible (Dijon, Bibliothèque Municipale) and the Souvigny Bible of the middle of the century (Moulins, Bibliothèque Municipale) were produced.

At the beginning of the new century, Burgundy yielded its primacy to Paris, which in the reign of St. Louis became the most active centre of the Plates 80–82 art of illumination. Beside Psalters, Apocalypses, and Lives of Saints, we find the *Bible Moralisée* or paraphrased Bible, which has come down to us in two examples (one now at Toledo, the other divided between Oxford, London and Paris), of great interest both for its iconography and for the history of costume in the thirteenth century.

Plates 72, 73 Especially famous is the Psalter of Blanche of Castille (Paris, Bibliothèque de l'Arsenal) in which the miniatures are presented, as in the *Bible Moralisée*, within medallions or shields, in a manner closely reminiscent of the decoration of window glass. By making use of luminous gold backgrounds, miniaturists seemed to vie with the art of stained glass

decoration, which achieved such splendour in Gothic Cathedrals.

The illustrations of the St. Louis Psalter (Paris, Bibliothèque Nationale), Plate 84 attributable to the years 1253–1270, are by contrast presented within architectural settings in the Gothic style. Scenes of the Old Testament unfold with great iconographical richness, showing a new spirit in their elegant proportions and softly flexible figures, which presage the development towards a stylised naturalism.

French Miniature Painting from the Fourteenth Century to the beginning of the Sixteenth Century

BY THE END of the thirteenth century, there were signs of a new spirit in the art of book decoration. At the side of the monk, who spent long, exhausting hours writing and illuminating for the edification of his soul and usually adhered closely to tradition, there appeared the lay master-miniaturist, who worked for his own profit and was ambitious to attain a place of first importance through his beautiful style and perfect technique.

Beside the production of church books, consisting of liturgical books, like breviaries and prayer books, and new pietistic works, there developed a fashion in elegant court society for secular works of historical or moral interest, such as the chivalric romances, encyclopaedias and chronicles, which proved the delight of the lords of the day.

Paris, as we have seen, was already an important centre for the production of manuscripts in the thirteenth century; but by the end of the century it had become the capital of miniature painting. In 1292 it counted seventeen master-miniaturists inscribed in the *Livre de la Taille,* or tax register. Among these, the most outstanding is Master Honoré, who worked in partnership with his son-in-law, Richard of Verdun. Little is know about him: in 1296 he is recorded as illuminator to the King, and it is to him that the Breviary of Philip the Fair (Paris, Bibliothèque Nationale) Plate 88 is usually attributed. A note at the end of the volume of Gratian's *Décretales* in the Library of Tours tells us that this book was sold by 'Honoré, illuminator, residing in Paris, in the street Herembourg-de-Brie'. All the same, only the initial decoration of the *Décretales* reveals a style identical to that of the Breviary; the rest of the decoration is certainly by a different hand, and can in all probability be attributed to the workshop of which Honoré was the head.

With the beginning of the new century, the activity of French artists,

both lay and religious, became even more intense. One of the most typical examples of French illumination of this period is the Legendary of Saint Denis in the Bibliothèque Nationale, which can be dated in about the year 1317. Many spirited and picturesque scenes of popular life are to be found here, which reflect the customs of the Paris of that time.

Gradually gold backgrounds were replaced by backgrounds of colour or landscapes, often framed by lively borders where grotesques, small animals and elegant birds nestle among differently-coloured foliage. The artist who best represents this change of taste is Jean Pucelle, who has left his own name in the Bible of Robert de Billyng, dated 1327, and the Belleville Breviary (both in the Bibliothèque Nationale). Together with his own name are those of his collaborators, whose salary he paid in his capacity of master of the workshop. The decoration, which is elegant and restrained in the Bible, is treated more freely in the Breviary; here the margins are enriched with charming scenes, executed with an exquisitely-refined technique, among gentle vines and ivy leaves populated by birds and butterflies.

However, it is not always possible to establish the authorship of these works, and many remain anonymous. Such is the case with the Bible of Jean de Sy (Paris, Bibliothèque Nationale), which was begun for King John the Good and remained unfinished because of the King's imprisonment. For want of his real name, the anonymous author of these miniatures and of others which closely resemble them in style has been called 'Maître aux Boqueteaux' for the special way in which he frequently paints small clumps of tufted trees. No other master of this period could equal his feeling for landscape, which he treated with great imagination and naturalism, and filled with every kind of animal.

Under Charles V, an ardent book-lover, miniature painting in France enjoyed a period of great splendour. The patronage of the sovereign made Paris a centre which attracted artists from many parts. Unfortunately, all too little is known about these masters, and their works generally remain anonymous. Such is the case with the so-called Breviary of Charles V (Paris, Bibliothèque Nationale), which is decorated with at least two hundred and forty-three small, delicately executed miniatures which conform to the tradition derived from Jean Pucelle. In the meantime, it is already possible to see motifs of foreign, especially Flemish, origin being introduced into French illumination: the name of Jean de Bruges, who decorated the first page of the Bible of Jean de Vaudétar (The Hague, Meerman-Westreenen Museum) with the portrait of Charles V, is a case in point.

At the end of the fourteenth century or the beginning of the fifteenth, we

come across another masterpiece of Paris illumination, the *Livre d'Heures* *du Maréchal de Boucicaut* (Paris, Musée Jacquemart-André), which Plate 108 clearly reflects the influence of Italian and Flemish art.

The fifteenth century saw the apogee of miniature painting. It had an amazing period of development in the last politically-troubled years of the reign of Charles VI, when the English invaded many fertile regions of France. Yet miniature painting flourished in face of all the horrors of war. The *Grandes Heures* and the *Très Riches Heures* of the Duke of Berry, Plates 109, 110, 112, 117, 118, 119 the *Livre d'Heures de Rohan*, the *Livre du Cuer d'Amours Espris,* the *Livre d'Heures d'Étienne Chevalier* the *Antiquités Judaïques* of Josephus, the *Livre d'Heures d'Anne de Bretagne* are all masterpieces which mark the end of great miniature painting in France.

One can distinguish two stylistically different periods in the course of this development. The first, which enjoyed the patronage of Jean de Berry and the Dukes of Burgundy, is characterised by strong Flemish influences. The second flourished at the time of Charles VII and Louis XI and was more purely French in character; it developed in the Loire valley and had its greatest exponents in the masters of the school of Tours.

Jean de Berry was an enthusiastic bibliophile who commissioned a series of books of unusual beauty: the Psalter of the Bibliothèque Nationale, the Plates 94, 95 *Très Belles Heures* of Brussels, the *Petites Heures* and the *Grandes Heures* of the Bibliothèque Nationale, the *Heures d'Ailly* (Rothschild Collection) and the *Très Riches Heures* of Chantilly. Plate 112

He employed several miniaturists, some of whom are known to us by name: André Beauneveu, illuminator of the Psalter, Jacquemart de Hesdin who, in collaboration with other artists, illuminated the *Très Belles Heures,* the *Petites* and the *Grandes Heures* as well as the three Limbourg brothers, Pol, Jehannequin and Hermand, Flemings by birth, who originally came from Guelders. The *Très Riches Heures* is the Limbourg brothers' Plate 112 masterpiece and also a masterpiece of miniature painting of all time: the artists' genius lay in combining into a balanced whole the vitality of their native Flemish art with the elegance and refinement of an earlier French tradition. The landscapes which they created in their miniatures are peopled with human forms, always however with a tendency towards the simplification of the volume, which was certainly derived from Italian art.

The great anonymous illuminator of the *Livre d'Heures de Rohan* Plates 109, 110 (Paris, Bibliothèque Nationale), on the other hand is interested primarily in the expression of the emotional and dramatic values, and his book is one of the greatest documents of French miniature painting for the expressive force of the grandiose figures that fill its pages.

Besides this prolific production of religious manuscripts, we should not

forget to mention the secular books which were produced in this period. Among the most outstanding of these is the so-called *Terence des ducs* of the Bibliothèque de l'Arsenal in Paris.

Secular work predominate in the collection of books executed for the Dukes of Burgundy. They consisted of adventure stories and chronicles which rival prayer books in the beauty of their decoration. The decoration of the *Boccaccio* of John the Fearless (Bibliothèque de l'Arsenal), which can be dated about 1410, shows different stylistic tendencies which correspond to the different masters who participated in its prodigious decoration. In some pages one can easily recognise the hand of miniaturists who belonged to the group most inclined towards the Flemish style in Paris. The Duke of Burgundy also liked to employ Flemish miniatures, as Charles V and Jean de Berry had done. It is not easy however to make a clear distinction between French and Flemish illumination in this period. It is only possible to talk of a Flemish school in the true sense of the word after Philip the Good of Burgundy had made the county of Flanders in the northern provinces of his vast Duchy the centre of its political and artistic life. His two predecessors, Philip the Bold and John the Fearless, remained by contrast substantially French. It was a French artist, Philip de Mazerolles, who was nevertheless responsible for a masterpiece of religious illumination at the time of Philip the Good, namely the *Miracles of Notre Dame* (Paris, Bibliothèque Nationale), which contains numerous illustrations in grisaille, according to the method used by André Beauneveu in the Psalter of the Duke of Berry. Devotion to the Virgin is here illustrated in a series of anecdotal scenes of great narrative ingenuity and freshness.

The other masterpieces executed for the Dukes of Burgundy, Philip the Good and Charles the Bold, will be described in a later section, and it only remains to mention here the Book of Hours (Bibliothèque Nationale) and the Breviary (British Museum) of John the Fearless, the second of which is full of realistic details heralding the Flemish taste in art. The miniature painting which flourished under the patronage of Jean de Berry and the Dukes of Burgundy is therefore characterised by the complete freedom of contact between Flemish and French artists, which brought about an interchange of influences. With the transference of the Kings of France – from Charles VII to Francis I – to the Loire valley, Tours, which had already in the Carolingian period played a role of first importance in the art of miniature painting, now enjoyed a new period of great splendour.

Jean Fouquet is the prince of French miniaturists. Born in Tours about the year 1420, he travelled to Italy and stayed in Rome during the pontificate of Eugenius IV. There he had the opportunity of getting to know the

work of the greatest masters of the Renaissance, while not remaining insensible to the appeal of antique art. He must be considered not only as a miniaturist, but also as a true panel painter: this should explain the ample style of his miniatures, which are no longer simple book-illustrations but small pictures painted with great compositional skill and naturalistic feeling. The eleven miniatures executed for Jacques d'Armagnac towards 1470, illustrating the *Antiquités Judaïques* (Bibliothèque Nationale) are his work. Here the landscapes, showing the gentle countryside where Fouquet was born, are spacious and at the same time meticulous in detail. Only a few scattered leaves now remain of the Book of Hours which Fouquet decorated for Étienne Chevalier after it was barbarously dismembered at the beginning of the eighteenth century, and these are divided between the Musée Condé at Chantilly, the Louvre, the Bibliothèque Nationale, the British Museum and private collections. Despite the fact that some of its architectural motifs show the influence of Italian Quattrocento art and contain details derived from the art of ancient Rome, yet its general tone is purely French, as the type of people, costume and landscape shows. And just as completely French are the illustrations of the *Grandes Chroniques de France* (Bibliothèque Nationale), executed by Fouquet with the help of some collaborators: episodes from the history of France are described there in a succession of different scenes, some of which achieve a breadth of vision comparable to large panel paintings. Without dwelling on works which cannot be attributed to Jean Fouquet with certainty, we must mention in passing the large miniature on the frontispiece of the *Statuts de l'Ordre de Saint-Michel* (Bibliothèque Nationale) and the Boccaccio at Munich.

Plate 119

Plate 118

An artist who was certainly in contact with the school of Tours is the great anonymous master of the *Livre du Cuer d'Amours Espris* (Vienna, Nationalbibliothek), who moved in the circles of King René of Anjou, a great patron of the arts and himself author of the romance. The adventures of the knight Cuer are illustrated in sixteen miniatures in which a poetic feeling for nature and delicate effects of light reveal the exceptional pictorial gifts of the artist.

Plate 117

The great line of French miniaturists comes to an end with Jean Bourdichon, who was responsible for the illumination of the Book of Hours of Anne of Brittany (Bibliothèque Nationale), executed between the years 1500 and 1508. A particular feature of his work was to fill the margins with brightly-coloured flowers and fruit, and insects painted with the minute exactitude of a botanist. So in place of the simple and somewhat stylised marginal decoration of earlier works is substituted real flora copied directly from nature. On the other hand, in his idealisation of the human figure

Bourdichon declines sometimes into the conventional. By forgetting the limits imposed on book decoration and tending more and more to the imitation of panel painting, the art of illumination, was nearing its end. When Bourdichon died, in about 1521, miniature painting was in full decline: in France, as elsewhere, the illuminated manuscript was being replaced by the engraved book, which was more easily adaptable to the tastes and needs of the time.

Miniature Painting in England, Germany, Bohemia, Flanders, Spain and Portugal from the Fourteenth Century to the beginning of the Sixteenth Century

FROM THE BEGINNING of the fourteenth century, English illumination tended towards a fluent and vigorous type of decoration, which seemed to be linked to the great tradition of drawing that had flourished in the south of England in the tenth century. Special care was lavished on the decoration of Psalters, which were particularly in demand by English customers (contrary to what happened in France, where the most sought-after books were Breviaries and Books of Hours). The large format of these books allowed the artists full scope to develop their inventive genius in sumptuous and ever-varied decoration.

English illuminated manuscripts of the first half of the fourteenth century are usually divided into two groups: firstly those belonging to the East Anglian school, which has left us several notable examples of its work in its brief period of development; and secondly a group difficult to define, but which has as its chief example the famous Queen Mary's Psalter (British Museum). The artist of this exceptionally richly-decorated masterpiece of English fourteenth-century illumination proves himself to be a worthy successor to the artists of the great Winchester school of Anglo-Saxon drawing. To its vast repertory of sacred subjects drawn from the Old and New Testaments and the Lives of Saints are added marginal scenes of contemporary life, which are secular in spirit and suggest that the book was decorated by a lay artist. So in England, too, the art of miniature painting was no longer an exclusive privilege of monks, confined within their cells, but passed into a predominantly lay profession of scribes and illuminators.

The East Anglian School is characterised by its astonishing wealth of

Plate 89

22

ornamentation and splendid total decorative effect, which is enriched by numerous marginal figures of men and animals, grotesques, and small scenes of medieval life. The imaginative fantasy of English miniaturists can be seen clearly in the Ormesby Psalter (Oxford, Bodleian Library), whose marginal borders are peopled with every kind of monstrous being. Also belonging to the East Anglian school is the Luttrell Psalter (British Museum), executed about 1340 and of foremost importance for its many illustrations drawn from scenes of every-day life. Yet it is already possible to see signs of decadence in these works, as they appear to lack an understanding for certain problems of composition, and are not quite as pleasing in colour. Plate 98 Plates 96, 97

Immediately after the middle of the fourteenth century, there is a gap of about twenty years in the history of English illumination; then, towards 1370, it began to revive, but even so it never attained the level achieved by the great schools of miniature painting on the Continent, even in its greatest works. The credit for this revival belongs largely to the patronage of the Bohun family. No less than six magnificent manuscripts now in existence are to be associated with this family, five of which closely resemble each other in certain details of style, and especially in their fine and precise draughtsmanship. Plate 99

Several years later, the Missal of Nicolas Lytlington, Abbot of Westminster (preserved in Westminster Abbey), offers us a securely-dated document (1383–1384) in which certain stylistic innovations can be noticed, particularly in the marginal decoration. This change of style, which became even more evident in the works belonging to the end of the fourteenth century, can no doubt be explained by the influence which Continental art exercised on English illumination. Among the manuscripts belonging to this period, we must mention the Missal executed for the Benedictine Abbey of Sherborne by John Siferwas and his collaborators during the years 1396–1407 (now at Alnwick Castle). The pages of this book are filled with marginal drawings containing architectural motifs and figures of men and animals skilfully portrayed with studied attention to nature. Contact with the art of the Continent, especially with the German art of Cologne, is here easily recognisable. Plate 100

Throughout the fifteenth century, English illumination was strongly influenced by the art of the Continent and closely resembles French miniature painting. We should also mention the *Marco Polo* in the Bodleian Library at Oxford and the Book of Hours of Queen Elizabeth (Dyson Perrins Collection, now in the British Museum), where the pleasing harmony of colours is to be greatly admired. Later, as foreign influences become more pronounced, it is difficult to decide which manuscripts should be classified Plate 101

as English, and often miniatures by artists from abroad are inserted in books written by English scribes. English illumination thus loses its essential individuality. English book-collectors often preferred to order their books directly from France, so that the art of miniature painting, which at one time had achieved a role of prime importance in England, was by now in full decline.

On the Continent, miniature painting developed with varying fortune. In Germany, for instance, after its splendid flowering in the Ottonian period, it was quite definitely reduced to a role of secondary importance. One is struck by the scarcity of religious as opposed to secular manuscripts in the fourteenth century. Among the latter, we should mention the so-called Manuscript of Manesse (Heidelberg University Library) containing numerous full page miniatures of love-scenes and of battles, and the Manuscript of Willehalm of Cassel, illustrated by an anonymous artist known as the 'Willehalm Master'.

The decline of miniature painting in Germany, which was fully advanced by the fifteenth century, is easily explained by the great popularity there of the art of wood-engraving, in competition with illumination.

It fared better in Bohemia, however, where it flourished in the fourteenth century under the patronage of Charles IV of Luxembourg, evidently in contact with French miniature painting, both in technique and style. Its success lasted through the fourteenth and fifteenth centuries, during which time a large number of illuminated manuscripts were produced.

We have already seen in the preceding chapter that one can only speak of a proper school of Flemish miniature painting after Philip the Good of Burgundy had made Flanders the political and artistic centre of his Duchy. Before that, the history of Flemish illumination was strictly bound to that of French miniature painting, and we have already mentioned the names of some famous masters, like the Limbourg brothers, who were Flemish by birth but worked in France.

There were many miniaturists at work at the court of Philip the Good towards the middle of the fifteenth century, such as Guillaume Vrelant, Jehan Dreux, Jean Tavernier, Loyset Liédet and Simon Marmion, to whom we can attribute several works with certainty. Jean Tavernier, for instance, illuminated the Conquests of Charlemagne in grisaille (now in Brussels, Bibliothèque Royale) with great sensitiveness for his medium. Also in the Bibliothèque Royale of Brussels is the History of Charles Martel, illuminated by Loyset Liédet. Simon Marmion, justly called 'prince d'enluminure' by his contemporaries for his skill in blending the most delicate ranges of colour, was author of the splendid manuscript *Grandes Chroniques de Saint-Denis* (Leningrad, State Public Library). This

contains the complete history of France up to the time of Charles V, with scenes of battle and landscape-backgrounds rendered with the skill of a great master. Also attributed to Marmion is the *Fleur des Histoires* Plate 121 (Brussels, Bibliothèque Royale), which is a masterpiece of colouring and polished technique.

Among religious books, the Breviary of Philip the Good (Brussels, Plate 116 Bibliothèque Royale) is notable for the intricacy of its decoration, on which more than one artist was at work.

One of the principal miniaturists of Charles the Bold, the son and successor of Philip the Good, was Sanders Bening, who was the head of a large family of artists. The death of Charles the Bold in 1477 marked the beginning of a new period – with the reign of Mary of Burgundy, wife of the Emperor Maximilian, and the regency of Margaret of Anjou. Up to this time French art had exercised considerable influence on Flemish artists; but now contacts became much less close. Ghent and Bruges became the centres of the new school of illumination, which developed alongside one another and in close touch with the new painting of Hugo van der Goes, Memling, Gérard David, Mabuse and Van Orley. One can detect a change in taste: no longer the realistic narrative painting of earlier miniatures, with its precise and minute rendering of innumerable details, but instead more spacious scenes, in which figures express noble moral sentiments in sumptuous natural settings. In their marginal decorations Flemish miniaturists loved to paint borders of fruit and flowers filled with every kind of insect. The Book of Hours of Mary of Burgundy (Berlin, Staatsbibliothek) and that of Maximilian (Vienna, Nationalbibliothek) are early masterpieces of this school, which later produced a work of exceptional interest in the Grimani Breviary in the Biblioteca Marciana in Venice. Several Plate 123 artists took part in the decoration of this huge book, among them the Bening family and Gérard Horenbout (Gérard de Gand). The attempt to imitate great oil paintings, which is to the detriment of those qualities specific to miniature painting, can already be observed in this famous book. Moreover the naturalistic motifs of its marginal borders are sometimes excessively exuberant.

It is already possible to see in the Grimani Breviary the first signs of a decline which was to become increasingly evident in the years which followed, up to the third decade of the sixteenth century. The Books of Hours produced in this period attempt to emulate the grandiose manner of panel paintings, forgetting that miniature painting is decoration which should adapt itself to the text of the manuscript.

In Spain, the taste for beautiful illuminated books lasted into the Gothic Plate 125 period and the Renaissance. We have evidence of this in several manu-

scripts which demonstrate the different stylistic tendencies of the art of the time. Thus while the *Cantigas del rey Sabio* of the Escorial Library, written and illuminated at Seville in the second half of the thirteenth century, reveals tastes and tendencies of Christian and Moslem Spain, the Book of Hours of Queen Juana Henríquez, mother of Ferdinand the Catholic (Madrid) is inspired by French or Flemish art.

The art of miniature painting was also practised in Portugal. Dating from the end of the thirteenth century is a Hebrew Bible, illustrated by Jose Osarfati with vivid and brilliant colouring. It is especially interesting for its illustration of Portuguese 'mudejar' architecture, showing clear Moslem influences. Miniature painting in Portugal also developed later. One of the most notable fifteenth-century manuscripts is the Chronicle of Gomes Eaunes de Azurara (Paris, Bibliothèque Nationale), which contains an interesting portrait of Henry the Navigator.

Miniature Painting in Italy from the Thirteenth Century to the beginning of the Sixteenth Century

WE HAVE ALREADY SEEN that the miniature painting which flourished in Italy during the eleventh and twelfth centuries was entirely religious in character because it was developed in Benedictine monasteries, especially in the strongly Byzantine South.

The thirteenth century marks a period of transition. Byzantinism did not disappear but was absorbed in the new forms of Western art in the different centres throughout Italy. Miniature painting was still essentially religious, but at the same time secular books became more widely diffused, especially books relating to the legal studies which had their centre in the University of Bologna. One artist who probably worked in Bologna is known to us by name – Oderisi of Gubbio, praised by Dante in the *Divine Comedy*, but none of his works have so far been identified.

With the fourteenth century a new era begins, and Italian illumination gradually acquires a physiognomy of its own, with different characteristics according to the centres in which it was developed. In the course of this century local schools flourished in every region, each of which produced artists with individual personalities. In Italy, as elsewhere in Europe, one sees the same phenomenon of the appearance of lay master-miniaturists beside monastic artists.

In Lombardy, an aristocratic art owing to ultramontane influences flourished under the patronage of the Visconti. There it is possible to recognise the work of several artists of undoubted importance: Giovanni di Benedetto da Como, who was responsible for decorating the Book of Offices of Bianca of Savoy (Munich, Staatsbibliothek), interpreting its religious theme in gentle narrative illustrations; Anovelo da Imbonate, an artist who loved to describe worldly elegance, and stands stylistically close to French miniaturists, remembered in particular for his Missal for the Coronation of Gian Galeazzo Visconti (Milan, Biblioteca della Basilica di Sant' Ambrogio); and Giovannino de' Grassi, a versatile man whose work was not confined to miniature painting alone. Among other things, Giovannino produced a sketch-book of drawings of great refinement, now in the Biblioteca Civica of Bergamo, the Book of Offices of Gian Galeazzo Visconti (Milan, Library of the Duke Visconti di Modrone), and part of the Landau-Finaly Office Book, which he painted with the help of pupils (Florence, Biblioteca Nazionale); his art had certainly come into contact with Franco-Flemish miniaturists, and by then he adhered completely to the naturalism of the International Gothic style. Belonging to this same stylistic current are the *Tacuina Sanitatis*, or notebooks of medical recipes (seen in two examplars in the Biblioteca Casanatense in Rome and the Nationalbibliothek of Vienna, which are illustrated by anonymous artists and provide a precious mine of information for the study of costume in the last years of the fourteenth century; their numerous vignettes, which are inspired by a lively realism, evoke a wonderfully real sense of nature.

There were many miniaturists, too, who worked in the learned town of Bologna in the fourteenth century. One could compile a long list of their names, but here it will be enough to mention two artists whose personalities dominated the art of miniature painting in Bologna in this century: Franco Bolognese, recorded by Dante as the artist who would obscure the glory of Oderisi of Gubbio, and Niccolò di Giacomo. It is not yet possible to attribute any miniatures to the first of these artists with certainty, but there are numerous works which are known to belong to the second, among them the *Decretals* of the Vatican Library and the Ambrosiana Library of Milan, the *Lucan* in the Trivulziana of Milan, and others. Niccolò was certainly in contact with the art of Tuscany, where in the fourteenth century the two towns of Florence and Siena already stand out with clearly-defined features of their own.

In Florence we find Bibles, Missals, Hymnals and also figured exemplars of literary texts. Frequently small allegorical pictures or portraits are introduced within the confined space of the initial letter with which the text of each page begins. For the most part these miniatures show a portrait bust

of the author clothed as a doctor, his head crowned with laurel. The margins are decorated with leaf patterns which join together at the initial letters. The most interesting religious manuscripts include a Missal in the Laurenziana in Florence, a Bible belonging to the Trivulziana in Milan and the Hymn Books of the National Library of Florence. The *Biadaiolo* (literally 'grain-dealer') in the Laurenziana belongs to a popular vein of miniature painting and is a document of great interest for the every-day life of Florence between 1320 and 1335. Among the literary texts, Dante's *Divine Comedy* enjoyed special popularity, yet in spite of this, the decoration of many exemplars of this book is only of mediocre quality. Outstanding among them for its delicate technique and spacious composition is the copy belonging to the Trivulziana in Milan.

Plates 106

Plates 103

In Siena, miniaturists tended towards paintings of exceptional refinement. The most obvious characteristics of Sienese art are to be found in the elegance of the figures, the sweetness of their expressions, and in the fine quality of technique. Simone Martini was a miniaturist as well as a painter; it is he who illuminated the famous frontispiece of the Virgil in the Ambrosiana of Milan. We know, too, of other miniatures by artists better known for their paintings than for their illuminations, such as Niccolò Tegliacci, who painted the large miniature at the beginning of the *Caleffo dell'Assunta* (a book of legal documents in the Siena State Archives), and Lippo Vanni.

Plate 107

The influence of Simone Martini can be seen in the work of the great anonymous illuminator who is called after his masterpiece in the Archives of St. Peter's in the Vatican City 'Master of the Codex of St. George'.

Miniature painting of the Renaissance is distinguished from that of the preceding period by a greater desire to seek pictorial effect and a tendency towards grandiosity.

Plate 140

Plate 130

The passage from the Gothic to the Renaissance is represented in Lombardy by artists such as Michelino da Besozzo, a precious example of whose work can be seen in a Sermon in the Bibliothèque Nationale of Paris; Bonifazio Bembo, illuminator of the *Tarocchi*, or tarot cards, in the Accademia Carrara of Bergamo and the Pierpont Morgan Library of New York; and Belbello of Pavia, who had the task of completing the Landau-Finaly Book of Offices left unfinished by Giovannino de' Grassi and his collaborators.

Plate 141

Among the later artists at work in Lombardy are Cristoforo de' Predis with his Borromei Book of Offices (Milan, Ambrosiana), Antonio da Monza, author of a large miniature of the Pentecost (Vienna, Albertina Collection) and Giovanni Pietro Birago with the Grammar of Donatus (Milan, Trivulziana), which he executed in collaboration with other masters. Girolamo of Cremona and Liberale of Verona, too, are among the

28

greatest representatives of Renaissance miniature painting in northern Italy, as can be seen from their extensive work in the Graduals of the Piccolomini Library at Siena: freely flowing, exuberant and imaginative, they seem to want to emulate the great art of panel painting and now and then anticipate the baroque.

Plates 138, 139

More important than all the other centres in Italy are those of Ferrara and Florence. At Ferrara the splendid flowering of miniature painting coincides in the middle of the fifteenth century with a period of vigorous civic life under the Este Dukes and the efflorescence of all the other arts. Guglielmo Giraldi, Taddeo Crivelli and Franco de' Russi were among the many masters who worked for the House of Este.

Plates 131, 132

Of the many and different masterpieces of Ferrarese art now extant, only the famous Borso Bible (Modena, Biblioteca Estense) need be mentioned here, among whose numerous illuminators a place of preeminence belongs to Taddeo Crivelli and Franco de' Russi. The influence of Ferrarese painters, and also of Pisanello, Piero della Francesca and Mantegna, is reflected in the magnificent decoration of this book, in which the figurative parts blend harmoniously with the marginal borders.

Plates 134, 136

In Florence the transition from the fifteenth to the sixteenth century is represented by the artists of the monastery of Santa Maria degli Angeli. At their head was Lorenzo Monaco, a painter and miniaturist who leaves incomparable evidence of his gifts of imagination and sense of colour in a Sunday Diurnal in the Laurentian library. He handles the late-Gothic style with great originality and knows how to blend successfully elements of Sienese and Florentine art with those derived from northern Europe.

Plate 129

In the second half of the fifteenth century, beside the religious production, another kind developed which can be called 'secular' because it was engaged in the decoration of literary texts, many of which were produced in the workshop of Vespasiano da Bisticci. Here books were made which were destined for the collections of the Medici family, the House of Aragon, the Dukes of Urbino and Ferrara, and as far afield as King Matthias Corvinus of Hungary. Among the Florentine miniaturists of this period who can be identified – for some still remain anonymous – are Zanobi Strozzi, whose hand can be recognised in many volumes in the Convent of San Marco; Francesco d'Antonio del Cherico, an artist who loved to paint large scenes crowded with figures, as in the Antiphonaries made for Santa Maria del Fiore (now in the Laurentian Library); and Gherardo and Monte del Fora, in whose work Flemish and Florentine influences combine to create a style of complete originality. Produced jointly by the two brothers is the Psalter and New Testament in the Laurentian Library, which forms part of a Bible executed for Matthias Corvinus.

Plate 128
Adhering firmly to a purely Tuscan tradition is the Florentine Attavante degli Attavanti, whose work is stylistically close to the art of Ghirlandaio in its description of contemporary life and customs, far from all the search after dramatic effect, and from the over-elaboration of decorative detail. Attavanti's masterpiece is the Urbino Bible (now in the Vatican Library), which prompted Vespasiano da Bisticci, who saw it at Urbino, to exclaim 'Here is a book which in our times has no equal'.

With the beginning of the sixteenth century, the art of illumination gradually approaches a period of decadence. In Florence we find Boccardino il Vecchio, the originator of a decorative manner which soon became conventionalised by constant repetition; in Milan, Agostino Decio, an artist of an affected charm, as can be seen in his Crucifixion in the Missal of the Pierpont Morgan Library; in Parma, Marmitta, who in the Plate 145 *Trionfi* of Petrarch (Library of Cassel) and the Durazzo Book of Offices (Genoa, Biblioteca Berio) shows himself to be an excellent miniaturist, well-acquainted with the problems of perspective, and with a wide knowledge of antique art.

Nevertheless, it is with Giulio Clovio, the last significant representative of Italian miniature painting, that this art is seen to be in full decline. Croat by birth and Roman by adoption, he was praised as a second Michelangelo by his contemporaries, who admired most those aspects of his art which we judge more severely; above all, they appreciated him for having introduced the methods of large-scale panel painting into the art of illumination. His compositions, which contain many figures in movement within a small space, and which he interprets with the potency and plasticism of Renaissance sculpture, exceed the limits that miniature painting rightly imposes. In his work it is already possible to see clearly how the very nature of this art was being destroyed by a vain search after grandiose effect.

And so the art of miniature painting soon moved to its close. When Vespasiano da Bisticci was at Urbino visiting the Library of Duke Federigo which he himself had largely helped to form, he became ecstatic at the sight of the series of magnificently-bound volumes among which there was not a single printed book. From this one can infer that the battle between the hand-written illuminated codex and the printed book decorated with engravings had already begun. It was to end with the triumph of the new mechanical art. For by indulging too often in a superficial love for decoration, miniature painting, in its last affirmation, had to a great extent lost the special charm which it had exercised from its earliest beginnings: it had provided a faithful mirror of deep human sentiment and reflected the cultures of different periods as they progressed through the centuries.

THE PLATES

1. The Ascension. *Syriac Gospels*. Byzantine, 586.
Florence, Biblioteca Laurenziana, MS. Plut. 1.56, fol. 13v.

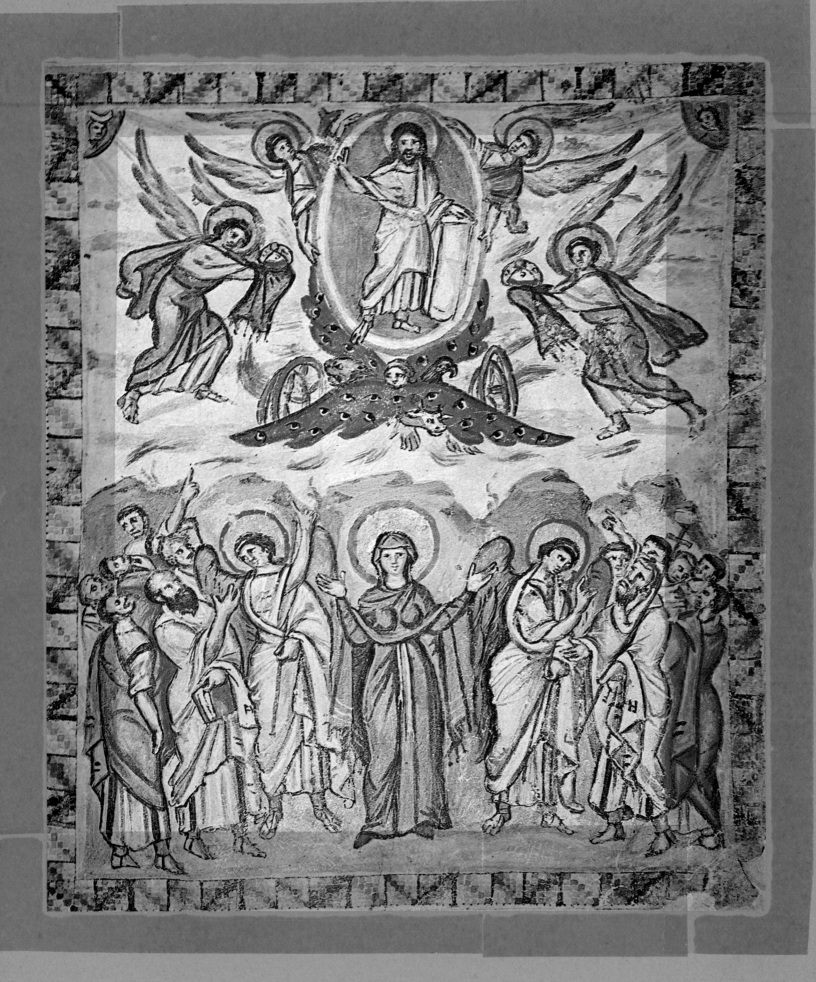

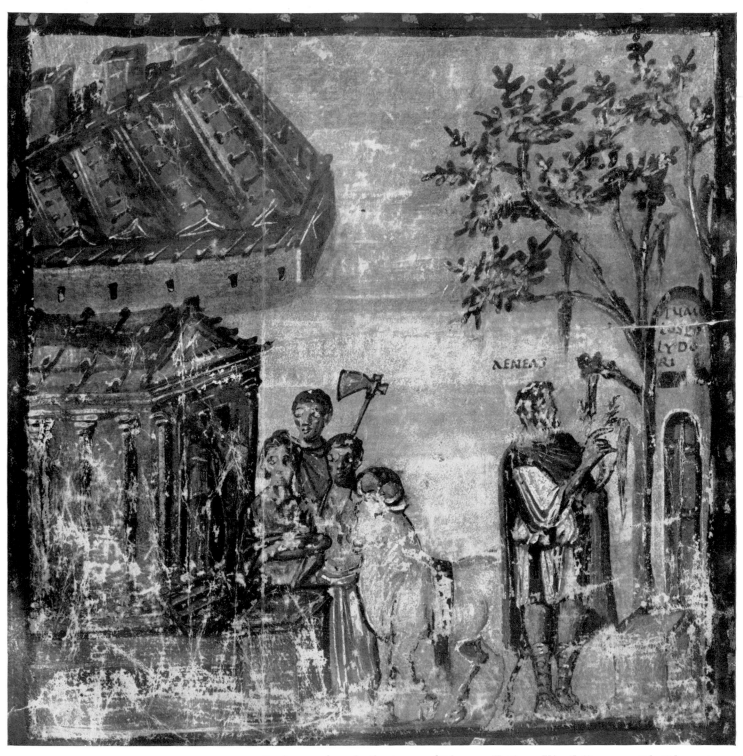

2. Aeneas founds the town of Thrace. *Vatican Virgil*. Roman, 4th-5th century.
Rome, Vatican Library, MS. Vat. lat. 3225, fol. 24.

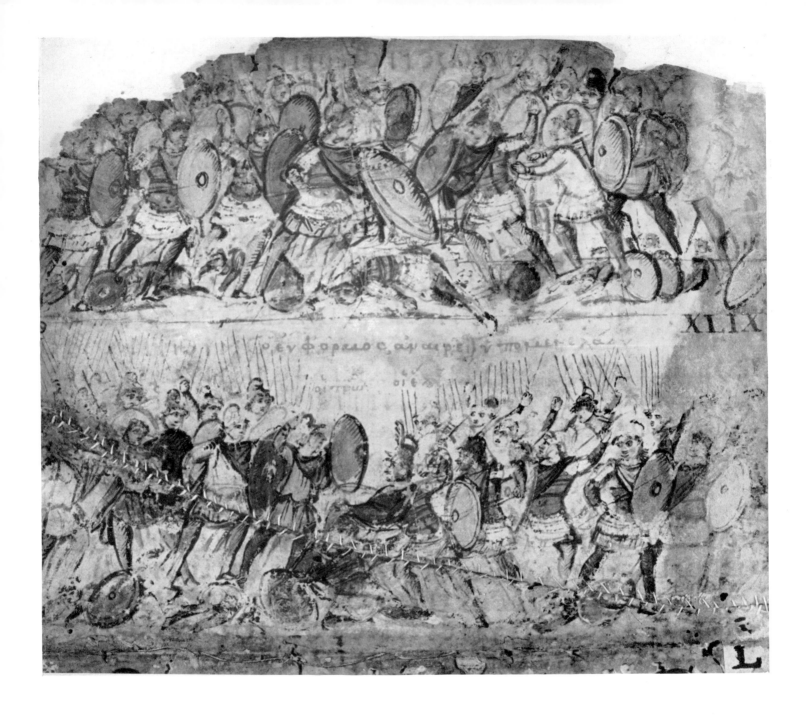

3. Menelaus protecting the body of Patroclus from the attack of Euphorbus; Menelaus killing Euphorbus. *Iliad*. Late Hellenistic, 5th century. Milan, Biblioteca Ambrosiana, Codex F. 205, inf. pict. XLIX–L.

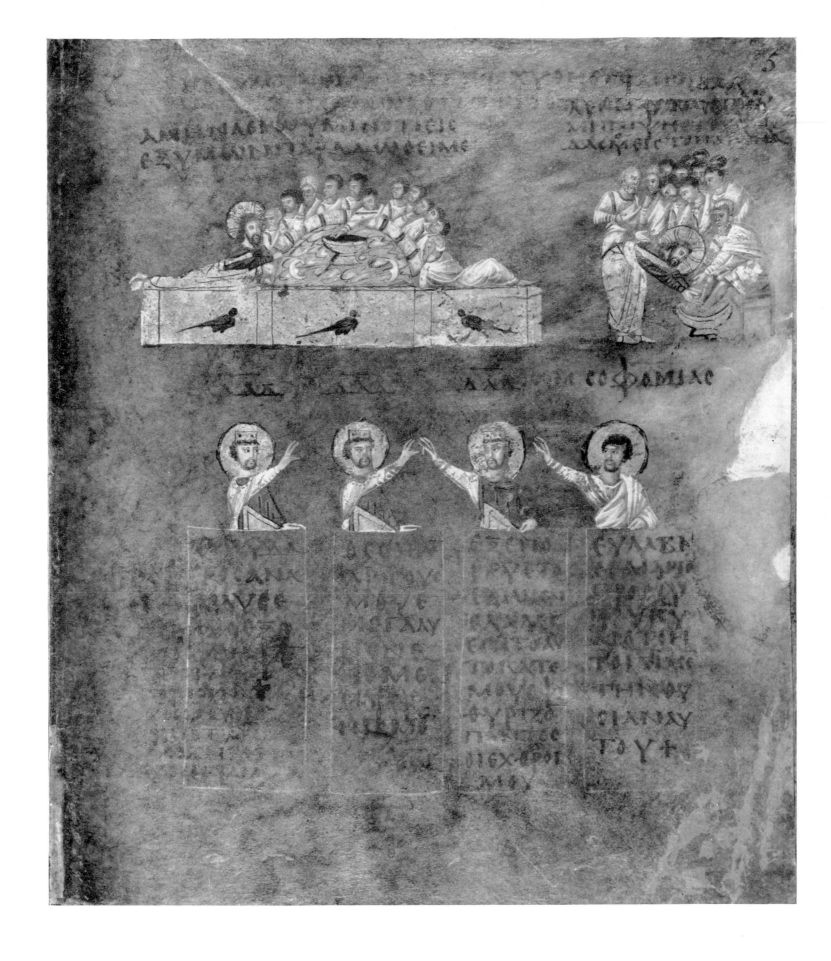

4. The Last Supper and the Washing of the Feet. *Greek Gospels*. Byzantine, 6th century.
Rossano in Calabria, Cathedral Library, fol. 3r.

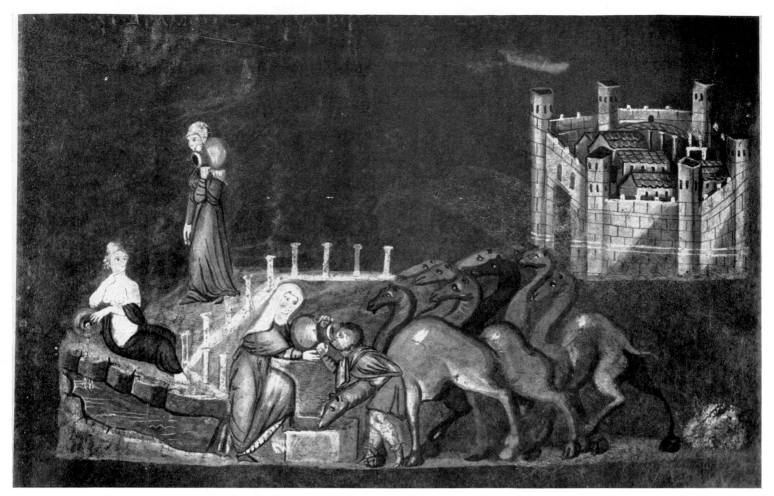

5. Rebecca and Eliezer at the well. *Vienna Genesis*. Byzantine, 6th century.
Vienna, Nationalbibliothek, MS. Vindobon., theol. gr. 31, fol. 7r.

6. Detail of Plate 5.

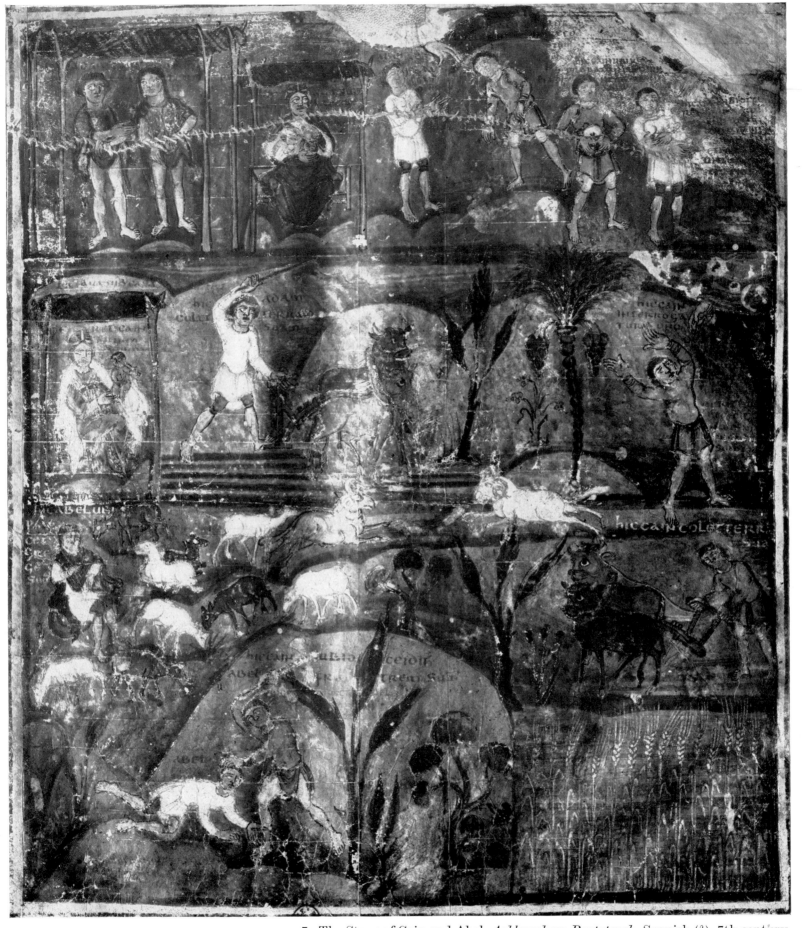

7. The Story of Cain and Abel. *Ashburnham Pentateuch.* Spanish (?), 7th century.
Paris, Bibliothèque Nationale, MS. nouv. acq. lat. 2334, fol. 6.

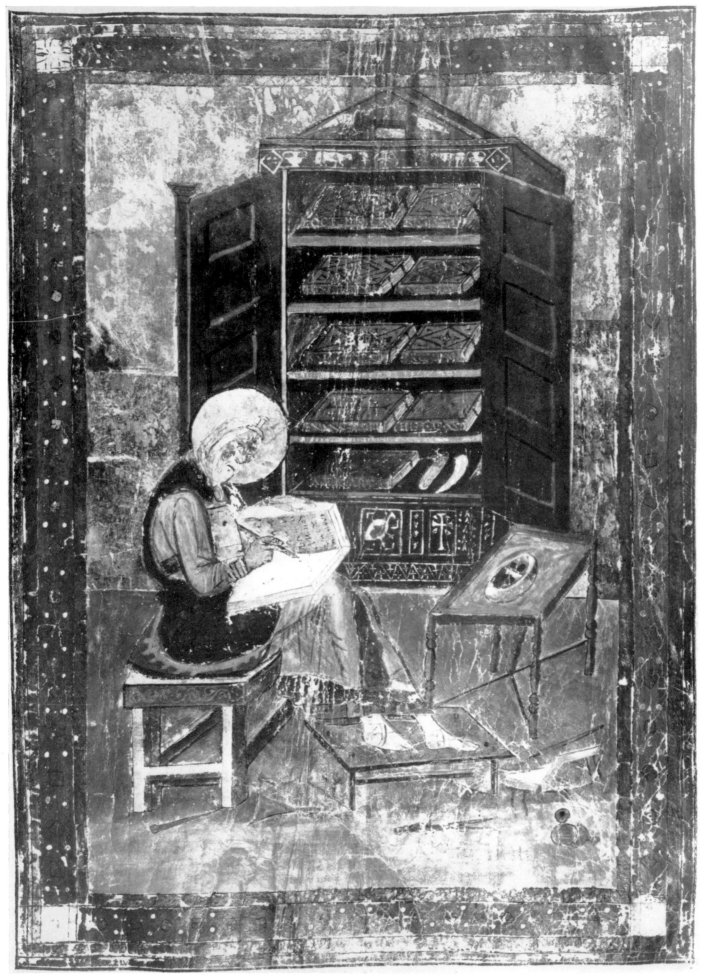

8. Ezra the Scribe. *Codex Amiatinus. Bible.* Italian ?, 7th–8th century.
Florence, Biblioteca Laurenziana, MS. Amiat. I, fol. 5r.

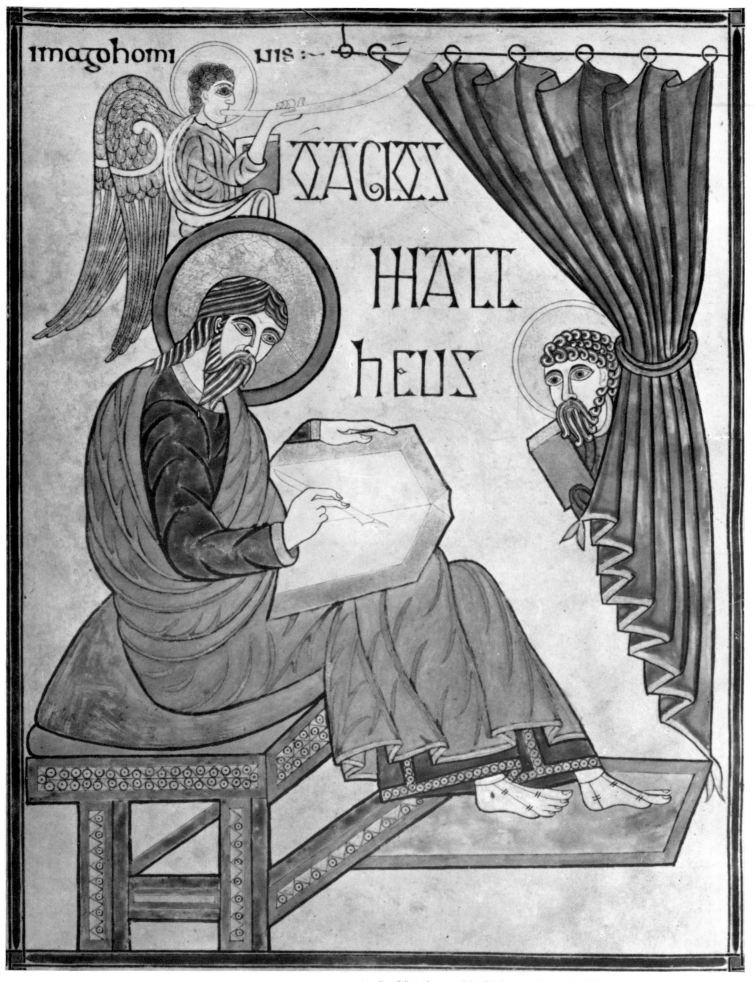

imago homi nis :~

O AGIOS

MATT

heus

9. St. Matthew. *Lindisfarne Gospels*. Hiberno-Saxon, about 700.
London, British Museum, MS. Cotton Nero D. IV, fol. 25v.

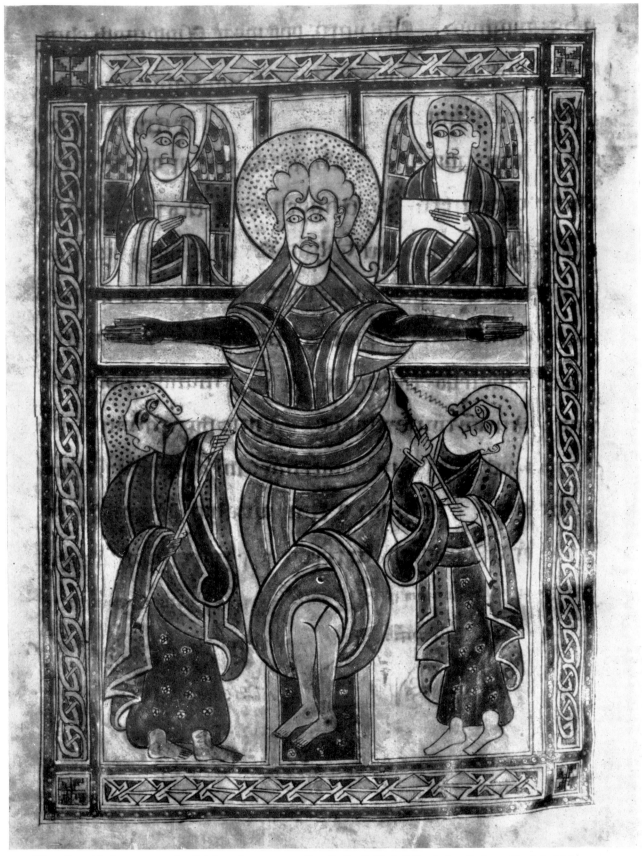

10. The Crucifixion. *Gospels*. Irish, about 750. St. Gall, Stiftsbibliothek, Codex 51, fol. 266r.

11. St. Matthew. *Book of Kells. Gospels*. Irish, late 8th century.
Dublin, Trinity College Library, MS. A.I.6, fol. 28v.

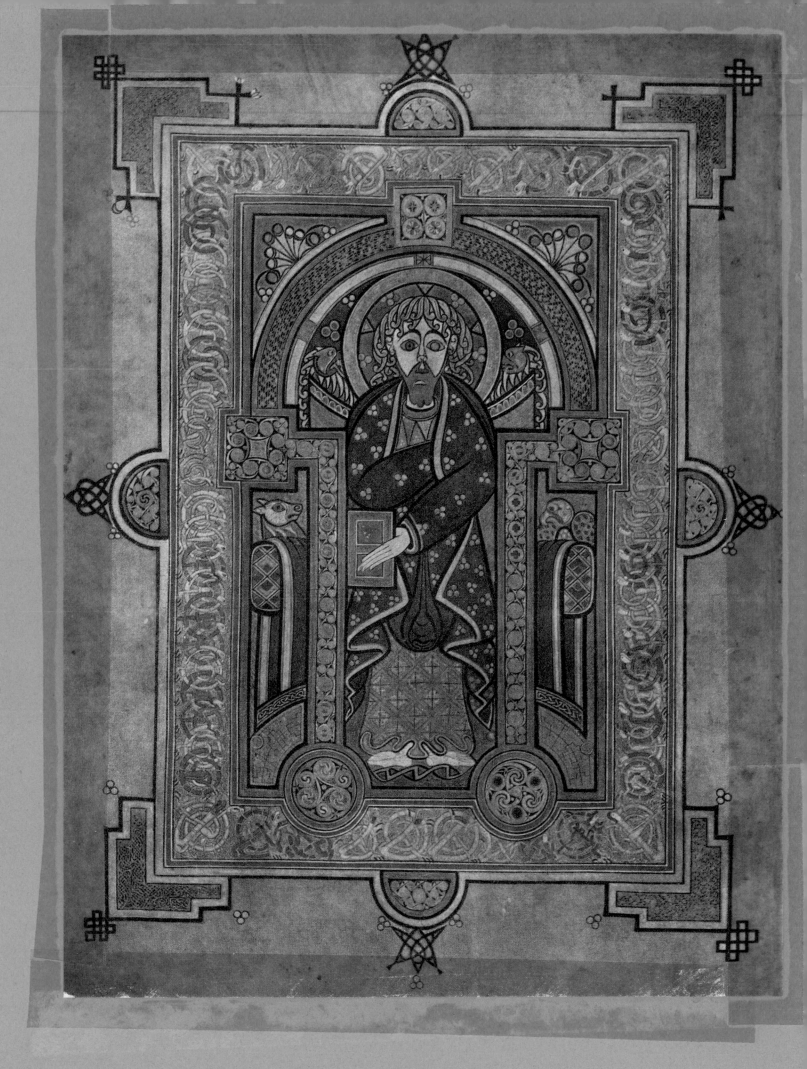

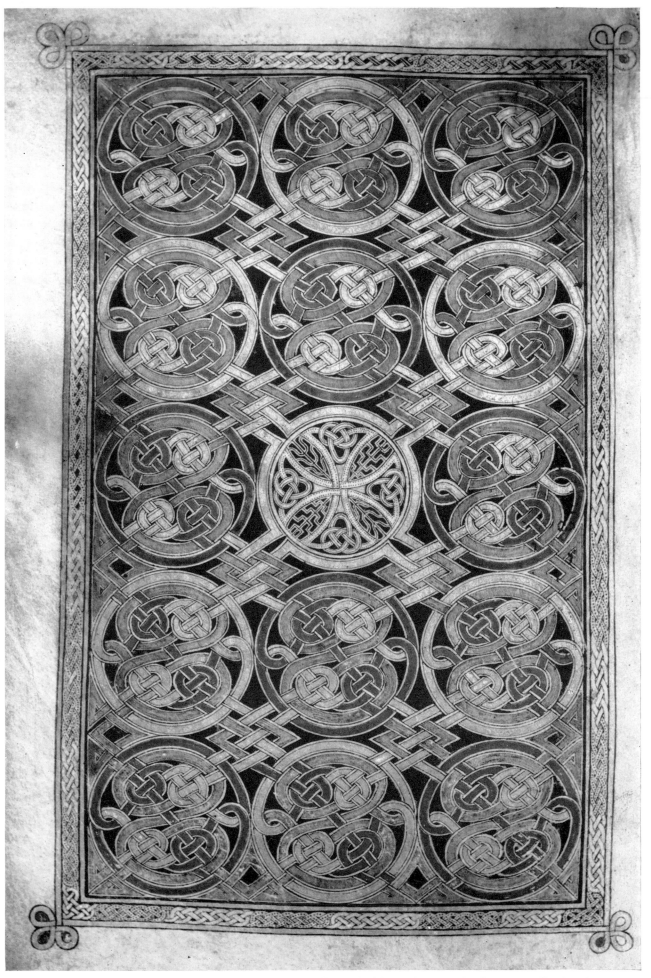

12. Carpet page to the Gospel of St. John. *Book of Durrow*. Irish, about 700.
Dublin, Trinity College, MS. 57, fol. 77v.

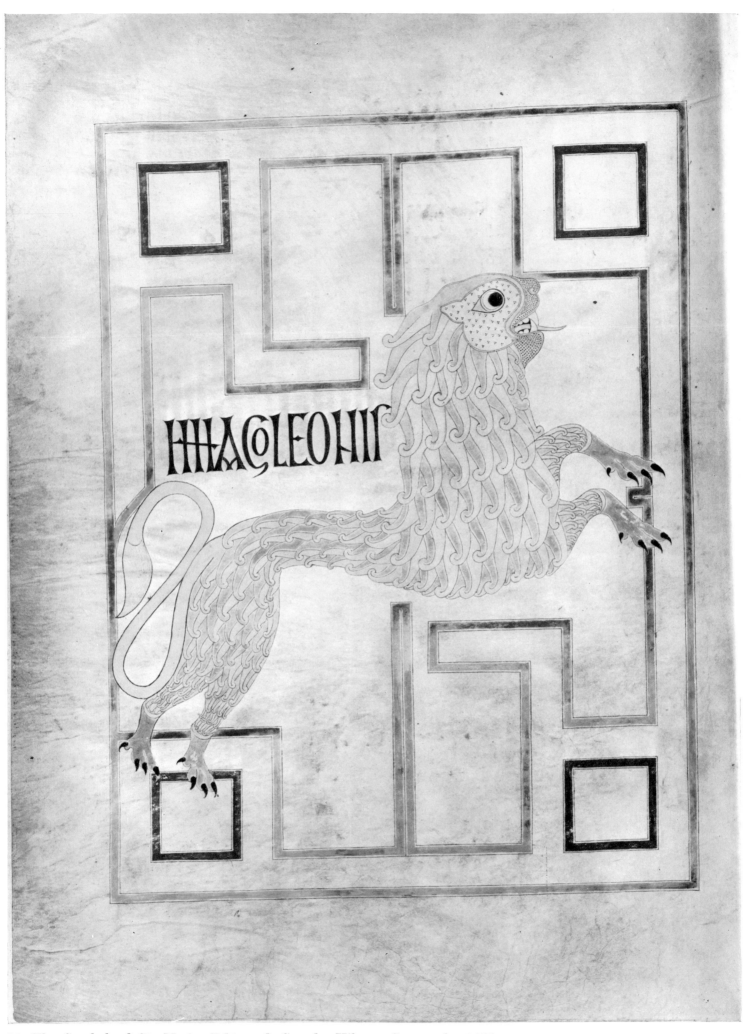

13. The Symbol of St. Mark. *Echternach Gospels*. Hiberno-Saxon, about 710.
Paris, Bibliothèque Nationale, MS. lat. 9389, fol. 75v.

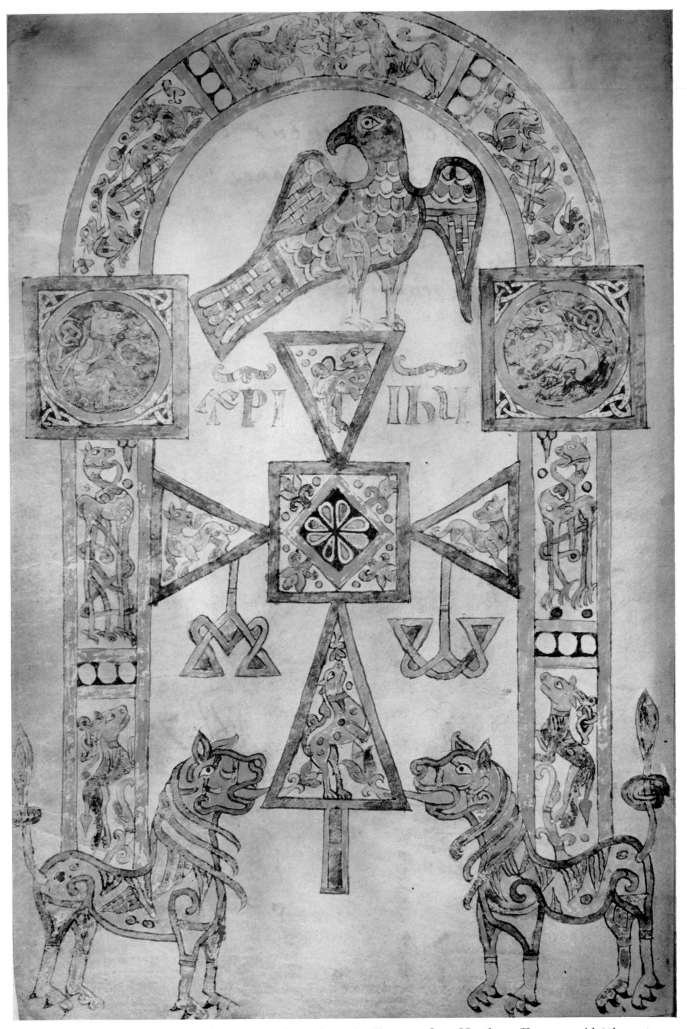

14. Frontispiece to St. Augustine's *Quaestiones in Heptateuchon*. Northern France, mid-8th century.
Paris, Bibliothèque Nationale, MS. lat. 12168.

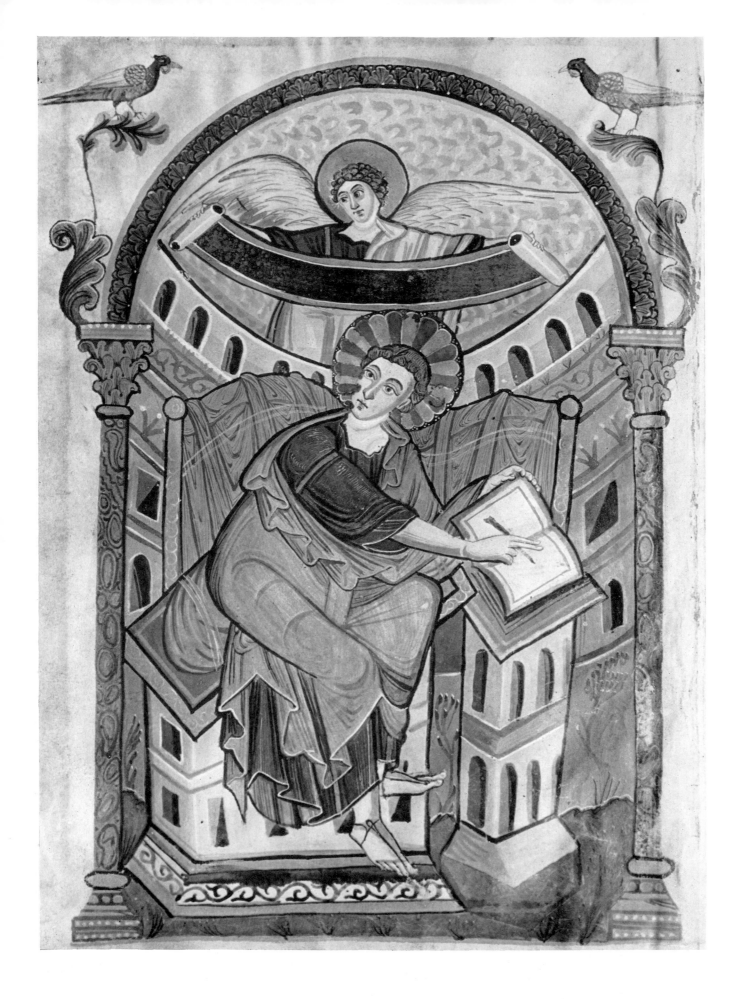

15. St. Matthew. *Ada Gospels.*
Carolingian, about 800. Trier, Stadtbibliotek, MS. 22, Codex Aureus, fol. 15r.

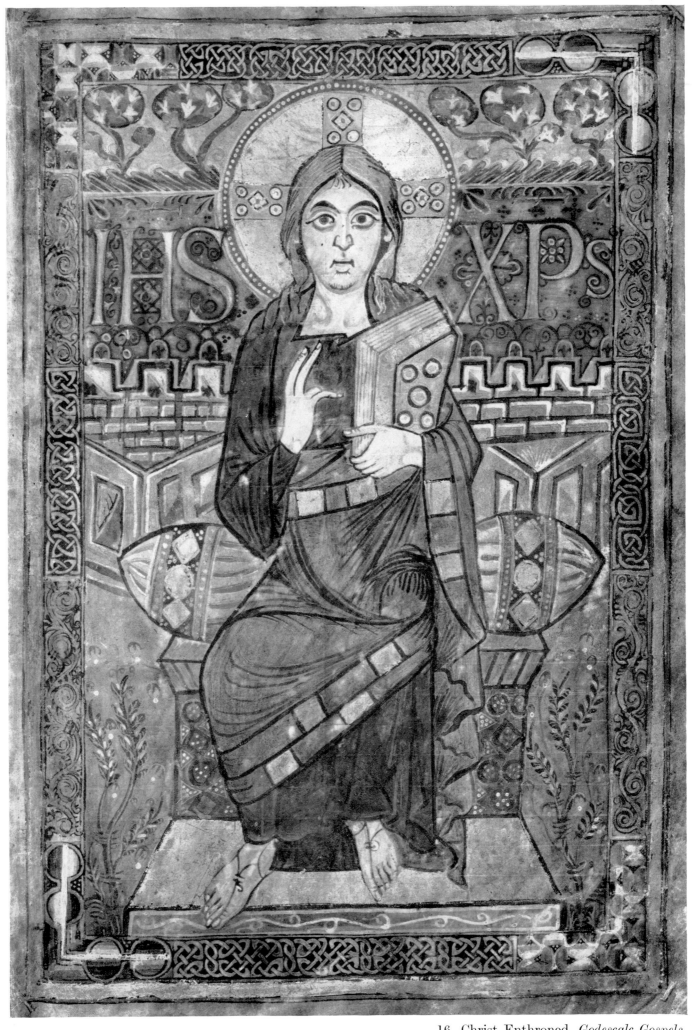

16. Christ Enthroned. *Godescalc Gospels.*
Carolingian, 781–783. Paris, Bibliothèque Nationale, MS. nouv. acq. lat. 1203, fol. 3r.

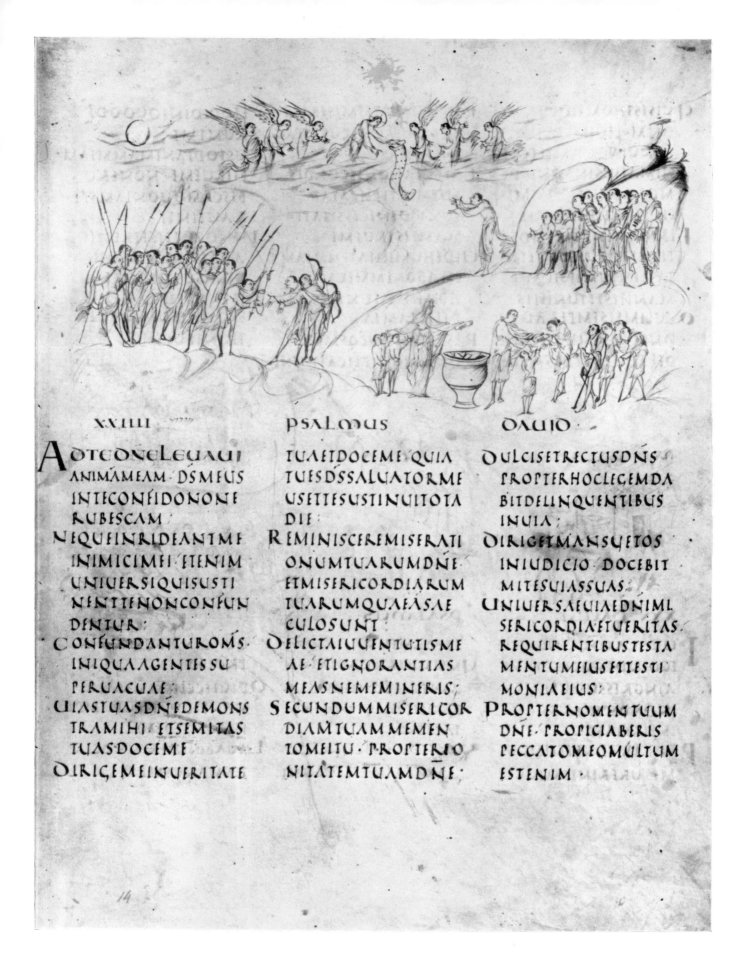

XXIIII PSALMUS DAUID

ADTEDNELEUAUI
ANIMAMEAM·DSMEUS
INTECONFIDONONE
RUBESCAM·
NEQUEINRIDEANTME
INIMICIMEI·ETENIM
UNIUERSIQUISUSTI
NENTTENONCONFUN
DENTUR·
CONFUNDANTUROMS
INIQUAAGENTISSU
PERUACUAE·
UIASTUASDNEDEMONS
TRAMIHI·ETSEMITAS
TUASDOCEME
DIRIGEMEINUERITATE

TUAETDOCEME·QUIA
TUESDSSALUATORME
USETTESUSTINUITOTA
DIE·
REMINISCEREMISERATI
ONUMTUARUMDNE·
ETMISERICORDIARUM
TUARUMQUAEASAE
CULOSUNT·
DELICTAIUUENTUTISME
AE·ETIGNORANTIAS
MEASNEMEMINERIS·
SECUNDUMMISERICOR
DIAMTUAMMEMEN
TOMEITU·PROPTERBO
NITATEMTUAMDNE·

DULCISETRECTUSDNS·
PROPTERHOCLEGEMDA
BITDELINQUENTIBUS
INUIA·
DIRIGETMANSUETOS
INIUDICIO·DOCEBIT
MITESUIASSUAS·
UNIUERSAEUIAEDNIML
SERICORDIAETUERITAS
REQUIRENTIBUSTESTA
MENTUMEIUSETTESTI
MONIAEIUS·
PROPTERNOMENTUUM
DNE·PROPICIABERIS
PECCATOMEOMULTUM
ESTENIM·

14

17. Illustrations to Psalm 24. *Utrecht Psalter*. Rheims, early 9th century. Utrecht, University Library, MS. 32, fol. 14r.

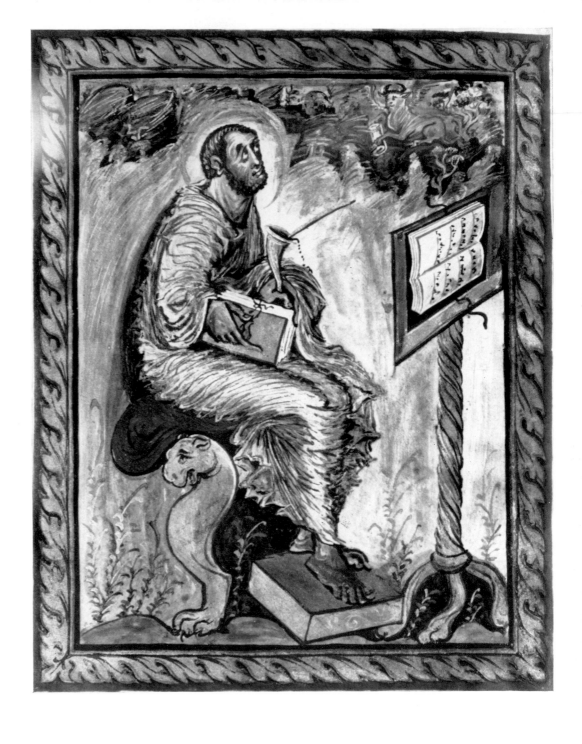

18. St. Luke. *Ebbo Gospels*. Rheims, 9th century. Épernay, Bibliothèque Municipale, MS. I, fol. 90v.

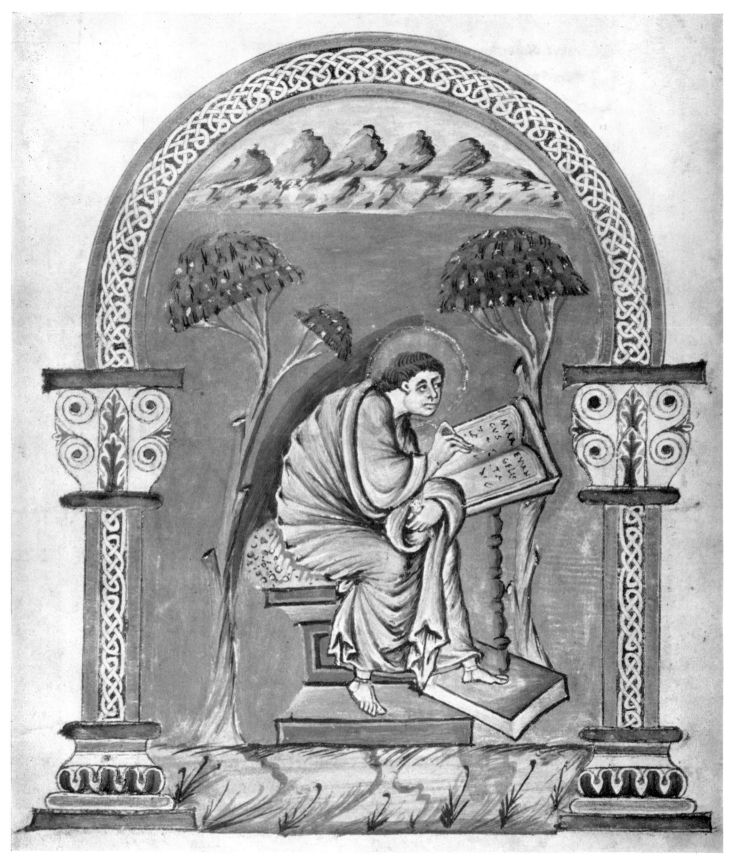

19. St. Mark. *Gospels of Francis II*. Franco-Insular School, 9th century.
Paris, Bibliothèque Nationale, MS. lat. 257, fol. 60v.

20. The four Evangelists. *Gospels*. Rheims, early 9th century.
Aachen, Cathedral Treasury, Codex Aureus, fol. 13r.

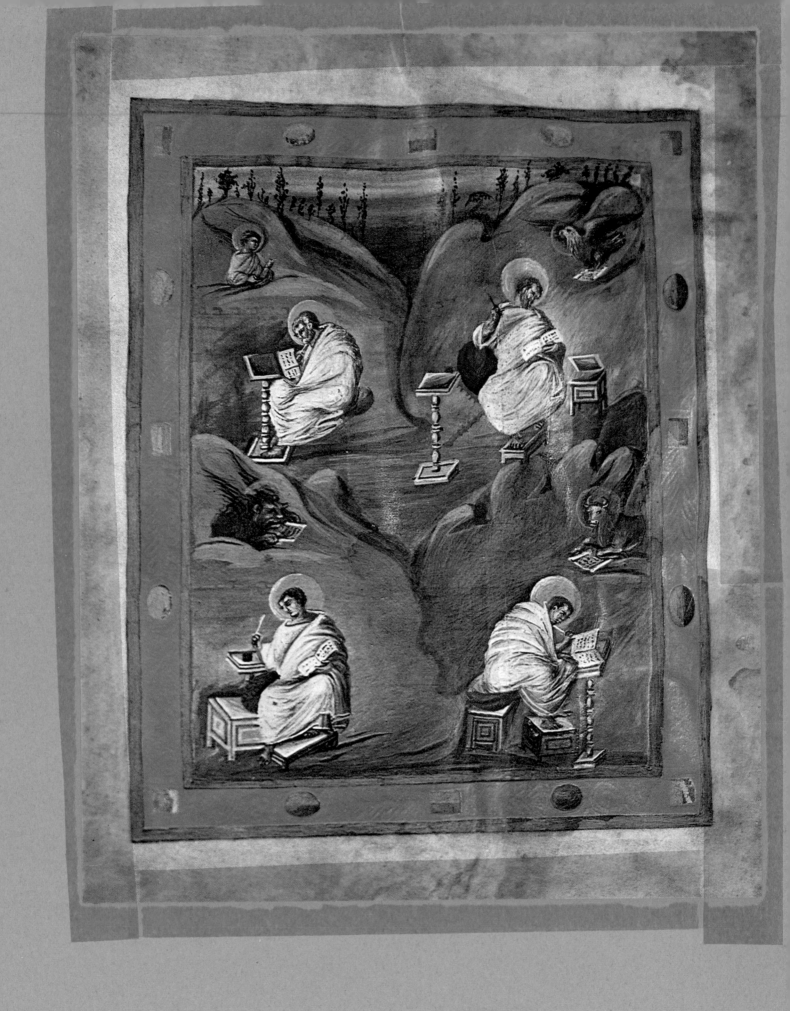

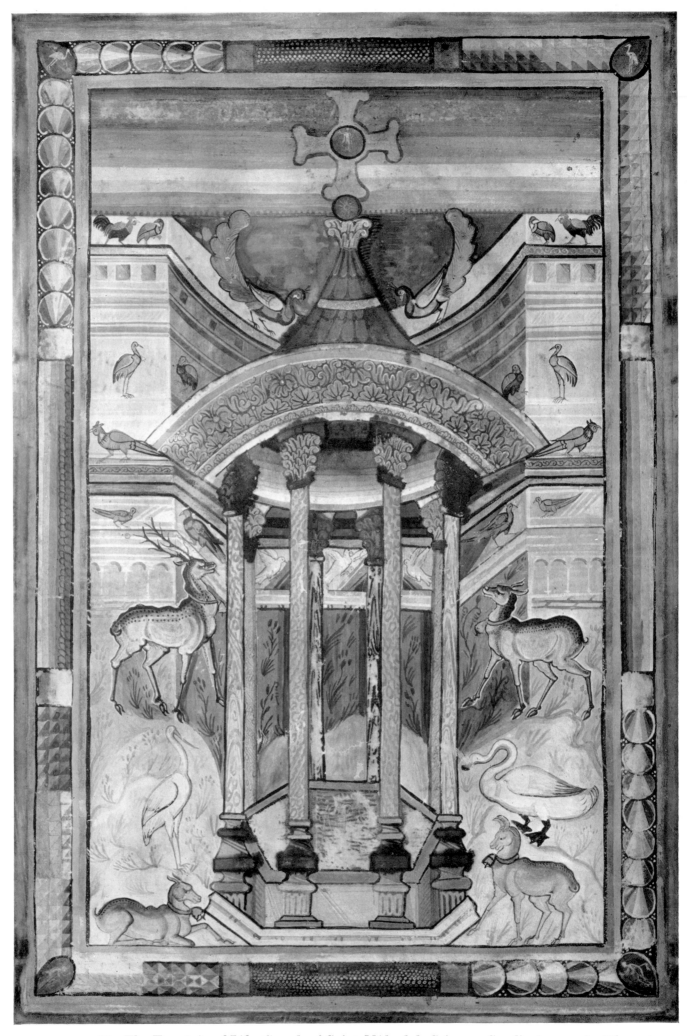

21. The Fountain of Life. *Gospels of Saint Médard de Soissons*. Carolingian, early 9th century.
Paris, Bibliothèque Nationale, MS. lat. 8850, fol. 6v.

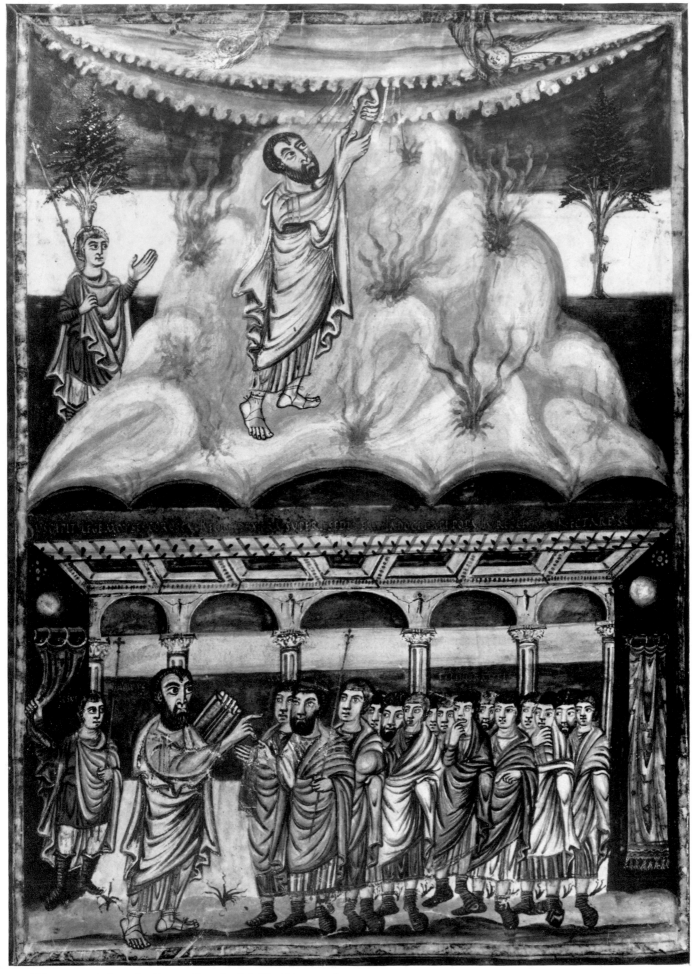

22. Moses receiving the Law. *Grandval Bible*. Tours, about 840.
London, British Museum, MS. Add. 10546, fol. 25v.

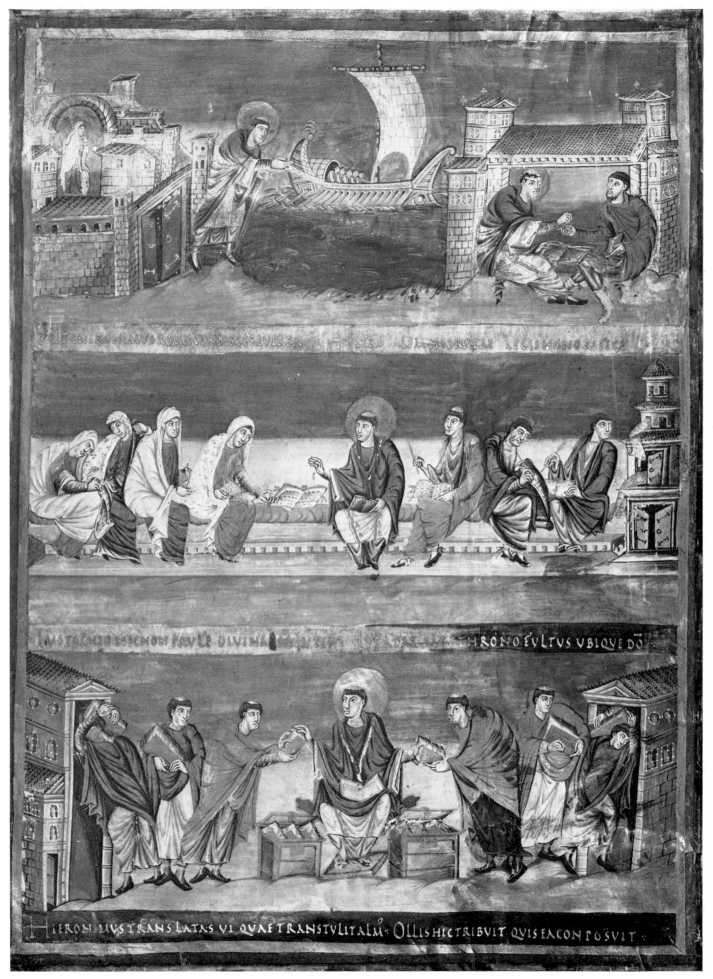

23. Scenes from the Life of St. Jerome. *Bible of Charles the Bald*. Carolingian, about 846.
Paris, Bibliothèque Nationale, MS. lat. I, fol. 3v.

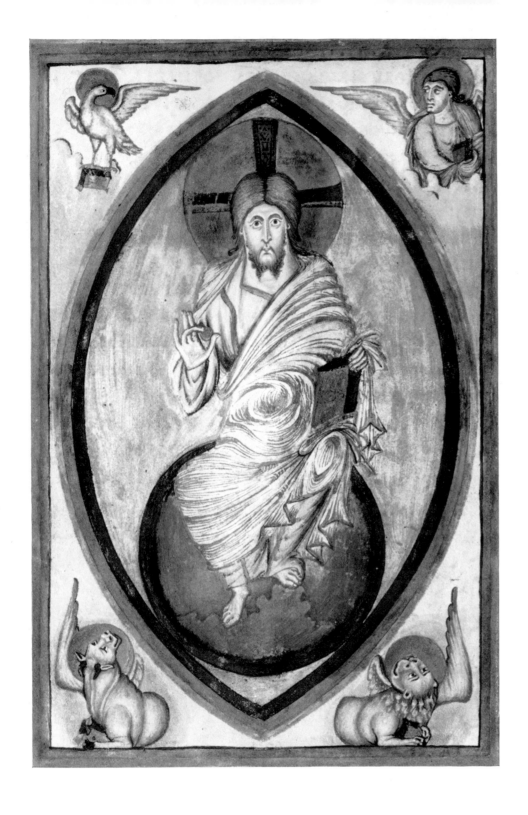

24. Christ in Majesty with the Symbols of the Evangelists. *Gospels of Lothair*.
Tours, 849–851. Paris, Bibliothèque Nationale, MS. lat. 266, fol. 2v.

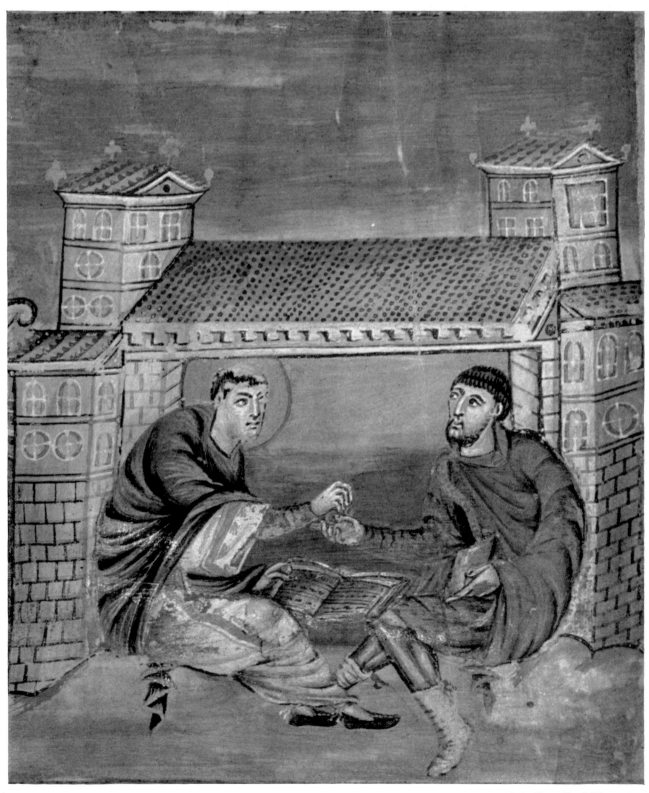

25. Detail of Plate 23.

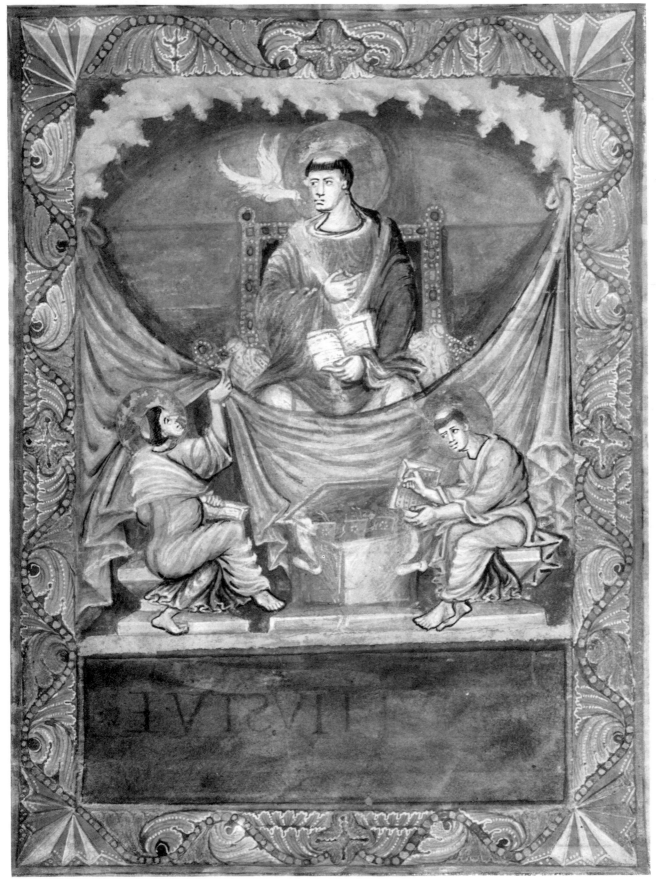

26. St. Gregory. Fragment of a *Sacramentary*. Rheims, 9th century.
Paris, Bibliothèque Nationale, MS. lat. 114l, fol. 3r.

27. The Adoration of the Lamb and the twenty-four Elders. *Gospels, Codex Aureus of St. Emmeram.*
Carolingian, 9th century. Munich, Staatsbibliothek, Clm. 14000, fol. 6r.

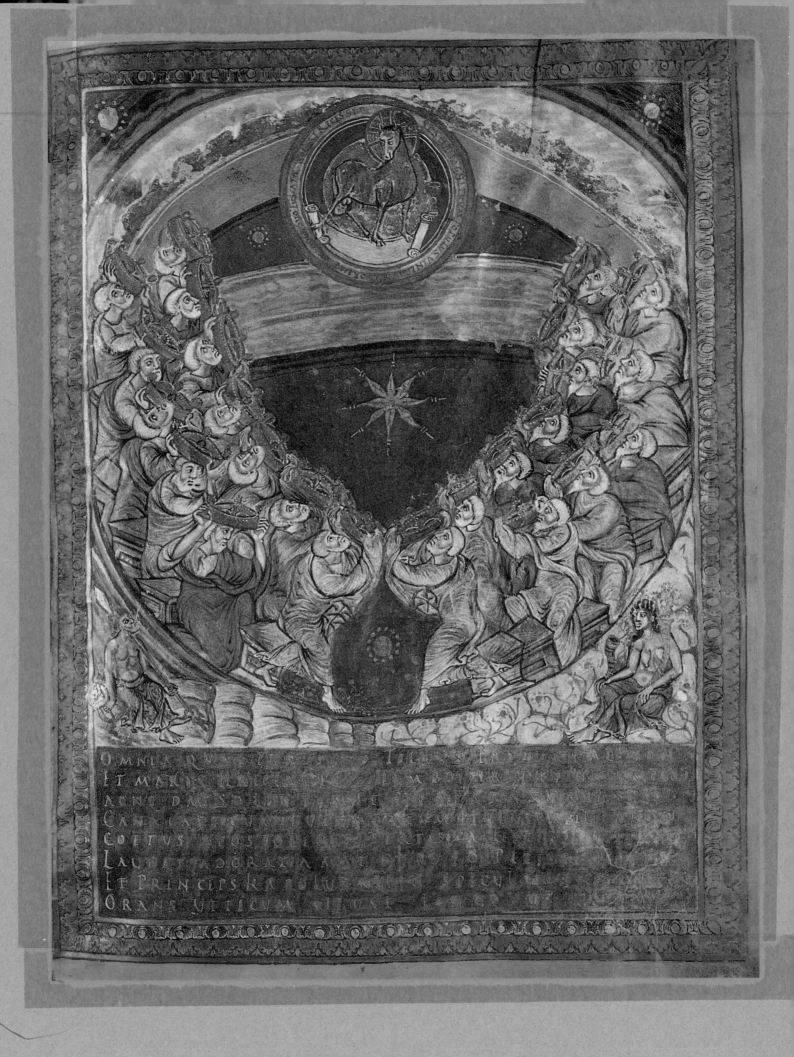

OMNIA QVI · · · · · · · · · IDE · S · ERYSIT · IN · ALTV · · · ·
ET · MARIS · · · · · · · · · · · · · IMBOS · VIR · TEN · NON · · · · · ·
ACNE · DNS · SOLI ·
CANVI · CELI · VI · · · · · · · · · · · · · · · · EM · IATI · · · · · BELL · · VROM ·
COETVS · APOSTOLI · · · · · · · · · · · TIS · IOA · · · · · · · · · · · ·
LAVDET · ADORA · · · · · · · · · · · QVOD · INS · I · SP · · · · · ·
ET · PRINCEPS · KAROLV · · · · · · · · · · · SPECVL · · · · · · · ·
ORANS · VTT · ICVM · · · · · · · · · AL · · I · · EO · · · · · · · · · · ·

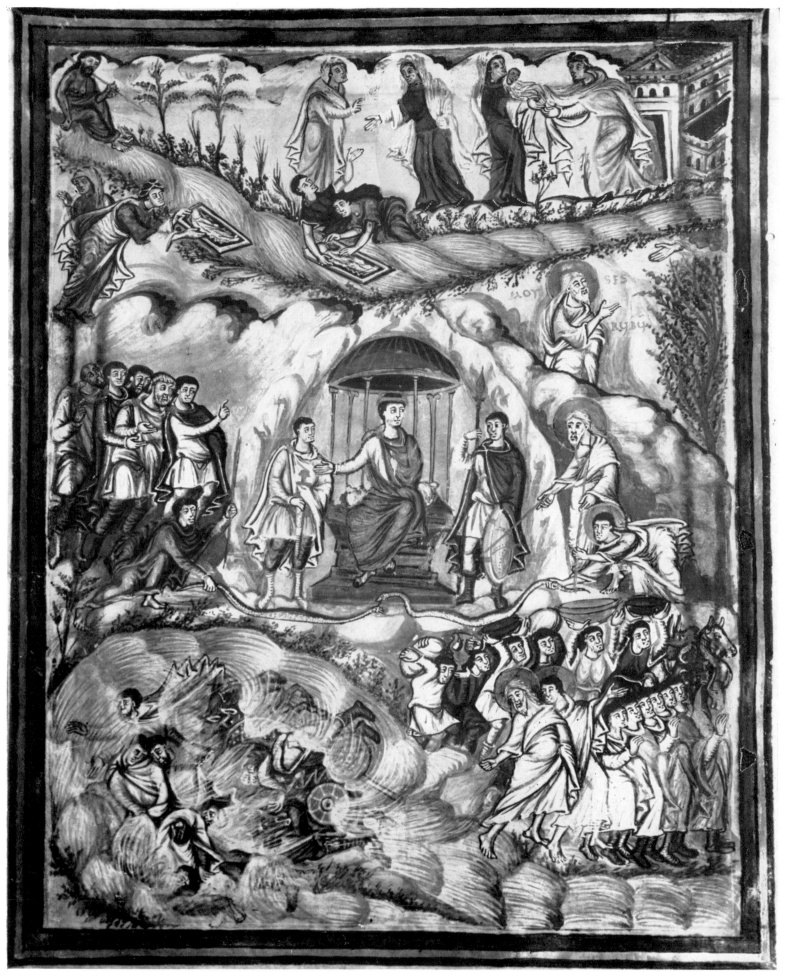

28. The Story of Moses. *Bible of San Callisto*. Corbie, about 870. Rome, Library of San Paolo fuori le Mura, fol. 20v.

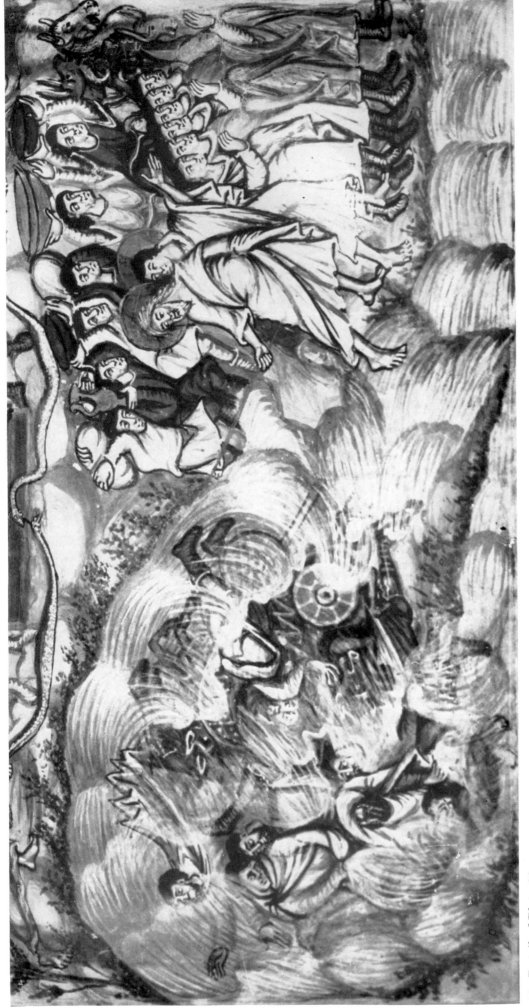

29. Detail of Plate 28.

30. Detail of Plate 27.

31. The Three Maries and the Angel at the Sepulchre. *Benedictional of St. Aethelwold.*
Winchester School, about 975–980. London, British Museum, MS. Add. 49598, fol. 51v.

32. St. Matthew. *Grimbald Gospels.* Winchester School, early 11th century.
London, British Museum, MS. Add. 34890, fol. 10v.

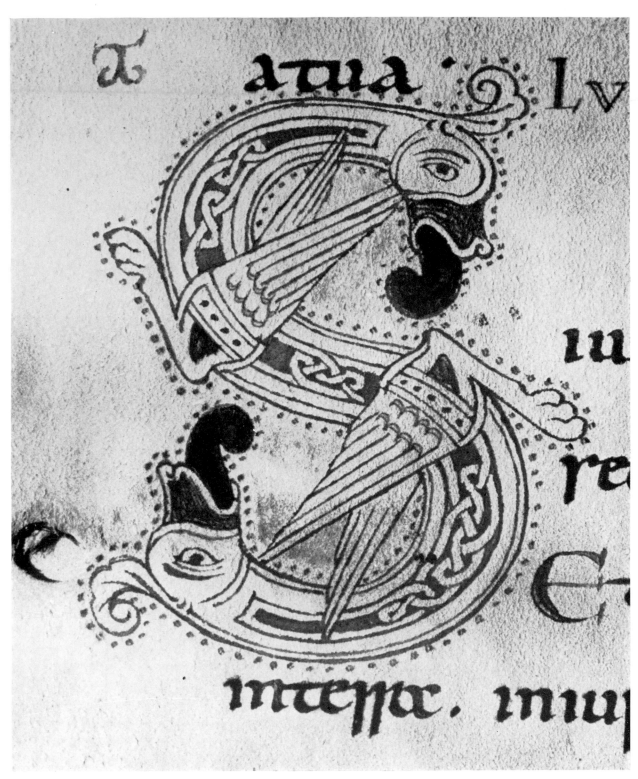

33. Initial 'S'. *Psalter from St. Bertin*. French c. 1000.
Boulogne, Municipale, MS. 20, fol. 63.

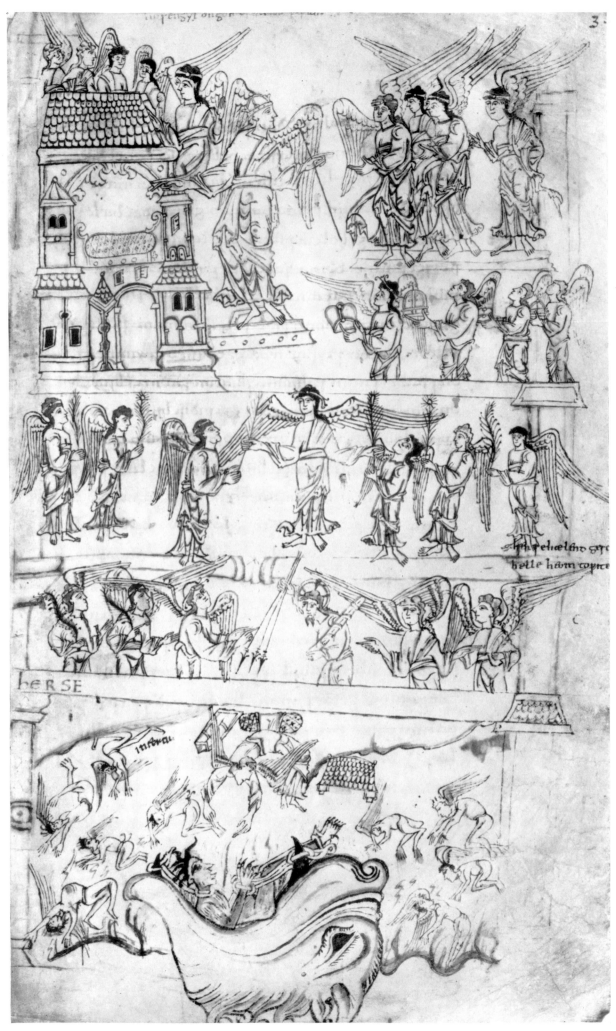

34. The Fall of the Angels. *Caedmon Poems*. English, about 1000.
Oxford, Bodleian Library, MS. Junius XI, fol. 3.

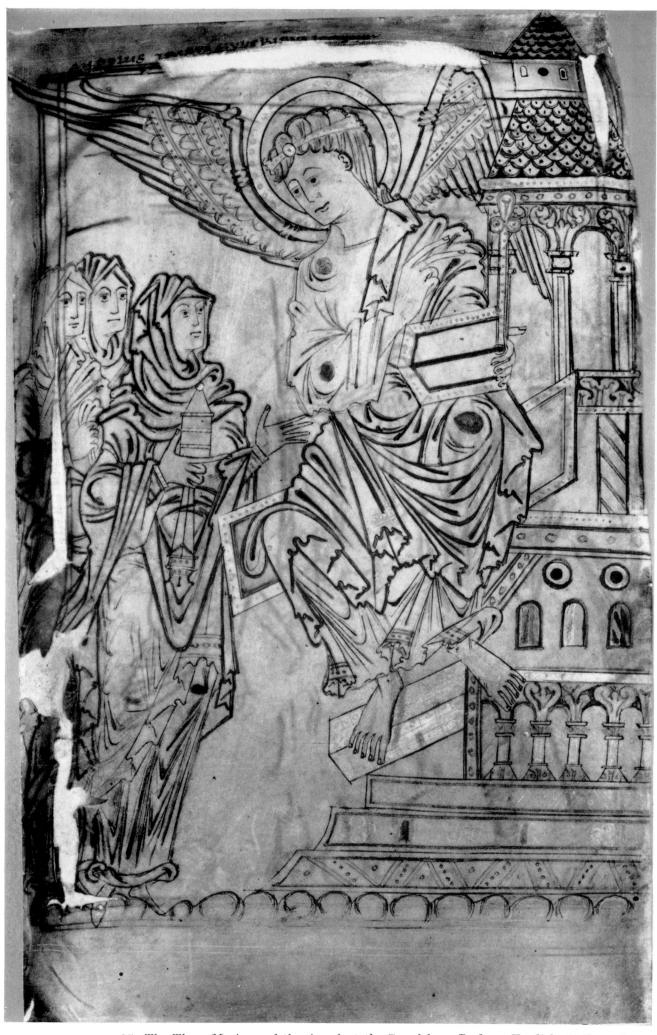

35. The Three Maries and the Angel at the Sepulchre. *Psalter*. English, 11th century. London, British Museum, MS. Cotton Tiberius C. VI, fol. 13v.

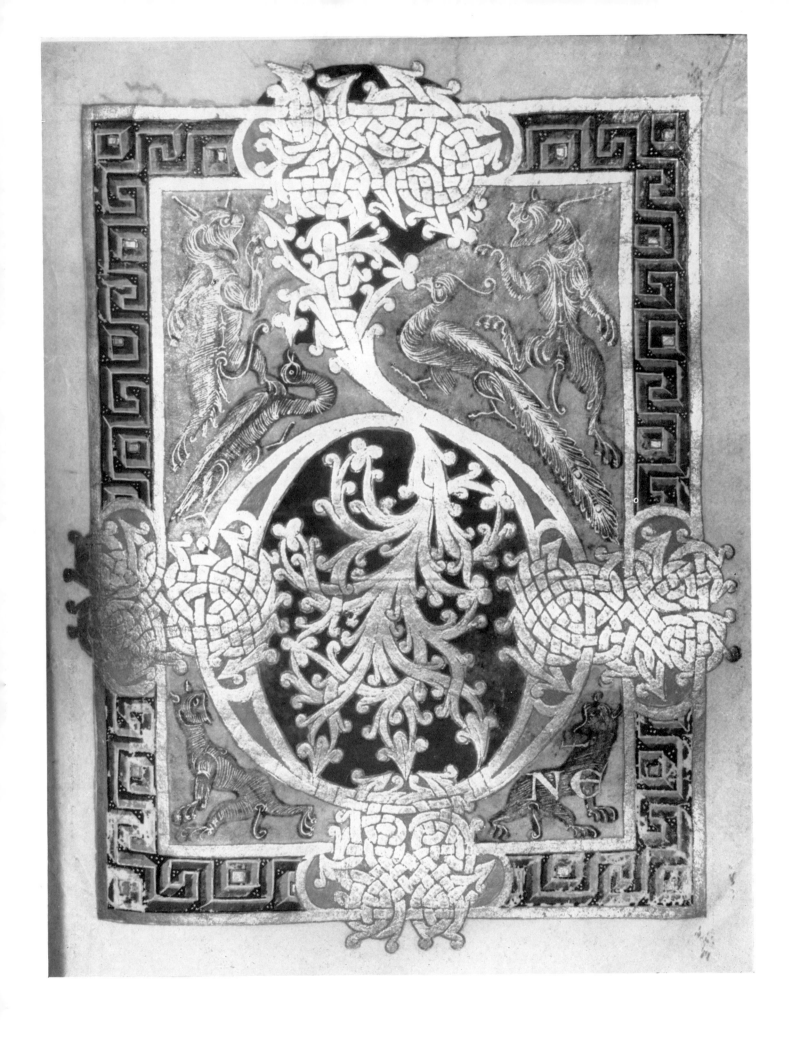

36. Initial 'D'. *Psalter of Egbert of Trier*. Ottonian, 10th century. Cividale, Museo Archeologico, MS. 55.

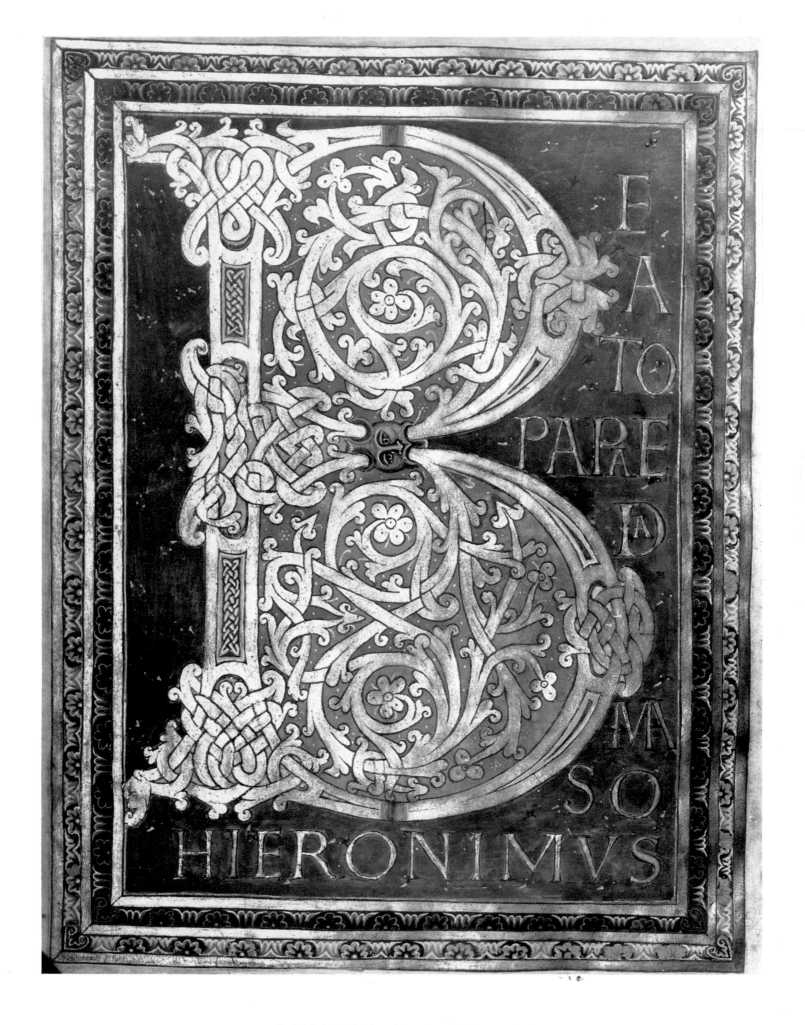

37. Initial 'B'. *Golden Gospels of Echternach*. School of Echternach, about 1035–40.
Nuremberg, Germanisches Nationalmuseum, MS. 156142, fol. **4r.**

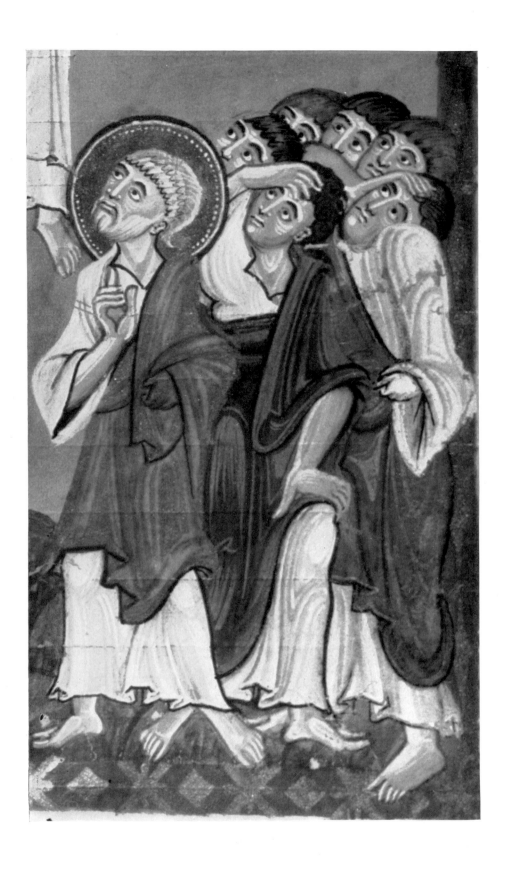

38 and 39. The Ascension. *Gospels*. Reichenau School, 10th century. Florence, Biblioteca Laurenziana, MS. Acquisti e Doni 91, fol. 96r.

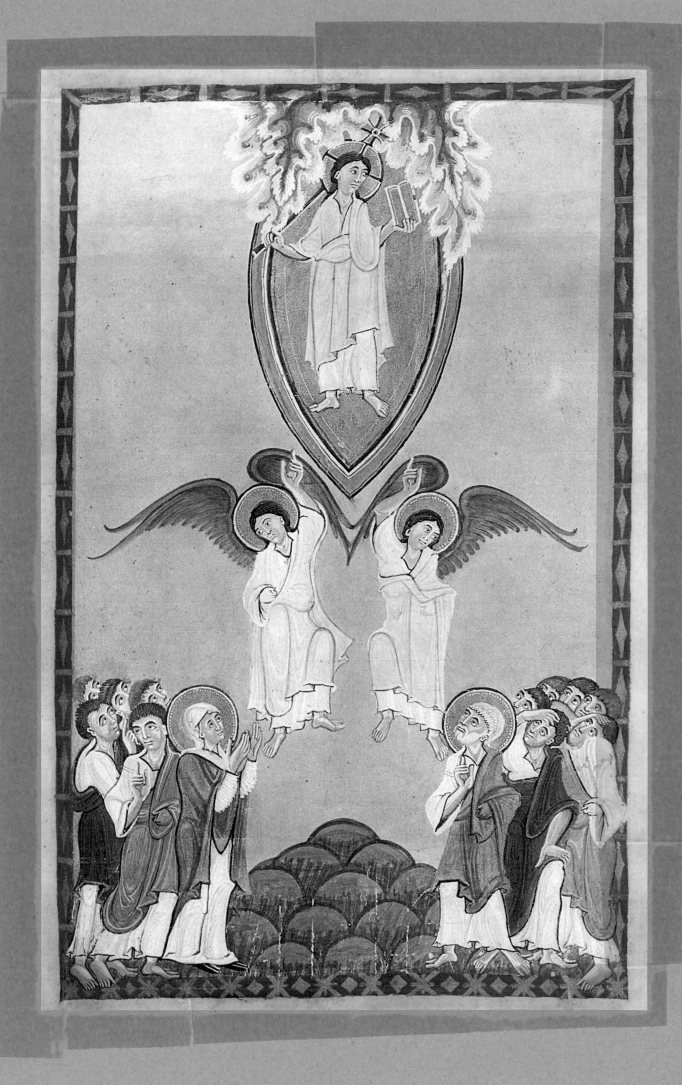

E

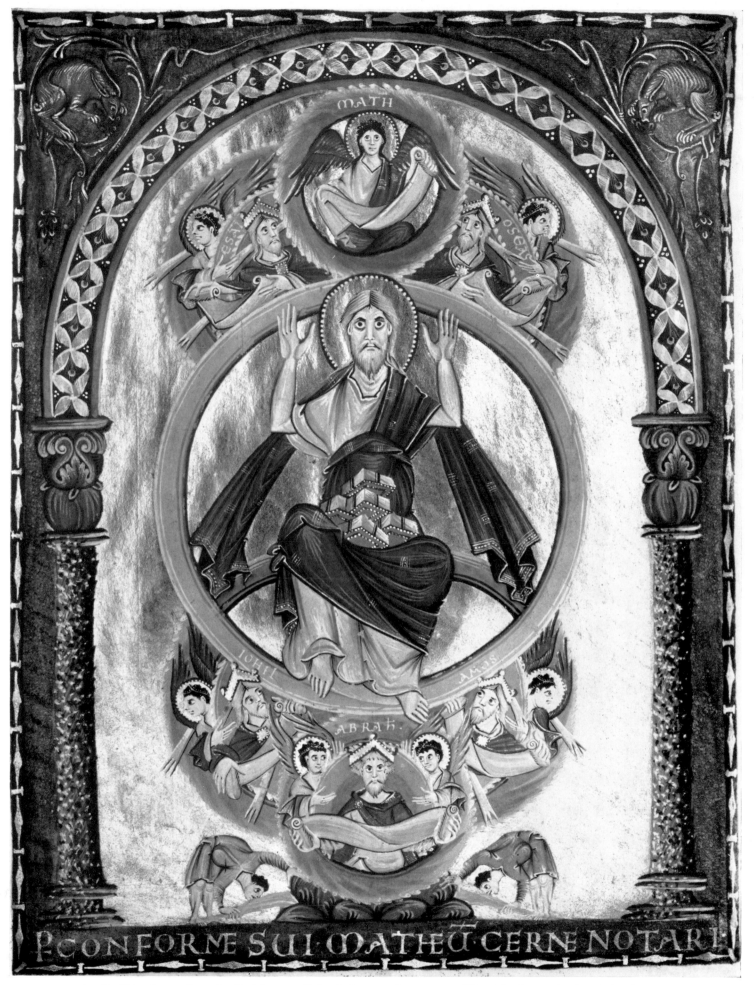

40. St. Matthew. *Gospels*. Reichenau School, late 10th century. Munich, Staatsbibliothek, Clm 4453, fol. 25v.

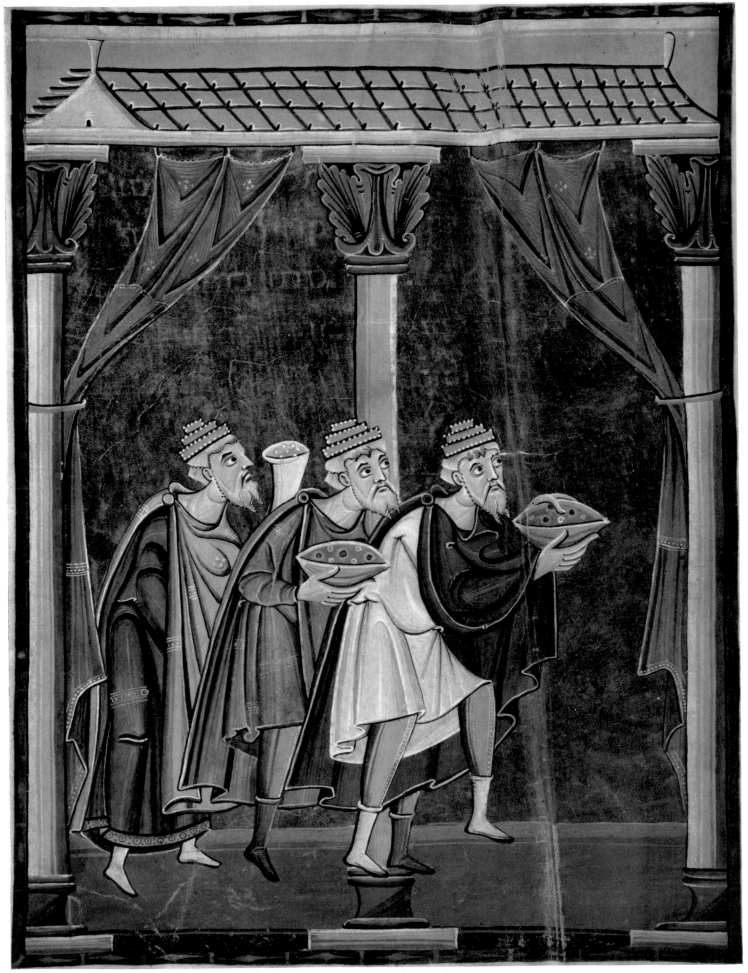

41. The Three Kings. *Pericope Book of Henry II.*
Ottonian, first quarter of the 11th century. Munich, Staatsbibliothek, Cod. lat. 4452, fol. 17v.

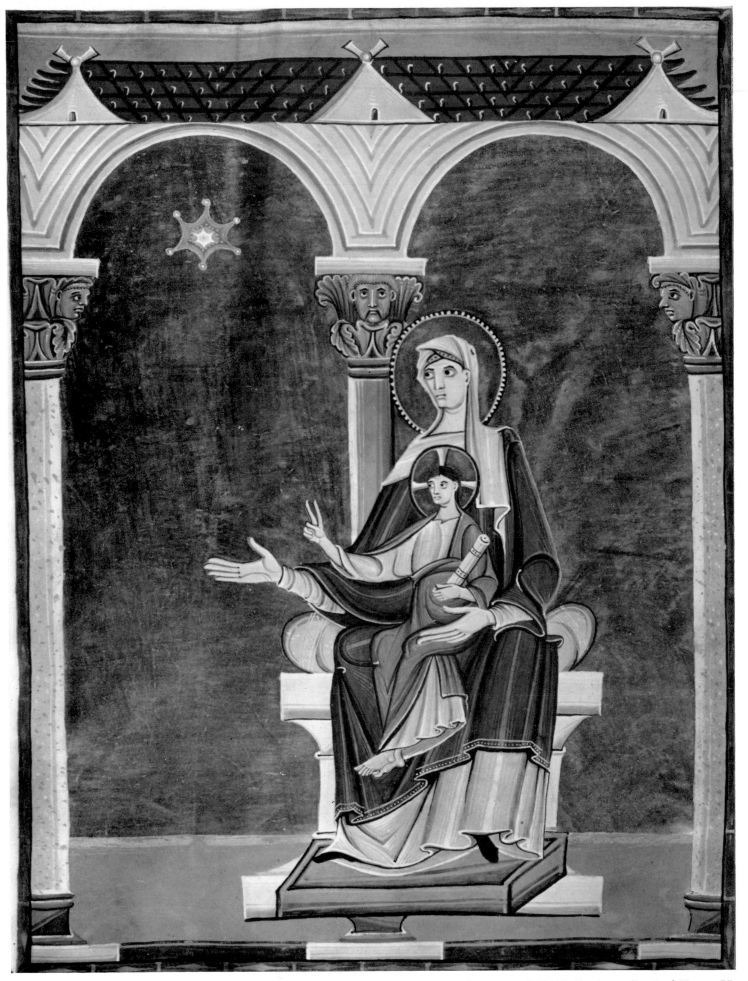

42. Virgin and Child. *Pericope Book of Henry II.*
Ottonian, first quarter of the 11th century. Munich, Staatsbibliothek, Cod. lat. 4452, fol. 18r.

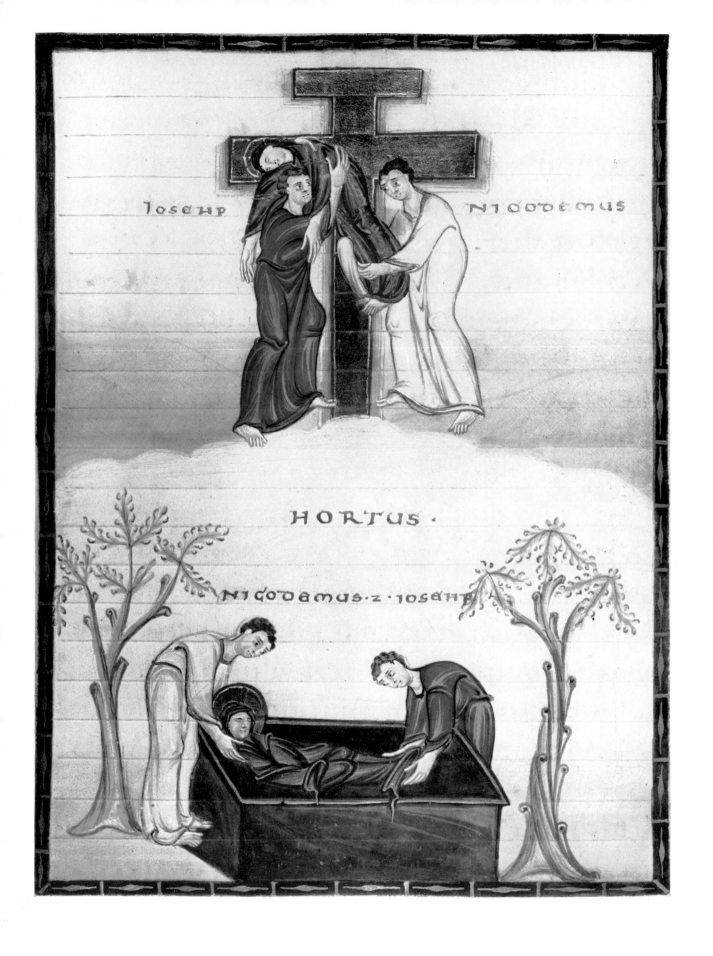

IOSEHP NICODEMUS

HORTUS·

NICODEMUS·Z·IOSEHP

43. The Deposition and Burial of Christ.
Egbert Codex. Reichenau School, about 980. Trier, Stadtbibliothek, Cod. 24, fol. 84r.

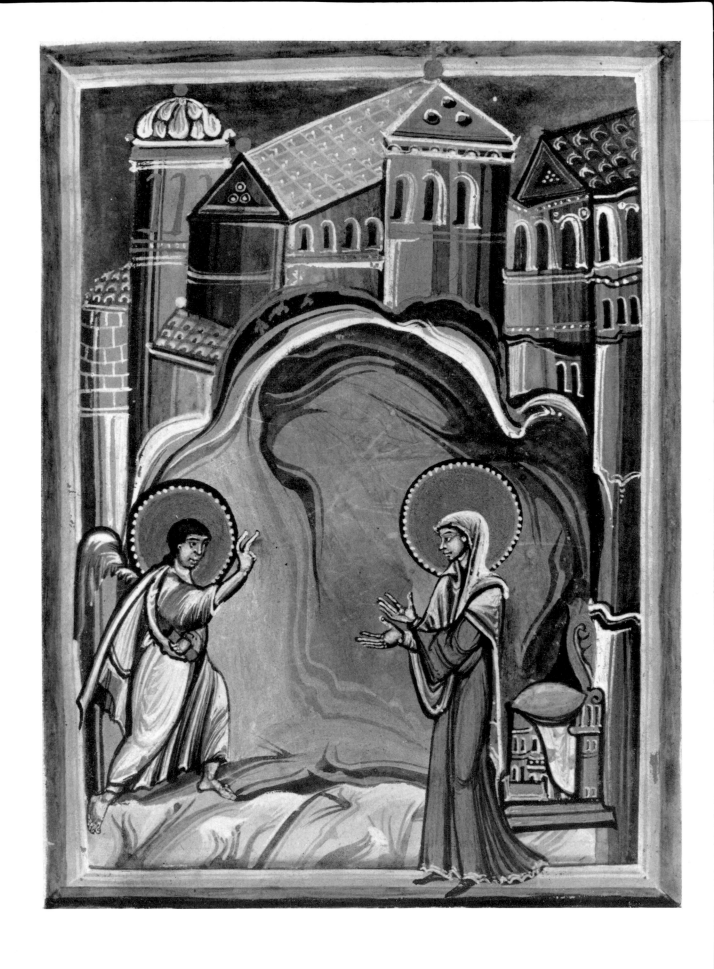

44. The Annunciation. *St. Gereon Sacramentary.*
Cologne, about 1000. Paris, Bibliothèque Nationale, MS. lat. 817, fol. 12r.

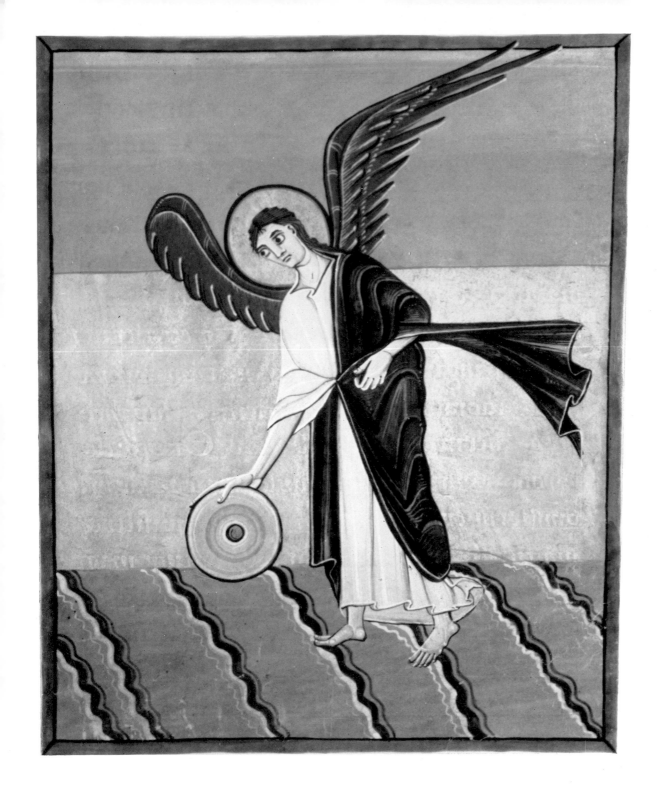

45. The Angel with the millstone. *Bamberg Apocalypse*. Reichenau School, about 1007.
Bamberg, Stadtbibliothek, MS. bibl. 140. A.S.95, fol. 46r.

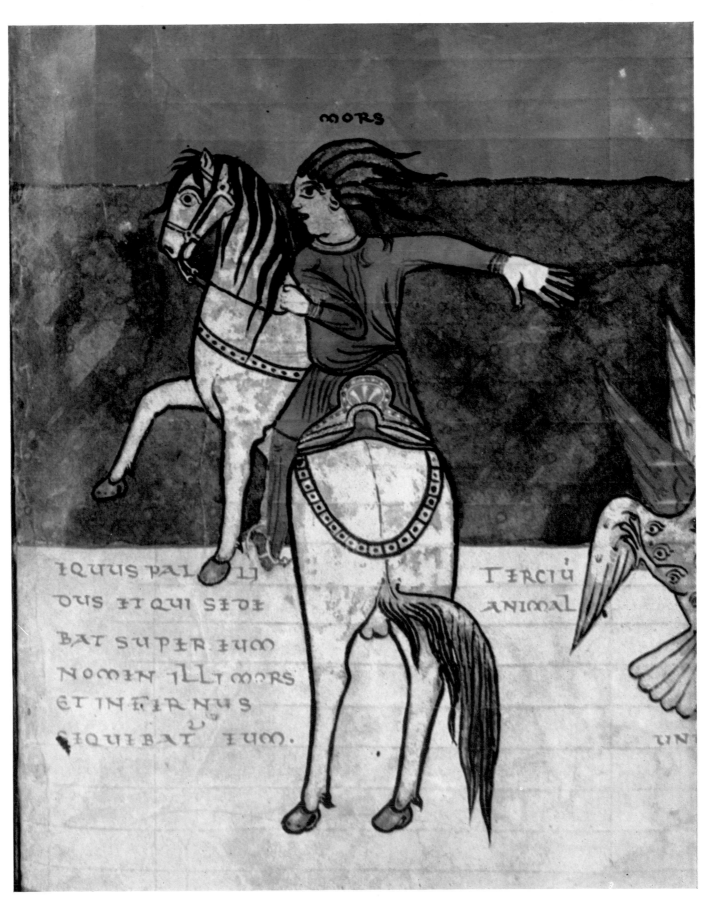

46. Horseman. *Apocalypse of Saint-Sever*. Franco-Spanish School, 1028–1072.
Paris, Bibliothèque Nationale, MS. lat. 8878, fol. 108v.

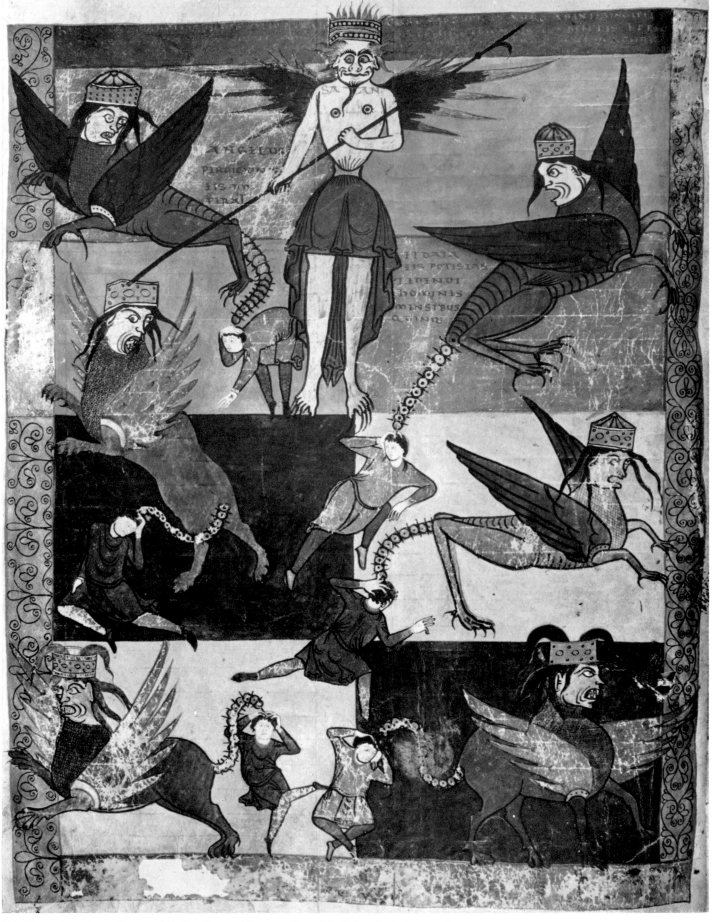

47. Locusts. *Apocalypse of Saint-Sever*. Franco-Spanish School, 1028–1072.
Paris, Bibliothèque Nationale, MS. lat. 8878, fol. 145v.

48. The Vision of the Lamb. Beatus of Liebana, *Commentary on the Apocalypse*.
Spanish, early 10th century. New York, Pierpont Morgan Library, MS. 644, fol. 87.

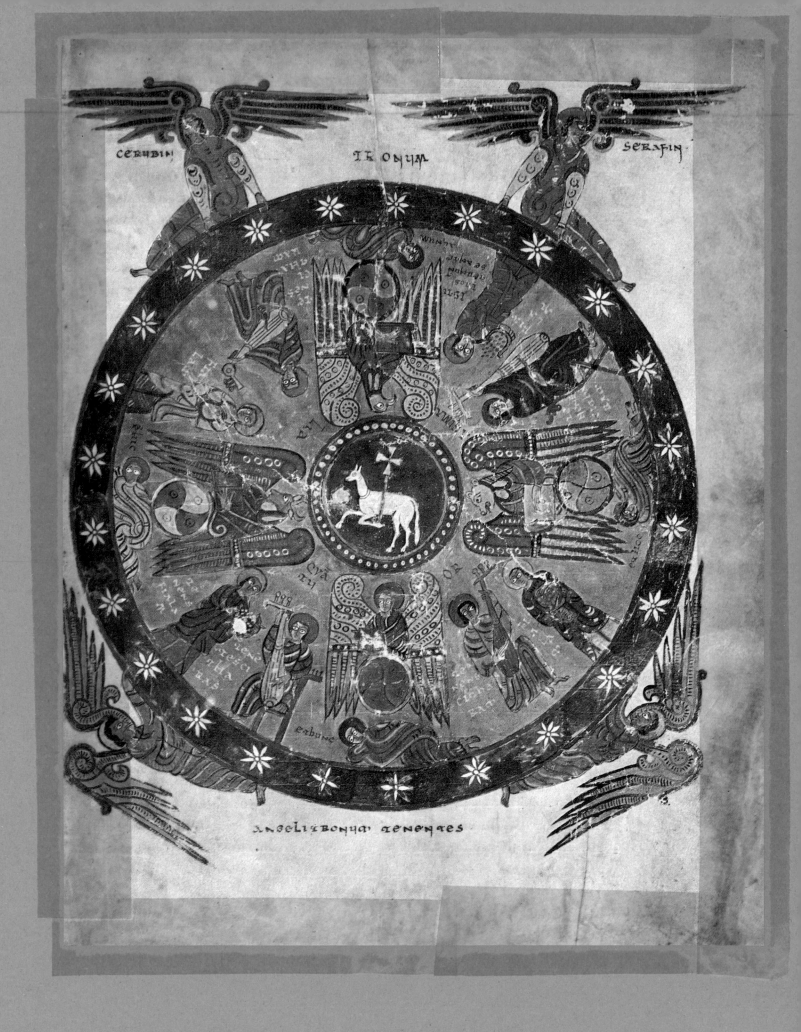

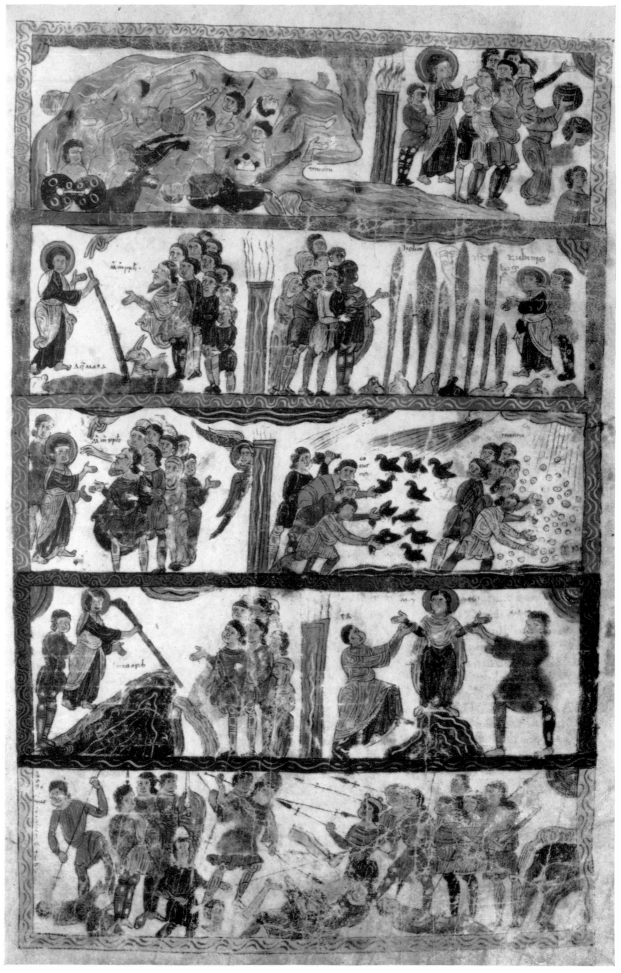

49. The Story of Moses. *Farfa Bible*. Spanish, about 1000.
Rome, Vatican Library, MS. Vat. lat. 5729, fol. 1.

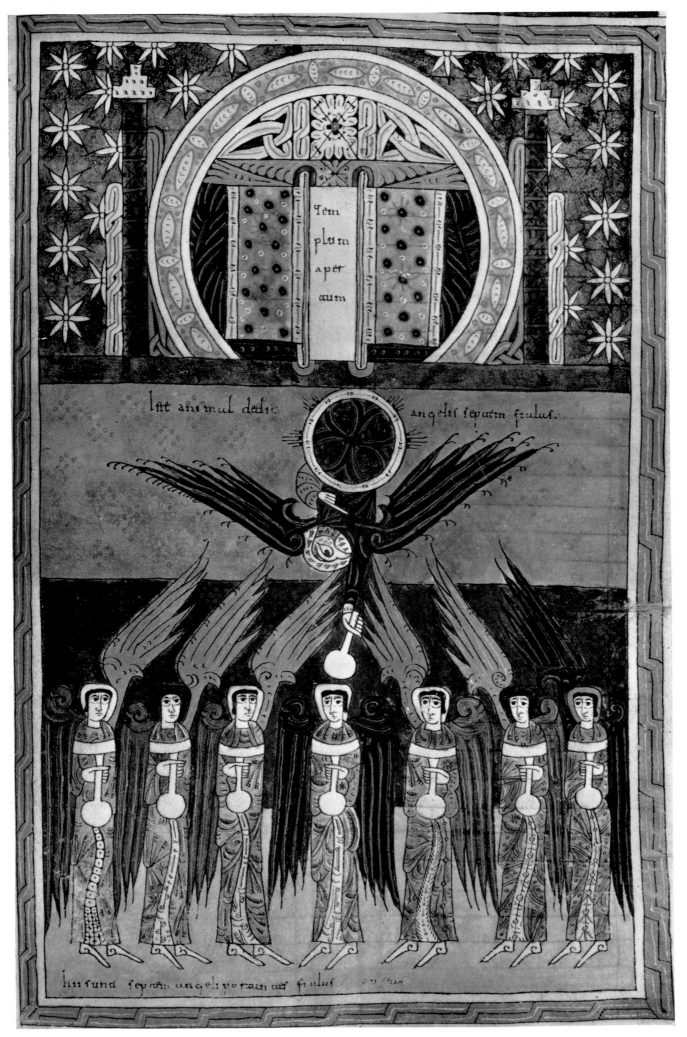

Tem
plum
aper
tum

Iſt aniſmal dedit angeliſ ſepaem fialuſ.

hiſ ſund ſepaem angeli rorantur ſr fialuſ

50. The Eagle gives to the seven Angels the Vials of the Wrath of God. Beatus *Commentary*.
Spanish, about 1109. London, British Museum, MS. Add. 11695, fol. 172r.

51. Illustration from
The Visions of Hildegard of Bingen.
German, 12th century. Destroyed manuscript,
formerly in the Library at Wiesbaden.

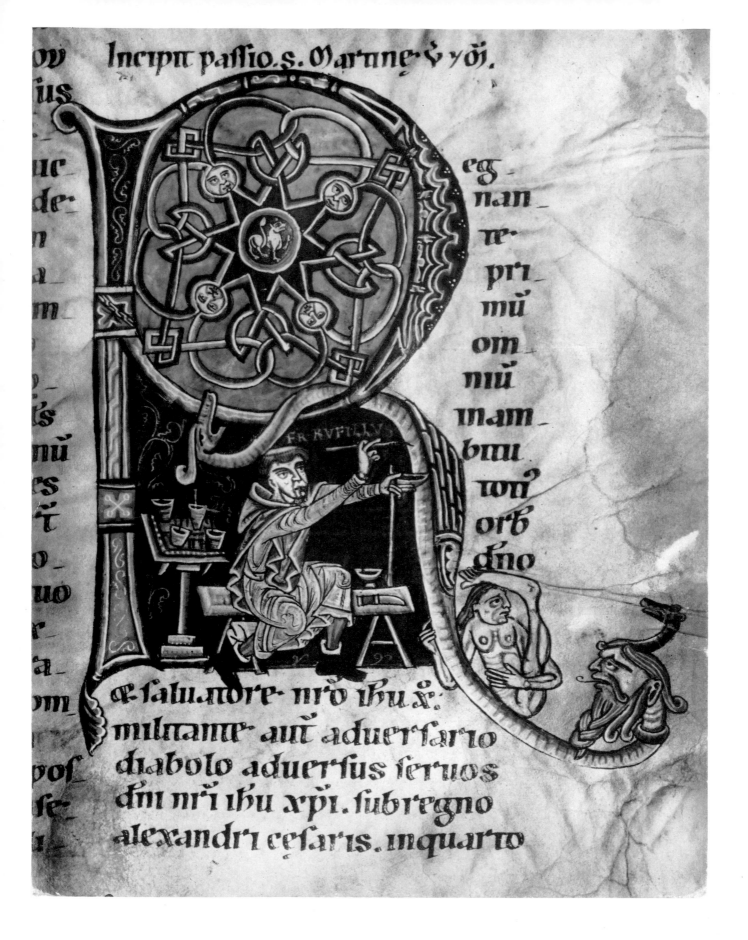

52. Initial 'R'. *Passional*.
German, 12th century. Sigmaringen, Hohenzollern Library, MS. 9, fol. 244r.

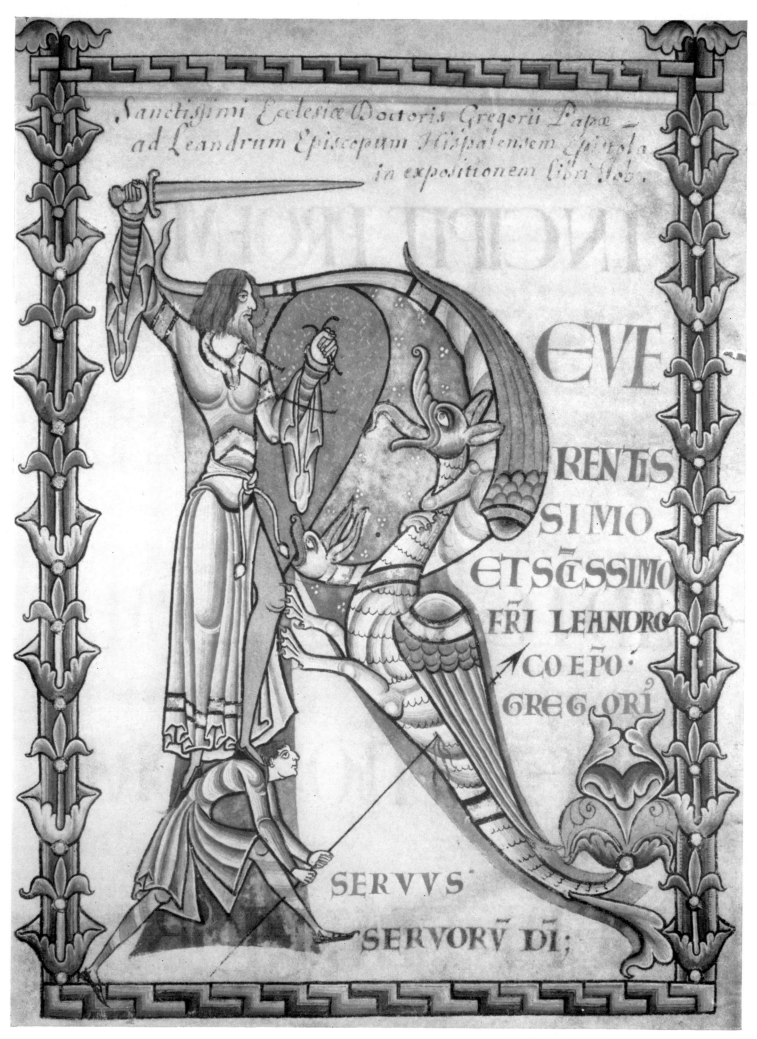

Within the illustration:

Sanctissimi Ecclesiæ Doctoris Gregorii Papæ
ad Leandrum Episcopum Hispalensem Epistola
in expositionem libri Job.

EVE
RENTIS
SIMO
ET SCISSIMO
FRI LEANDRO
CO EPO
GREGORI

SERVVS

SERVORV DI;

53. Initial 'R'. Gregory, *Moralia in Job.*
French, early 12th century. Dijon, Bibliothèque Municipale, MS. 168–170, vol. I, fol. 4v.

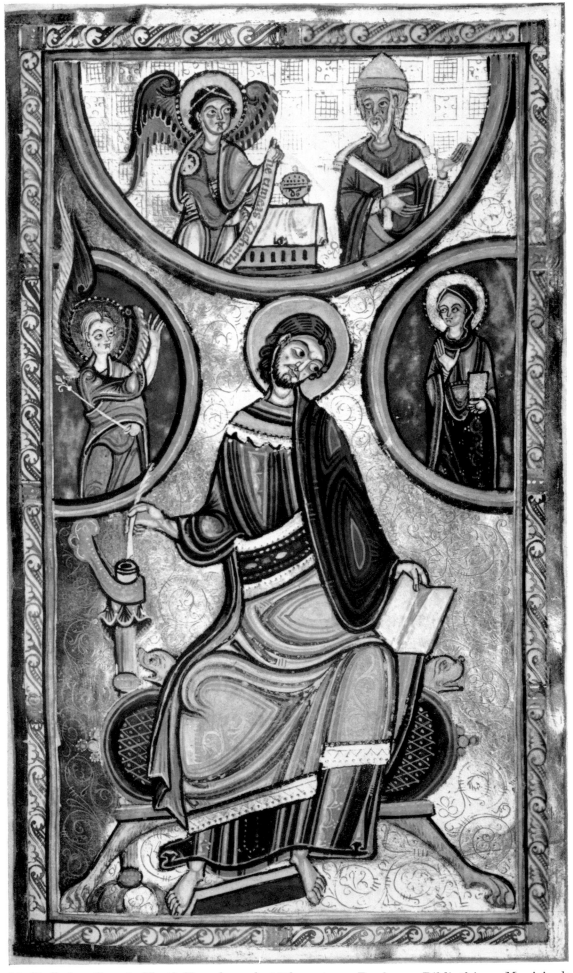

54. St. Luke. *Gospels*. North French, early 12th century. Boulogne, Bibliothèque Municipale, MS. 14, fol. 5r.

55. Detail of Plate 57.

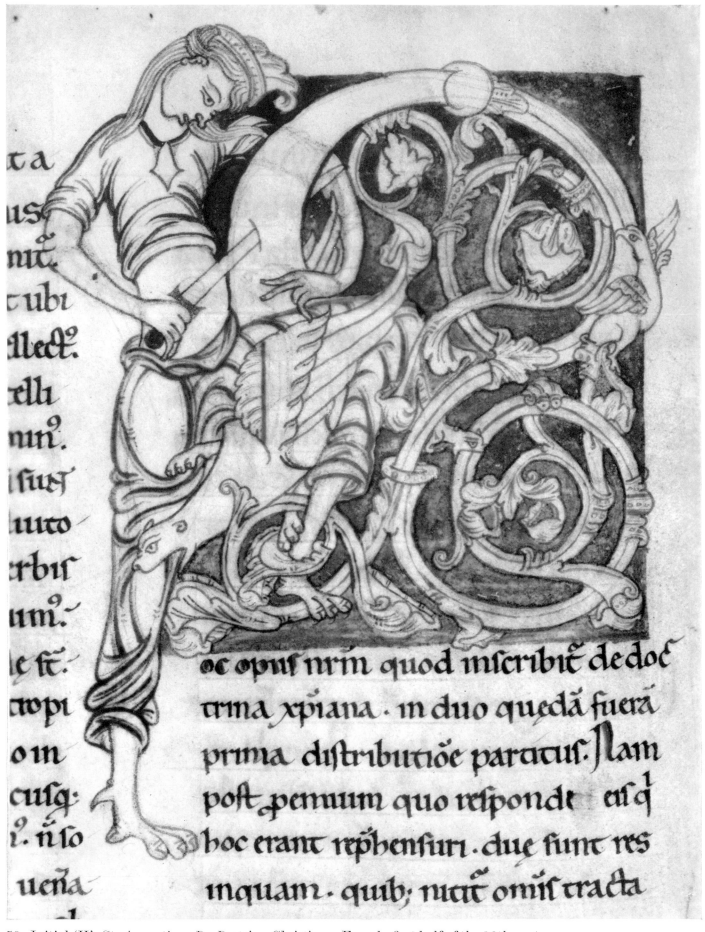

oc opus nrm quod inscribit de doc
trina xpiana . in duo quedam fuera
prima distributioe particus . Nam
post pmium quo respondt eis q
hoc erant rephensuri . due sunt res
inquam . quib; nichil omis tracta

56. Initial 'H'. St. Augustine, *De Doctrina Christiana*. French, first half of the 12th century.
Cambrai, Bibliothèque Municipale, MS. 559, fol. 40v.

57. The Virgin enthroned between St. Jerome and Isaiah. St. Jerome, *Commentaria in Isaiam Prophetam*.
English, early 12th century. Oxford, Bodleian Library, MS. Bodley, 717, fol. 6v.

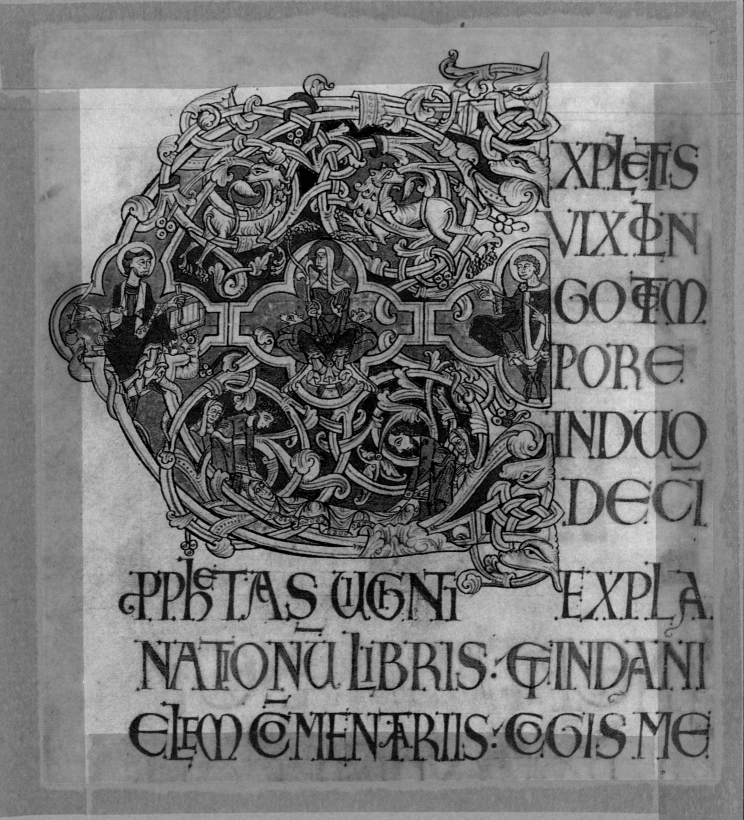

XPLETIS
VIX IN
GO TM
PORE
IN DUO
DECI

PPHETAS UGNI EXPLA.
NATONU LIBRIS: ET IN DANI
ELEM COMENTARIIS: COIS ME

F

EXPLICIUNT CAPLA INCI
LIBER VAIEGRA QVI LATIR
DICITVR LEVITICVS

& locutus est ci dñs de tabernaculo testimo

58. Initial to the Book of Leriticus. *Winchester Bible*. English, mid-12th century.
Winchester Cathedral Library. Detail of fol. 34v.

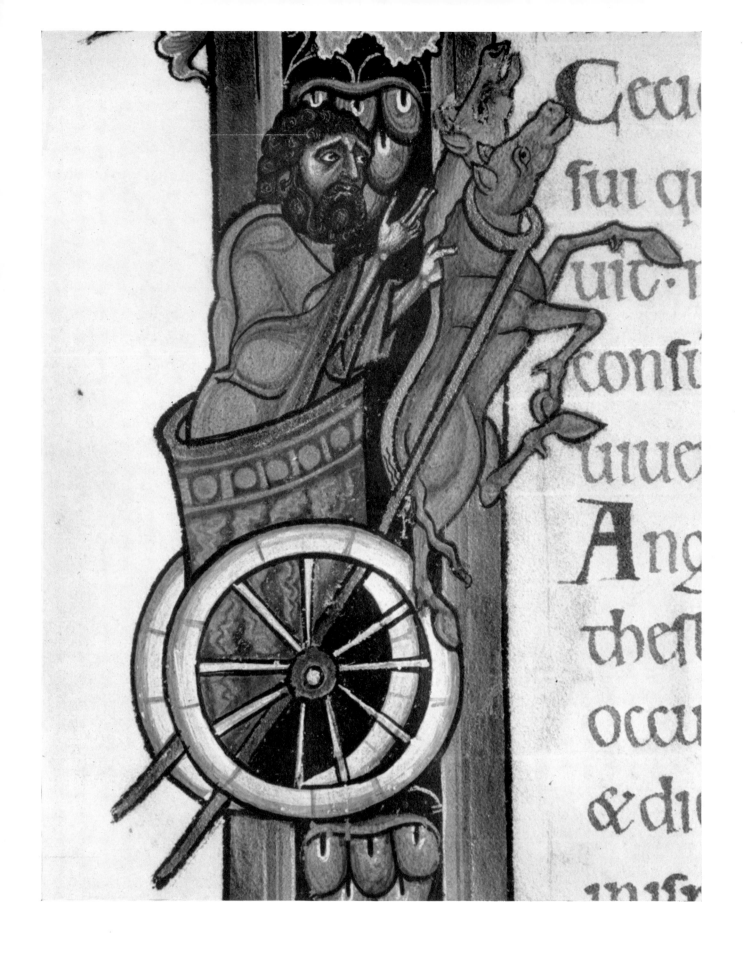

59. Elijah in the Chariot of Fire. *Winchester Bible*. English, mid-12th century.
Winchester Cathedral Library. Detail of fol. 120v. (enlarged).

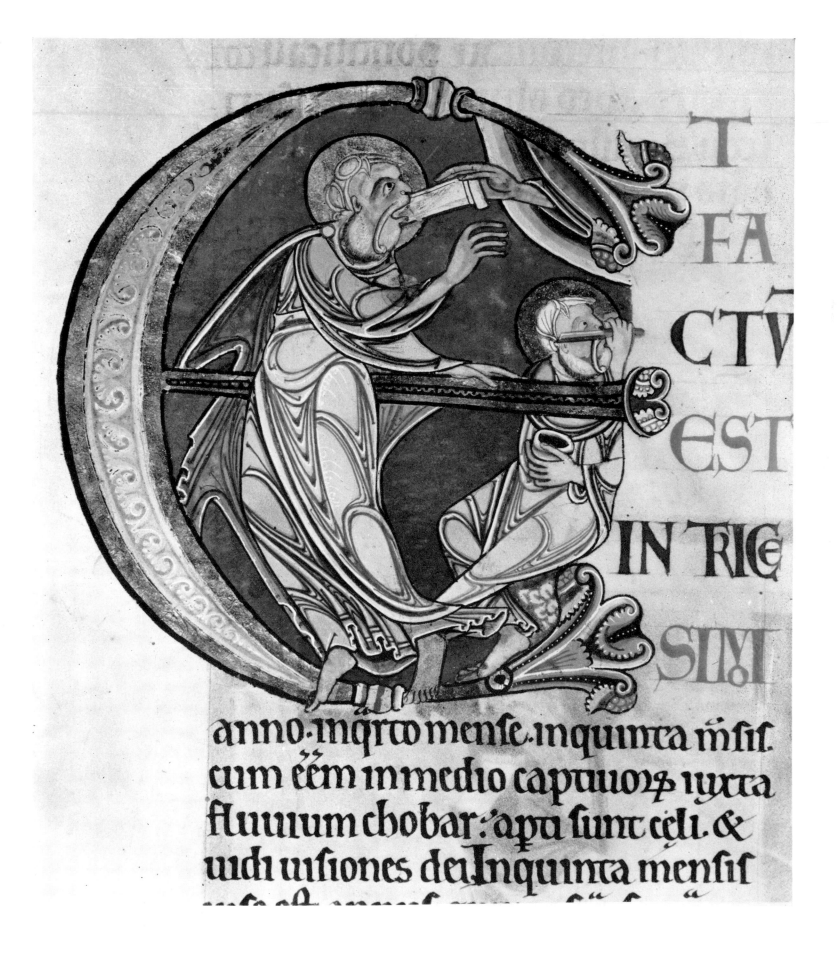

anno. in qrto mense. in quinta m̄sis.
cum ēēm in medio captiuorꝮ iuxta
fluuium chobar: apꞇi sunt cẹli. &
uidi uisiones dei. In quinta mensis

60. Ezekiel receiving in his mouth a scroll from the hand of God. *Lambeth Bible*. English, mid-12th century.
Lambeth Palace Library, MS. 3, fol. 258v.

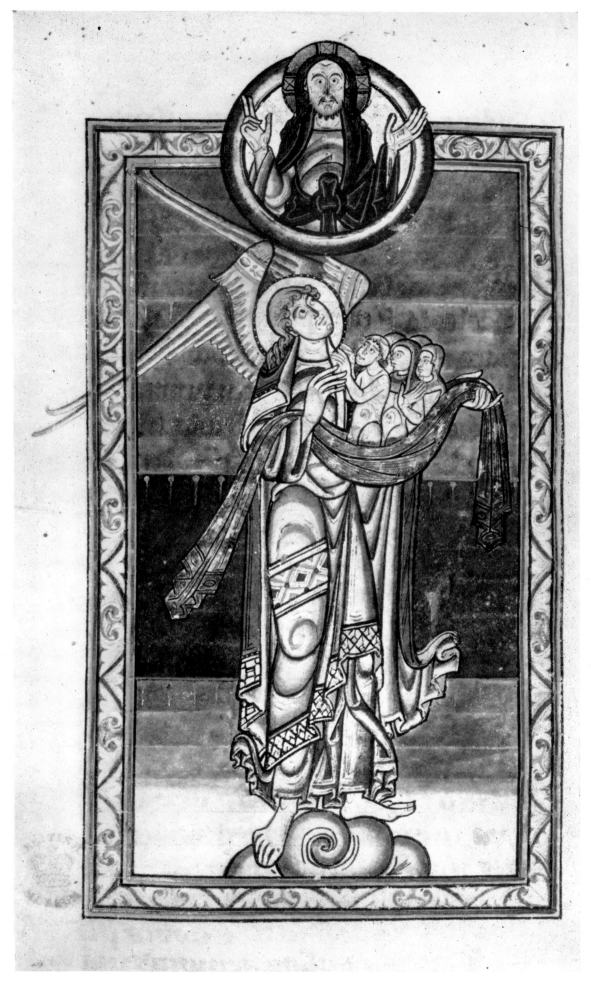

61. St. Michael with Souls in his Arms. *Shaftesbury Psalter*. English, early 12th century. London, British Museum, MS. Lansdowne 383, fol. 168v.

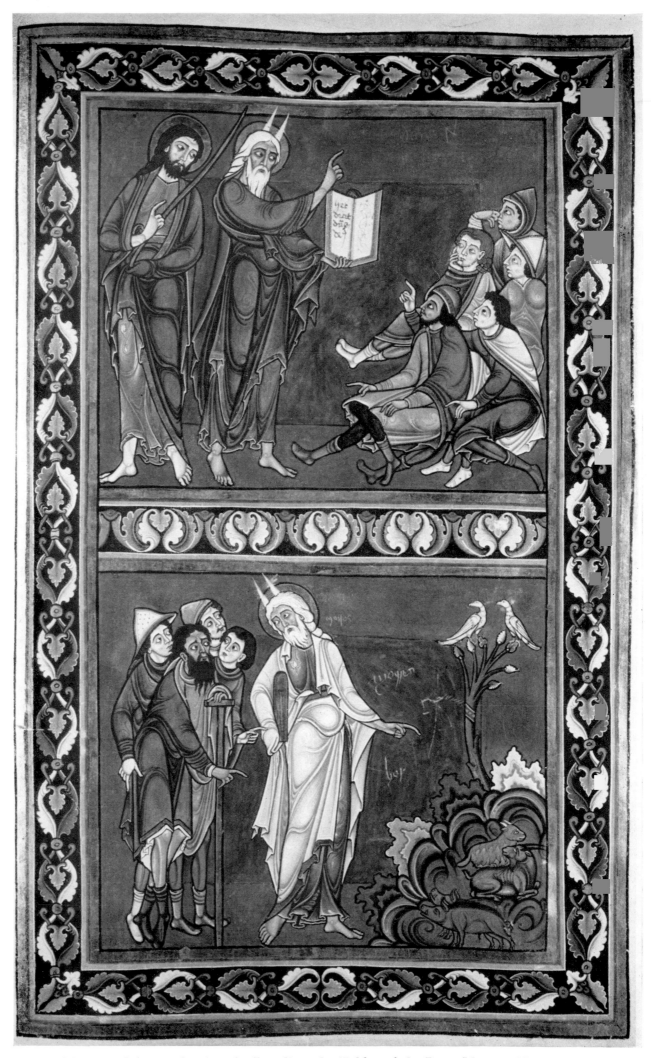

62. Moses and Aaron showing the Israelites the Tables of the Law; Moses addressing the People.
Bury St. Edmunds Bible. English, 1121–1148. Cambridge, Corpus Christi College, MS. 2, fol. 94r.

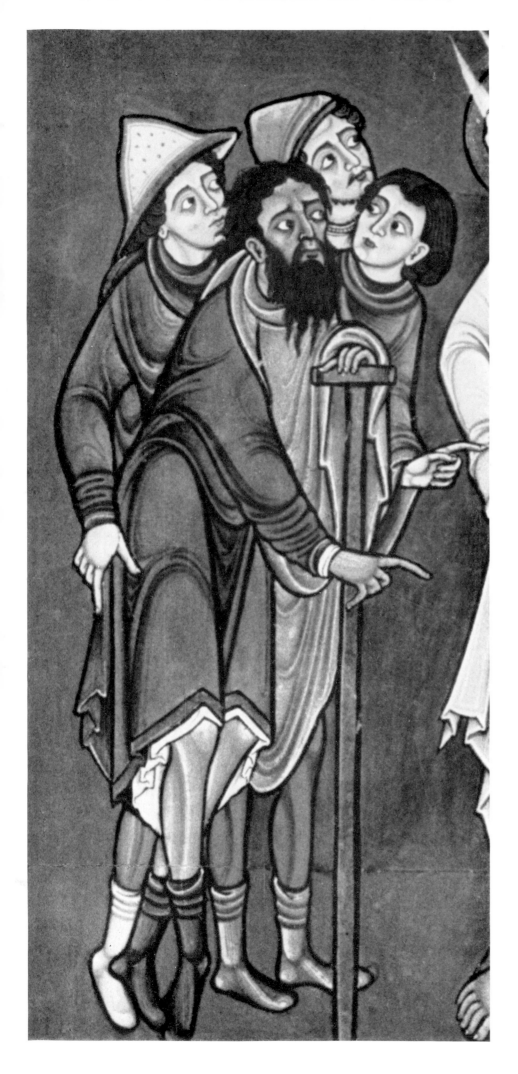

63. Detail of Plate 62.

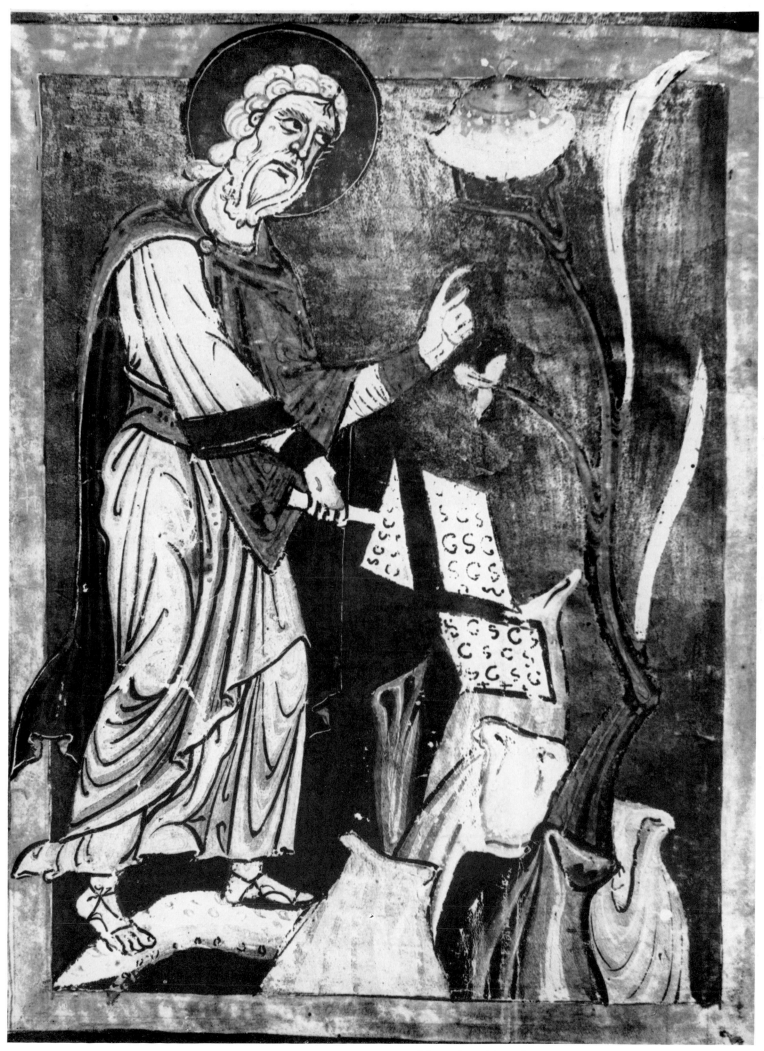

64. Moses breaking the Tablets of the Law. *Admont Bible.*
Austrian, 12th century. Vienna, Nationalbibliothek, CPV. ser. nov. 2701, fol. 41v.

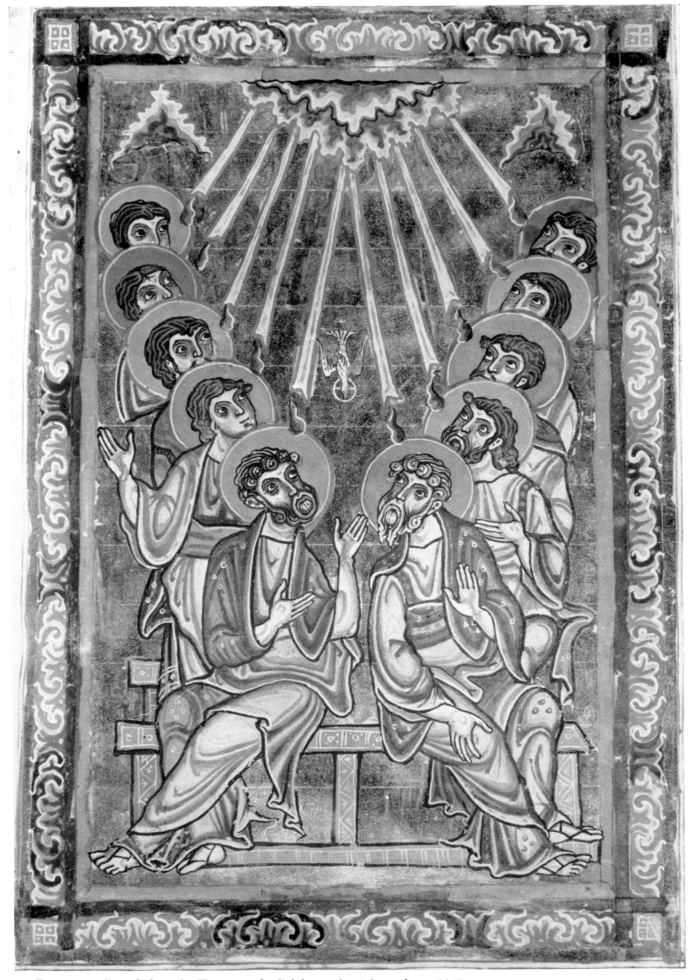

65. Pentecost. *Gospels* from St. Ermentrude, Salzburg. Austrian, about 1140.
Munich, Staatsbibliothek, Cod. lat. 15903, fol. 63r.

66. The Ascension. *Gospels*. Italian, 1170. Padua, Biblioteca Capitolare, Codex Isidoro, fol. 38v.

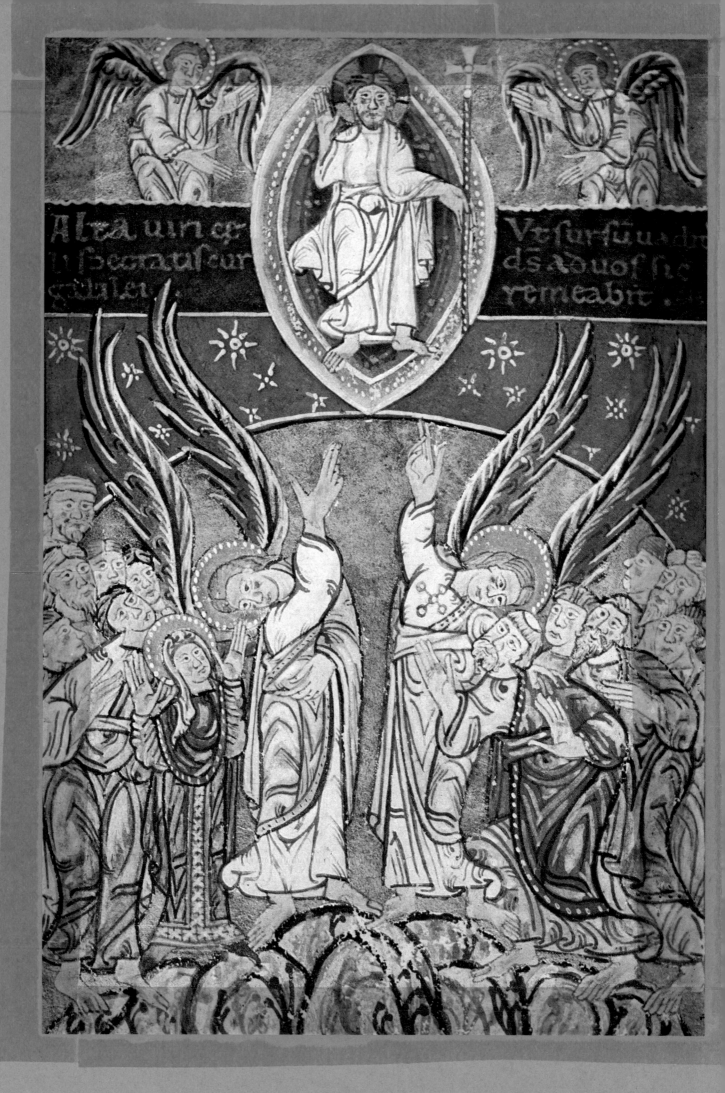

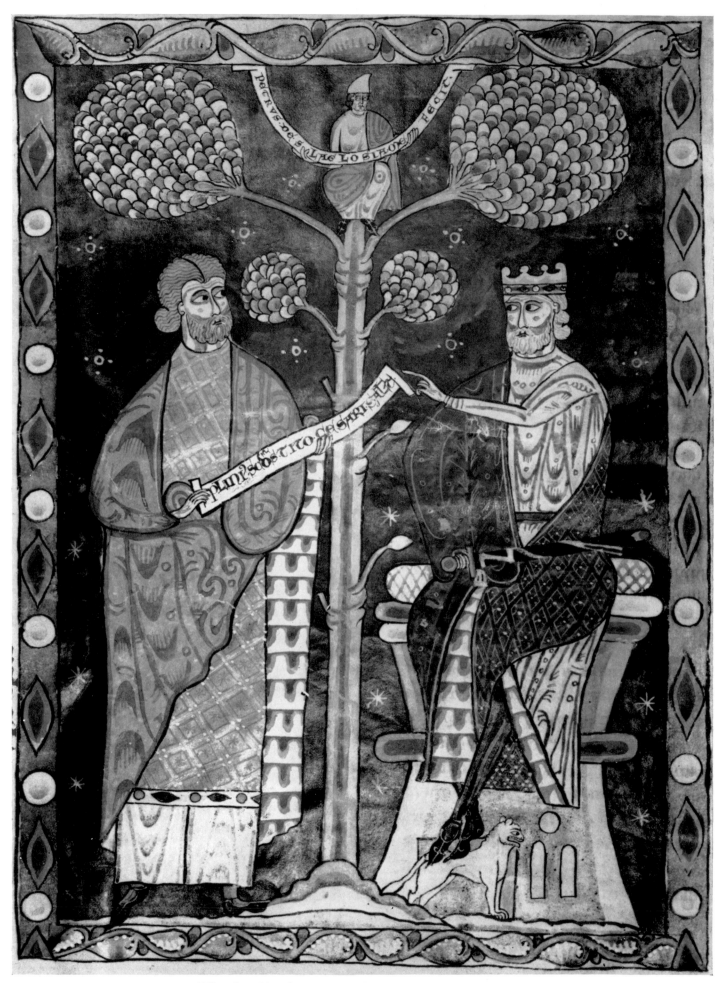

67. Pliny handing his work to the Emperor Titus. Frontispiece, Pliny *Historia Naturalis*.
Danish (?), 12th century. Florence, Biblioteca Laurenziana, MS. Plut. 82, 1, fol. 2v.

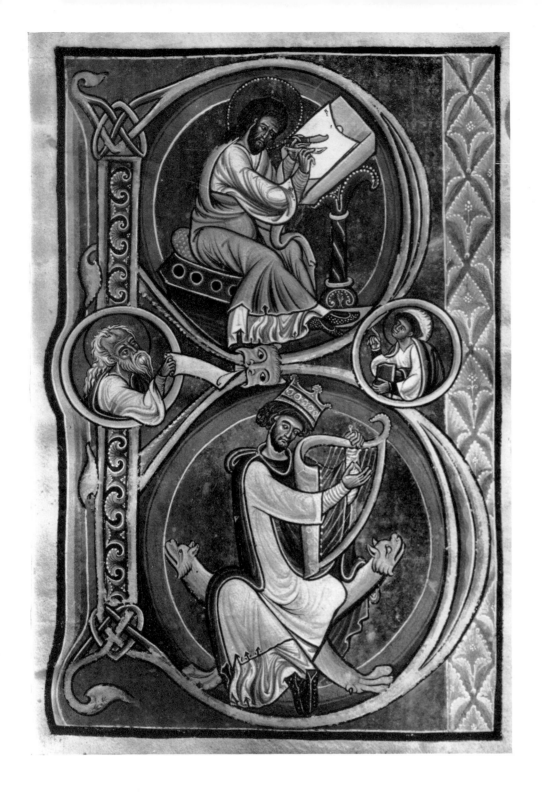

68. Initial 'B'. *Bible*. English, about 1175.
Oxford, Bodleian Library, MS. Auct. E., inf. 2, fol. 2r.

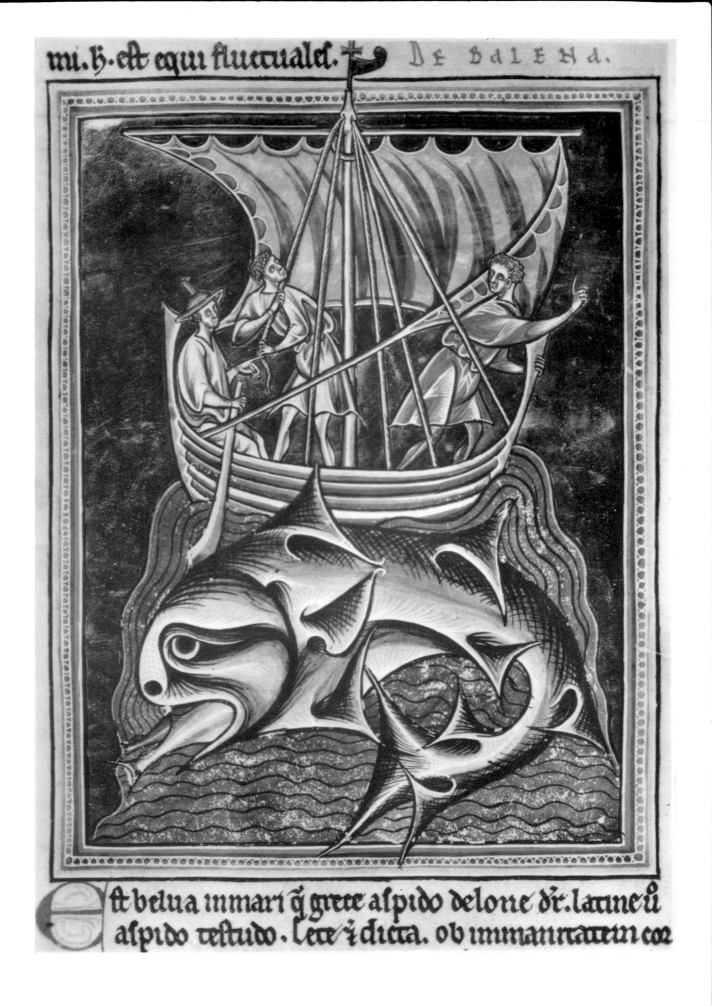

Eft belua inmari q̃ grece aspido delone dr̄. latine ū
aspido testudo. lete ꝛ dicta. ob immanitatem cor

69. The Whale. *Bestiary*. English, late 12th century. Oxford, Bodleian Library, MS. Ashmole 1511, fol. 86v.

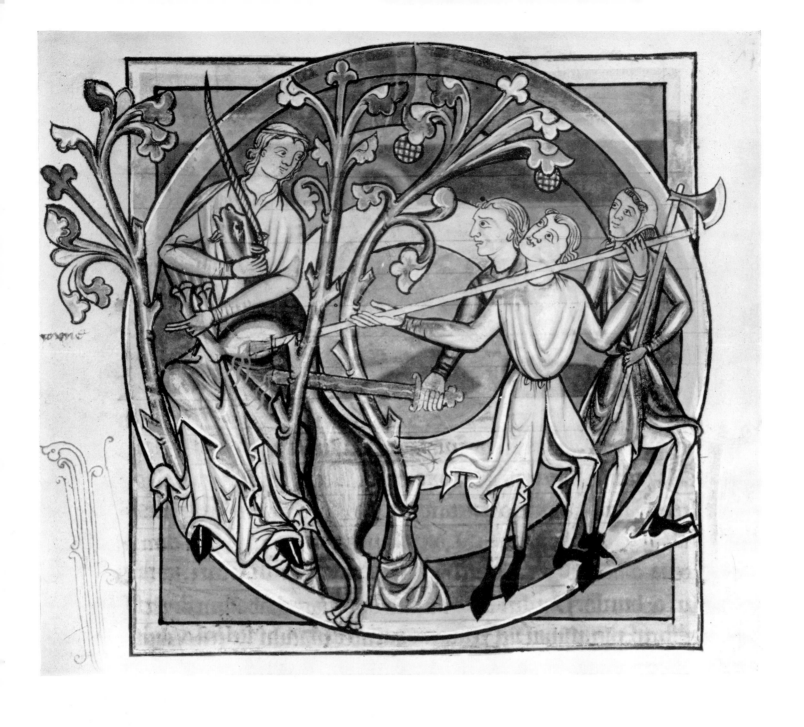

70. Capture of a Unicorn. *Bestiary*. English, late 12th century.
London, British Museum, MS. Harley 4751, fol. 6v.

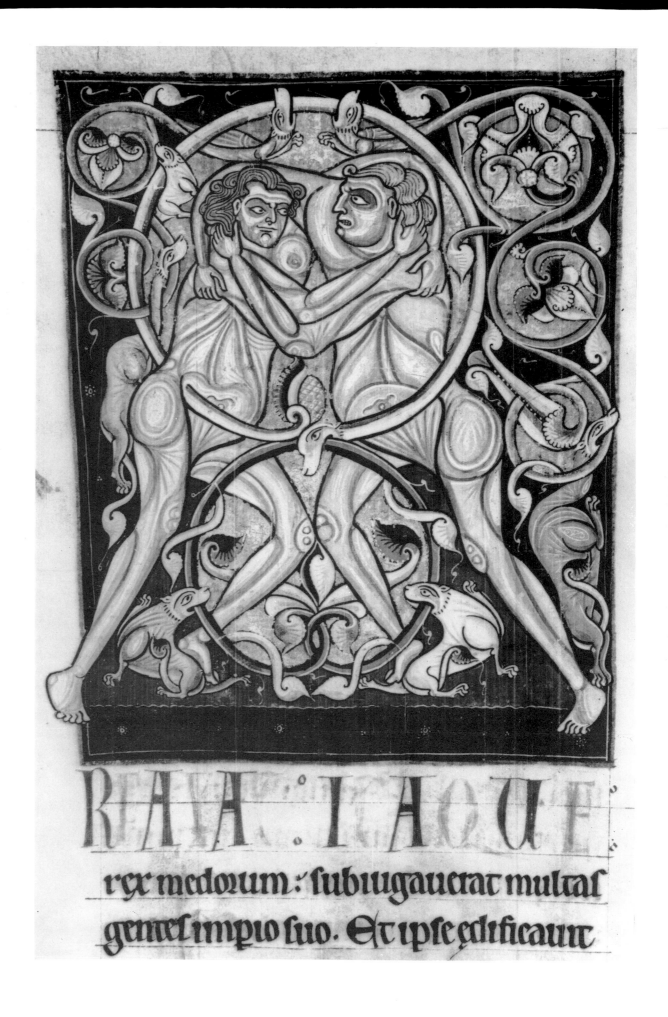

rex medorum : subiugauerat multas

gentes imperio suo. Et ipse edificauit

71. Initial 'R'. *Bible of Saint André-au-Bois*. French, second half of the 12th century.
Boulogne, Bibliothèque Municipale, MS. 2, fol. 81r.

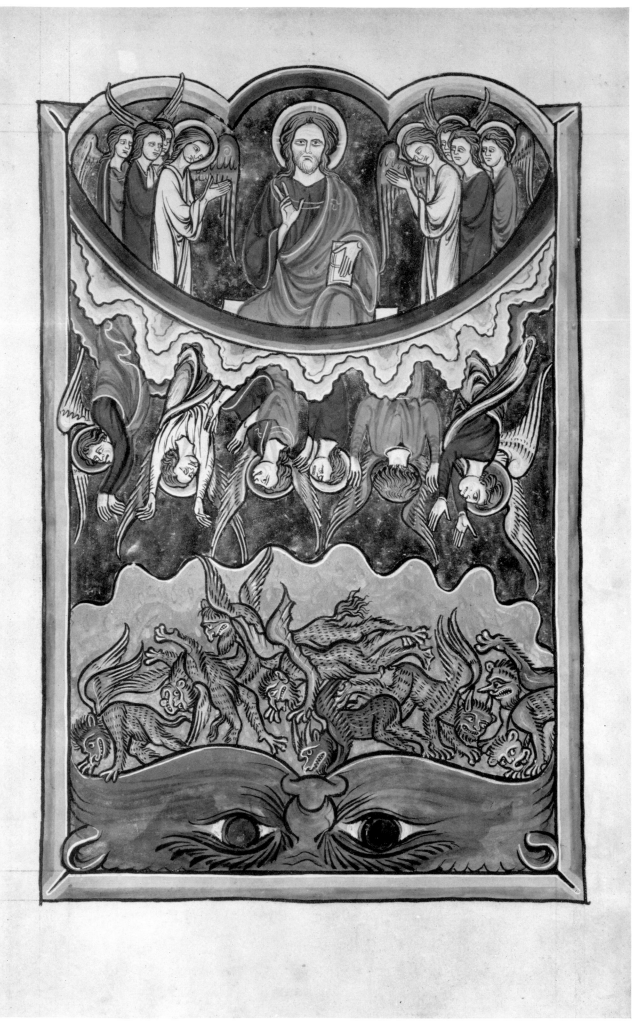

72. The Fall of the Angels. *Psalter of Saint Louis and Blanche of Castille*. French, early 13th century.
Paris, Bibliothèque de l'Arsenal, MS. 1186, fol. 9v.

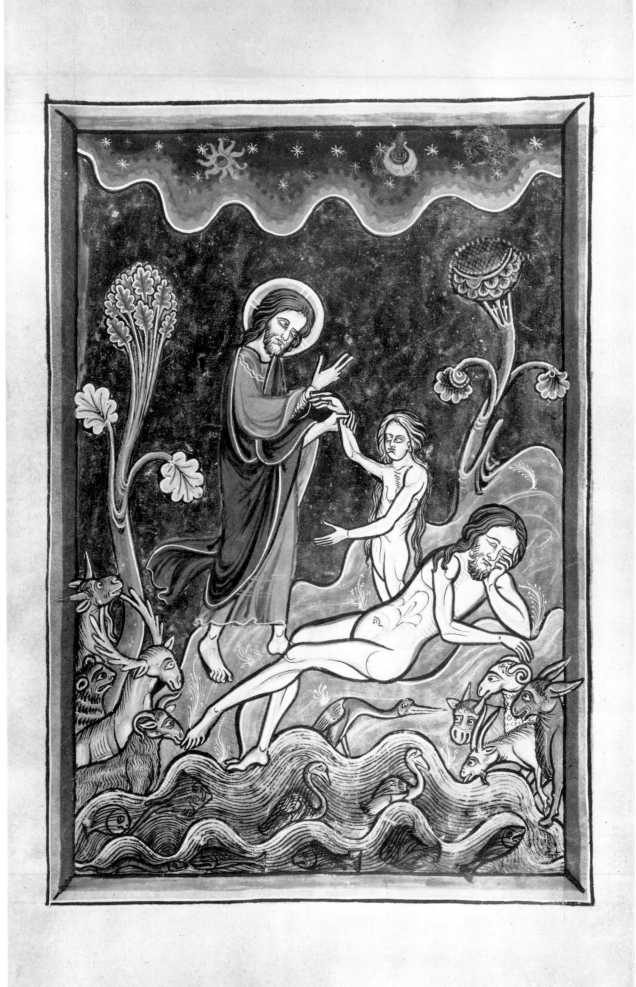

73. The Creation of Eve. *Psalter of Saint Louis and Blanche of Castille*. French, early 13th century. Paris, Bibliothèque de l'Arsenal, MS. 1186, fol. 10r.

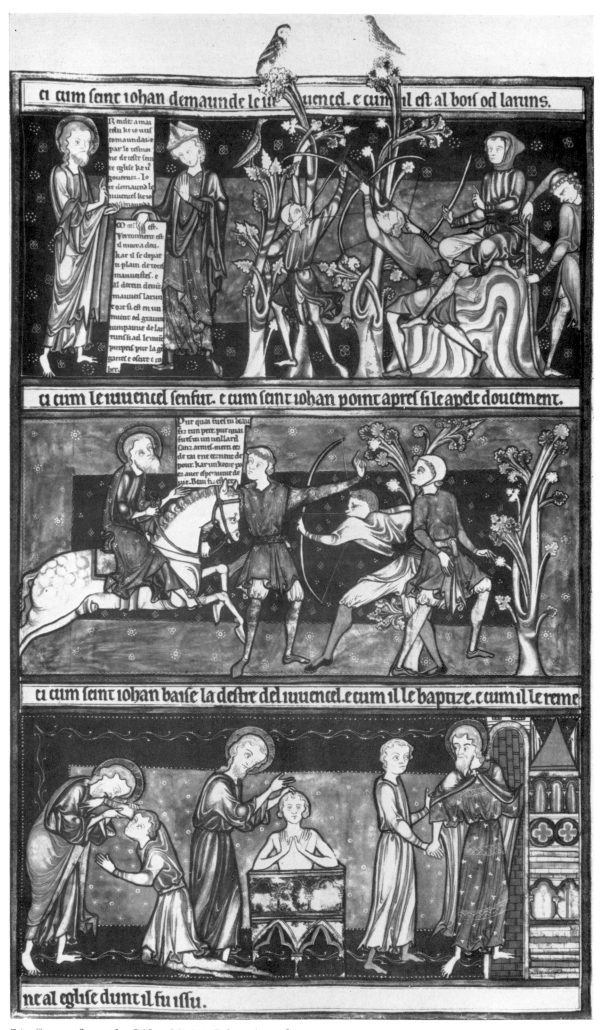

74. Scenes from the Life of Saint John. *Apocalypse.*
English, about 1230. Cambridge, Trinity College Library, MS. R. 16.2, fol. 30v.

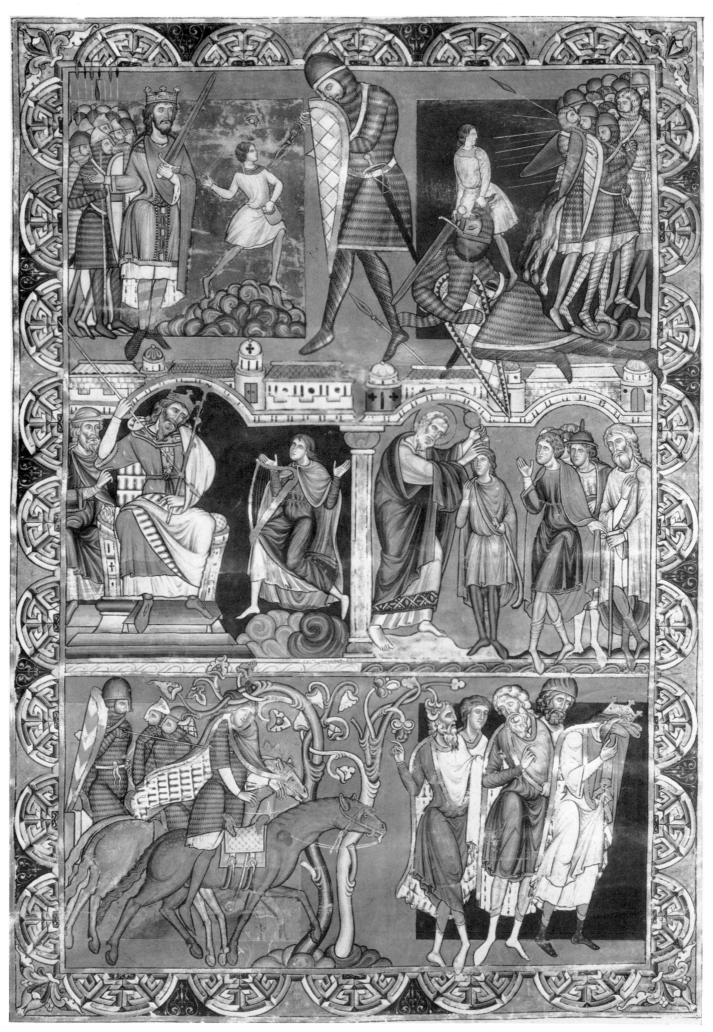

75. The Story of David. Morgan Leaf, from a *Bible*.
English, late 12th century. New York, Pierpont Morgan Library, MS. 619, fol. 1v.

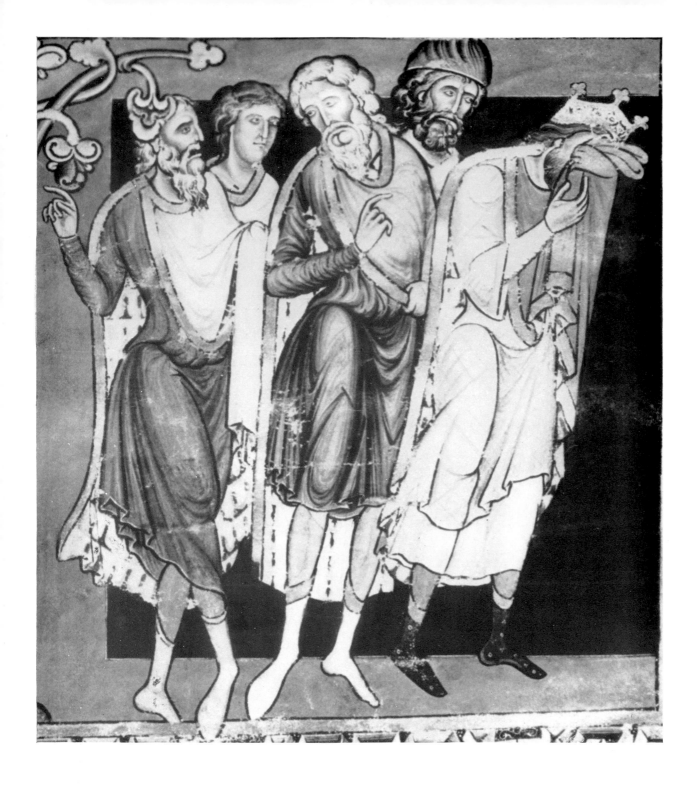

76. Detail of Plate 75.

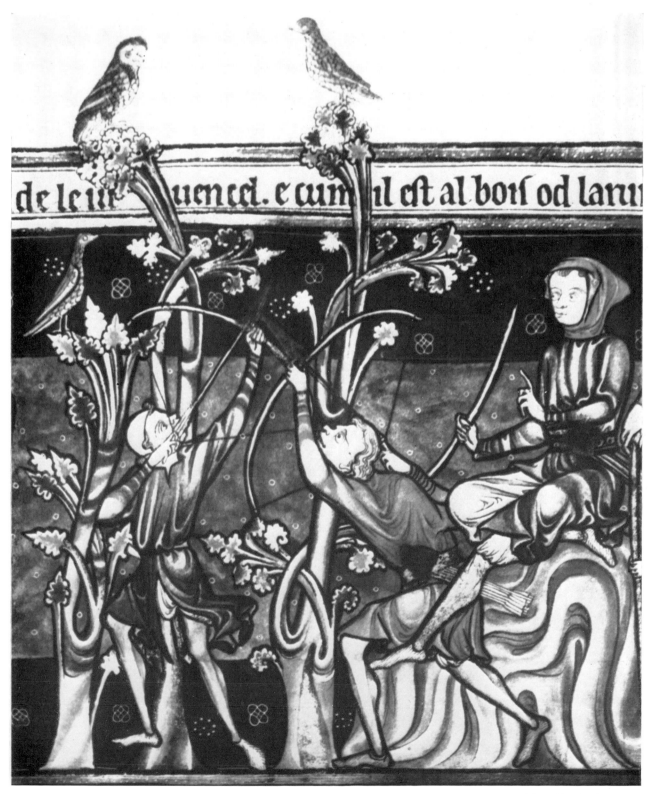

77. Detail of Plate 74.

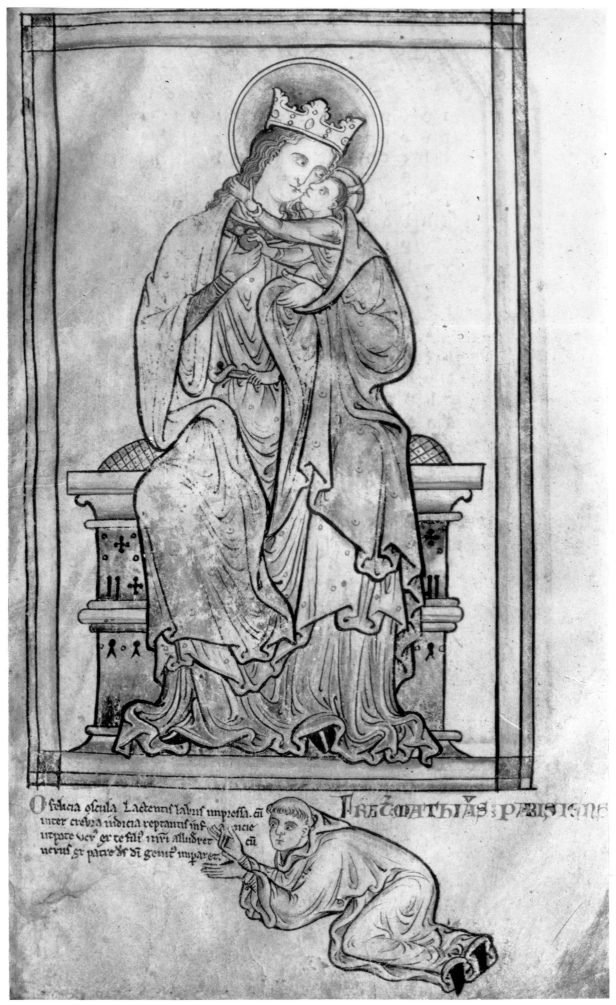

78. Virgin and Child. Matthew Paris, *Historia Anglorum*. English, mid-13th century.
London, British Museum, MS. Royal 14 C VII, fol. 6r.

79. Virgin and Child. *Seitenstetten Missal*. Venetian, second half of the 13th century.
New York, Pierpont Morgan Library, MS. 855, fol. 110v.

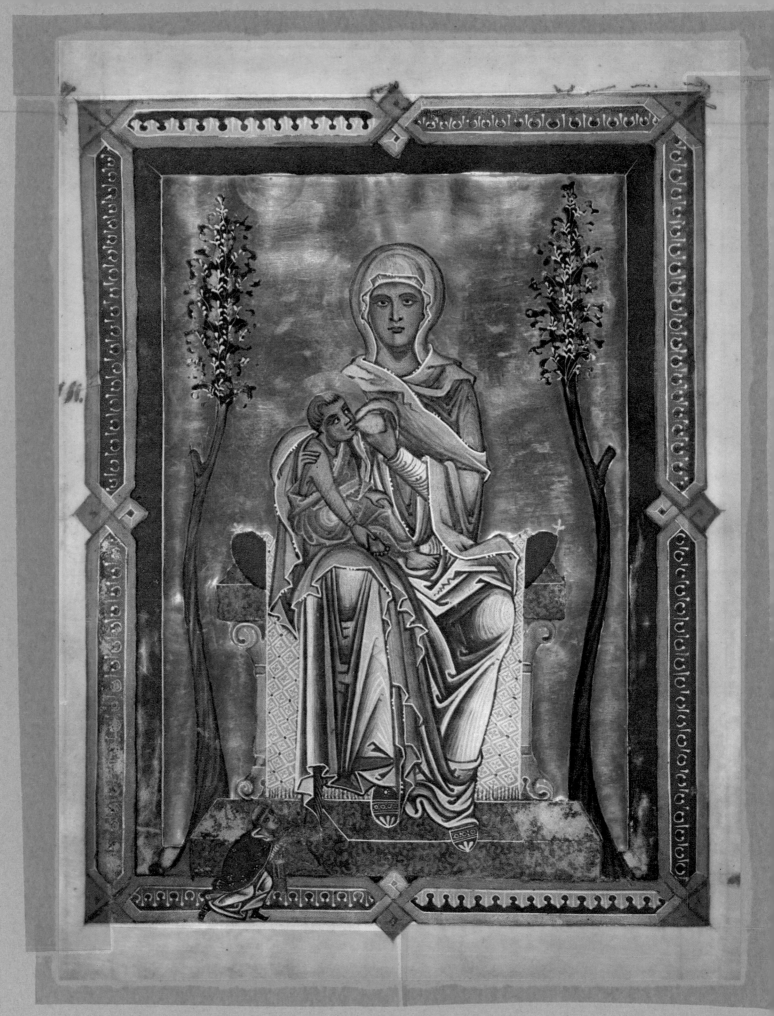

G

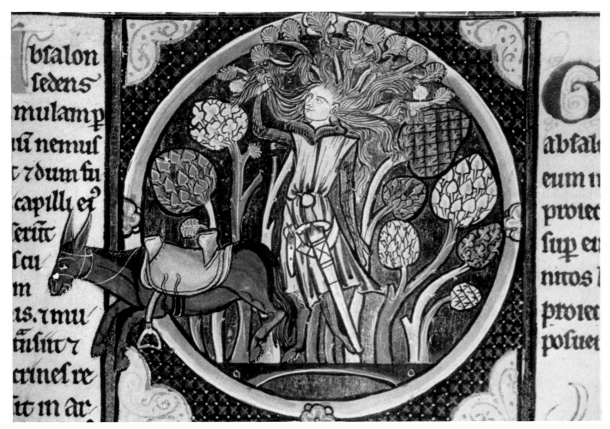

80. Abaslom caught in a Tree. *Bible Moralisée*, French, mid-13th century.
Toledo, Cathedral Library, MS. I, fol. 126r.

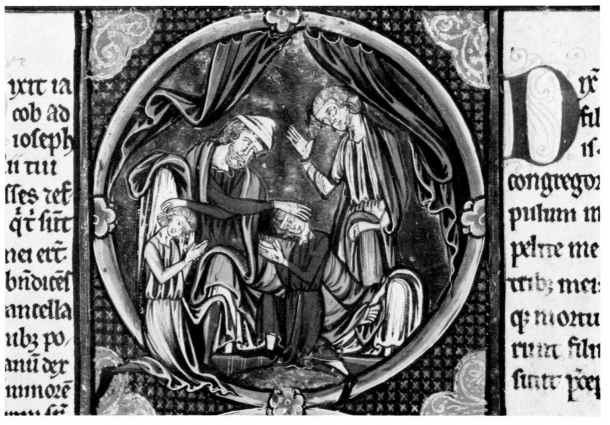

81. Jacob blessing the Sons of Joseph, *Bible Moralisée*, French, mid-13th century.
Oxford, Bodleian Library, MS. Bodl. 270b, fol. 34r.

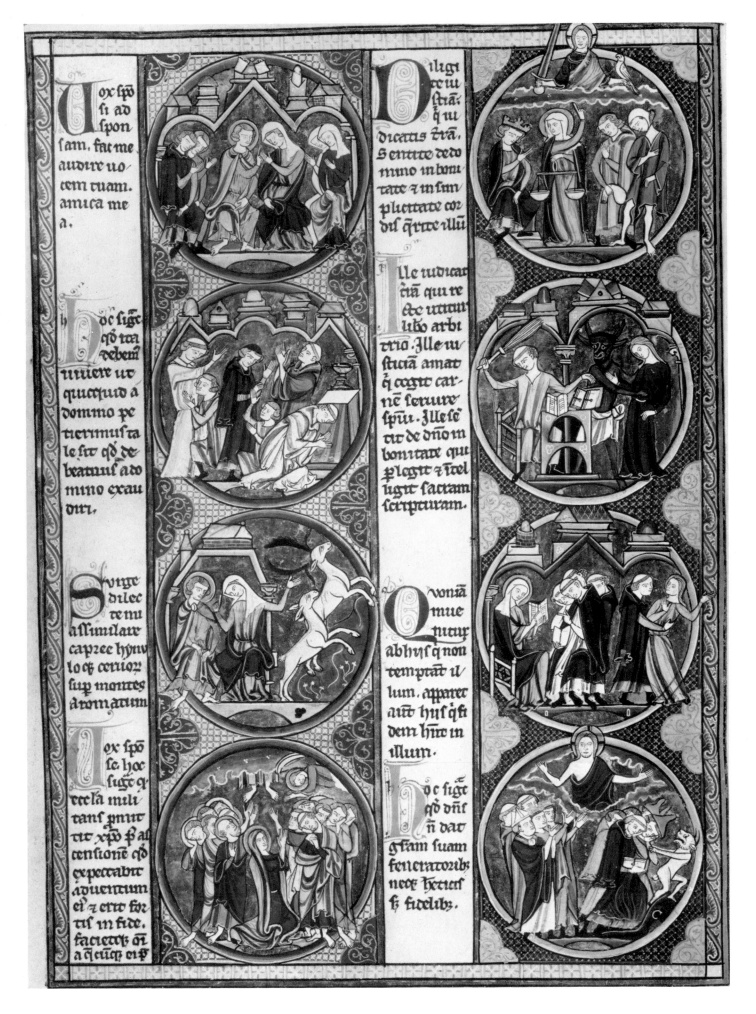

82. Illustrations to *Canticum Canticorum* and *Sapientiae*. *Bible Moralisée*. French, mid-13th century.
Paris, Bibliothèque Nationale, MS. lat. 11560, fol. 93v.

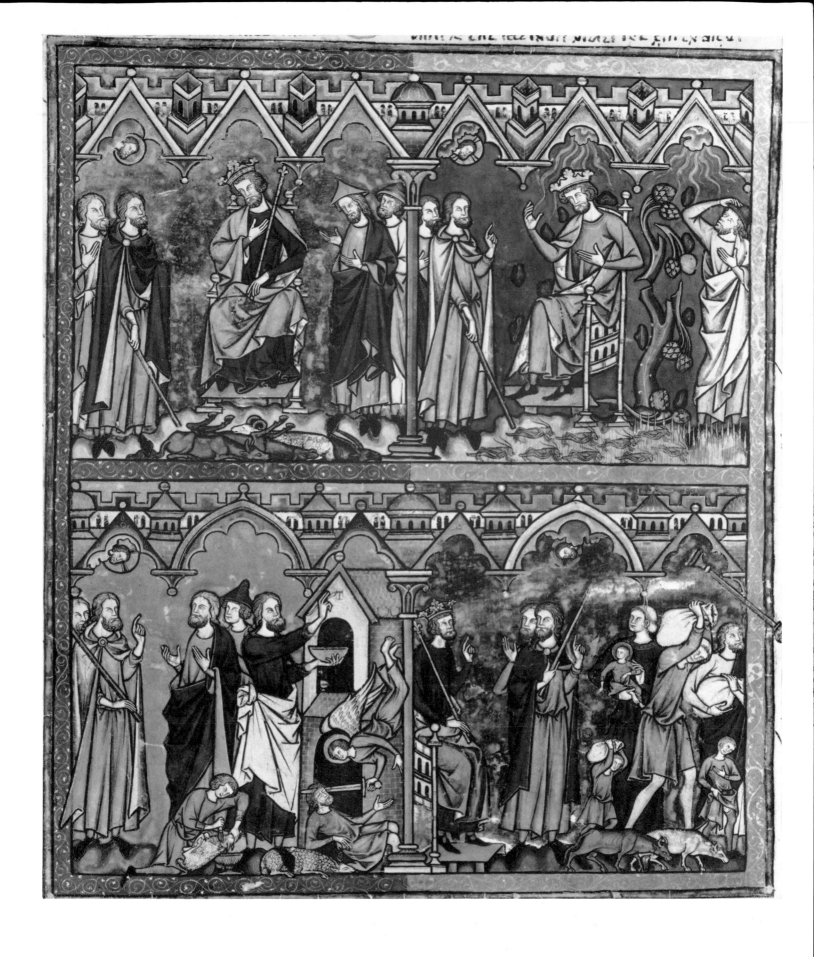

83. Scenes from the Story of Moses. *Maciejowski Bible.* French, 13th century.
New York, Pierpont Morgan Library, MS. 638, fol. 8v.

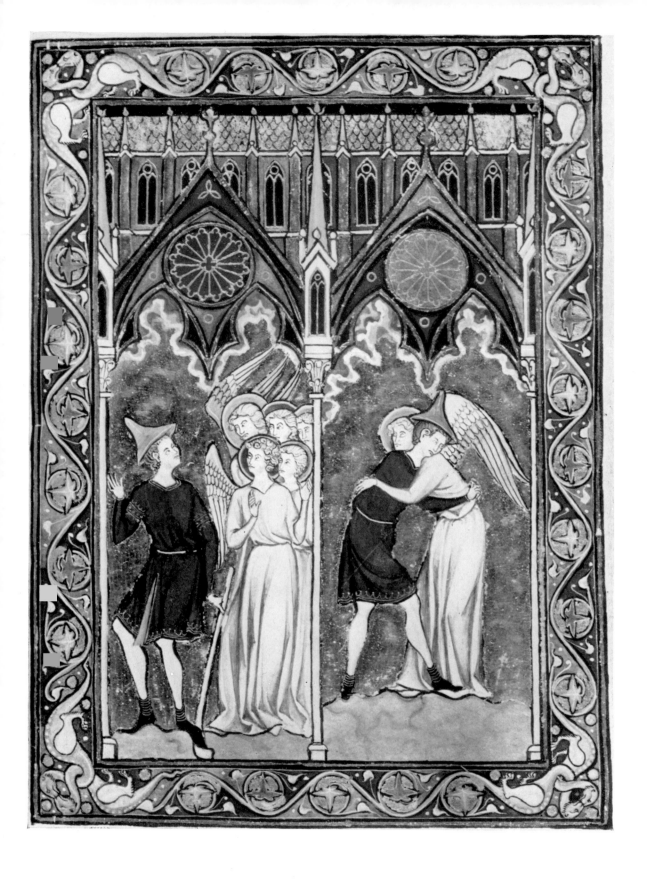

84. Jacob wrestling with the Angel. *Saint Louis Psalter*. Paris, third quarter of the 13th century.
Paris, Bibliothèque Nationale, MS. lat. 10525, fol. 14.

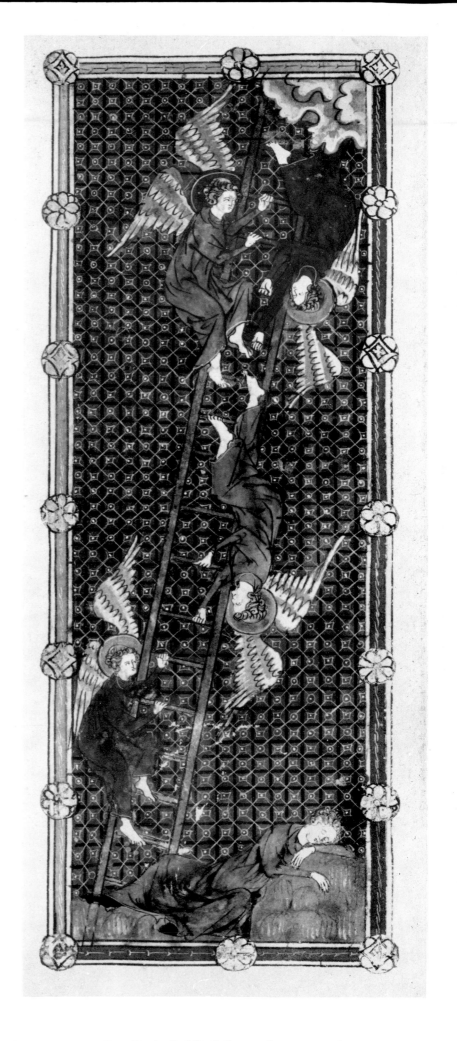

85. Jacob's Ladder. *Bible Historiée*. French, about 1300. New York, Public Library, Spencer Collection, MS. 5.

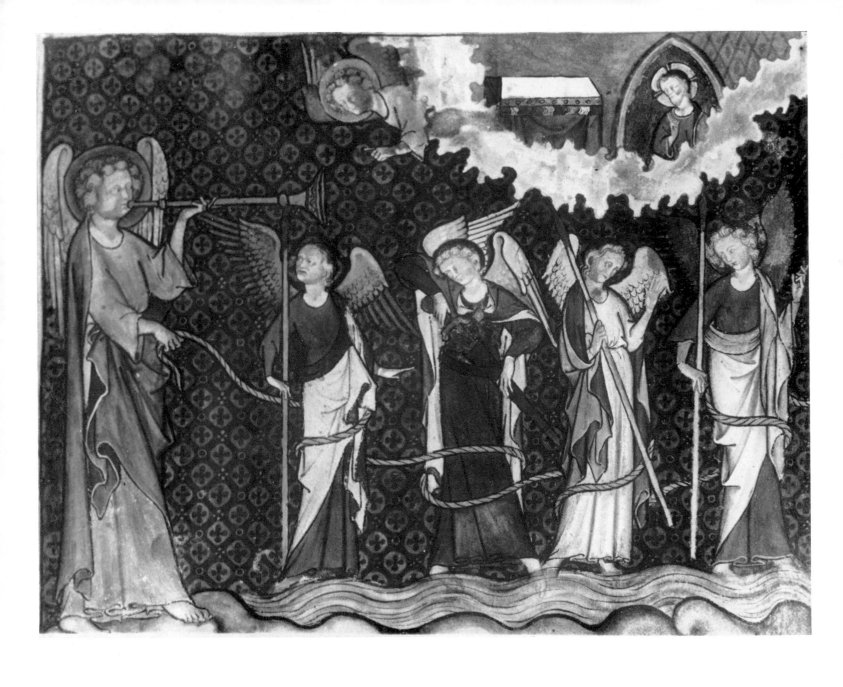

86. Trumpeting Angel. *Apocalypse*. English (?), early 14th century. London, British Museum, MS. Add. 17333, fol. 14r.

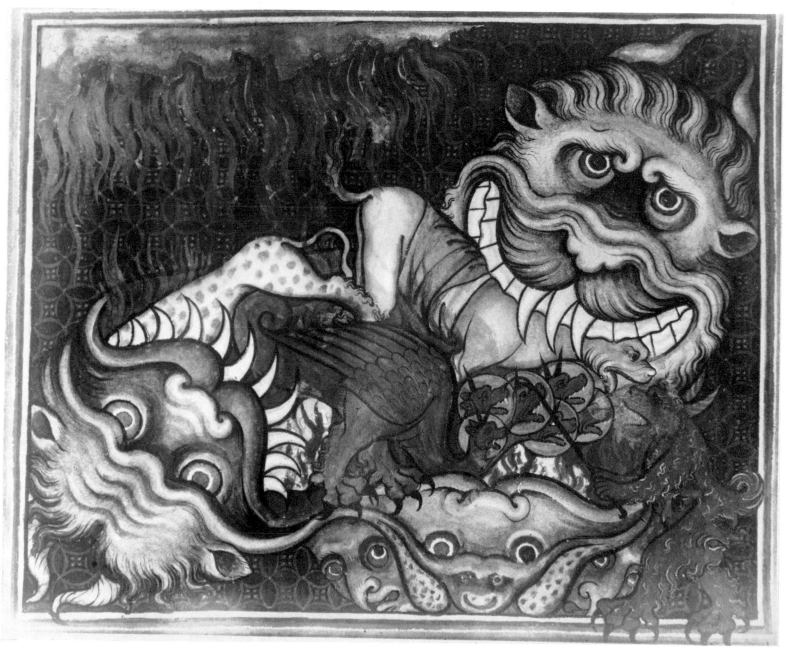

87. Hell. *Apocalypse*. English (?), early 14th century. London, British Museum, MS. Add 17333, fol. 43r.

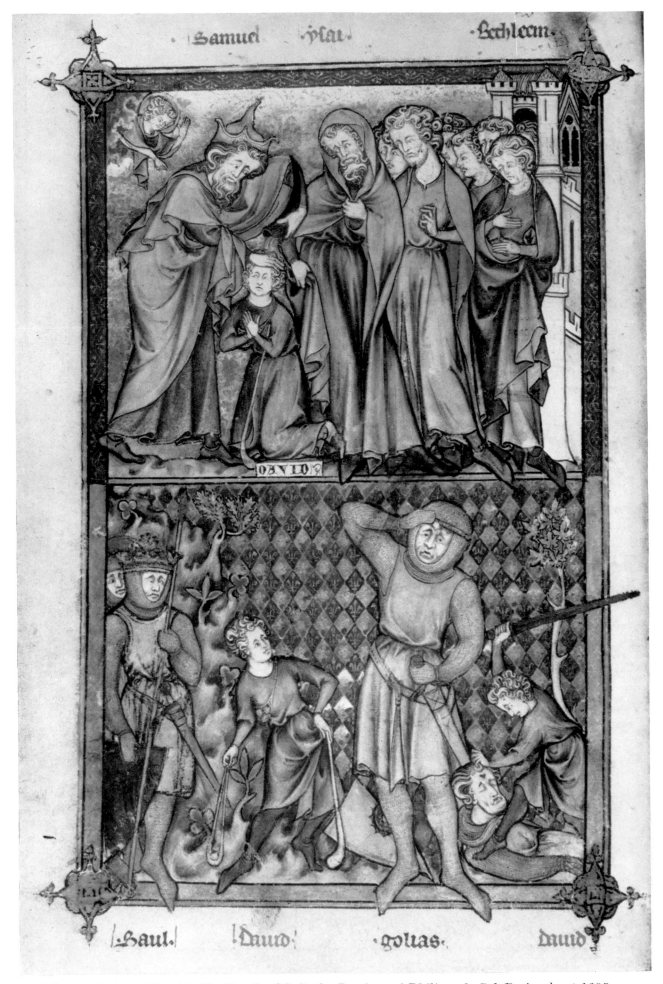

88. The Anointing of David: The Death of Goliath. *Breviary of Philippe le Bel*. Paris, about 1295.
Paris, Bibliothèque Nationale, MS. lat. 1023, fol. 7v.

89. *Queen Mary Psalter*. English, early 14th century.
London, British Museum, MS. Royal 2 B VII, fol. 151r.

sūt ī īniquitatibʒ: non est qui fa
ciat bonum

Deus de celo prspexit super filios ho
minū: ut uideat si est intelligens

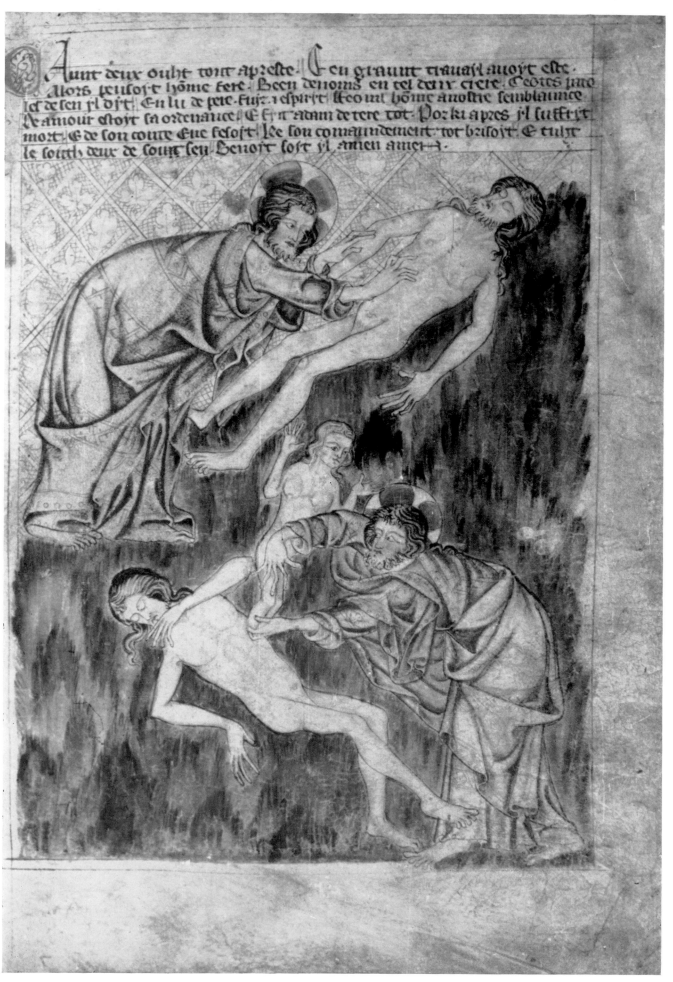

90. The Creation of Adam and Eve. *Holkham Bible Picture Book.*
English, mid-14th century. London British Museum, MS. Add. 47682, fol. 3.

91. Saul threatening David, Cain killing Abel, Personifications of the Eucharist and Charity. *Belleville Breviary*. French, about 1323–1326. Paris, Bibliothèque Nationale, MS. lat. 10483, fol. 24v.

Within the illustration:

il ne font pas painti fi come il
doluent feoir man lordre eft en
faillor preudoie.

il ne font pas painti fi come il
feoir maif lordre eft au faillor preudoie.

92. Philippe VI and his Council. *Actes du Procès de Robert d'Artois*. French, 1336.
Paris, Bibliothèque Nationale, MS. lat. 18437, fol. 2r.

maifuic. et dit le maiſtir q̃ abram
ꝯptiens anſmetique. z aſtronomic

uoir le ſaiptur q̃ue nomme aucu
maniers. lune qui ſont dune men

Aſcendit ergo
abram. et cet̃.
Quant au p̃
mier il dit amſi. Donq̃s

abram ſen monta de
egipte lui et ſa femme
et toutes les choſes q̃ il
auoient. auec lui. z loth

in de departur de loth ſauoſa. Apres cō
mint richeſſe a auenir li deuiſa. Actc

tinux a moy aduerſite. et a toy proſ
paiz. Car mier uaut aduerſite en u

93. The Parting of Abraham and Lot. *Bible of Jean de Sy.* French, mid-14th century.
Paris, Bibliothèque Nationale, MS. fr., 15397, fol. 14v.

94. Micah. *Psalter of the Duc de Berry.* French, 1380–85.
Paris, Bibliothèque Nationale, MS. fr. 13091, fol. 29v.

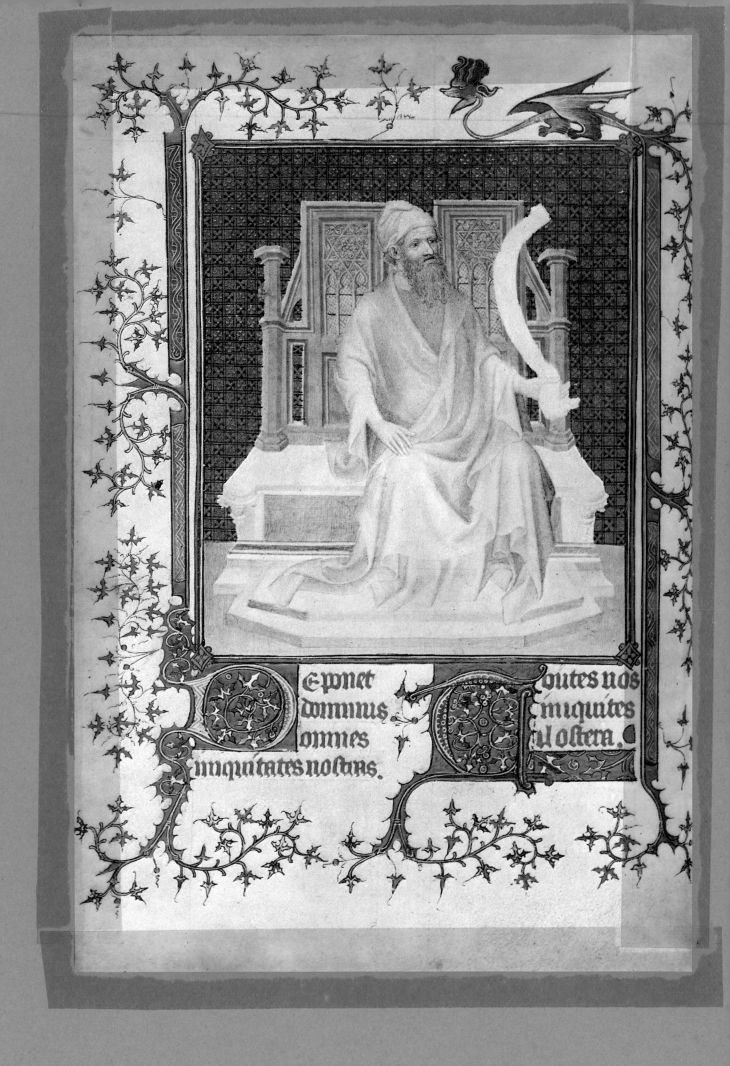

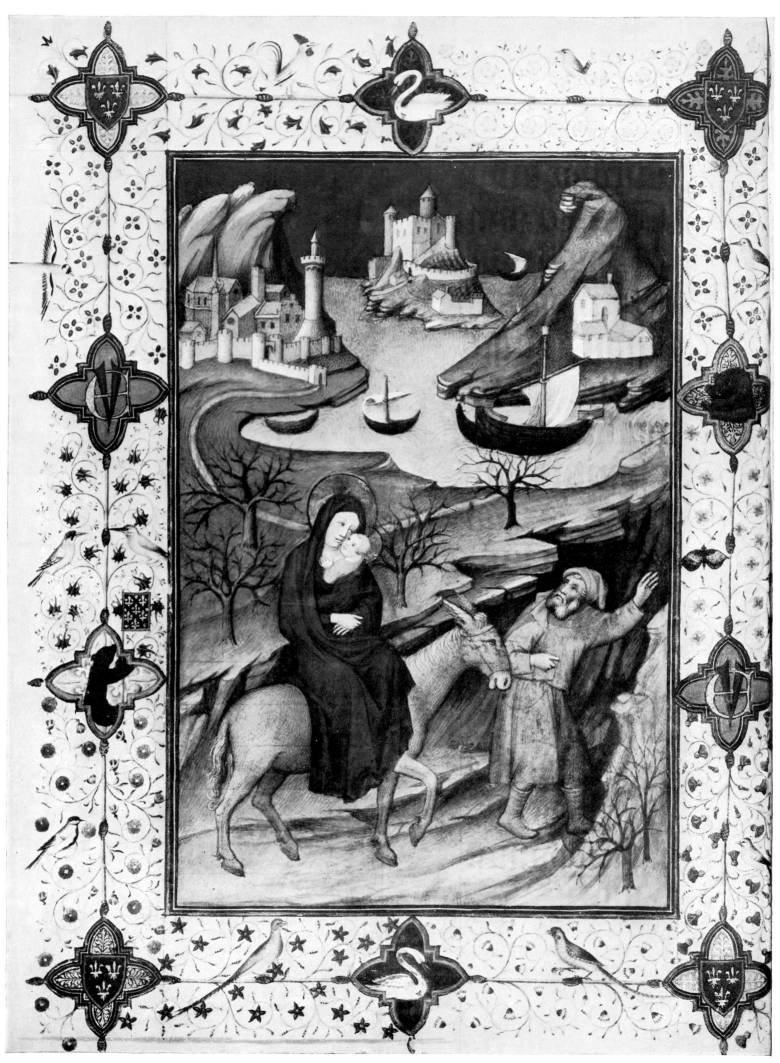

95. Flight to Egypt. *Brussels Hours*. French, end of the 14th century. Brussels, Bibliothèque. Royale, MS. 11060–1, fol. 106.

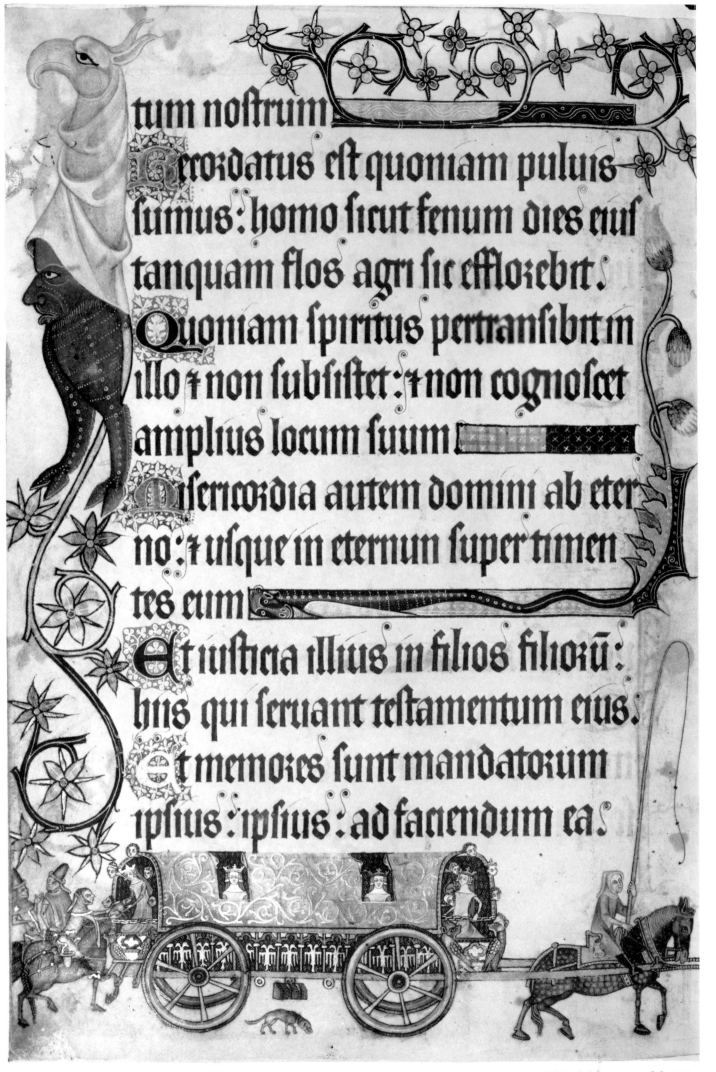

tum nostrum

Recordatus est quoniam puluis
sumus: homo sicut fenum dies eius
tanquam flos agri sic efflorebit.

Quoniam spiritus pertransibit in
illo ⁊ non subsistet: ⁊ non cognoscet
amplius locum suum

Misericordia autem domini ab eter
no: ⁊ usque in eternum super timen
tes eum

Et iusticia illius in filios filioꝛū:
hiis qui seruant testamentum eius.
Et memoꝛes sunt mandatoꝛum
ipsius: ipsius: ad faciendum ea.

96. Train of Royal Ladies. *Luttrell Psalter*. English, about 1340. London, British Museum, MS. Add. 42130, fol. 181v.

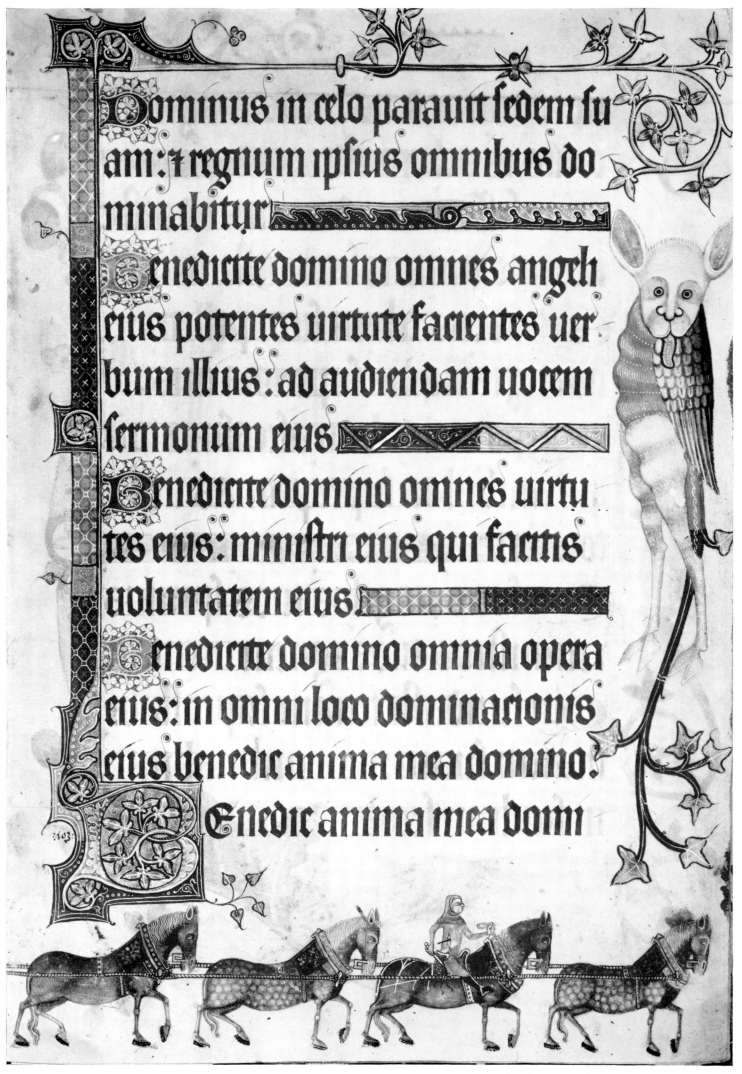

Dominus in celo parauit sedem su
am: 7 regnum ipsius omnibus do
minabitur

Benedicite domino omnes angeli
eius potentes uirtute facientes uer
bum illius: ad audiendam uocem
sermonum eius

Benedicite domino omnes uirtu
tes eius: ministri eius qui facitis
uoluntatem eius

Benedicite domino omnia opera
eius: in omni loco dominacionis
eius benedic anima mea domino.

Enedic anima mea domi

97. Horses drawing a carriage. *Luttrell Psalter*. English, about 1340. London, British Museum, MS. Add. 42130, fol. 182r.

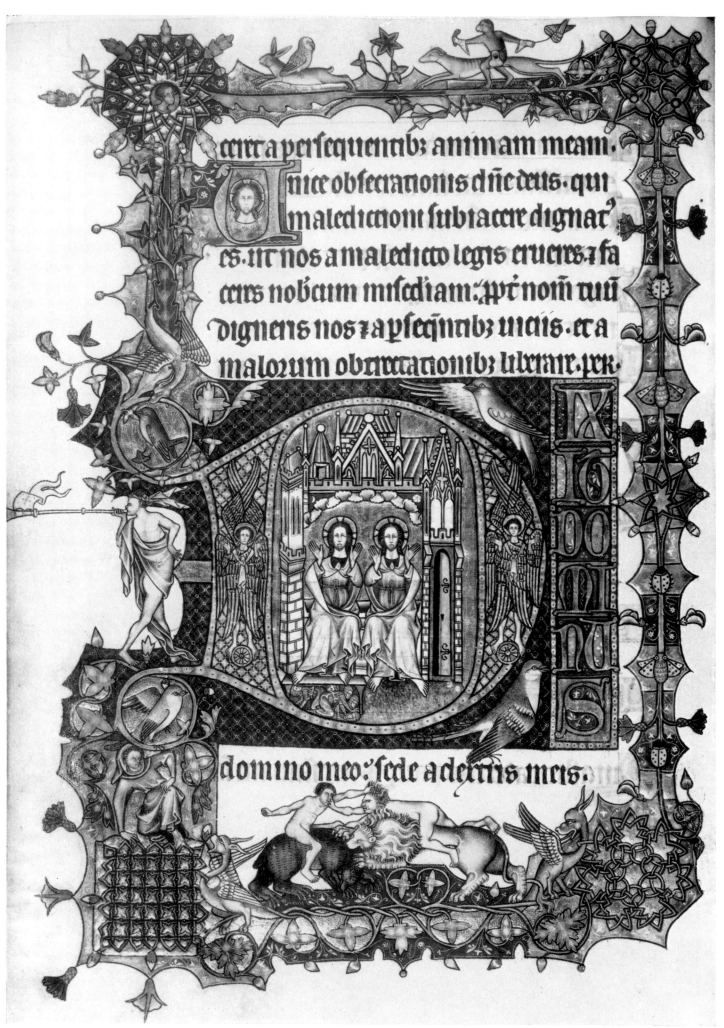

98. The Trinity. *Ormesby Psalter*. English, about 1320–30.
Oxford, Bodleian Library, MS. Douce 366, fol. 147v.

99. Illustrations to Psalm 51. *Psalter of Humphrey de Bohun*.
English, about 1370. Oxford, Exeter College, MS. 47, fol. 33v.

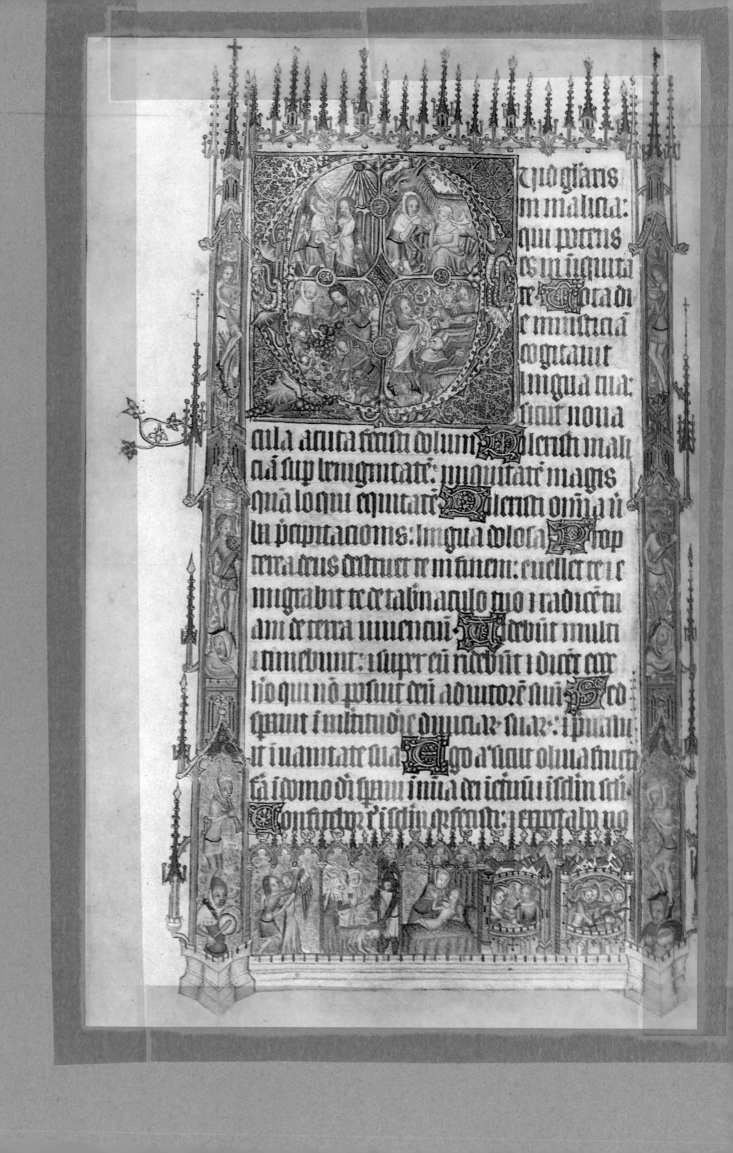

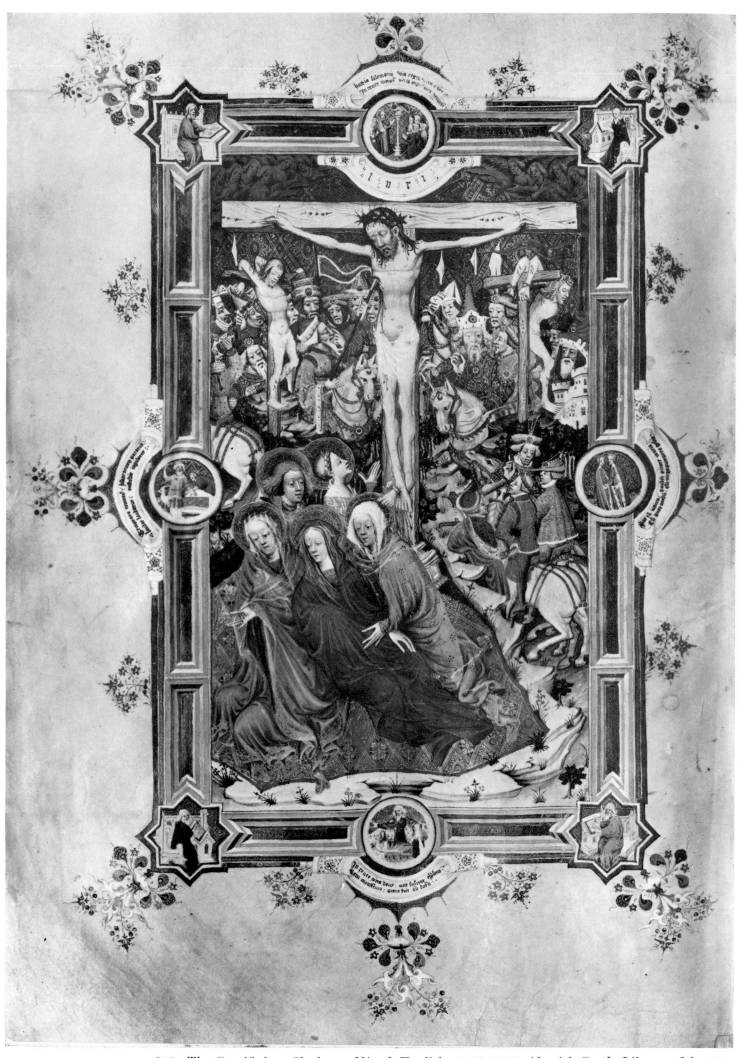

100. The Crucifixion. *Sherborne Missal*. English, 1396–1407. Alnwick Castle Library, fol. 380r.

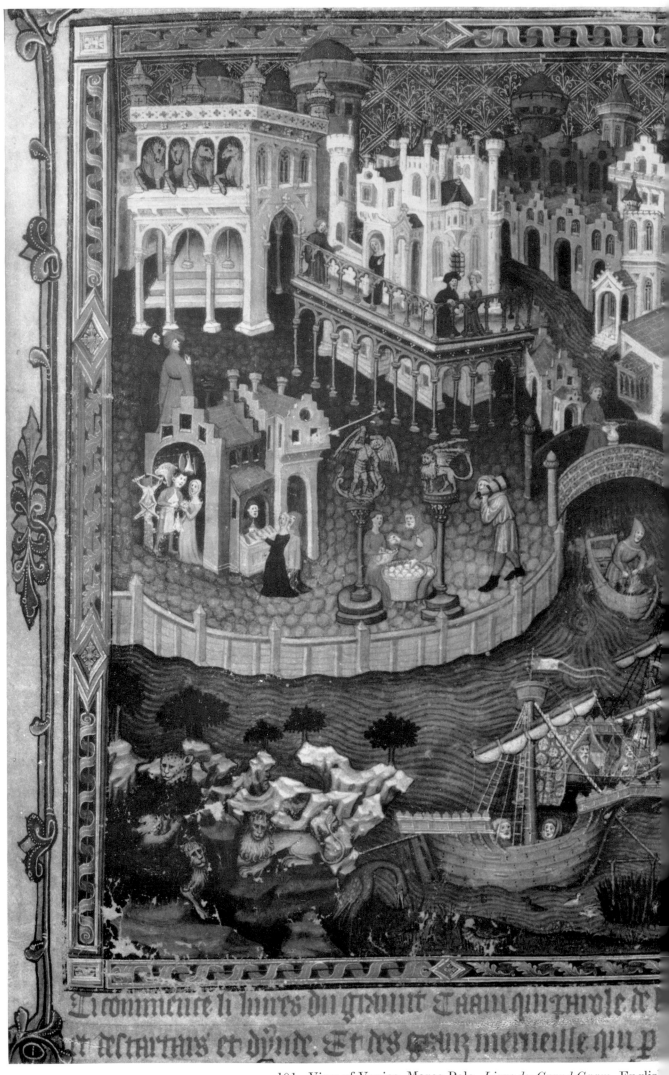

Li commence li liures du grannt Caam qui apole de
et de Tartaris et de Ynde. Et des grauz merueille qui p

101. View of Venice. Marco Polo, *Livre du Grand Caam*. Englis

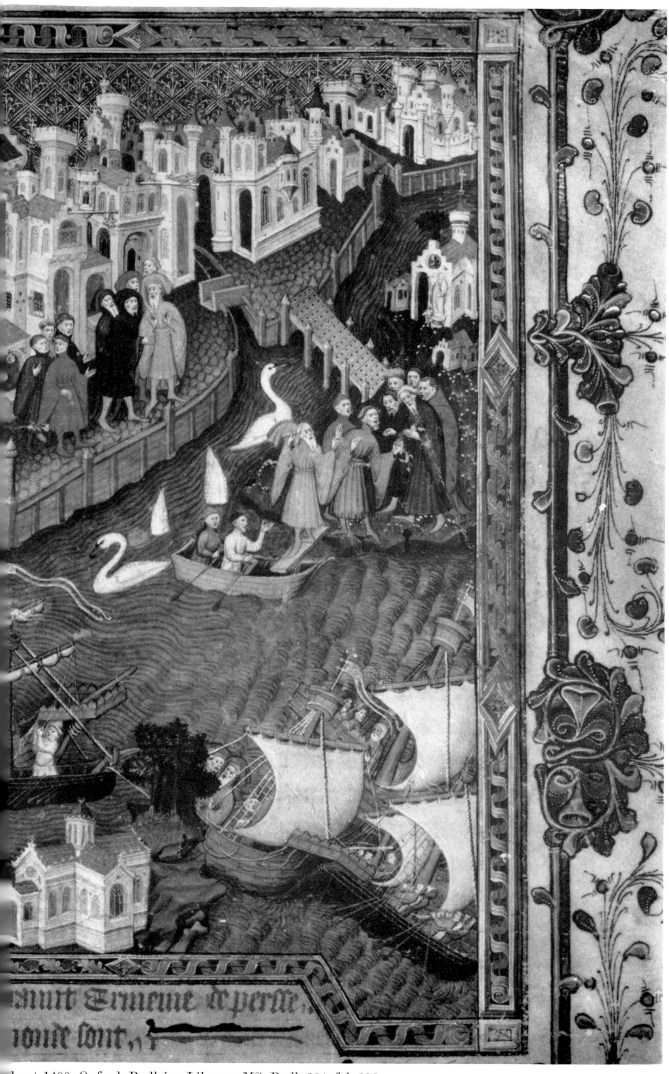

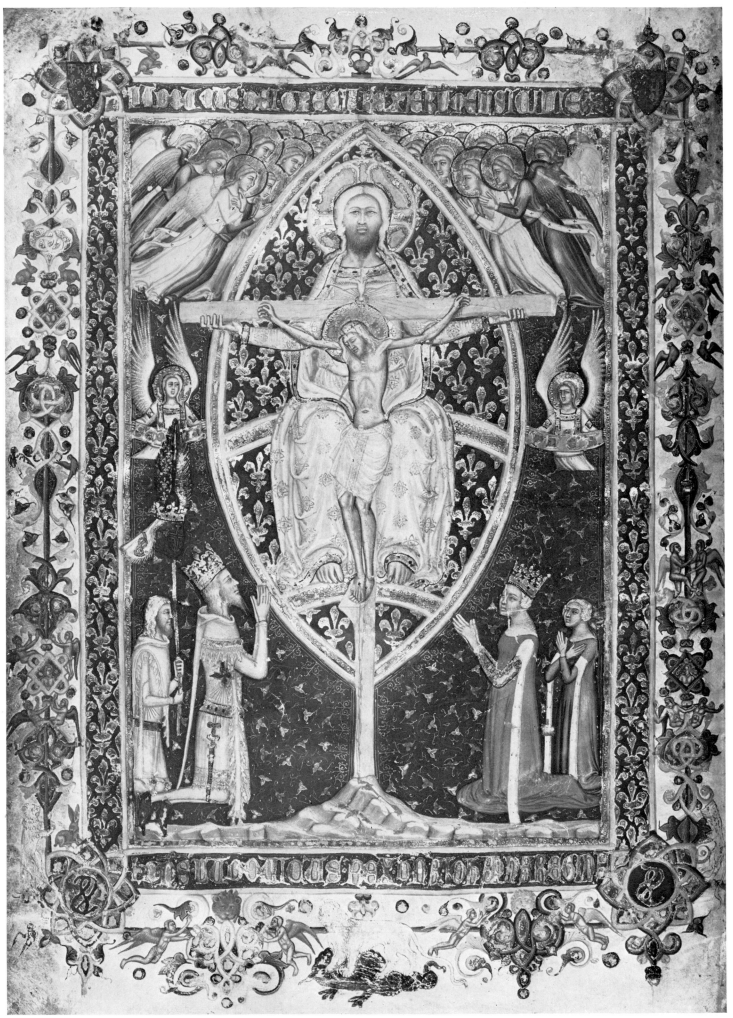

102. The Trinity with Louis de Tarente, King of Naples, and Jeanne de Navarre.
Statutes for the Order of the Saint Esprit. Neapolitan, 1352. Paris, Bibliothèque Nationale, MS. fr. 4274, fol 2v.

103. The Assumption of the Virgin. Sienese, first half of the 14th century. Siena, Archivio di Stato, MS. Capitoli 2, fol. 1r.

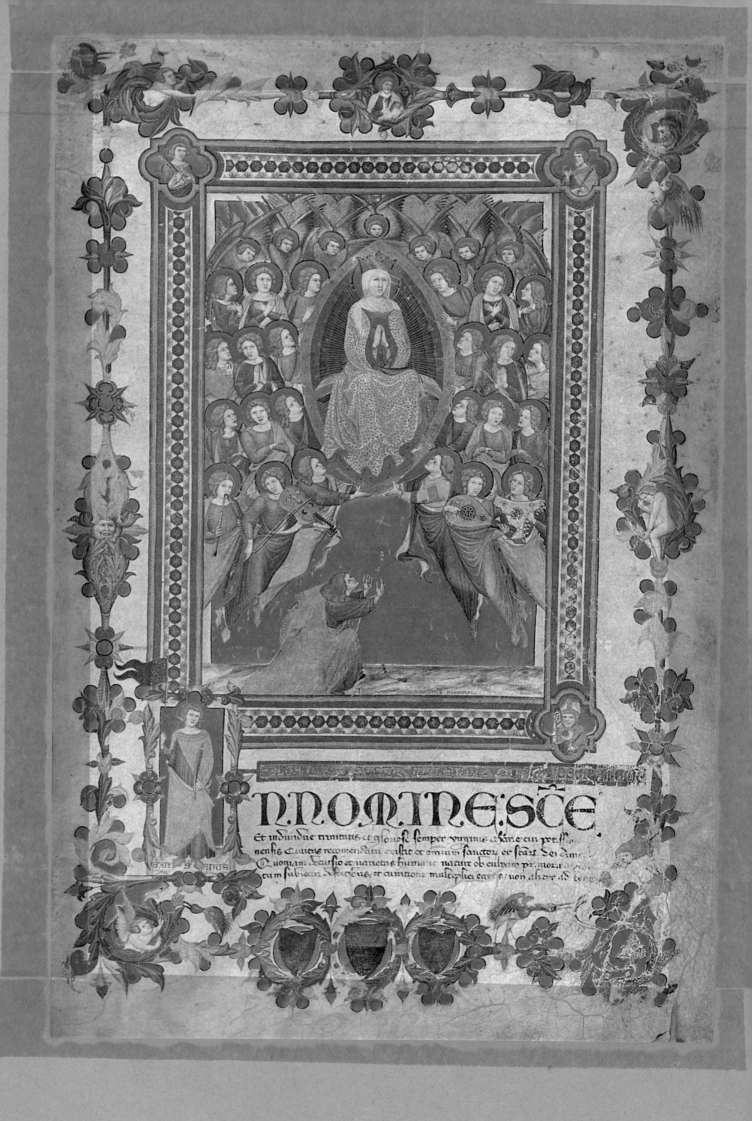

NNOMINE SCE
Et indiundue trinitatis et gloriose semper virginis ethane cui potissi
nentis Ciuitas recomendata existit et omnium sanctoy et scas Dei Ame
Quoniam recursio et nanetus humane naturt ob cultum pr moni
eum subiecit Necessarius et cunctorum multiplici capi et non exhor ad ben

SANCTORANUS

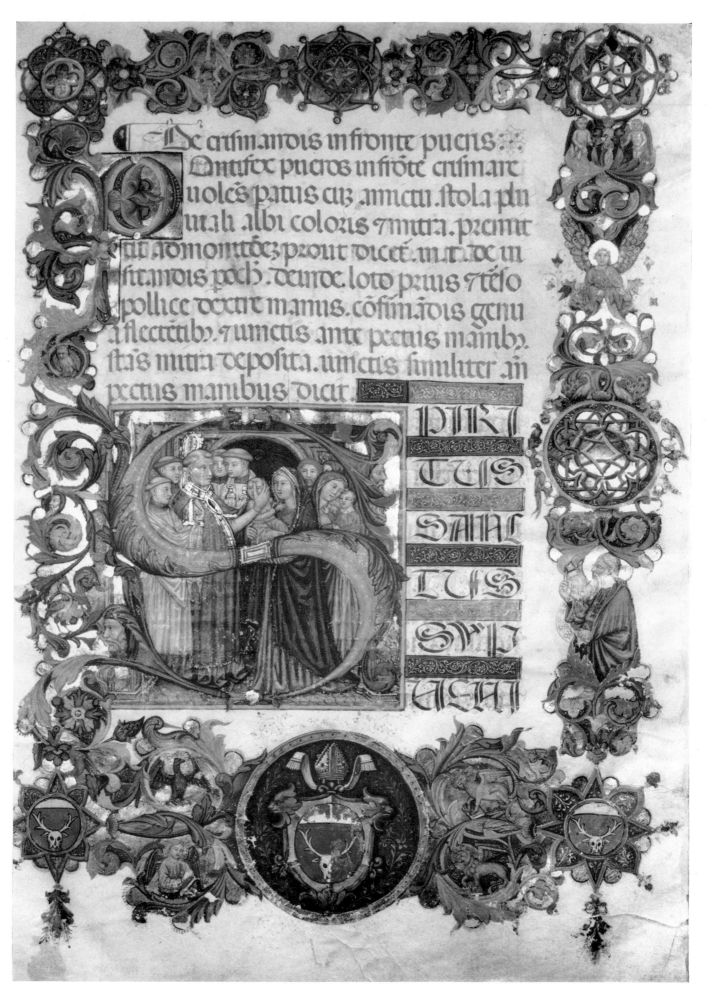

104. The Sacrament of Confirmation. *Pontifical*. Italian, about 1380.
Cambridge, Mass., Harvard College Library, MS. Type. I fol. 4.

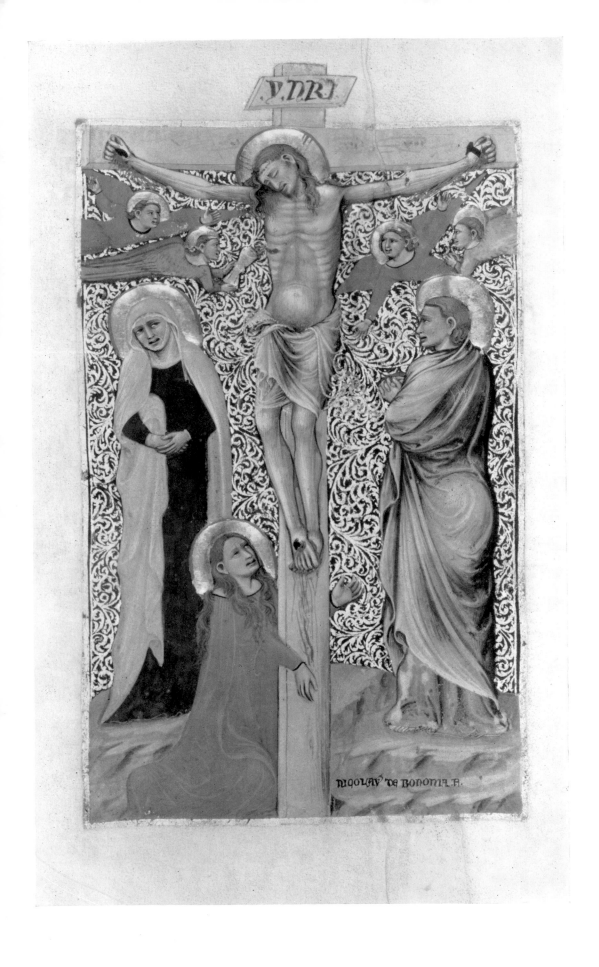

105. The Crucifixion. *Ordo Missae*. Niccolò da Bologna, about 1370.
New York, Pierpont Morgan Library, MS. 800, fol. 39v.

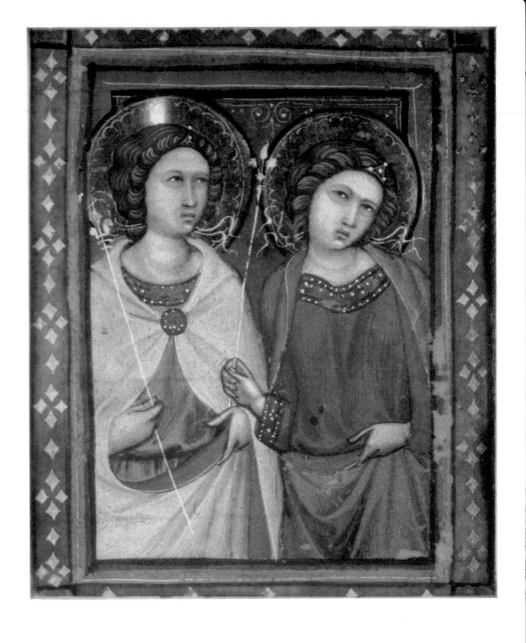

106. Two Saints. Detached Miniature. Italian, Sienese, 14th century.
Cleveland, Museum of Art, J. H. Wade Collection, MS. N.24, 430.

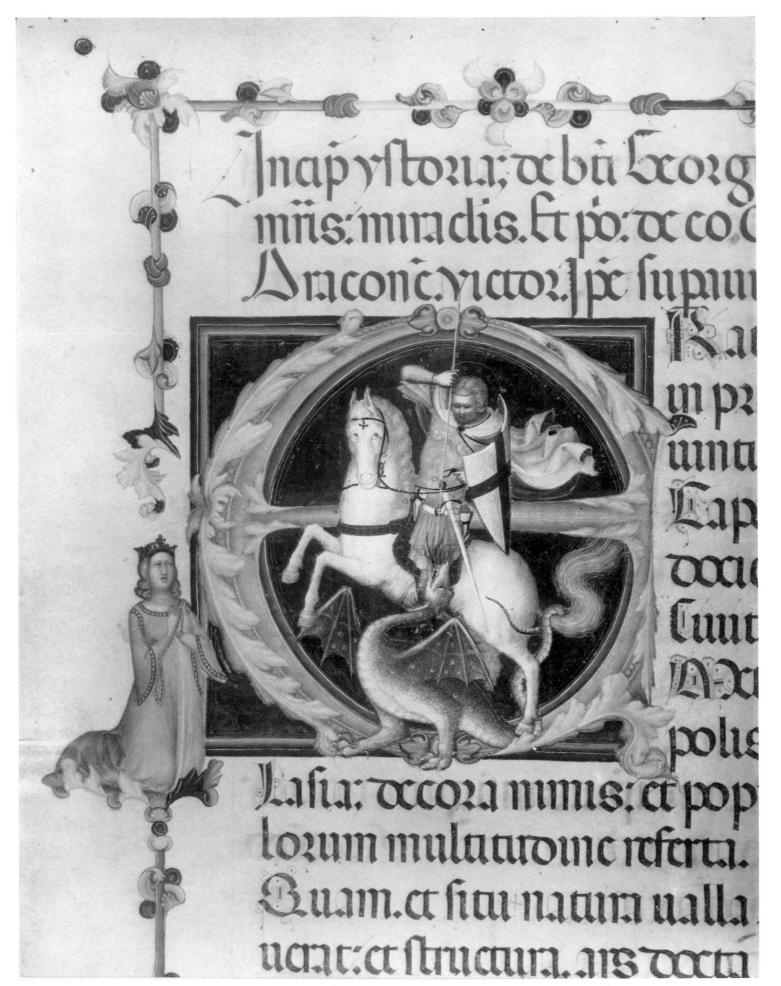

107. St. George and the Dragon.
Sienese, first half of the 14th century. Rome, Vatican Library, Archivio Capitolare, MS. C. 129, fol. 18v.

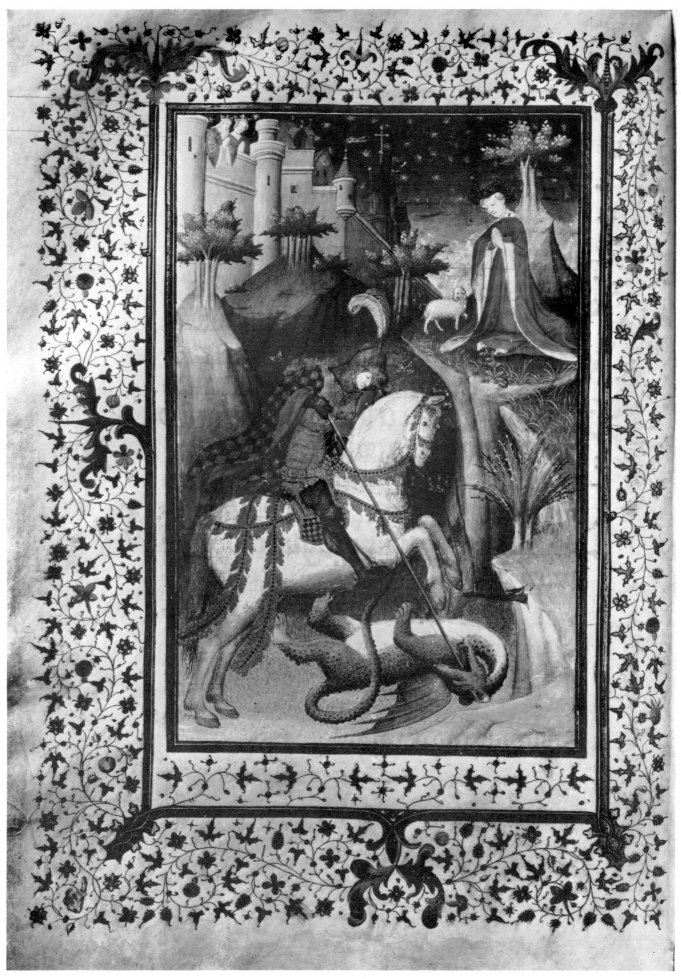

108. St. George and the Dragon.
Boucicaut Hours. French, 1396-1416. Paris, Musée Jacquemart-André, MS. 2, fol. 23v.

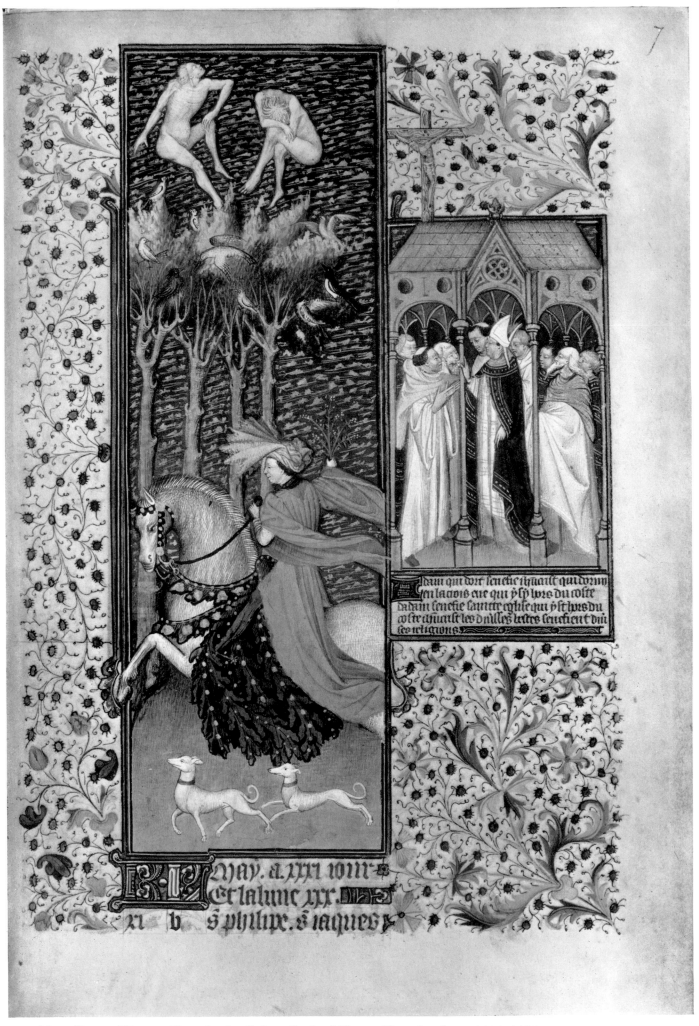

109. May: Young Man on Horseback. *Rohan Book of Hours*. French, about 1418–1420.
Paris, Bibliothèque Nationale, MS. lat. 9471, fol. 7r.

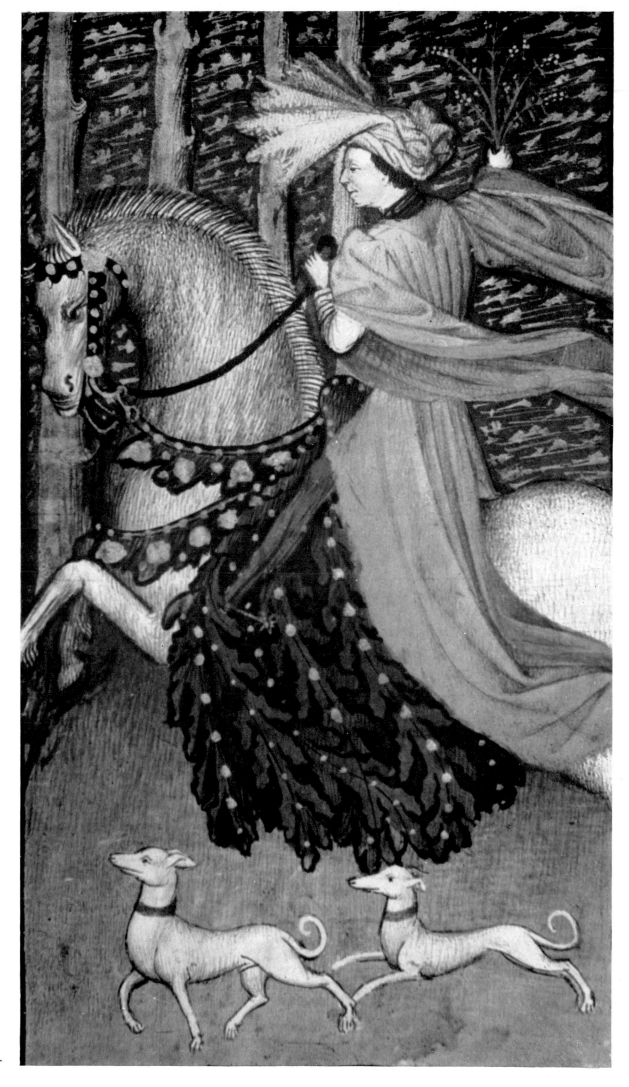

110. Detail of Plate 109.

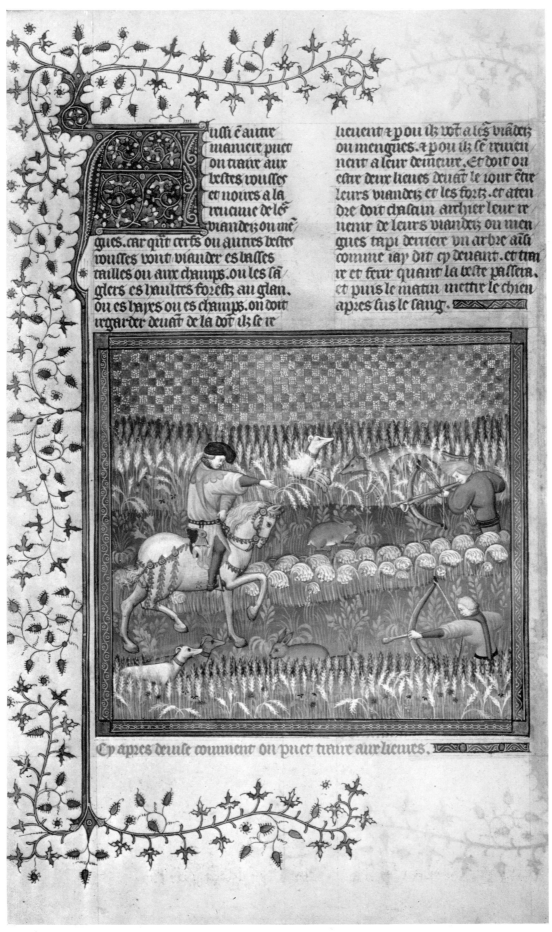

ulli ē autre manieie puet on tiaire aux bestes rousses et noires a la ieuaiue de lẽ viandez ou mē gues. car qūt cerfs ou autres bestes rousses vout viander es basses tailles ou aux champs. ou les fã glers es haultes forestz au glan. ou es haies ou es champs. on doit irgarder deuãt de la voy ilz se ie

lieuent z pou ilz vot a les viādez ou menques. z pou ilz se teuien nent a leur deneure. et doit on estre deux lieues deuãt le iour estre leurs viandez et les fortz. et aten dre doit chascun archier leur ie nenir de leurs viandez ou men gues tapi demeie vn arbre aiñ comme iay dit ey deuant. et tim ie et ferir quant la beste passeia. et puis le matin mettie le chien apres sus le sang.

Cy apres deuise comment on puet tiaire aux lieures.

111. Killing the Hare. *Livre de Chasse de Gaston Phébus*, French, about 1405–1410.
Paris, Bibliothèque Nationale, MS. fr. 616, fol. 118.

112. May: A May-Day Cavalcade near the town of Riom.
Très Riches Heures of the Duc de Berry. French, before 1416. Chantilly, Musée Condé, MS. lat. 1284, fol. 5v.

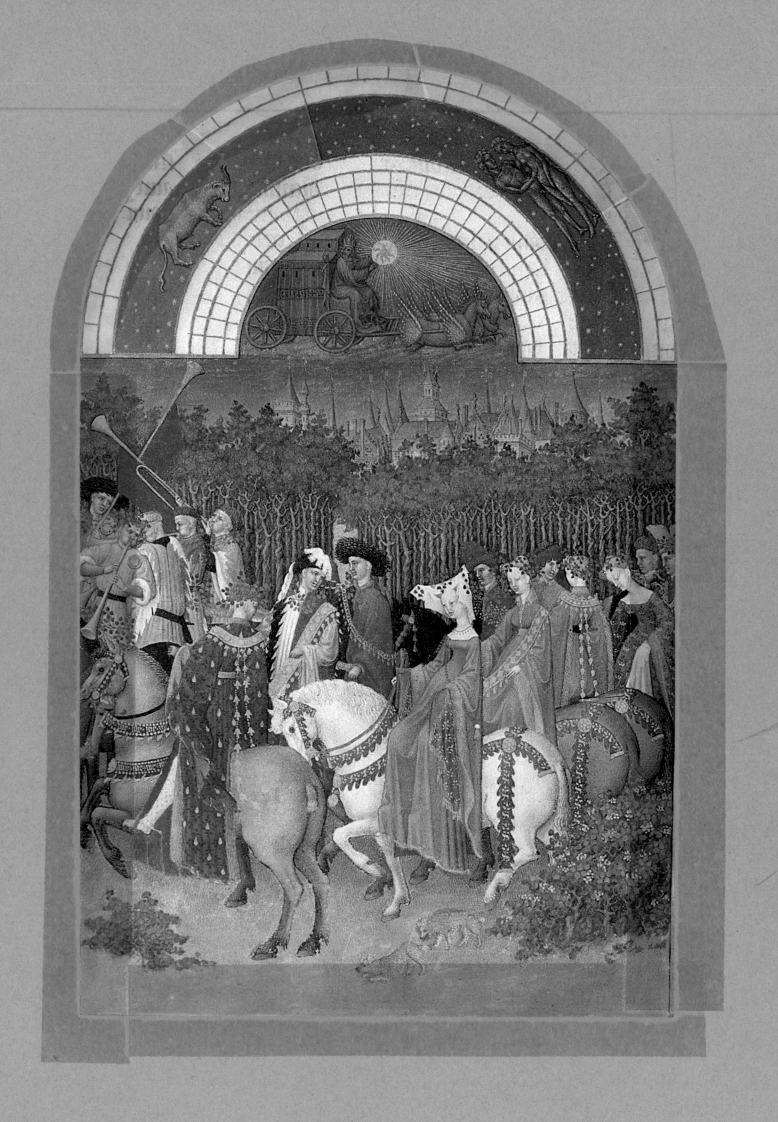

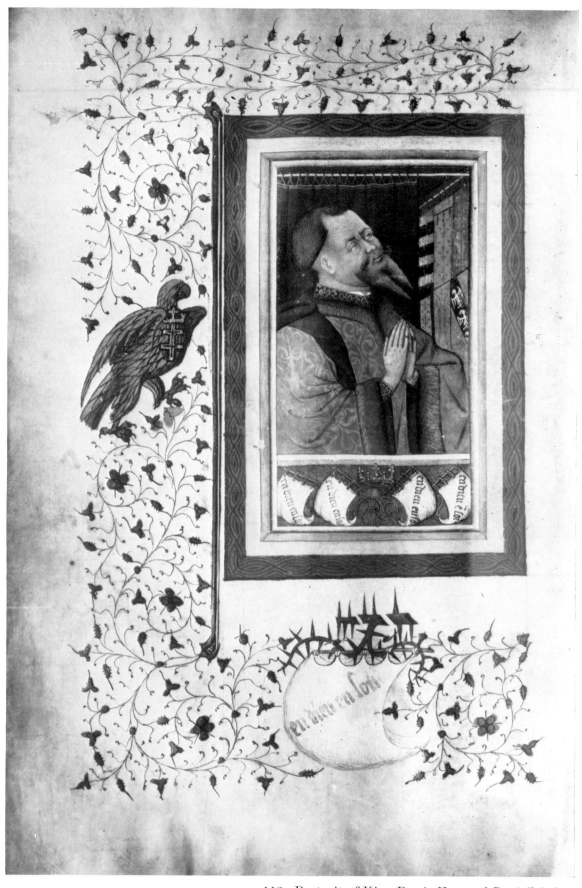

113. Portrait of King René. *Hours of René d'Anjou.*
French, second quarter of the 15th century. Paris, Bibliothèque Nationale. MS. lat. 1156A, fol. 81v.

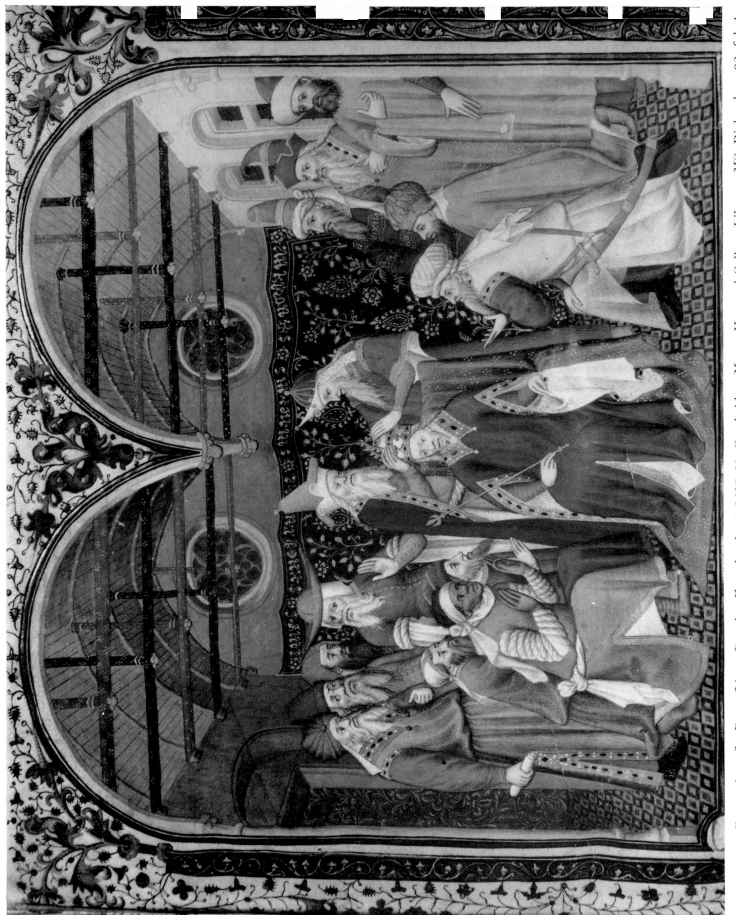

114. Coronation of a Pope. Livy, *Decades*. French, about 1425–30. Cambridge, Mass., Harvard College Library, MS. Richardson 32, fol. 1r.

115. Jean Wauquelin presenting his work to Philippe le Bon. *Chroniques de Hainaut*. Flemish, 1446. Brussels, Bibliothèque Royale, MS. 9242, fol. 1r.

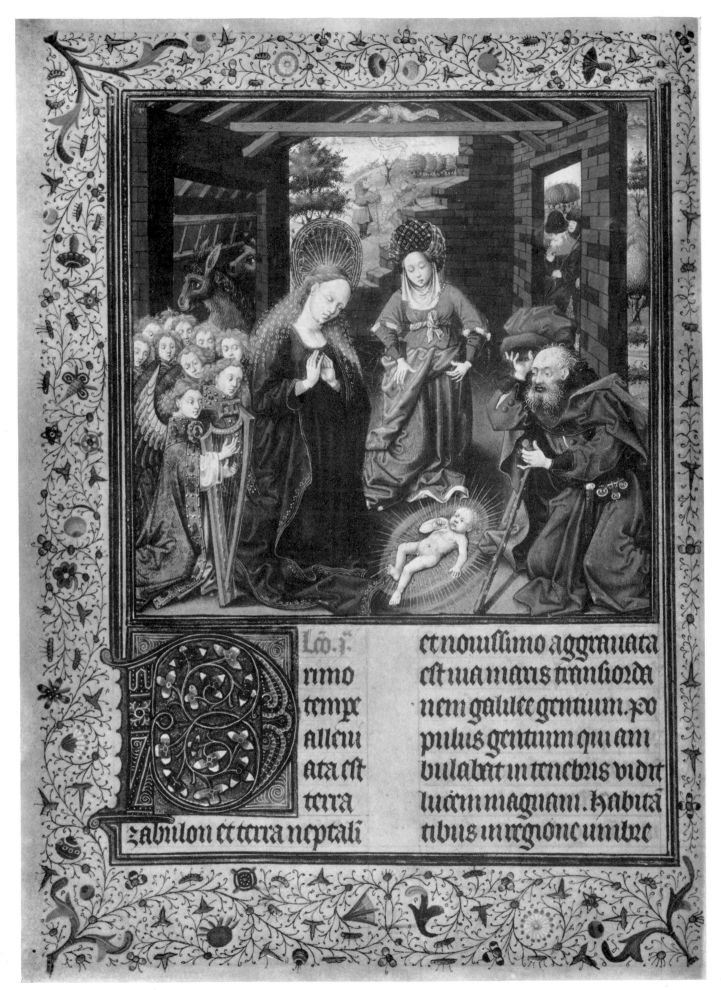

Léo.j.

rimo tempe alleui ata est terra

zabulon et terra neptali

et nouissimo aggrauata est uia maris trinsiorda nem galilee gentium. po pulus gentium qui am bulabat in tenebris vidit lucem magnam. habita tibus in regione umbre

116. The Nativity. *Breviary of Philippe le Bon*. Flemish, 1430–1440.
Brussels, Bibliothèque Royale, MS. 9511, fol. 43v.

117. The Awakening of Cuer; Cuer reads the Inscription on the Magic Fountain.
Le Livre du Cuer d'Amours Espris. French, about 1465. Vienna, Nationalbibliothek, MS. 2597, fol. 15r.

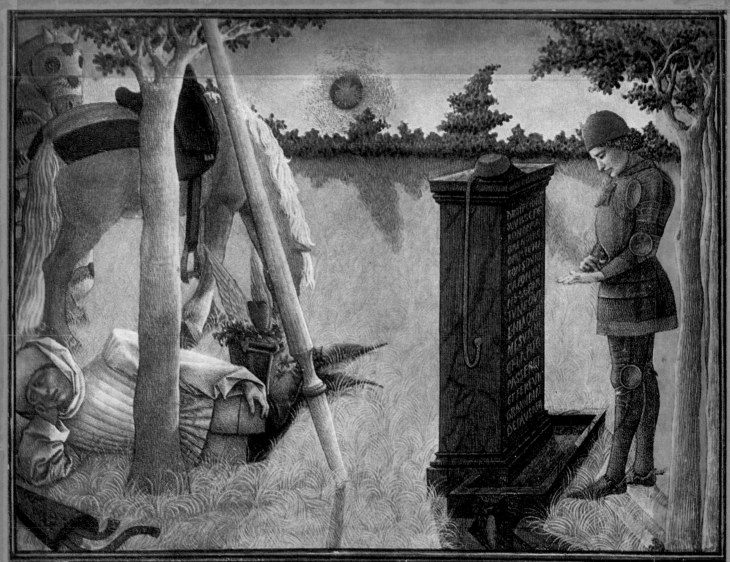

Tout cy deuant foubz ce peron
De marbre noir comme charbon
Sourt la fontaine de fortune
Ou il nya quelle neffune
Et la fift compaffer et faire
Ung tyrant Joyant de fauly affaire

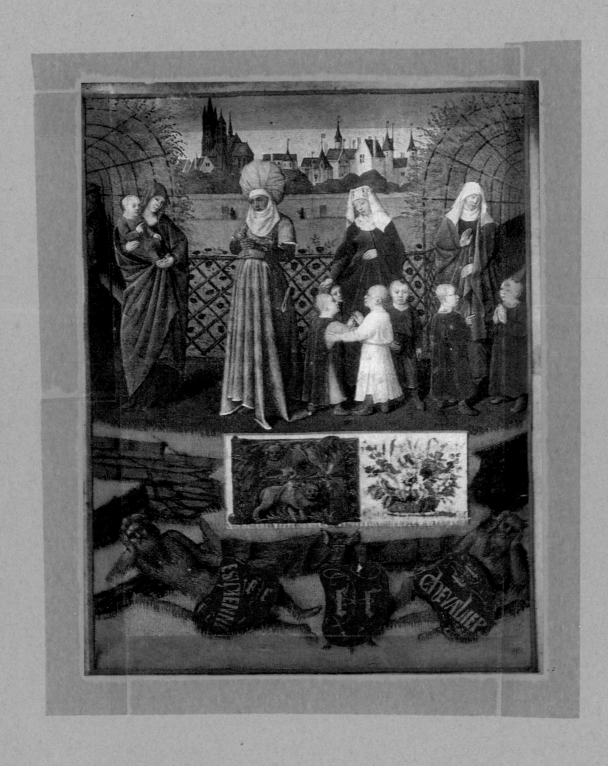

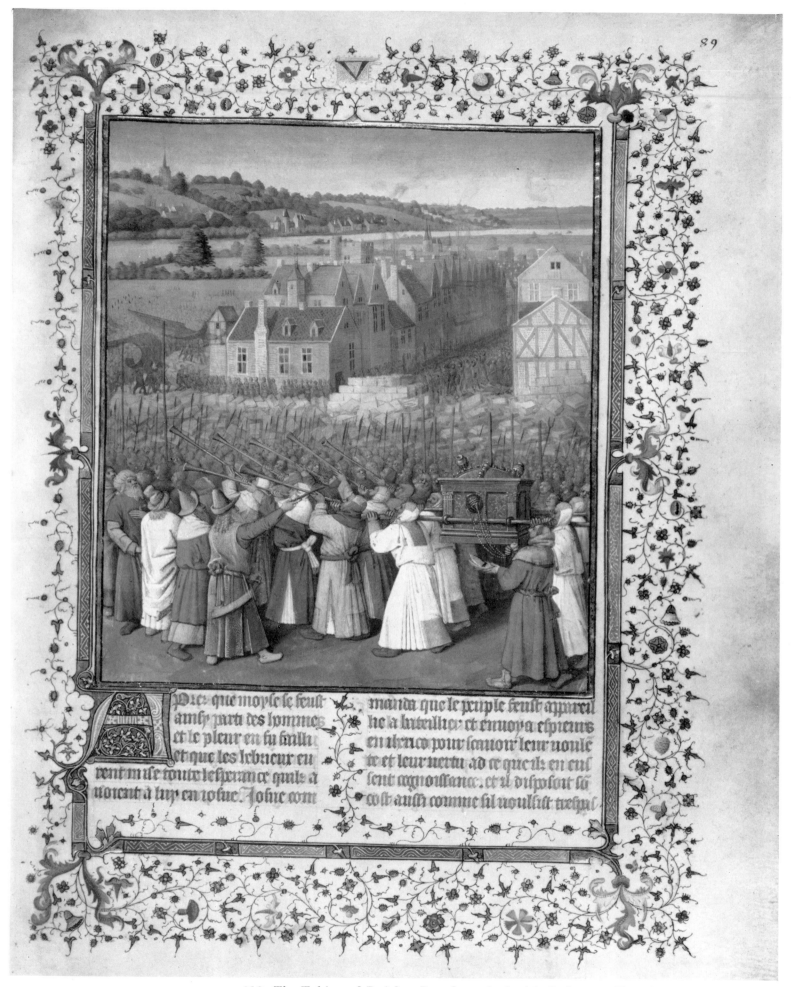

Pour que moyse se feust
ainsi parti des hommes
et le pleur en fu sailli
et que les hebrieux eu
rent mise toute lesperance quilz a
uoient a luy en iosue. Iosue com

manda que le peuple feust appareil
le a bataillier. et enuoya espieurs
en iherico pour scauoir leur voule
te et leur vertu ad ce que ilz en eus
sent cognoissance. et il disposoit son
cost ausi comme sil voulsist trespa

119. The Taking of Jericho. Josephus, *Antiquités Judaïques*. French, mid-15th century.
Paris, Bibliothèque Nationale, MS. 247, fol. 89r.

118. St. Anne and the Three Maries. *Hours of Étienne Chevalier.*
French, about 1455–60. Paris, Bibliothèque Nationale, MS. nouv. acqu. lat. 1416, fol. 1r.

Cnfieut le mirour
de la faluation humaine

120. Initial 'S'. *Miroir de la Salvation Humaine.* Flemish, 1448–9.
Brussels, Bibliothèque Royale, MS. 9249–50, fol. 1v.

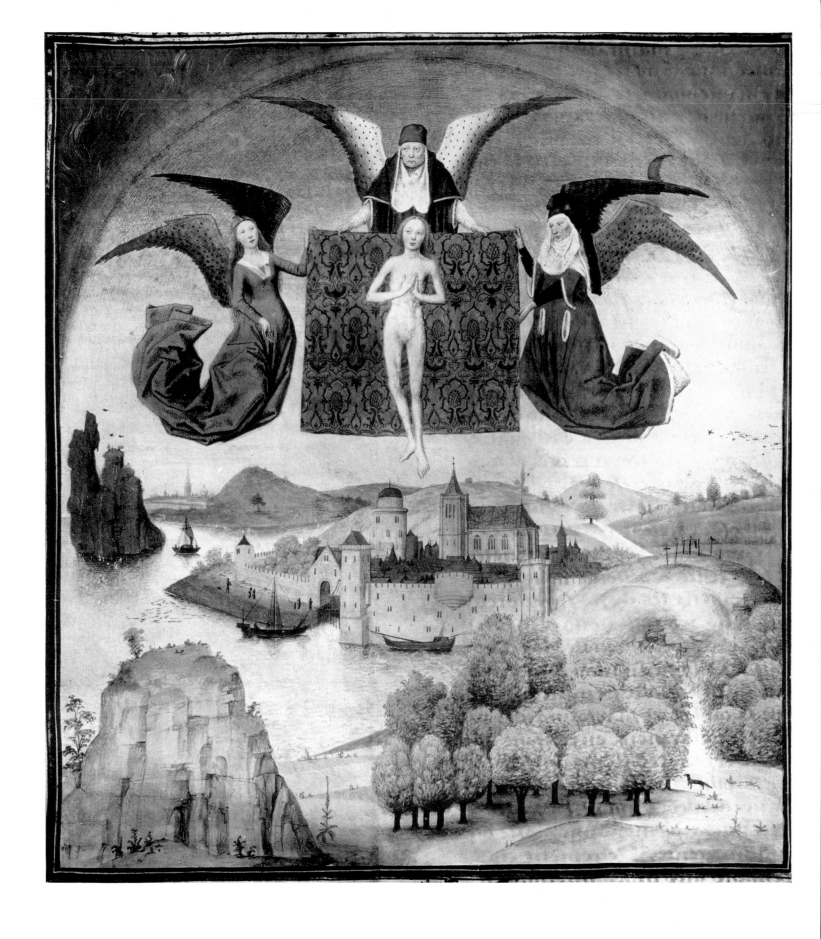

121. The Creation of Soul. Jean Mansel, *Fleur des Histoires*. Flemish, second half of the 15th century.
Brussels, Bibliothèque Royale, MS. 9232, fol. 815r.

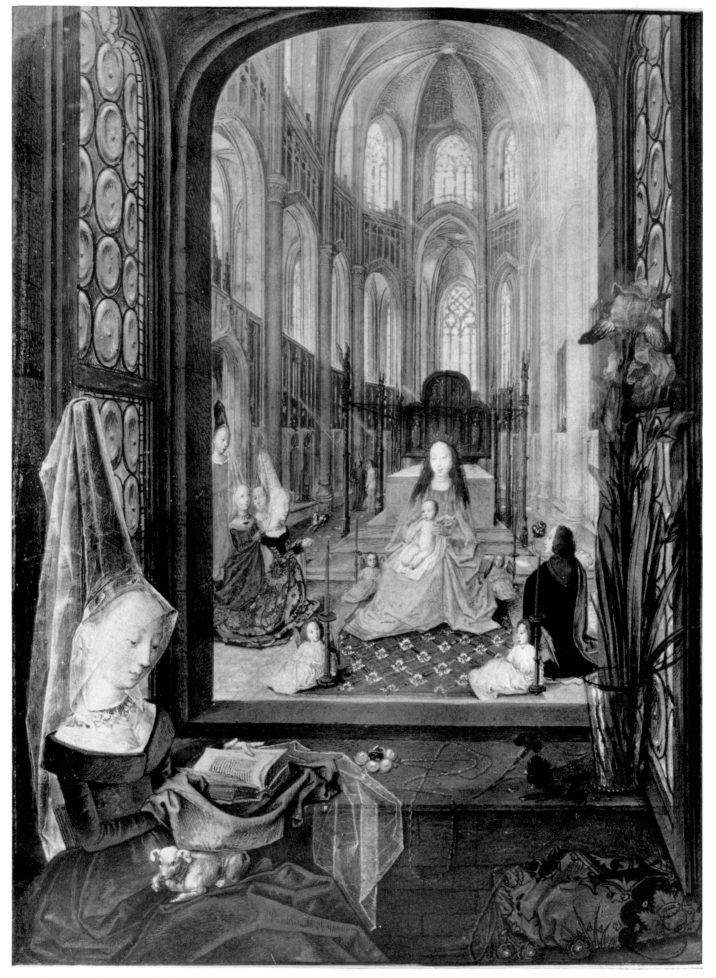

122. The Virgin and Child with Mary of Burgundy and Maximilian of Austria. *Hours of Charles the Bold.*
Flemish, 15th century. Vienna, Nationalbibliothek, MS. 1857, fol. 14v.

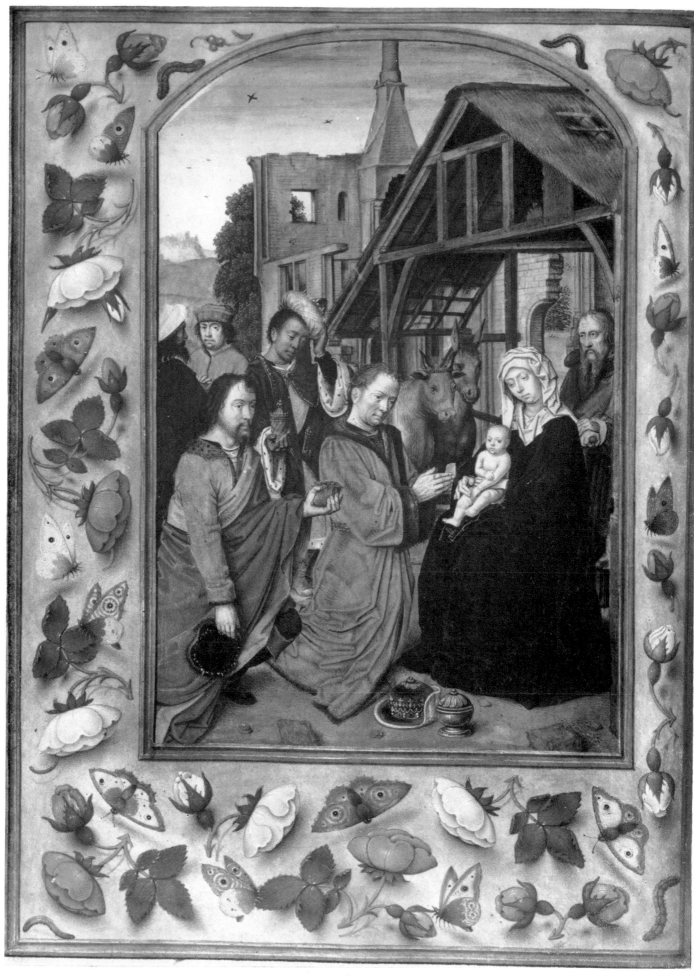

123. The Adoration of the Magi. *Grimani Breviary*. Flemish, early 16th century. Venice, Biblioteca Marciana, fol. 74v.

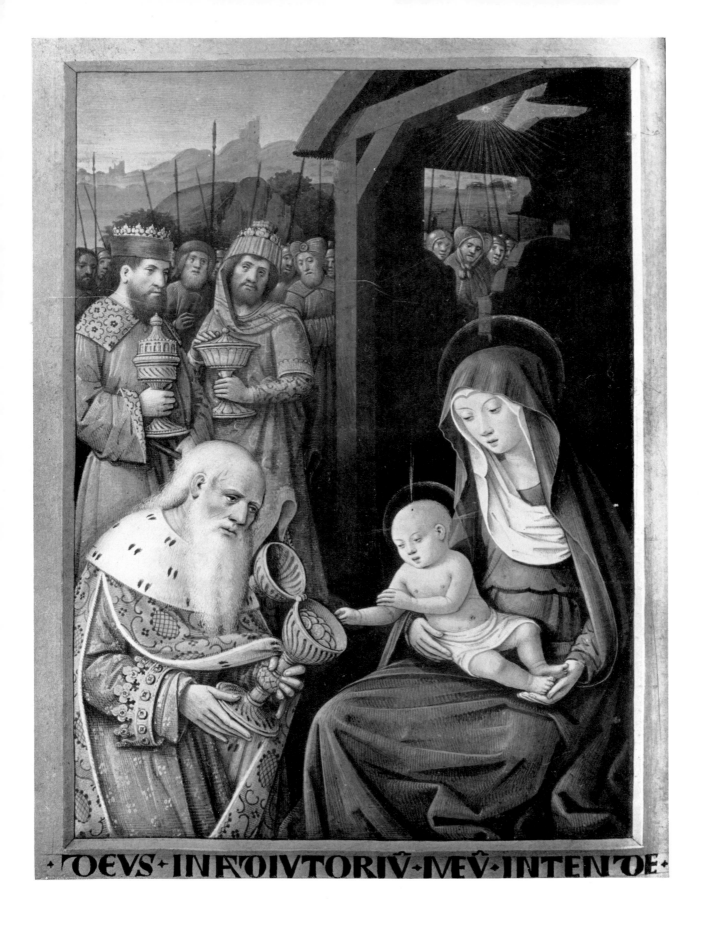

124. The Adoration of the Magi. *Hours of Charles d'Angoulême*. French, late 15th–16th century.
Paris, Bibliothèque Nationale, MS. lat. 1173, fol. 22v.

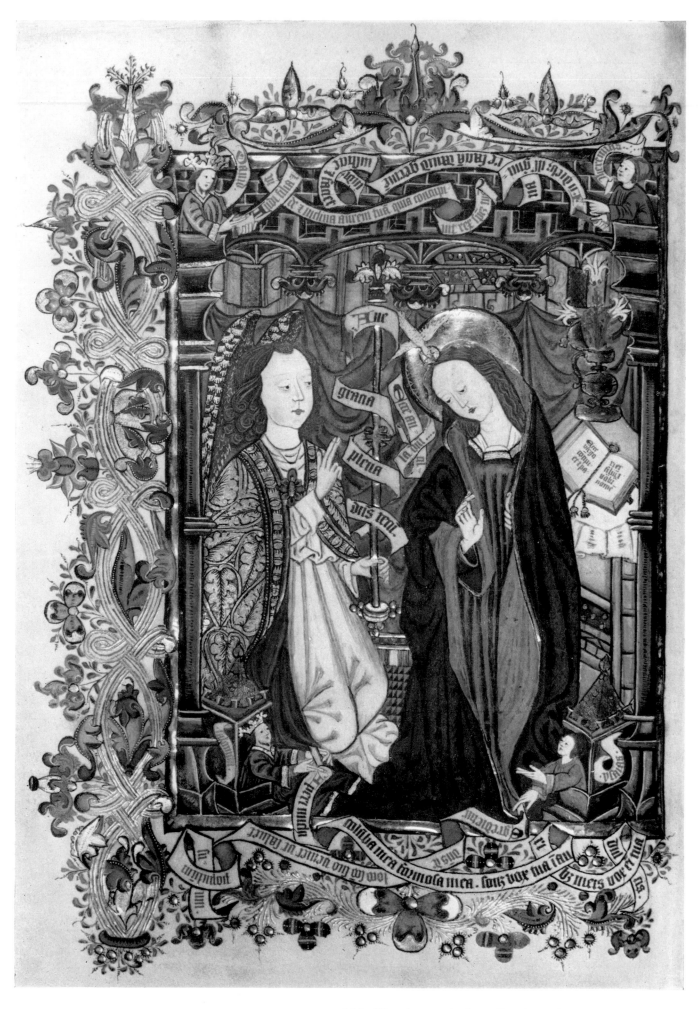

125. The Annunciation. *Breviary*. Spanish, about 1490.
Cambridge, Mass., Harvard College Library, MS. Typ. 189 H, fol. 7v.

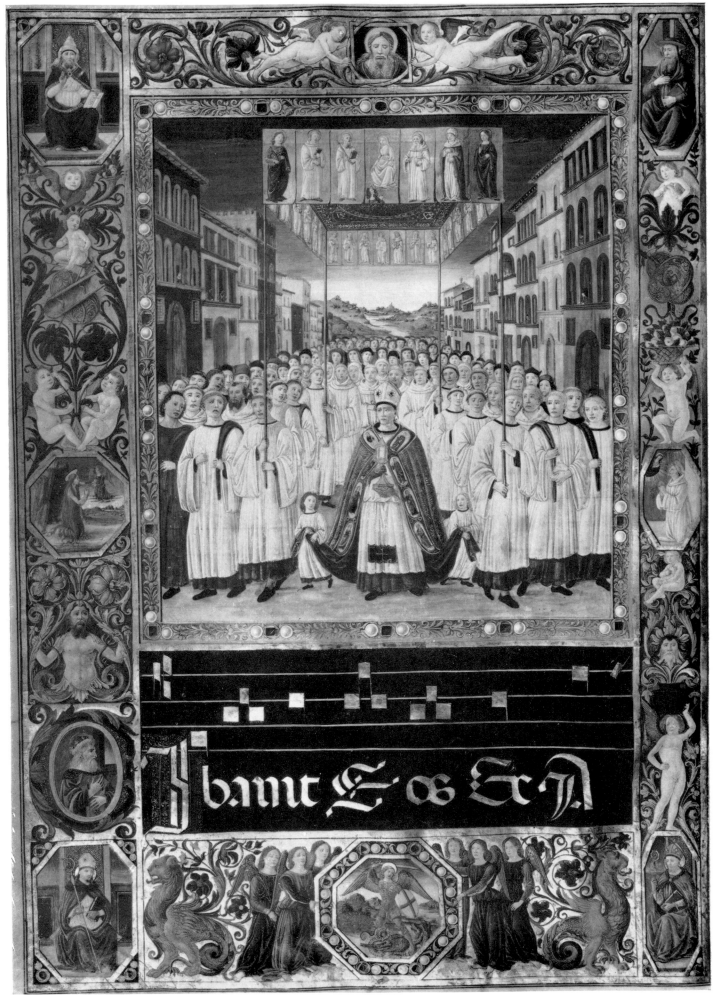

126. Corpus Christi Procession. *Gradual*. Florentine, second half of 15th century. Florence, Biblioteca Laurenziana, MS. Cor. Laur. 4, fol. 7v.

127. David in Prayer. *Psalter and New Testament*. Florentine, second half of the 15th century. Florence, Biblioteca Laurenziana, MS. Plut. 15.17, fol. 2v.

128. The Annunciation. Frontispiece to a *Prayer Book*. Italian, Florentine, late 15th century.
Cleveland, Museum of Art, J. H. Wade Collection, MS. N.53, 280.

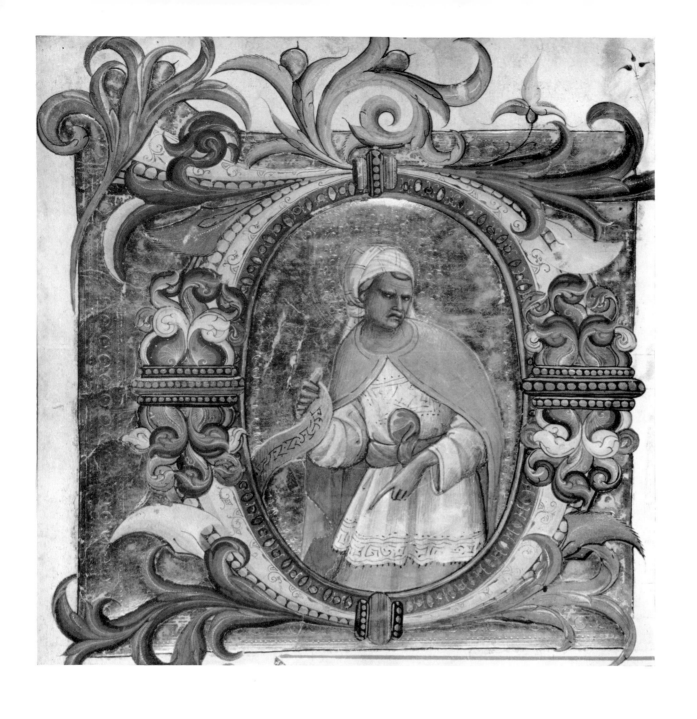

129. Prophet. Detached miniature by Lorenzo Monaco.
Florentine, early 15th century. Cleveland, Museum of Art, J. H. Wade Collection, MS. N.49. 536.

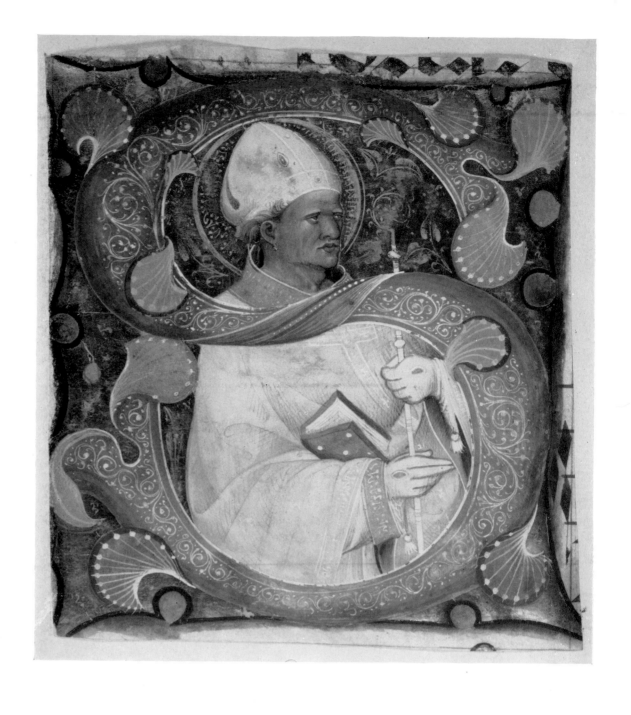

130. Saint Augustine (?). Detached Miniature.
Lombard, 15th century. Cleveland, Museum of Art, J. H. Wade Collection, MS. N.54, 257.

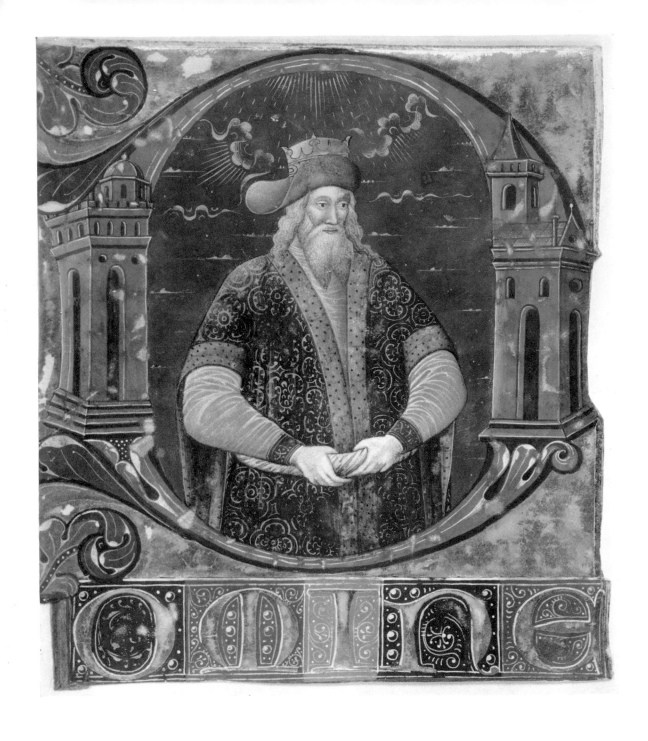

131. King Solomon. Detached miniature. Ferrarese, third quarter of the 15th century.
Cleveland, Museum of Art, J. H. Wade Collection, MS. N. 51.548.

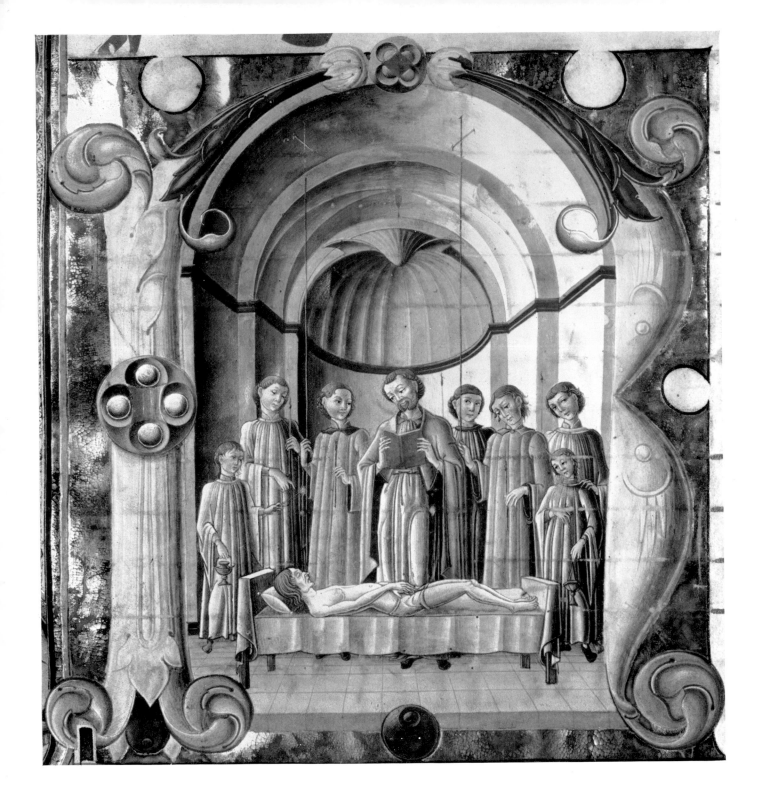

133. Detail of Plate 135.

134. Detail of Plate 136.

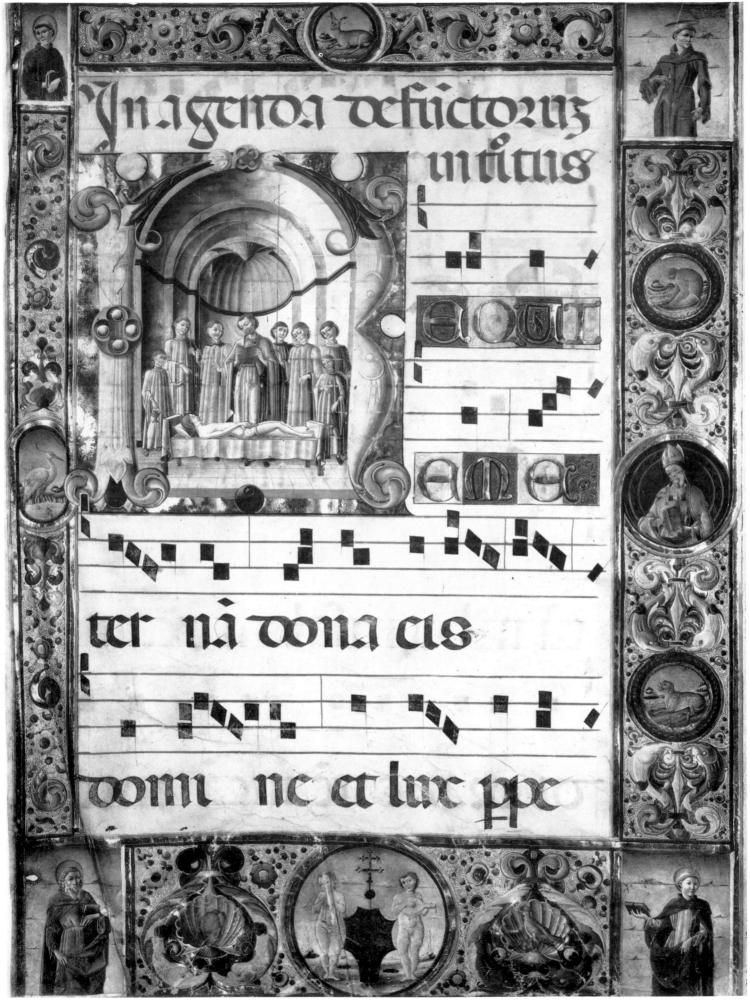

135. Page detached from a *Gradual*, attributed to Cosimo Tura.
Ferrarese, late 15th century. Cleveland, Museum of Art, J. H. Wade Collection, MS. N.27.426.

136. The Beginning of the Book of Ecclesiastes. *Borso Bible*.
Italian, second half of the 15th century. Modena, Biblioteca Estense, MS. V.G.12 (lat. 429), fol. 280v.

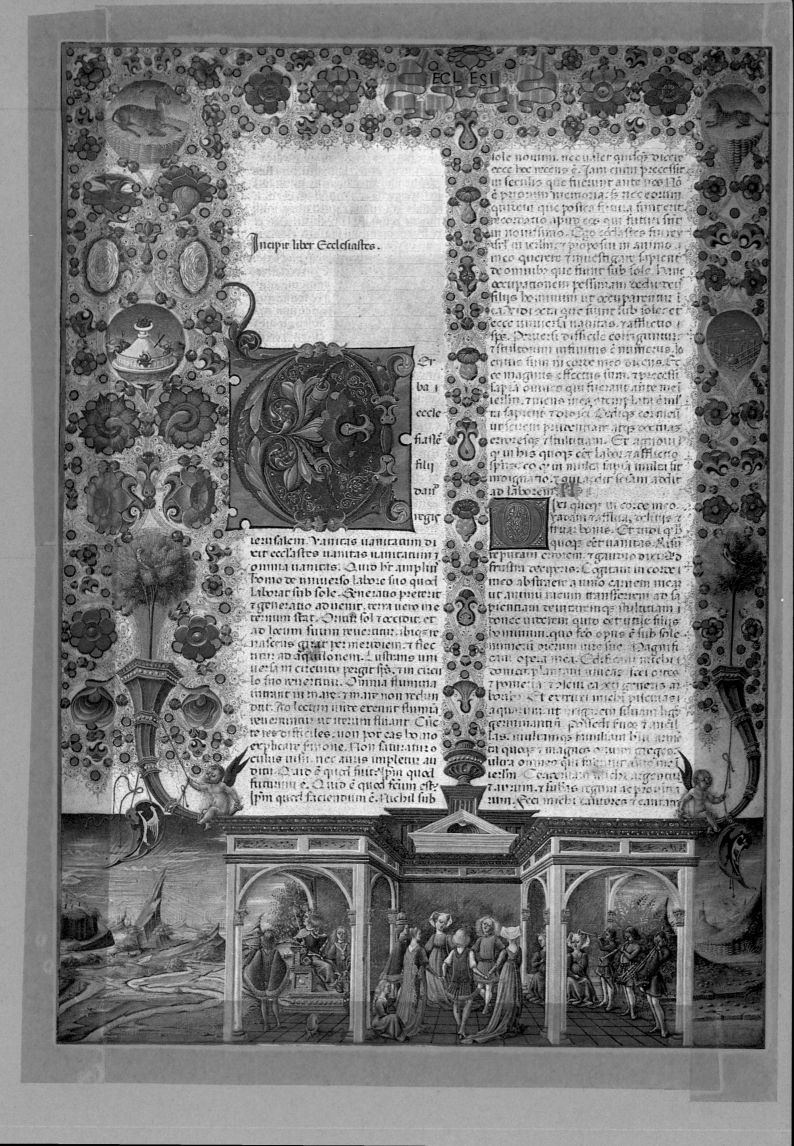

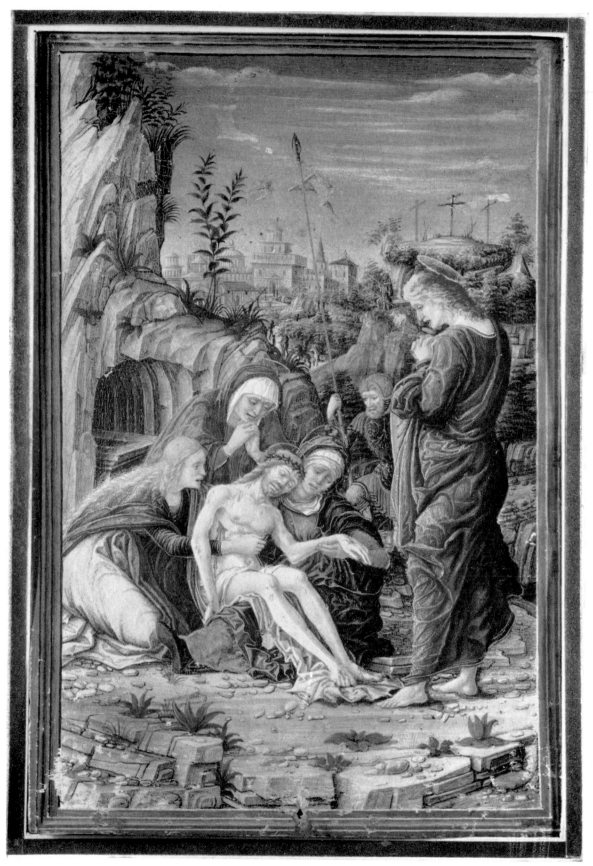

137. Pietà. Detached miniature attributed to Mantegna. Venetian, second half of the 15th century.
Cleveland, Museum of Art, J. H. Wade Collection, MS. N.51, 394.

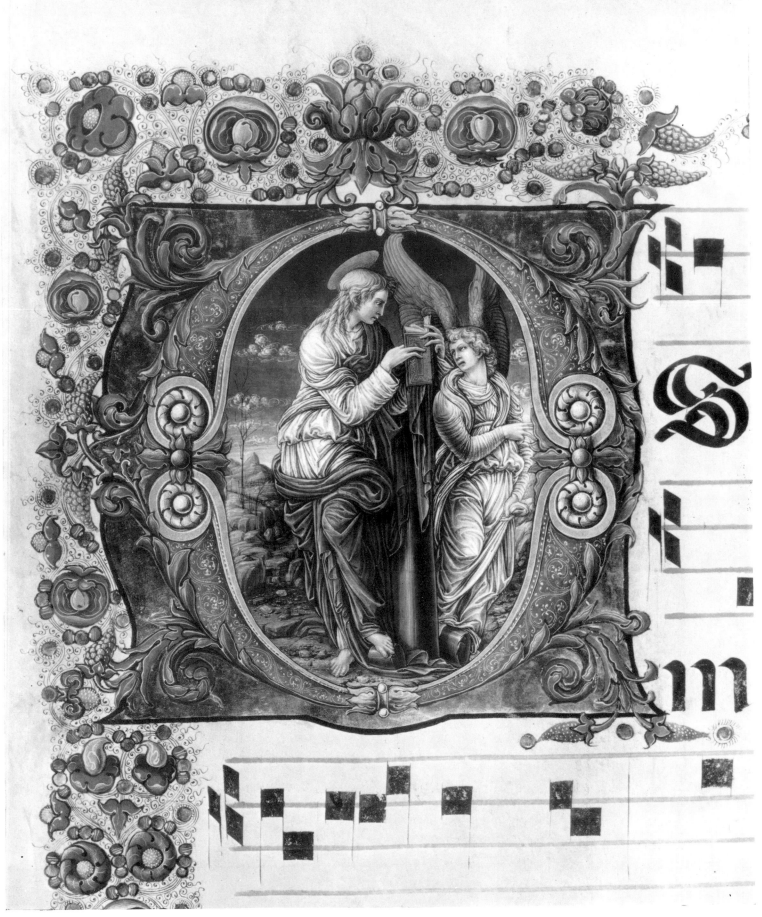

138. St. Matthew and the Angel. *Gradual*. Venetian, 15th century.
Siena, Libreria Piccolomini, MS., cor. 12, fol. 76r.

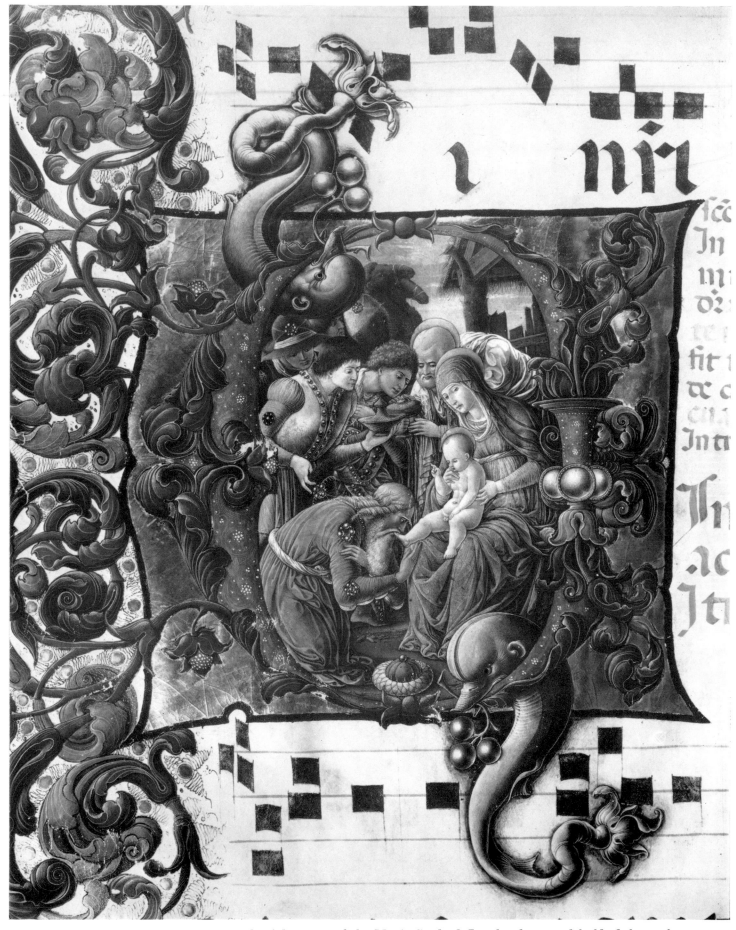

139. The Adoration of the Magi. *Gradual.* Lombard, second half of the 15th century. Siena, Libreria Piccolomini, MS. cor. 4, fol. 7v.

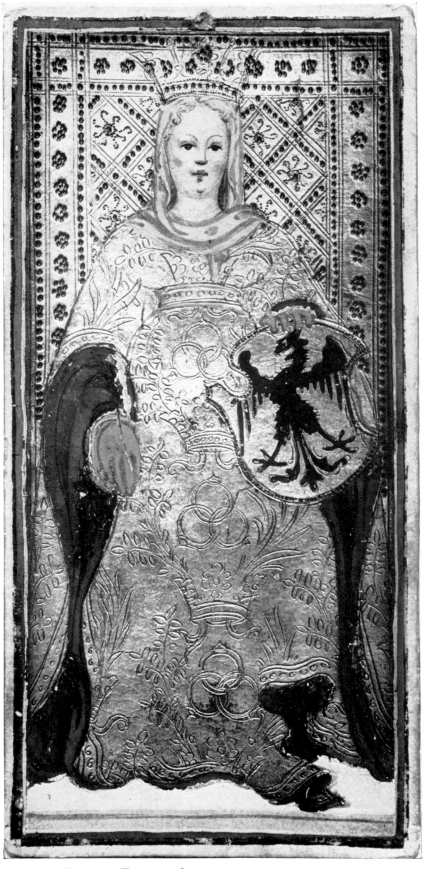

140. The Empress. Tarot card.
Italian, Lombard, mid-15th century. New York, Pierpont Morgan Library, MS. 830.

141. Maximilian Sforza attending to his Lessons. Aelius Donatus, *Grammatica*.
Lombard, 15th century. Milan, Biblioteca Trivulziana, MS. 2167, fol. 13v.

142. Christ on the Mount of Olives. Detached miniature. Umbro-Bolognese, late 15th century. Cleveland, Museum of Art, J. H. Wade Collection, MS. N.27.161.

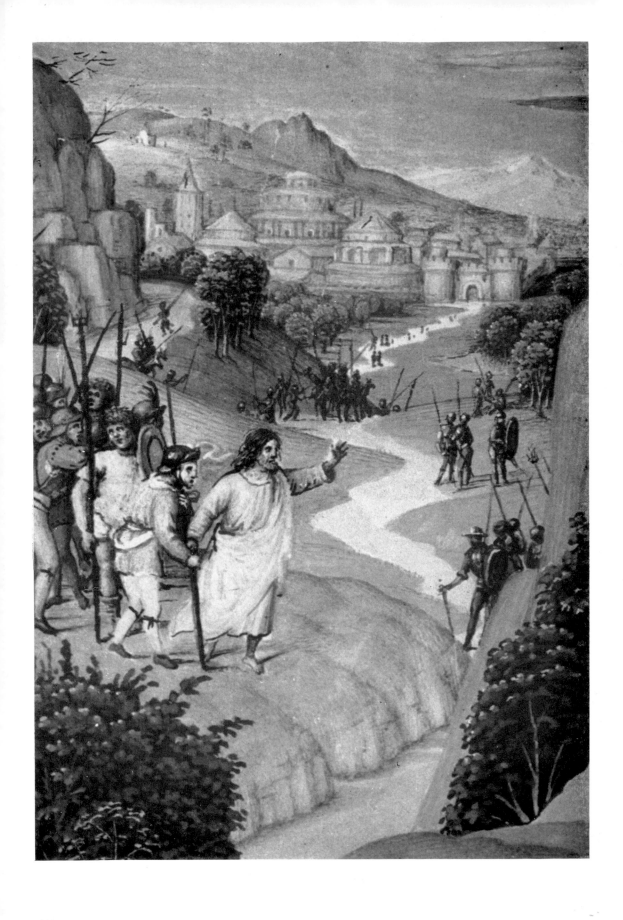

143. Detail of Plate 142.

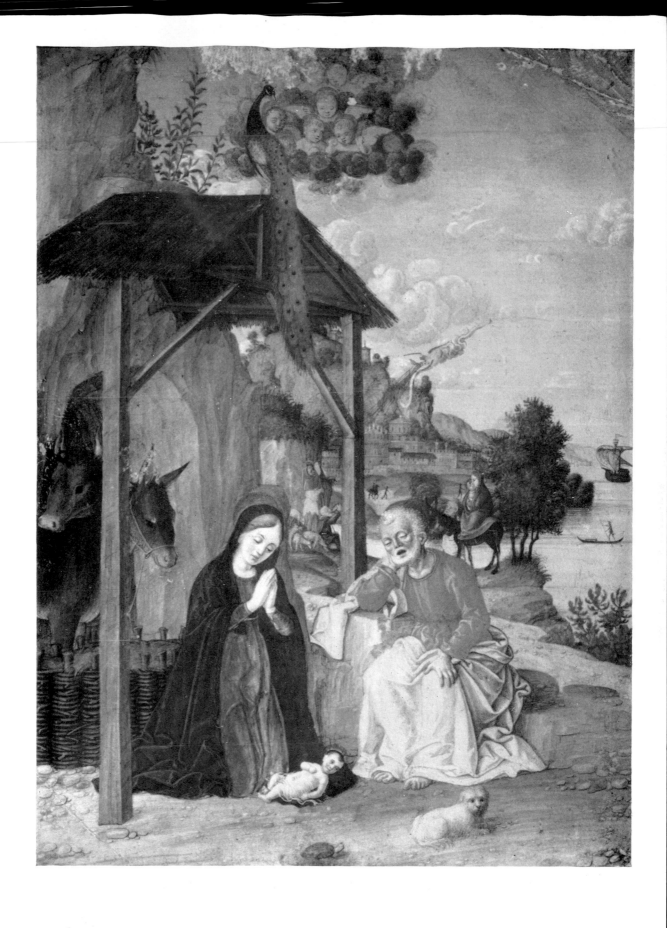

144. The Holy Family. Detached Miniature.
Venetian, 16th century. Cleveland, Museum of Art, J. H. Wade Collection, MS. N.53, 281.

145. Celebration of the Mass. *Uffiziolo Durazzo*. Emilian, 16th century.
Genoa, Biblioteca Berio.

NOTES ON THE PLATES

NOTES ON THE PLATES

1

GOSPELS (in Syriac). 335×255 mm. A.D. 586. Florence, Biblioteca Laurenziana, MS. Plut. 1,56.

A vellum manuscript containing 292 leaves written in Syriac in two columns, of which ff. 15–19 are a later addition on paper. According to a note at the end of the book, it was copied by the monk Rabula in the monastery of St. John at Zagba in Mesopotamia. The miniatures, which form a separate gathering added afterwards, illustrate many iconographical themes typical of the painting of Syria and the Middle East. The Ascension (fol. 13 v.) shows Christ within an oval supported by two angels, and beneath him, the Evangelist symbols; in the lower part, the Virgin in the centre between two angels and the Apostles. The heavy impasto and the variety of colours suggest the impressionistic technique of antique painting, while the use of landscape backgrounds provides evidence that the Hellenistic style had not yet died out in Syria.

J. A. Herbert, *Illuminated Manuscripts*, 1911, pp. 32–33; A. Grabar *Byzantine Painting*, Geneva 1953, pp. 161, 164 (plate in colour); Facsimile, *The Rabbula Gospels*, ed. M. Salmi, C. Cecchelli and G. Furlani, Olten and Lausanne, 1959.

one, contains a larger, square miniature and no text. The scene illustrated here depicts the events described in the *Aeneid* Book III, lines 13–22: Aeneas founds the town of Thrace. While he is about to sacrifice to Venus and the gods for their favour towards the building of the town, he sees a tomb with a cherry tree and a myrtle tree growing beside it. When he picks branches from the trees to use for his sacrifice, blood falls from the tree. This is the place where Polydorus lies buried, and Aeneas hears the latter's voice reproaching him. On the left of the scene at the top, a building represents the town. In front of it is a temple with an altar; above the altar, just visible in a niche, is the statue of Venus. To the right stand three figures, a girl with a bowl, a man holding an axe, and a younger man. Next to them is the ox with a red 'frontale' between its horns and a decorated band round its body. Aeneas is on the right, one hand veiled and the other hand holding a branch. An inscription identifies him, and on the tomb are the words 'Tumulus Polydori'. The tomb is represented as a building similar in type to those used on sarcophagi for the sepulchre of Christ.

J. De Wit, *Die Miniaturen des Vergilius Vaticanus*, Amsterdam, 1966.

2

VATICAN VIRGIL. 159×167 mm. Late Antique, 4th to 5th centuries in Italy. Rome, Vatican Library, MS. Vat. lat. 3225 fol. 24.

One of the very few illuminated manuscripts to survive from late antique times, this copy of Virgil's *Aeneid* has been dated by comparisons with dated gems and sarcophagi, and the mosaics of the nave of S. Maria Maggiore, to the last quarter of the 4th century or the early years of the 5th century A.D. The miniatures are generally arranged, as in the Milan *Iliad*, in rectangular frames above passages of the text, which is written, as always the case with Virgil manuscripts, in rustic capitals. Some pages, like this

3

AMBROSIAN ILIAD. 172×220 mm. Late Hellenistic, 5th century. Milan, Biblioteca Ambrosiana, MS. F. 205 P. Inf.

The vellum manuscript, which is incomplete, consists of 52 separate leaves, containing in all 58 illustrations and 810 lines. The writing resembles that of papyri and would seem to be the work of a Latin scribe. Its miniatures are of the greatest importance since the iconography appears to be based on a more ancient tradition: the figurations are contained within rectangular spaces in the form of small pictures, and in their colour technique and freedom of composition closely resemble the frescoes

at Pompei. Shown here are the two scenes of Menelaus protecting the body of Patroclus from the assault of Euphorbus and Menelaus killing Euphorbus (ff. XLIX–L).

Facsimile, *Ilias Ambrosiana*, ed. A. Calderini, A. Mai and A. M. Ceriani, Olten and Berne, 1953.

4

GOSPELS (in Greek). 307×260 mm. Byzantine, 6th century. Rossano, Cathedral Library.

The famous Codex of the Cathedral of Rossano in Calabria, a Greek Gospel Book, possibly of the 6th century, is written in Greek uncials of silver on purple-dyed vellum. Its miniatures are illuminated in many vivid colours which, as Toesca points out, provide evidence that the impressionistic manner of classical art was still being practised on the shores of Asia Minor. The Codex Rossanensis reflects the splendours which had been achieved by Hellenistic art, and provides a bridge between this art and the art of Byzantium. Reproduced here are the Last Supper (f. 3r), a composition of simple, meditative gravity, and the Washing of the Feet; below are four prophets.

A. Haseloff, *Codex purpureus Rossanensis*, Leipzig 1898; A. Muñoz, *Il Codice Purpureo di Rossano*, Rome 1907.

5, 6

VIENNA GENESIS. 260×150 mm. Byzantine, 6th century. Vienna, Nationalbibliothek, MS. Vindobon. theol. Gr. 31.

The Vienna Genesis consists of 26 leaves, of which 24 are decorated on both sides with miniature paintings. The vellum is dyed purple and the text inscribed in letters of gold and silver. Together with the Joshua Roll, this is the most ancient illustration of the Bible. The lower half of the pages is filled by the miniatures, which can be divided into two groups, small rectangular pictures painted on coloured backgrounds and others painted directly onto the purple of the vellum. The most obvious merit of these illustrations is their colouring. They are pervaded throughout by a feeling of freshness and spontaneity typical of primitive art; the design is simple, the figures and ornamentation highly stylised, with little or no sense of perspective. The illustration reproduced here (f. 7r), entirely classical in inspiration, shows the meeting of Rebecca and Eliezer at the well of Nahor.

Facsimile, *Die Wiener Genesis*, ed. H. Gerstinger, Vienna, 1931; E. Wellesz, *The Vienna Genesis*, London 1960.

7

ASHBURNHAM PENTATEUCH. 375×320 mm. Spanish (?), 7th century. Paris, Bibliothèque Nationale, MS. nouv. acq. lat. 2334.

This illumination illustrates scenes from the Book of Genesis, from the Expulsion of Adam and Eve from Paradise to the Murder of Abel (fol. 6). The page is roughly divided into four registers. At the top Adam and Eve are shown wearing skins, followed by Eve suckling a child, and by Cain and Abel making their sacrifices to God, whose hand appears from a cloud. Below Eve is again shown with a child, followed by Adam ploughing and, separated by decorative trees, Cain reprimanded by God for the murder of his brother. In the next register Abel tends his flock and Cain ploughs, while the murder is enacted in the last register, and Cain is shown killing Abel with an axe. In the 9th century the Pentateuch was owned by the monastery of St. Gratien at Tours, where it received certain alterations. Its previous provenance has been a matter of much controversy on account of the lack of close parallels, although it contains iconographic and decorative motifs from a wide number of different sources. The text however is closest to that of Spanish Bibles and the palaeography is also most akin to Spanish.

W. Neuss, *Die Katalanische Bibelillustration*, Bonn & Leipzig, 1922, pp. 60, 61; J. Bordona, *Spanish Illumination*, vol. I, Florence, 1930.

8

CODEX AMIATINUS. 491×330 mm. Italian (?), 7th or 8th century. Florence, Biblioteca Laurenziana, MS. Amiat.I.

This book was in Northumbria in the late seventh century and was presented to the pope by Cleofrid,

Abbot of Wearmouth, on one of his visits to Rome. It is known as the 'Codex Amiatinus' because it was given late in the ninth century to the monastery of Monte Amiata near Siena. The leaf reproduced here (fol. 5 r.) represents Ezra the Scribe, identified by an inscription on the leaf above the miniature. He is writing, seated at a desk, before an open cupboard filled with books, and his writing vessels are on the floor at his feet, near the footstool. This leaf and the gathering of which it is part did not originally belong to the present manuscript, a Northumbrian product. The miniature is totally unrelated to the essentially decorative style of Northumbria and it is probably a copy of a South Italian model as is the text of the Bible.

9

LINDISFARNE GOSPELS. 343 × 247 mm. Hiberno-Saxon, 7th or 8th century. London, British Museum, MS. Cotton Nero D.IV.

The Lindisfarne Gospels were probably written for Eadfrith, Bishop of Lindisfarne (698–721), who is named in a tenth-century colophon. The scale and intricacy of the illumination is remarkable. It contains five 'carpet' pages on which the design is cruciform, six pages of decorative text, sixteen pages of canon tables enclosed by ornate arches and four pages containing the portraits of the Evangelists with their symbols. This feature is the most outstanding, and St. Matthew (fol. 25 v.) is reproduced here. The figure is closely modelled on the Ezra figure of the Codex Amiatinus, which was in Northumbria at the time the Lindisfarne Gospels were made. The northern artist has misunderstood the footstool, which is here represented as a mat, and he omits the sandals on the feet although the thongs are there. The evangelist is named 'O Agios Mattheus' in Greek and his symbol 'imago hominis' in Latin. The figure behind the curtain is of doubtful interpretation, possibly a duplicated St. Matthew figure which the artist copied from a different model.

E. G. Millar, *The Lindisfarne Gospels*, London 1923; Facsimile: *Codex Lindisfarnensis*, ed. Sir Thomas Kendrick, T. J. Brown, R. L. S. Bruce-Mitford, H. Roosen-Runge, A. E. A. Werner, A. S. C. Ross and E. G. Stanley, Olten and Lausanne, 1956 and 1960.

10

GOSPEL BOOK (in Latin). 221 × 293 mm. Irish, about 750. St. Gall, Stiftsbibliothek, codex 51.

This is one of eleven Irish manuscripts in St. Gall. It was written and illuminated in Ireland about 750 and taken with others to St. Gall in the 9th century. The miniature of the Crucified Christ (f. 266r) is entirely abstract in design and makes no attempt at realism. On either side of the fair head of Christ are two angels; below, Longinus lifts his spear against Christ's side, and Stephaton raises the sponge to His lips. The symmetry of its composition and the unearthly calmness of its static, multicoloured figures combine to create a sense of solemnity and beauty.

The Irish Miniatures in the Abbey Library of St. Gall, ed. J. Duft and P. Meyer, 1954, pl. XIII.

11

BOOK OF KELLS. 330 × 241 mm. Hiberno-Saxon, late 8th century. Dublin, Trinity College Library, MS. A.I.6.

The Book of Kells is named after the monastery of Kells, County Meath, a foundation which depended on the monastery of Iona, and the book was probably begun at Iona and finished at Kells, where it was taken by monks driven out by the Vikings in the early ninth century. The decorative scheme includes a programme wider in scope than that of the Lindisfarne Gospels or the St. Gall Gospels. It includes canon tables, some with the Evangelist symbols in the tympana, pages containing the Evangelist symbols, portraits of Christ and the Evangelists, the Virgin and Child, the Temptation and Betrayal of Christ, decorative pages facing the opening page of each of the Gospels, and decorative pages in the text. The standing figure of St. Matthew (fol. 28 v.), holding a book, is placed within an arch filled with animal heads, drapery and interlaced motifs terminating in dragon heads.

E. Sullivan, *The Book of Kells*, 2nd ed. London 1920; A. M. Friend, *Canon Tables in the Book of Kells*, in *Mediaeval Studies in Memory of A. Kingsley Porter*, ed. W. R. W. Koehler, Cambridge, Mass. 1939; Facsimile, *The Book of Kells*, ed. E. Alton and P. Meyer, Olten and Berne, 1950.

12

BOOK OF DURROW. 157×246 mm. Hiberno-Saxon, about 700. Dublin, Trinity College MS. 57.

This Gospel Book was made at the monastery of Durrow in Ireland, one of the foundations of S. Columba in the mid 6th century. Like most of the other Irish illuminated manuscripts of similar date, the decoration of the Book of Durrow consists largely of pages of interlace patterns, sometimes with dragon-head terminals. Each of the four Gospels texts opens with a decorative initial, preceded by an illuminated carpet page, and a page containing the relevant Evangelist symbol. Here reproduced is the carpet page to the Gospel of Saint John (fol. 77v), on which the motifs are entirely abstract. The colours are simple, consisting only of dark green, brownish yellow and red.

Zimmermann, *Vorkarolingische Miniaturen*, Berlin, 1916, pp. 93–112, 231–240.

13

ECHTERNACH GOSPELS. 273×193 mm. Hiberno-Saxon, early 8th century. Paris, Bibliothèque Nationale, MS. Lat. 9389.

This manuscript was illuminated by a Northumbrian artist, and takes its name from the monastery of Echternach near Trier. It was either brought there by St. Wilibrord or illuminated there by a northern artist. It can probably be dated to about 710. The lion, symbol of St. Mark (fol. 75 v.), is an extremely striking composition. The animal is represented in motion, its realistic claws almost tearing the page, against an effectively simple background filled in with a geometrical pattern.

14

ST. AUGUSTINE, 'QUAESTIONES IN HEPTATEUCHON'. 300×205 mm. Northern France, middle of the 8th century. Paris, Bibliothèque Nationale, MS. Lat. 12168.

This manuscript, which possibly originated in Laon and has certain insular characteristics, was at Corbie by the beginning of the 9th century, as is shown by its annotations in the hand of Maurdramnus, abbot of Corbie at the end of the 8th century. Its rich decoration is based on small polychrome letters and zoomorphic initials. The majuscule initials of the chapters are arranged to form part of the multicoloured borders framing the page. The frontispiece, reproduced here, is decorated with many small floral motifs and more formal, stylised figures of animals, whose natural outlines are distorted to achieve greater decorative effect, in imitation of the art of enamelling. The predominant colours are orange, green and violet.

15

ADA GOSPELS. 245×365 mm. Carolingian, about 800. Trier, Stadtbibliothek, MS. 22, Codex Aureus.

This Gospel Book gives its name to the whole group of manuscripts with which it is associated. It contains a dedicatory inscription stating that the work was made for Ada, sister of Charlemagne, and contains many other references to her.

The manuscripts of the 'Ada Group' all contain Evangelist portraits that are very similar. In all, the Evangelists are seated writing beneath an arch of which the tympanum contains their symbol. This iconography is derived from late antique prototypes such as the St. Luke in the St. Augustine Gospels, and is represented by the St. Matthew of the Codex Aureus (fol. 15 r.). The stylistic features of the figure's pose, the drapery folds and the clear attempt to represent spatial depth derive equally from late antique traditions.

Die Trierer Ada Handschrift, ed. Mentzel and others, Leipzig 1889.

16

GODESCALC GOSPELS. 310×210 mm. Carolingian, 781–783. Paris, Bibliothèque Nationale, MS. nouv. acq. lat. 1203.

This manuscript was written for Charlemagne by the scribe Godescalc between 781 and 783. It is one of a large group consisting mainly of Gospel Books illuminated at the court and generally known as the 'Ada Group' after the so-called 'Ada' Gospels made for Charlemagne's sister (see no. 15). The precise location of the workshop, whether at Aachen, Trier or elsewhere on the Lower Rhine, has never been con-

clusively established. The manuscript is written on purple-stained parchment in golden letters. The illumination is all at the beginning of the book; the portraits of the four Evangelists, Christ in Majesty, and the Fountain of Life. At the end of the book are the dedication, calendar, and Paschal Tables. Christ in Majesty (fol. 3 r.) is shown seated on a cushioned throne, holding a book and blessing. The background contains architectural and landscape motifs and the border leaf and geometrical decoration.

W. Köhler, *Die karolingischen Miniaturen*, part III.

17

UTRECHT PSALTER. 377×250. Carolingian, early 9th century. Utrecht, University Library, MS. 32.

This manuscript is perhaps the most remarkable product of Carolingian illumination. It was probably made at the monastery of Hautvillers near Rheims in the early 9th century. Each psalm is illustrated by a complex series of drawings covering the three columns of the text, and the drawings are literal representations of the words they illustrate. This method of psalm illumination derives from Byzantine traditions and is new in the West. It was to be copied in later Psalters from Canterbury, where the Utrecht Psalter was in the centuries immediately following its execution. Copies were made of it in the 11th century (British Museum, MS. Harley 603), mid-12th century (Trinity College, Cambridge, MS. R.17.I), and the late 12th century (Paris, B.N. MS. Lat. 8846). Here shown is the illustration (fol. 14 r.) to Psalm 24. At the top, Christ with six angels holds out a scroll to the Psalmist (v. 4, 'Show me Thy ways, O Lord, teach me Thy paths'). On the left, the armed men are the Psalmist's enemies, from whom he asks protection (v. 8) and the group behind him represent the 'sinners and the meek' (v. 9). Below, a God-fearing man distributes alms to the fatherless and widowed (left), and to the poor and crippled (v. 12). The figures are very small and sketchily drawn, creating the agitated effect characteristic of the Rheims School.

E. T. Dewald, *The Illustrations of the Utrecht Psalter*, Princeton 1940; D. Tselos, *Sources of the Utrecht Psalter Miniatures*, Minneapolis 1955.

18

GOSPEL BOOK OF EBBO, ARCHBISHOP OF RHEIMS. 260×208 mm. Carolingian, 9th century. Épernay, Bibliothèque Municipale, MS. 1.

This manuscript, written in gold minuscules, is preceded by a dedication of the abbot Pierre de Hautvillers to the Archbishop Ebbo in rustic capitals, also of gold. The text, which is in an excellent state of preservation, is illustrated by canon tables on pediments supported by two columns, either marbled or decorated with branches; some of the pediments are surmounted by figures of people and animals. There are full-page portraits of the Evangelists, and each Gospel opens with a large initial in gold and other colours. Reproduced here is the figure of St. Luke (f. 90 v.). This manuscript is considered to be the most important example of the school of Rheims, and of all Carolingian manuscripts most faithful to the ancient (Gallo–Roman) tradition.

P. Durrieu, in *Mélanges Julien Havet*, pp. 639–657; A. Grabar and C. Nordenfalk *Early Medieval Painting*, Lausanne, 1957, p. 146 (reprod. in colour); Exhib. Cat., *Byzance et la France Mediévale*, Paris, Bibliothèque Nationale 1958, no. 106.

19

GOSPELS OF FRANCIS II. 300×255 mm. Carolingian, 9th century. Paris, Bibliothèque Nationale, MS. lat. 257.

The binding of this book, according to Réau, was made during the reign of Francis II, from whom the manuscript takes its name. It belongs to the 'Franco-Insular' school, so called because of its obvious contacts with the art of the other side of the Channel, and is the only work of this school to be decorated with human figures. Traces of the school of Rheims can be seen both in the figures of the Evangelists, of whom St. Mark (f. 60 v.) is reproduced here, and in the different features of its landscapes.

20

GOSPEL BOOK. 240×305 mm. Carolingian, early 9th century. Aachen, Cathedral Treasury.

This book also comes from the school of Rheims,

which, together with the schools of Metz, Corbie, Saint-Denis, Tours and Aix-la-Chapelle (Aachen), immortalised Carolingian miniature painting, in which – as well as the influence of Byzantine models – can be seen traces of Irish and Anglo-Saxon style. We reproduce the only full-page illustration, representing the four Evangelists (f. 13 r.). The book also contains many richly-decorated pages, and elegant canon tables of concordance, which show clearly that its anonymous artist was inspired by late Roman models of five centuries earlier. Its decoration too repeats all the same themes and motifs which are to be found in works of an earlier period.

A. Goldschmidt, *German Illumination*, Florence 1928, I, pl. 23.

21

GOSPELS OF ST. MÉDARD, SOISSONS. 365 × 260 mm. Carolingian, early 9th century. Paris, Bibliothèque Nationale, MS. lat. 8850.

This book was given as an Easter gift in 827 to Angilbert, Abbot of St. Médard, Soissons, by Louis le Débonnaire and his wife, but it is probably an earlier product dating from the time of Charlemagne, and made in the Rhineland. The decoration includes a full-page miniature of the Heavenly Jerusalem with the Adoration of the Lamb by the twenty-four Elders; the Evangelist portraits precede each of the Gospels, the text of which is written in gold on a purple background. The Fountain of Life (fol. 6 v.), shown here, precedes the Canon Tables. This subject is common to the books of the 'Ada School' and first occurs in the Godescalc Gospels (see above, no. 16). The Fountain stands in the centre of the composition, surrounded by animals, and the scene is enclosed by the architectural archway motif. The iconography derives from Byzantine sources and the animal motifs are inspired by late antique traditions.

P. A. Underwood, *The Fountain of Life in the Manuscripts of the Gospels*, Dumbarton Oaks Papers, vol. V, 1950, pp. 43–138.

22

GRANDVAL BIBLE. 510 × 357 mm. Carolingian, about 840. London, British Museum, MS. Add. 10546.

This Bible is so called because it belonged in the 16th

century to the monastery of Moutiers-Grandval in Switzerland. It is one of the most important products of the School of Tours in the mid-9th century. Like the Rheims School, much of the inspiration of the Tours School is derived from late antique sources. The decoration contains, as well as ornate initials, four full-page miniatures representing Genesis, Moses, Christ in Majesty and the Apocalypse. In the page showing Moses receiving the Law and expounding it to the Israelites (fol. 25 v.) the artist attempts to represent in the upper register landscape elements and in the lower an architectural setting, an elaborate building with coffered ceiling and decorated arcade, both undoubtedly copied from a Roman model.

W. Köhler, *Die karolingischen Miniaturen*, part I, Berlin 1930, p. 386 ff.

23, 25

BIBLE OF CHARLES THE BALD. 495 × 375 mm. Carolingian, about 846. Paris, Bibliothèque Nationale, MS. lat. 1.

This Bible was given to Charles the Bald by the Abbot Vivian, as is illustrated in the miniature in the manuscript itself, which provides the earliest representation of a contemporary event in western art. The manuscript, known as the 'first Bible of Charles the Bald', was given in 1675 to Colbert by the canons of Metz. It is considered one of the most precious documents of Carolingian miniature painting. Of its many outstanding illuminated pages, we reproduce here one illustrating three scenes from the life of St. Jerome (f. 3 v.). The artist seems to have been constantly concerned to introduce complete symmetry into his composition. The decoration of this manuscript makes use of many gold and coloured initials and titles written in gold capitals on bands of purple.

24

LOTHAIR GOSPELS. 320 × 250 mm. Carolingian, between 849 and 851. Paris, Bibliothèque Nationale, MS. lat. 266.

This manuscript is one of the main products of the School of Tours. A dedicatory inscription explains that it was made under the direction of Siglaus by order of Lothair for a community of St. Martin, either

St. Martin at Tours or Marmoutier in the kingdom of Charles the Bald. It can be dated between the reconciliation of Charles the Bald and Lothair his half-brother in 849, and the death of Lothair's wife Hermingarde, who is mentioned in the dedication, in 851. Lothair himself is represented on fol. 1 v., and Christ in Majesty with the Evangelist symbols, here shown, on fol. 2 v. The rest of the decoration consists of elaborately decorated Canon Tables, and Evangelist portraits before each of the Gospels.

W. Köhler, *Die karolingischen Miniaturen I: Die Schule von Tours*, Berlin 1930, p. 403 ff., part I, pp. 71, part II.

26

FRAGMENT OF A SACRAMENTARY. 270 × 210 mm. Carolingian, 9th century. Paris, Bibliothèque Nationale, MS. lat. 1141.

This sacramentary contains only the common Preface and Canon of the Mass, beginning in uncial letters and continuing in gold minuscules. It opens with green, red and gold capitals and an illuminated initial. It is decorated with five full-page miniatures showing clear traces of the school of Rheims. Shown here is St. Gregory, the famous Doctor of the Church and Pope, on f. 3r. The Carolingian period was drawing to its close, and it is clear both from the design and use of colour that the art of illumination, no less than the other arts, was gradually losing distinction. Two centuries were to pass before it again achieved the high quality which had already once been responsible for its revival and had earned for it a deserved place of distinction among the arts.

27, 30

CODEX AUREUS OF ST. EMMERAM. 410 × 310 mm. Carolingian, 9th century. Munich, Staatsbibliothek, MS. Clm. 14000.

The provenance of this manuscript is a matter of debate. The style of its illumination is similar in many respects to that of Rheims, though the script is different. The canon tables derive from those of the Gospels of St. Médard, Soissons, while there is also much in the book that is under the influence of Tours. The lavish decoration with abundant use of gold, as well as the largely original and complex iconographical scheme, suggest that this work was made for Charles the Bald; it may come from St. Denis. The book cover is a remarkable piece of metal-work in relief and filigree with precious stones, and the illumination is equally ornate. The text is in gold on a purple ground as shown on the leaf with the Adoration of the Lamb (fol. 6 r.). This scene represents heaven as a circle, beneath which sit the personifications of earth and sea; within the circle two symmetrical groups of Elders offer up their crowns to the Lamb, represented within a medallion containing an inscription.

Facsimile, ed. G. Leidinger, *Der Codex Aureus in der bayrischen Staatsbibliothek München*, Munich 1921–5.

28, 29

BIBLE OF SAN CALLISTO. 395 × 305 mm. Carolingian, about 870. Rome, San Paolo fuori le Mura, Library.

The Bible was begun for Charles the Bald in 870 at the time of his marriage to Richildis. It was made at the court school, which was probably located at Corbie, though Rheims, Compiègne and St. Denis have also been postulated. The style of the miniatures is similar in many respects to that of the Tours School. The miniatures are by several hands, and some of the illumination has been stuck into the Bible, whose text was written by a certain Ingobert. The iconography, like that of much of the Tours School, owes a great deal to the late antique, and this is particularly noticeable here in the naturalistic treatment of the movement of water, which is so prominent a feature of the Moses page (fol. 20 v.).

H. Schade, *Studien zu der karolingischen Bilderbibel aus St. Paul vor den Mauern in Rom*, Wallraf-Richartz Jahrbuch XXI, 1959, pp. 9 ff.

31

BENEDICTIONAL OF ST. AETHELWOLD. 220 × 180 mm. English, 975–980. London, British Museum, Add. MS. 49598.

The Benedictional of St. Aethelwold is a superb masterpiece of the Winchester School. There is reason to think it was written and illuminated by a monk

called Godeman, whose name occurs on f. 5. The Benedictional contains 49 decorated pages, 28 of which are illustrated in water-colours on streaky-coloured backgrounds, representing subjects which were new to English illumination. Shown here is the scene of the Angel appearing to the Maries at the Sepulchre (f. 51 v.). In its general subject matter, this representation differs little from that found in continental manuscripts; the originality of the artist lies rather in his treatment of the draperies and the rich border. The technique used by this artist and others to paint faces has been described by Sir George Warner.

F. G. Warner and H. A. Wilson, *The Benedictional of St. Aethelwold*, Oxford 1910; O. Homburger, *Die Anfänge der Malschule von Winchester*, Leipzig 1912, pp. 7 ff.

32

GOSPELS. 317 × 247 mm. English, early 11th century. London, British Museum, Add. MS. 34890.

This book is known as the Grimbald Gospels on account of a letter contained at the end in which Fulk recommends Grimbald to King Alfred the Great. It was produced at Winchester, probably at New Minster, at the beginning of the 11th century. In it we find all the themes and decorative elements characteristic of English miniature painting in the previous centuries. It shows however certain innovations in its decoration – as regards the colouring, one should notice the use of silver, while in the border decoration it is apparent that the customary foliage is gradually being reduced and partly replaced by medallions enclosing abstract ornamental motifs or small miniatures. Reproduced here is the portrait of St. Matthew (f. 10 v.), whose background is the vellum itself. The manuscript also contains full-page portraits of the other three Evangelists.

E. G. Millar, *English Illuminated Manuscripts from the X to the XIII century*, pp. 12–13, 74, pl. 16; J. A. Herbert, *Illuminated Manuscripts*, London 1911, pp. 131–132.

33

PSALTER. 255 × 315 mm. (full page size). Northern French, about 1000. Boulogne, Bibliothèque Municipale, MS. 20.

An inscription on fol. 1 v of this Psalter tells us that the illumination was the work of Odbert, while Dodolin prepared the text and Herivée wrote it. The book contains several full-page miniatures, and historiated initials for the opening letter of the Psalms that mark the major divisions of the Psalter text. The full-page pictures are in colour while the historiated initials are only partially coloured, more emphasis being given to the outline drawing, which is clear and precise. In addition, each of the minor Psalms opens with a pen-drawn decorative initial like the one reproduced here, (fol. 63), for Psalm 57. The bars of the initial consist of two winged dragons joined together, with a head with a curling tongue and leafy crest at each end. The dragons' body contains an interlace pattern of the type similar to that found in early Hiberno-Saxon, Spanish and Italian manuscripts.

Leroquais, *Psautiers* I, p. 94. *Exhibition Catalogue: Les Manuscrits à peintures en France du 7e au 12e s.* 1954.

34

CAEDMON POEMS. 324 × 178 mm. Anglo-Saxon, about 1000. Oxford, Bodleian Library, MS. Junius XI.

Probably this manuscript was produced at Canterbury. It dates from about 1000 and the illumination is by various hands, two of which worked in a style similar to that of the Utrecht Psalter and its early 11th-century copy made at Canterbury, hence the probable provenance of the manuscript. Other hands, however, use motifs derived from the Scandinavian 'Ringerike' style, while others use the 'Winchester acanthus'. The drawings illustrate the Old English Biblical poems of Caedmon, and are done in red, green and brown inks. The 'Fall of the rebel angels before Creation' (fol. 3) is here reproduced. In the top register the rebel angel, crowned and holding a sceptre, points to an elaborate throne. Other angels surround him, four of whom hold crowns. An inscription at the top says 'hus (e) engyl ongon ofer mod wesan' (how the angel began to be presumptuous). In the second register the victorious Satan receives palms; in the third, God with angels throws three javelins from a quiver after Satan, who falls headlong, together with his companions and his throne; Satan is shown again below, bound hand and foot, in the mouth of Hell; his chains are fastened to the teeth of

the monster. The inscription reads 'her se haelend gesce(op) helle heom to wite' (here the Saviour created Hell as a punishment for them).

Sir Israel Gollancz, *The Caedmon Manuscript*, London 1927.

35

PSALTER. 565 × 420 mm. Anglo-Saxon, 11th century. London, British Museum, MS. Cotton Tiberius C. VI.

This manuscript from Winchester represents an 11th-century continuation of traditional Anglo-Saxon expressionism in an extreme form. It contains one miniature in pigment (David and the Musicians, fol. 30 v.), but the rest are executed in coloured inks. The illumination is mainly contained in a series of pages preceding the text and consists of cycles from the lives of David and Christ, derived from insular, Byzantine, and continental sources. The illustration here (fol. 13 v.) shows the Three Maries on the left, with the larger figure of the Angel seated on the tomb of Christ, a highly elaborate construction with columns, arches and a turret. The bad condition of the manuscript is due to the fire that damaged the Cotton Library in the 18th century.

F. Wormald, *An English Eleventh-Century Psalter with Pictures: British Museum Cotton Tiberius C. VI.* in *The Walpole Society* 38, 1960–62, pp. 1–14.

36

PSALTER OF EGBERT OF TRIER. 238 × 188 mm. Ottonian, 10th century. Cividale, Museo Archeologico, MS. 55.

This Psalter was made at Reichenau or more probably at Trier for the Archbishop Egbert of Trier. It was a gift from one Ruodprecht who was probably the scribe. Two miniatures, fol. 16 v. and 17, represent Ruodprecht handing the book to Egbert. The Schools of Trier and Reichenau are very closely linked and there is much controversy in the literature over the provenance of most of the products of the two schools. This Psalter has been ascribed to Trier on liturgical and historical grounds. Full-page miniatures of saints, bishops, and David are interspersed with decorative initial pages, which precede each group of ten Psalms. Here reproduced is the initial 'D' which

begins Psalm 101. The initial is made up of twisted stalks closely knit into four patterns of interlace. The centre of the 'D' is filled with trefoil leaves, a typical feature of the Trier and Reichenau Schools. The initial is enclosed by a border of Greek Key and the corners are filled with lions and peacocks.

H. V. Sauerland and A. Haseloff, *Der Psalter Erzbischof Egberts von Trier*, Trier, 1901.

37

GOLDEN GOSPELS OF ECHTERNACH. 440 × 310 mm. Ottonian, about 1035–1040. Nuremberg, Germanisches Nationalmuseum, MS. 156142.

Like the School of Trier, that of Echternach was closely linked to Reichenau. Most of the illumination of this Gospel Book consists of narrative cycles arranged in several registers, often over two pages, canon tables, Evangelist portraits, and purple text pages. Decorative initials are an important feature as well. The initial 'B' (fol. 4 r.) begins the text of Jerome's letter to Pope Damasus, which is interpolated into the Gospel Book as the writings of St. Jerome frequently were. The bars of the initial contain interlace motifs and the two halves of the 'B' are linked by a mask-head. Scroll and leaf buds with trefoil and five-petal flowers fill in the rest of the initial and an acanthus border frames the composition.

P. Metz, *Das Goldene Evangelienbuch von Echternach*, Munich 1956; E. Verheyen, *Das Goldene Evangelienbuch von Echternach*, Munich 1963.

38, 39

LIBER EVANGELIORUM CUM CAPITULARE. 355 × 254 mm. Ottonian, 10th century. Florence, Biblioteca Laurenziana, MS. Acq. e Doni 91.

This manuscript, acquired by the Laurentian Library in 1823, has been attributed to the school of Reichenau, with the exception of the large decorated initials, which were possibly the work of a Tuscan hand about a century later. Ff. 1 v.–7 r. contain a first series of Eusebian canon tables, whose columns, arches and decoration remain incomplete and for the most part only outlined in pencil. The series of canon tables is repeated on ff. 8 r.–13 v.; they are decorated

(but not all completed) in pen, mainly in red ink. At the beginning of each Gospel (ff. 30 v., 71 v., 101 v., 145 v.) are full-page Evangelist portraits, and on f. 96 r. is a full-page illustration of the Ascension, which is reproduced here.

40

GOSPEL BOOK FROM THE CATHEDRAL TREASURY AT BAMBERG. 350 × 250 mm. Ottonian, end of 10th century. Munich, Staatsbibliothek, Clm 4453.

Among the manuscripts belonging to the Cathedral Treasury at Bamberg which were executed at Reichenau, this Gospel Book is outstanding. It owes its deserved fame above all to its full-page Evangelist portraits. Illustrated here is the triumph of St. Matthew (f. 25 v.). In features and gestures, it more closely resembles earlier representations of the Messiah than the Apostles. The colours of gold, violet, red and blue predominate. In general, the Ottonian style developed more elaborate decorated initials than those of the Carolingian period, with bursting foliage and original fusions of animals, such as birds and serpents. Its decoration shows traces of Hellenism. Especially notable is its use of architectonic motifs.

A. Goldschmidt, *German Illumination*, II, pl. 25.

41, 42

PERICOPE BOOK OF HENRY II. 264 × 190 mm. Ottonian, early 11th century. Munich, Staatsbibliothek, MS. lat. 4452.

A Pericope Book contains passages from the Bible selected to be read during the Mass. This volume was made for Henry II between 1002 and 1014 and was presented to him in Bamberg Cathedral, probably in 1012, when the cathedral was consecrated. Like the Codex Aureus of St. Emmeram, this book has a splendid cover, containing enamels, filigree and ivories. The illumination is equally splendid. The models for the illuminators were a combination of Carolingian and Byzantine. Many of the scenes are spread over two pages like the Adoration of the Magi (fols. 17 v. & 18 r.). Each half of this composition is enacted beneath buildings with columns and sloping roofs; the column appearing beneath the feet of the Magi shows how far the artist's attempt at representing spatial depth is misconceived.

G. Leidinger, *Miniaturen aus Handschriften der königlichen Hof-und Staatsbibliothek, 5. Das Perikopenbuch Kaiser Heinrichs II*, Munich 1914; A. Boeckler, *Das Perikopenbuch Kaiser Heinrichs II*, Berlin 1944.

43

CODEX EGBERTI. 270 × 210 mm. Ottonian, about 980. Trier, Stadtbibliothek, cod. 24.

The Ottonian schools most clearly influenced by the art of late antiquity are those of Trier and Reichenau. To the latter, a Benedictine house, belongs the codex executed for Egbert, Archbishop of Trier, when he accompanied the Emperor Otto II to Italy. The miniature reproduced here (fol. 84 r.) illustrates Christ's Deposition from the Cross and Burial, illuminated on a full page within the same border. Its composition is perfectly balanced, its ornament sober and unadorned, with a simple linear design and great expressive force of gesture. The figures are touched with gold, which is also used for the border and the names of Joseph and Nicodemus written on the background. The artists sign themselves Kerald and Heribert. Scholars have nevertheless wanted to identify the hands of at least four artists in this book, among them the anonymous miniaturist of the 'Registrum Gregorii' who worked in Reichenau.

A. Goldschmidt, *German Illumination*, Florence 1928, II, pp. 6–8; F. X. Kraus *Die Miniaturen des Codex Egberti in der Stadtbibliothek zu Trier*, Freiburg 1884, pl. LI; A. Grabar and C. Nordenfalk, *Early Medieval Painting*, p. 200.

44

SACRAMENTARY OF ST. GEREON, COLOGNE. 268 × 184 mm. Ottonian, about 1000. Paris, Bibliothèque Nationale, MS. lat. 817.

Most of the illumination of the School of Cologne was predominantly influenced by 'Reichenau', but there is also evidence of Greek manuscripts being imported and Byzantine influence is strong because of this. The Virgin of the Annunciation (fol. 12 r.) stands on the frame of the picture and the scene is enacted within a strange combination of a cave-like landscape, in which the Virgin's throne is incongruously placed, and an architectural setting with many different build-

ings. The use of white for highlights on drapery and ground is a prominent feature of the Cologne School; the drapery folds flow more freely and are more sketchily drawn than in the 'Reichenau' style, although the dotted borders of the haloes and the large prominent hands are common to both styles.

45

BAMBERG APOCALYPSE. 295 × 204 mm. Ottonian, about 1007. Bamberg, Stadtbibliothek, MS. 140.

This manuscript was made for Henry II and is a product of the 'Reichenau' workshop. In style it is particularly close to the Pericope Book, which was also made for Henry (nos. 41, 42). There is an extensive cycle of full-page illuminations, and many other smaller miniatures below or above passages of the text. The Angel with the Millstone (fol. 46 r.) stands isolated against an unpatterned sky and is most strikingly portrayed. The scene illustrates the words 'And a strong angel took up a stone as it were a great millstone, and cast it into the sea, saying, Thus with a mighty fall shall Babylon the great city, be cast down, and shall be found no more at all.' (Apocalypse, XVIII, 21.)

H. Wölfflin, *Die Bamberger Apokalypse*, Munich 1918.

46, 47

THE BEATUS APOCALYPSE OF SAINT-SEVER. 365 × 280 mm. Franco-Spanish, 1028–1072. Paris, Bibliothèque Nationale, MS. lat. 8878.

This manuscript was produced at Saint-Sever in a region of southern France whose schools were strongly influenced by Spanish illumination. It was written and illuminated between 1028 and 1072, since a certain Gregory, who was abbot of the monastery during this period, is several times mentioned. It contains the Commentary on the Apocalypse composed by Beatus of Liebana, a Spanish monk, from whom it derives its name. On the shaft of a column on f. 6 is written the name 'Stephanus Garcia', the artist possibly responsible for the miniatures. The decoration is filled with representations of fantastic beings. Details of fols. 108 v. and 145 v. are reproduced here.

Van Moé, *L'Apocalypse de Saint-Sever*, 1943.

48

BEATUS COMMENTARY ON THE APOCALYPSE. 381 × 281 mm. Spanish, early 10th century. New York, Pierpont Morgan Library, MS. 644.

This is the earliest extant illuminated copy of the Beatus Commentary. An inscription on fol. 293 relates that it was illuminated about 926 by a certain Maius at the command of Abbot Victor, for a monastery dedicated to St. Michael, possibly the monastery of San Miguel de Escalada, near León, Spain. The symmetrical composition on fol. 87 represents the Vision of the Lamb and the Four Living and illustrates Apocalypse IV, 6–7.

'. . . . and before the throne, as it were a glassy sea like unto crystal; and in the midst of the throne, and round about the throne, four living creatures full of eyes before and behind. And the first creature was like a lion, and the second creature like a calf, and the third creature had a face as of a man, and the fourth creature was like a flying eagle.'
The Living are accompanied by Elders holding viols and incense bowls, and Heaven is upheld by a cherub, a seraph, and two angels. Inscriptions in Latin explain the identity of the figures.

49

FARFA BIBLE. 550 × 377 mm. Spanish, about 1000. Rome, Vatican Library, MS lat. 5729.

The illumination in this Bible is scattered unevenly in the text, most of it being found in the earlier books. The page reproduced here (fol. 1) illustrates part of the Heptateuch and shows scenes from the life of Moses, from the Crossing of the Red Sea to the Death of Moses. The scenes are presented on five registers separated by decorative bands, and captions in latin help to clarify the scenes. The text of this Bible follows Catalan patterns and the book was almost certainly made at the monastery of S. Maria at Ripoll. Both the text and the illumination of this book are similar to those of the Roda Bible, now in Paris, which may have been made in Ripoll at approximately the same date as the Farfa Bible. The latter is so-called because it was for some time thought to have come from the monastery of Farfa in Italy instead of Spain.

W. Neuss, *Die Katalanische Bibelillustration*, pp. 10–28, Bonn and Leipzig, 1922.

50

BEATUS COMMENTARY ON THE APOCALYPSE. 375 × 241 mm. Spanish, about 1109. London, British Museum, MS. Add. 11695.

This Apocalypse is well documented by inscriptions on fol. 275 v. and 277 v., from which we know that it was written for the monastery of San Domingo of Silos by the monk Domingo and his cousin Muños, illuminated by Pedro the Prior, and completed in 1109. The decoration includes some double-page illuminations and many single pages and initials in a style that is essentially decorative and highly coloured, predominantly in dark green, bright yellow and orange. The scene on fol. 172 r. illustrates Apocalypse XV, 7.

'And one of the four beasts gave unto the seven angels seven golden vials full of the wrath of God, who liveth for ever and ever.'

Inscriptions explain the scene. The patterned design at the top represents the Temple of the Tabernacle of the Testimony with its open door (Apocalypse XV, 5).

51

VISIONS OF HILDEGARD OF BINGEN. German, 12th century. Destroyed manuscript, formerly in the Library at Wiesbaden.

St. Hildegard (1098–1179) entered a Benedictine convent at the age of eight and became its abbess in 1136. In 1147 she moved her community from Diessenburg to Rupertsburg near Bingen, where she built a convent to house it. She was a notable visionary and wrote a great deal in the years following 1140, including commentaries on the Gospels and an exposition on the Rule of St. Benedict, as well as works on science and medicine, lives of saints, poems and hymns. Her best-known work is the *Scivias*, and this was the text of the Wiesbaden manuscript. It is an apocalyptic work concerned with the Last Judgement, expressed in symbolical and allegorical terms. The illustration, stars falling from the sky, is reminiscent of the backgrounds in the Apocalypse manuscripts.

F. M. Steele, *The Life and Visions of St. Hildegard*, 1914; ed. Maura Boeckler, *Wisse die Wege, Scivias*, Salzburg 1954.

52

PASSIONAL. German, 12th century. Sigmaringen, Hohenzollern Library, MS. 9.

From this richly decorated manuscript we reproduce the illuminated initial letter *R* on f. 244 r. It is filled with ribbon interlaces, grotesques and the small figure of a monastic illuminator. The latter is shown seated at a small table bearing little pots of paint, holding the pen with which he has just written the words 'fr. Rufillus'. It seems, then, that this Rufillus, a monk from the monastery of Weissenau, was responsible for the miniatures, which are executed in an unpolished and energetic manner tending towards a form of expressionism typical of the German school.

F. de Mély, 'Signature de primitifs', in *Revue Archéologique* 1911, pp. 93–4, fig. 18 (p. 91).

53

ST. GREGORY, MORALIA IN JOB. 350 × 240 mm. French, early 12th century. Dijon, Bibliothèque Municipale, MSS. 168–170.

The work consists of four volumes: the first three were completed on 24 December 1111, while the Englishman Stephen Harding, previously a monk of Sherborne, was Abbot of Cîteaux; the fourth volume some years later. The decoration is the work of the anonymous miniaturists of the famous Bible of St. Stephen, also called the Bible of Cîteaux. The initial letters are nearly always decorated with intertwining grotesques typical of Romanesque art. From the beginning of the first volume we reproduce a full-page miniature of the letter *R* (f. 4 v.), showing two monks fighting a double-headed dragon. The decorated border is also very effective.

C. Oursel, *La miniature du 12ᵉ siècle à l'abbaye de Cîteaux*, Dijon 1926; A. Grabar and C. Nordenfalk, *Romanesque Painting*, Lausanne 1957, pp. 203–5; C. Oursel, *Miniatures cisterciennes*, Macon 1960.

54

GOSPEL BOOK. 325 × 205 mm. French, first half of 12th century. Boulogne, Bibliothèque Municipale, MS. 14.

Written in two volumes, each of which contains two large miniatures typical of the style of St. Bertin at

St. Omer, where among others, the learned canon Lamberto worked. It used to belong to the monastery of Hénin-Liétard. Shown here is St. Luke (f. 5 r.): on either side of him, in two aureoles, Gabriel and the Virgin. Above, in a third aureole, the Angel announces to the aged Zachariah the son miraculously to be born to him. A careful study of the illumination has made opinion more divided about the extent to which miniature painting on the Continent was affected by the growing influence of Byzantine art at this time.

55, 57

ST. JEROME, COMMENTARY ON ISAIAH. 371 × 260 mm. English, first half of 12th century. Oxford, Bodleian Library, MS. Bodley 717.

This manuscript, which formerly belonged to Exeter Cathedral, was illuminated by Hugo Pictor, a monk-illuminator whose self-portrait is contained in the present manuscript. Illustrated here is the miniature on f. 6 v.: the Virgin enthroned between St. Jerome and Isaiah, the one clad in green on red and the other two in red on green; below, a burial scene. This could refer to the burial of the Virgin herself, which would make the whole theme that of her Assumption, but if so, it seems strange that none of the figures wears a halo. It is also possible that the artist intended to illustrate the death of Paula, the devoted disciple of Jerome, whose death is described in the first line of the text on this page. The colours of green, azure, crimson and vermilion predominate. If the design and the faces and attitudes of the figures are somewhat crude, as Millar suggests, the decoration is very beautiful and typical of the Romanesque style, consisting of leaves, grotesques and abstract motifs skilfully interwoven with great decorative effect.

O. Pächt, 'Hugo Pictor' in the *Bodleian Library Record*, 111 (1950–51), pp. 96–103; T. S. R. Boase, *English Art 1100–1216*, Oxford 1953, pp. 29–30, pl. 5a (detail); and M. Rickert, *Painting in Britain: The Middle Ages*, London 1954, p. 70.

56

ST. AUGUSTINE, OPERA. 320 × 215 mm. French, first half of 12th century. Cambrai, Bibliothèque Municipale, MS. 559.

This manuscript belonged to the Abbey of St. Sepulchre in Cambrai, but there is no reason to suppose that it was either written or illuminated there. Its miniatures show clear traces of insular art. It comprises four treatises: De doctrina christiana; De pastoribus; De avaritia et luxuria; De mendacio. The first is illustrated solely by initials, one of which is reproduced here (f. 40 v.); its design is original, consisting of a winged dragon, whose tail becomes transformed into stylised leaf-patterns, biting the leg of a male figure with bird's feet, who pierces him with a sword. The other three treatises open with framed pictures which are curiously oriental in style and for the most part incomplete.

58, 59

WINCHESTER BIBLE. 597 × 406 mm. English, middle of the 12th century. Winchester, Cathedral Library.

These illustrations are from one of the three large Bibles illuminated in England in the mid-12th century. The Winchester Bible was made over a long period of time, and its decoration executed by several hands. It was probably begun at Winchester under the patronage of the Bishop Henry of Blois, who was well known for his interest in the arts. The book contains some full-page illuminations, of which one leaf is in the Pierpont Morgan Library, New York, and another, the Maccabees page, is in line drawing. Most of the miniatures, however, are in the form of historiated initials at the beginning of each of the books of the Bible. The Elijah miniature (fol. 120 v.) was executed by one of the earlier masters, known as the 'Master of the Leaping Figures' on account of the lively agility which his figures display. The most striking stylistic feature of this period, the 'damp-fold', found in this master's work and in other contemporary products, is a method of treating drapery in broad areas separated by ridges, as though the material were damp. Prominent also is the use of white in the modelling of face, hands and arms. Fol. 34 v., which is also reproduced here, is the initial to Leviticus.

W. Oakeshott, *The Artists of the Winchester Bible*, London 1945.

60

LAMBETH BIBLE. 520×311 mm. English, middle of the 12th century. London, Lambeth Palace Library, MS. 3.

One volume of this Bible is now in the Library at Lambeth Palace, the other, much damaged, is in the Maidstone Library. The slight documentary evidence seems to point to Canterbury as a likely provenance for the book. Very close stylistic parallels also exist with manuscripts made at the Abbey of Liessies, one being dated to 1146. As in the Winchester Bible, the decorative scheme consists of full-page illuminations, six in number, and a large series of historiated initials, a few of which extend the full length of the page. The initial here shown (fol. 258 v.) is from the book of Ezekiel. The twisted figures echo the curve of the initial and the drapery is represented in an extreme form of the 'damp-fold' convention, with white patterns filling in the surface, and the convention extends even to the treatment of the hair.

C. R. Dodwell, *The Great Lambeth Bible*, London 1959.

61

PSALTER FROM SHAFTESBURY ABBEY. 225× 137 mm. English, beginning of 12th century. London, British Museum, Lansdowne MS. 383.

This Psalter was executed for a nun of Shaftesbury Abbey, who can be seen in one of the miniatures of the book kneeling at the feet of the Virgin and Child.
The miniatures are thoroughly characteristic of the first half of the 12th century, the period to which this book evidently belongs. It may be doubted whether the manuscript itself was really executed at Shaftesbury, although the leaves of the Calendar which form part of it leave no doubt as to its destination. It was possibly commissioned at St. Albans. The miniature illustrated here (f. 168 v.) shows St. Michael holding a cloth with souls and looking up to the Almighty, who is represented within a medallion at the top of the page. Here are to be found all the elements of the Winchester school renewed and fused into a new and original style through its contact with the Ottonian school on one hand and the French schools on the other.

M. Rickert, *Painting in Britain: The Middle Ages*,

pp. 83–4, pl. 68 b; M. A. Farley and F. Wormald, 'Three Related English Romanesque MSS.' in *Art Bulletin*, XXII (1940), pp. 157–61.

62, 63

BIBLE OF THE ABBEY OF BURY ST. EDMUNDS. 527×356 mm. English, 1121–1148. Cambridge, Corpus Christi College, MS. 2.

In this Bible Master Hugo realised one of the great masterpieces of English Romanesque illumination. Almost all its illustrations were designed on separate leaves of the softest vellum which were then pasted down on to the appropriate sheets of the book. The miniature reproduced here is the frontispiece of Deuteronomy (f. 94 r.). It illustrates: above, Moses and Aaron showing the tables of law to the Israelites; below, the reference to the law of the unclean animals in Deuteronomy, chapter XIV, Moses addressing a group of men and pointing to some animals lying in the grass and two birds on a tree. The book is rich in colour, certain in design and authentic in inspiration, nor does the formal skill of Master Hugo scorn the use of decorated borders and initials.

E. G. Millar, *English Illuminated Manuscripts from the 10th to the 13th Century*, pp. 30 sqq. 83, pl. 38; C. M. Kauffmann, *The Bury Bible*, in *Journal of the Warburg and Courtauld Institutes*, 1966, pp. 60–81.

64

ADMONT BIBLE. 565×420 mm. Austrian, 12th century. Vienna, Nationalbibliothek, Cod-Ser. 2701–2702.

This is an important product of the Salzburg School of illumination. It is known as the Bible of Gebhard because it has been erroneously identified with a bible documented as being made during the abbacy of Gebhard (1060–88). On stylistic grounds it must be assigned to the early 12th century. The decorative scheme consists of a series of full-page miniatures, several of them divided into two registers, and other miniatures set above the text. In style the Salzburg school is very much under the influence of Byzantine art, as shown in the sharply accentuated folds of the drapery, ending in 'umbrella' folds, the facial types, and the modelling of the features, with dark hollow

eyes, and white highlighting on cheeks and forehead. Folio 41 v. is reproduced here, showing Moses breaking the Tablets of the Law.

G. Swarzenski *Die Salzburger Malerei*, Leipzig 1913.

65

PERICOPE BOOK FROM ST. ERMENTRUDE, SALZBURG. 311×223 mm. Austrian, about 1140. Munich, Staatsbibliothek, MS. Clm. 15903.

Inscriptions at the beginning and at the end of the book give its provenance as the convent of St. Ermentrude, Salzburg. The 56 full-page illuminations form one of the most extensive New Testament cycles in Salzburg illumination. There are many stylistic similarities between this book and the Admont Bible, also a product of the Salzburg school. As in the latter, Byzantine influence is important in this volume. Characteristic also is the use of white for highlighting on faces and drapery. The page illustrated (fol. 63 r.) shows the Descent of the Holy Ghost upon the Apostles.

66

GOSPEL BOOK, 270×184 mm. Italian, 1170. Padua, Biblioteca Capitolare.

The manuscript was written and illuminated in Padua by the cleric Isidor, 'doctor bonus', and bears clear traces of the school of Reichenau. It contains eight full-page miniatures on gold backgrounds representing the principal festivals of the church year. This miniature (f. 38 v.) illustrates the Ascension: above, Christ Triumphant within a mandorla and an angel on either side; below are two other angels, the apostles and the Virgin.

67

PLINY THE YOUNGER 'HISTORIA NATURALIA'. 405×300 mm. Danish (?) Romanesque, 12th century. Florence, Biblioteca Laurenziana, MS. Plut. 82, I.

The dedicatory miniature on fol. 2 v., of this MS shows Pliny handing to the seated Emperor Titus a scroll, symbolising his work. The words on the scroll describe the scene: 'Plinius secundus Tito Cesaris salutet'. Above, looking down from a tree, is a small figure, probably that of the illuminator, holding a scroll with the words 'Petrus de Slagosia me fecit.' Although the place here referred to is Slagelse in the island of Zeeland, Denmark, there are no Danish illuminated manuscripts of similar date comparable to this one, and it has been suggested that the illumination is actually German work. The miniatures are noteworthy on account of their rich and intense colouring and for the wide variety of decorative patterns used.

Exhibition catalogue, *Mostra Storia Nazionale della Miniatura*, Rome, 1954, no. 153.

68

BIBLE. 548×387 mm. English, about 1175. Oxford, Bodleian Library, MS. Auct.E.inf. 2 (S.C. 2427).

It is not easy to attribute this manuscript to any particular school of English Romanesque illumination. According to Boase, it is more richly decorated with initials than any other Romanesque manuscript. It is a Bible of large proportions, in two volumes, dating from about 1175. The initial reproduced here (f. 2 r.) is the letter *B* of the word 'Beatus' which opens the Psalms. David is portrayed within it: above, intent on writing the Psalms, below, singing them to the accompaniment of the harp. On either side, in two small medallions, are two Prophets. Characteristic of the Romanesque style is the animal head binding the two rings of the initial together, the closely-clinging draperies, which are modest and severe, and the decoration. The predominant colours of the decoration are greens and blues, in contrast to the figures, in which the colours of white, red, golden-yellow and brown predominate.

E. G. Millar, *English Illuminated Manuscripts of the 10th to the 13th Century*, p. 115; T. S. R. Boase, *English Art 1100–1216*, pp. 4, 9 (pl. 12).

69

BESTIARY. 280×185 mm. English, late 12th century. Oxford, Bodleian Library, MS. Ash. 1511.

During the latter part of the 12th century the Bestiary became very popular in England and numerous illuminated copies of it survive. The Bestiary is a text-book of natural history, derived from the earlier

encyclopaedias, but the interpretation of each animal's story is related to Christian mythology. Together with MSS. Aberdeen 24 and Oxford, Bodleian Library, Douce 151, this forms a group of Bestiaries like Harley 4751 and Bodley 764. The story of the whale, (fol. 86 v), told in the Bestiary, is that it lifts its back out of the sea and sailing ships take it to be an island and anchor there; the whale, however, suddenly plunges to the depths of the water and pulls down the ship with it. This is an allegory of unbelievers, who are ignorant of the wiles of the devil, attach themselves to him and are dragged down to hell.

70

BESTIARY. 150×170 mm. English, late 12th century. London, British Museum, MS. Harley 4751.

The exact provenance of the manuscript illustrated here is uncertain, but it forms a pair with MS. Bodley 764 in the Bodleian Library, Oxford. The legend of the Unicorn (fol. 6 v.) related that it could only be caught when it took refuge with a virgin, placing its head in her lap. This forms a parallel to the life of Christ, who was born of a Virgin and killed by men.

71

BIBLE ATTRIBUTED TO THE MONASTERY OF ST. ANDRÉ-AU-BOIS. 515×345 mm. French, second half of 12th century. Boulogne, Bibliothèque Municipale, MS. 2.

Particularly outstanding for its decoration, which consists mainly of large historiated initials, vigorous in design and brightly coloured, this must be considered one of the finest Romanesque books to be produced in France or England, although it shows no stylistic affinities with the schools flourishing in these countries at that time. The initial letter reproduced here (f. 81 r.) is one of the most beautiful of the whole book. The customary decorative patterns are so well fused with the two struggling figures that the latter become a purely decorative motif rather than the object of a representation. The expression of the faces is vigorous and the design clear and almost realistic.

A. Boutemy, 'La Bible de St.-André-au-Bois' in *Scriptorium*, V (1951), pp. 222–237, esp. p. 234.

72, 73

PSALTER OF ST. LOUIS AND BLANCHE DE CASTILLE. 280×200 mm. French, early 13th century. Paris, Bibliothèque de l'Arsenal, MS. 1186.

Traditionally this manuscript is said to have belonged to Blanche of Castille, then to St. Louis. There is a prayer on fol. 190 written for a woman, and the richness of decoration suggests that the book was intended for a member of the court. Evidence other than this is lacking, however, and the hypothesis is tenuous. Twenty-five full-page miniatures, forming a cycle from the Fall to the Redemption, precede the Psalter text, and in addition there are ten full pages and ten historiated initials in the text itself. Of the two miniatures (fols. 9 v., 10 r.) reproduced here, one shows the Fall of the Angels before the Creation, in which the scene is treated in three registers, God as Judge and eight angels pleading with Him, six angels being thrust head downwards from heaven, and finally the monsters writhing in the mouth of hell. The second page shows the Creation of Eve, surrounded by the animals, birds and trees of Paradise.

V. Leroquais, *Psautiers*, Paris 1940–41, vol. II, p. 13.

74, 77

APOCALYPSE. 432×304 mm. English, about 1230. Cambridge, Trinity College, MS. R. 16, 2.

This is one of the most beautiful and richly decorated manuscripts known to us. Though attributed by James to the abbey of St Albans on account of its sumptuous decoration, lively design and vivid colouring, its place of origin is uncertain. It is twice as large as most of the known Apocalypses. The miniature reproduced here (f. 30 v.), like many of the other illustrations, depicts scenes from the Life of St. John: above, the Saint learns from a Bishop that the young man he had entrusted to his care was to be found in a wood with robbers; in the centre, St. John rides in search of him; below, having found him, he kisses his hand, baptises him, and leads him back to the Church.

E. G. Millar, *English Illuminated Manuscripts from the 10th to the 13th century*, pp. 55, 60, note 2, 97–8, pl. 86; Facsimile, ed. P. Brieger, London 1967.

75, 76, Frontispiece

LEAF OF A BIBLE. 574×386 mm. English, end of 12th century. New York, Pierpont Morgan Library, MS. 619.

This very beautiful leaf probably formed part of a manuscript of the Winchester school. Its writing is almost identical with that of the famous Winchester Bible, and the stylistic affinities of their miniatures make it almost certain that at least one of the same artists was at work on them both. The opinion that this leaf was possibly detached from the Winchester Bible would seem to be disproved by the fact that the leaf reproduced here (fol. 1 v.) is also found in the Winchester Bible. Above, on the left and the right, David and Goliath; in the centre on the left, Saul threatening David, and on the right, David anointed King; below, the death of Absalom and David's grief. The six scenes presented in this way within a heavy cornice help to create a sense of monumentality, and present David in a beautiful and coherent synthesis as King, warrior and psalmist. This miniature forms the frontispiece to the Book of Kings. One notes the ever-growing influence of Byzantine art even on English illumination of the 12th century.

E. G. Millar, *English Illuminated Manuscripts from the 10th to the 13th century*, pp. 35-6, 42-3, 85-6, pl. 48; *Pierpont Morgan Library: Exhibition of Illuminated MSS.*, New York 1934, pp. 18-19, pl. 32.

78

MATTHEW PARIS, 'HISTORIA ANGLORUM'. 355 ×237 mm. English, middle of the 13th century. London, British Museum, MS. Royal 14, C. VII.

The figure of Matthew Paris is an interesting one, for he was at the same time painter and miniaturist, goldsmith and historian, and worked at the monastery of St. Albans from 1236 until his death in 1259. He represents in the history of English miniature painting the passage from the Romanesque to the new transitional style. The use of lightly-tinted outlines serves to animate his drawings and emphasises the dramatic expressive force of his personages. His *Historia Anglorum* is especially well known. It is illustrated with marginal drawings, and also contains a full-page miniature, reproduced here (f. 6 r.), of the Virgin and Child with Matthew Paris kneeling at their feet.

M. R. James, *The Drawings of Matthew Paris*, in *Walpole Society*, vol. 14, 1925-6, pp. 1-26.
E. G. Millar, *English Illuminated Manuscripts from the 10th to the 13th Century*, pp. 56 sqq., 98, pl. 87.
F. Madden, *Matthaei Parisiensis Historia Anglorum*, Rolls ser. 1866, *The Old Royal Library*, London (British Museum) 1957, p. 10, pl. 5.

79

MISSAL FOR SEITENSTETTEN. 329×229 mm. Venetian, second half of 13th century. New York, Pierpont Morgan Library, MS. 855.

The miniatures of this manuscript are partly the work of Austrian artists, and partly the work of an Italian artist of the Venetian school. To the latter are attributed thirteen historiated initials, the signs of the Zodiac in the calendar, a Crucifixion, and the Virgin Enthroned, which we reproduce here (f. 110 v.). The iconography of this miniature, showing Mary flanked by two flowering trees, is clearly related to contemporary Venetian painting. Note the clusters of three white dots at the edge of the drapery, which serve to soften the outline.

80, 81

BIBLE MORALISÉE. Size of medallion 70×70 mm. French, 13th century. Toledo, Cathedral Library, MS. 1. Oxford, Bodleian Library, MS. Bodl. 270 b.

The two details display admirably the notable stylistic features of the bibles. Absalom caught in a tree is one of the eight medallions from a page (fol. 126 r.) of the Toledo version of the Bible, made in France about the time of the Oxford, Paris and London copy. This page forms the illustration to the second book of Kings. Absalom's long hair is entwined in the branches of the central tree, while his horse bounds off out of the medallion. The other trees in the background almost provide a pattern-book of the different kinds of convention for representing leaves. The second miniature is from the Oxford copy (fol. 34 r.) and shows Jacob blessing the sons of Joseph; it is from the page illustrating Genesis 48-50. The kneeling sons are partially outside the frame of the medallion. The rigid vertical drapery folds, heavily accentuated in black, are very clear in this composition; it is the main characteristic of the style of these Bibles.

82

BIBLE MORALISÉE. 410 × 305 mm. French, middle of the 13th century. Paris, Bibliothèque Nationale, MS. lat. 11560.

The text of the Bible Moralisée consists of extracts from the Vulgate version of the Old Testament with which are juxtaposed typologically related passages from the New Testament or passages pointing a moral application. These extracts are combined with their illustrations in such a way as to form continuous illuminated pages of eight historiated roundels accompanied by text passages, the whole being enclosed by a border. There are several versions of this work, made in France, probably in Paris, about the middle of the 13th century. The most complete version is in three volumes, now divided between the Bodleian Library, Oxford (MS. 270), Paris (B.N. MS. Lat. 11560) and London (B.M. MS. Harley 1526). The page from the Paris section (fol. 93 v.) shows a series of illustrations to The Song of Songs and Ecclesiastes.

A. de Laborde, *La Bible Moralisée conservée à Oxford, Paris et Londres*, 5 vols., Paris 1911–27.

83

MACIEJOWSKI BIBLE. 381 × 298 mm. French, 13th century. New York, Pierpont Morgan Library, MS. 638.

This manuscript is so called because it belonged in the 16th century to Count Bernard Maciejowski of Poland; he presented it to Shah Abbas the Great of Persia in 1604 and he had the meanings of the pictures transcribed into Persian. The book also contains 14th-century Italian explanations for each illumination. The series of Old Testament illustrations was originally prefixed to a Bible or a Psalter. Scenes from the Creation up to the second book of Samuel are portrayed and they are particularly remarkable as a source of information on contemporary civil and military dress and practice. The volume was probably produced in French court circles soon after the St. Louis Psalter. Common to both is the architectural frame with aediculae carried on columns, used here even above a scene that takes place out of doors, but the treatment of this work is far more complex. The episodes from the story of Moses (fol. 8 v.) shown are at the top, Moses and Aaron before Pharaoh with on

the left the Egyptians' cattle dying (Exodus ix), on the right the hail-storm (Exodus ix) and the plague of locusts (Exodus x). Beneath are the Passover and the Exodus (Exodus xii).

S. C. Cockerell and M. R. James, *A Book of Old Testament Illustrations . . . in the Library of J. Pierpont Morgan*, Roxburghe Club 1927.

84

PSALTER OF ST. LOUIS. 210 × 145 mm. French, third quarter of the 13th century. Paris, Bibliothèque Nationale, MS. lat. 10525.

A 14th-century note on fol. Av indicates that this Psalter belonged to St. Louis. The assertion is substantiated by the fact that the liturgical use is that of the Ste. Chapelle, the royal chapel, and the calendar contains the dates of the deaths of Philippe Auguste, Louis VIII, Blanche de Castille and Robert d'Artois. The Psalter opens with a remarkable series of full-page illuminations, 78 in number, representing scenes from the Old Testament, from the Sacrifice of Cain and Abel to the Coronation of Saul. The scenes face each other on verso and recto, and on the back of each is an explanatory text. The quality of execution is of the very highest and contains an abundance of gold, used in the backgrounds and in the 'filigree' scroll-work of the borders. There is much that is original in the composition of the scenes, particularly in the delicately drawn gothic architectural canopy beneath which the scenes take place. Fol. 14 shows two scenes from the story of Jacob.

V. Leroquais, *Psautiers*, vol. II, p. 101, pl. LXXXII–LXXXV, 1940–41; H. Omont, *Le Psautier de St. Louis*, Paris 1902.

85

BIBLE HISTORIÉE. 311 × 222 mm. French, about 1300. New York, Public Library, Spencer Collection MS. 5.

The text of the book includes extracts from Old and New Testament stories, and from lives and miracles of the Apostles, saints, and martyrs. There are at present over 800 illuminations still in the text, executed by various hands. The most frequent arrangement is a column of illumination with a parallel column of text explaining the facing miniature. The scene here

represented is the Dream of Jacob, in which four angels climb up and down the ladder, whose top is in the clouds, and at the foot of which Jacob lies asleep. The ground is naturalistically represented, as are the clouds, but the sky is a coloured diaper pattern, a very frequent motif in French manuscripts of the late 13th and 14th centuries.

Illuminated Books of the Middle Ages and Renaissance, Catalogue of an Exhibition at the Baltimore Museum of Art, 1949, no. 47, pl. 28.

86, 87

APOCALYPSE. 175 × 130 mm. English (?), early 14th century. London, British Museum, MS. Add. 17333.

This volume was produced in the early 14th century, although it is of uncertain provenance. It has been claimed as English or German. The first scene (fol. 14 r.) illustrates Apocalypse IX, 13–15:
'And the sixth angel sounded, and I heard a voice from the four horns of the golden altar which is before God, saying to the sixth angel which had the golden trumpet, Loose the four angels which are bound in the great river Euphrates. And the four angels were loosed, which were prepared for an hour, and a day, and a month, and a year, for to slay the third part of men.'
The second scene (fol. 43 r.) shows the beasts of the Apocalypse being devoured in the mouths of hell. In the centre is the red dragon with seven heads (XII, 3), the leopard with the feet of a bear is on the left of the dragon (XIII, 2), and on the lower right is the beast with two horns and a voice like a dragon (XIII, II). The diaper backgrounds are prominent features of both compositions.

88

BREVIARY OF PHILIP THE FAIR. 205 × 135 mm. French, about 1295. Paris, Bibliothèque Nationale, MS. lat. 1023.

This book belongs to the most splendid period of French miniature painting, which had its beginnings in the last years of the 13th century, when sacred and profane texts first began to be decorated by lay artists. It provides one of the earliest examples of this new production and is attributed to the Parisian artist Honoré, who must have executed it for Philip the Fair before 1296. We reproduce here f. 7 v. illustrating: above, the Anointing of David, against a background of vine tendrils; and below, against a background of lozenges with *fleurs-de-lis*, the David's combat with Goliath, watched by Saul. Already certain naturalistic tendencies can be observed in the gestures of the people.

E. G. Millar, *The Parisian Miniaturist Honoré*, London 1959.

89

QUEEN MARY PSALTER. 275 × 174 mm. English, beginning of 14th century. London, British Museum, MS. Royal, 2.B.VII.

This is the most richly decorated of all known English manuscripts. As well as many miniatures, it also contains a notable series of drawings softly tinted in green, red, brown, and other colours, which reveal the exceptional quality of the anonymous artist, a worthy continuator of the great Winchester tradition of drawing. His figures, and especially the women, are delineated with a deep sensibility for grace and refinement of features. The fondness of its artist for scenes of contemporary life, especially in the marginal illustrations, make it clear that it was illuminated by a lay miniaturist and not a monk. Illustrated here is Jesus's Disputation with the doctors in the Temple (f. 151 r.), and in the lower margin a hunting scene.

E. G. Millar, *English Illuminated Manuscripts of the 14th and 15th Centuries*, pp. 13–15, 52–53, pl. 32. E. M. Thompson, *English Illuminated Manuscripts*, pp. 13–5, pl. 14, 15; M. Rickert, *Painting in Britain: The Middle Ages*, pp. 142–3; J. Dupont and C. Gnudi, *Gothic Painting*, Geneva and Paris 1954, p. 25 (in colour); J. A. Herbert, *Illuminated MSS.*, pp. 221–3.

90

HOLKHAM BIBLE PICTURE BOOK. 285 × 205 mm. English, middle of the 14th century. London, British Museum MS. Add. 47682.

This book is, as the title suggests, a collection of pictures illustrating scenes from the Old and New Testaments. Generally there are two scenes per page; more occasionally, as here in the miniature showing

the Creation of Adam and Eve (fol. 3), one scene only. Short texts in Anglo-Norman French prose or verse explain the subjects of the pictures. The technique used in the book is that of outline drawing with a light colour wash, a method with a long pedigree in England. This Creation scene shows God moulding Adam with his hands, and God drawing Eve from the side of Adam. The wound thus made in the side of Adam was considered as the anti-type of the wound Christ received at the Crucifixion.

W. O. Hassall, Facsimile, 1954.

91

BELLEVILLE BREVIARY. 240 × 170 mm. French, about 1323–1326. Paris, Bibliothèque Nationale, MS. lat. 10483.

A work of great merit, executed for Olivier de Clisson and his wife Jeanne de Belleville, this manuscript passed into the possession of the French Royal House in 1343 and later into the hands of John, Duke of Berry. It consists of two volumes richly illuminated by the greatest French artist of the first half of the 14th century, Jean Pucelle, and his collaborators Jaquet Maci, Anciau de Cens and J. Chevrier. The page illustrated here (f. 24 v.) is elegantly decorated in the margins with vines, leaves, flowers and small lively figures of grotesques and animals, and shows two biblical scenes illuminated with exquisite refinement: above, Saul threatening David, below, Cain killing Abel, and also the allegory of Charity.

R. Blum, 'J. Pucelle et la Miniature Parisienne du XIV siècle; in *Scriptorium* III (1949), pp. 211–217; K. Morand, *Jean Pucelle*, Oxford 1962.

92

PROCÈS DE ROBERT D'ARTOIS. 350 × 270 mm. French, 1336. Paris, Bibliothèque Nationale, MS. fr. 18437.

Robert III of Artois (1287–1343) was the great-grandson of St. Louis' brother. He was condemned in 1309 and again in 1318 for his attempts to reclaim Artois, a territory taken over by his aunt Mahaut. After Mahaut's death he managed to obtain a revision of the court's decision, but he was subsequently sentenced to exile and went to England. This is the original manuscript of the trial. The miniature (fol. 2 r.) shows the court of peers in session; ecclesiastics sit on the right of the king, Philip VI, laymen on his right, each with his coat of arms depicted above him.

Ed. Porcher, *Manuscrits à Peinture du XIIIe au XVe siècle*, Bibliothèque Nationale, Paris 1955, no. 110, pl. XIII.

93

BIBLE OF JEAN DE SY. 420 × 300 mm. French, middle of the 14th century. Paris, Bibliothèque Nationale, MS. fr. 15397.

The decoration of this Bible, which was translated into French by order of King John the Good, remained unfinished because of the imprisonment of the sovereign after the battle of Poitiers. Many pages contain no more than sketches of drawings. However, whenever there was a chance of painting landscapes, the anonymous artist (identified by some with Jean de Bruges) drew small clusters of trees, thus earning the name of 'Maître aux boqueteaux'. His work is characterised by extreme sureness of drawing as well as a delicate feeling for decorative detail and richness of colour.

The finest miniatures are those at the beginning of the book, of which we reproduce here the Parting of Abraham and Lot (f. 14 v.).

94

PSALTER OF THE DUC DE BERRY. 250 × 175 mm. French, 1380–1385. Paris, Bibliothèque Nationale, MS. fr. 13091.

The text of the Psalter is in Latin and French and the liturgical use is that of Bourges. A cycle of twenty-four miniatures precedes the text, consisting of portraits of the twelve Apostles with the twelve Old Testament Prophets facing them. Beneath are texts in Latin and French. Those beneath the Old Testament figures foretell events in the New Testament and beneath the New Testament figures are the relevant articles of the Credo. The book is documented in the Inventory of the Duc de Berry's Library made in 1402, and from this the illuminator is known to have been André Beauneveu, who was equally known as a sculptor, his most notable works being the tombs of Charles V, Philippe VI, and Jean le Bon. The minia-

tures show three-dimensional qualities in the treatment of the thrones and in the seated figures, each of which is like an individual portrait.

V. Leroquais, *Psautiers*, vol. II, pp. 144–6, pl. CXVIII–CXXVII, 1940–1; Millard Meiss, *French Painting in the Time of Jean de Berry: The Late Fourteenth Century and the Patronage of the Duke*, London 1967, pp. 135–154, pls. 51–82.

95

BRUSSELS HOURS. 275 × 185 mm. French, late 14th century. Brussels, Bibliothèque Royale, MS. 11060–1.

This volume has been identified with an entry in the inventory of the possessions of Jean Duke of Berry for 1402, where the illuminator is named as Jaquemart de Odin (or Hesdin as he is generally known). In addition to the work of Jaquemart the book contains a few miniatures by an Italian illuminator and a diptych by an earlier master in which Jean de Berry is presented to the Virgin and Child by his patron saints. The miniature shown here is Jaquemart's Flight into Egypt (fol. 106). The scene is enacted against a rocky landscape with mediaeval boats and walled towns in the background. This treatment is particularly noteworthy in view of French painters' previous preference for gold or diapered backgrounds and shows that Jaquemart was working in a style derived from the work of Italians like Lorenzetti and Duccio. The borders framing the central scene contain the arms of Jean de Berry and his devices of swan, bear, and the initials 'VE'.

M. Meiss, *French Painting in the Time of Jean de Berry*, vol. 1, pp. 321–2, London & New York, 1967.

96, 97

LUTTRELL PSALTER. English, about 1340. London, British Museum, MS. Add. 42130.

This Psalter, decorated towards 1340 for Sir Geoffrey Luttrell, belongs to the last phase of East Anglian illumination when it was already approaching decadence. Its lack of taste can be seen in the monstrous grotesque figures painted at the sides of the pages with crude colouring and little understanding of problems of composition. Contrasting with these is a series of small marginal pictures bearing no relation to the text, which illustrate scenes from contemporary life. One of these, on ff. 181 v–182 r., illustrated here, shows an elegant train of royal ladies travelling in a finely decorated carriage drawn by a team of proud chargers.

M. Rickert, *Painting in Britain: The Middle Ages*, pp. 148–9.

98

ORMESBY PSALTER. 377 × 254 mm. English, 1320–1330. Oxford, Bodleian Library, MS. Douce 366.

Outstanding among East Anglian illuminated manuscripts of the 14th century, this Psalter derives its name from the monk Robert of Ormesby, who gave it to the Cathedral Priory of Norwich around 1320–1330. The representation of the Trinity (f. 147 v.) was probably illuminated in about 1310. The rich border of small grotesque figures of men and animals is typical of the taste of the East Anglian school. In the lower part, a battle takes place between two nude young men riding a bear and a lion.

E. G. Millar, *English Illuminated Manuscripts of the 14th and 15th centuries*, Brussels 1928, pp. 2–3, 44–5, pl. 4; M. Rickert, *Painting in Britain: The Middle Ages*, pp. 143–4, pl. 125.

99

PSALTER OF HUMPHREY DE BOHUN. 285 × 197 mm. English, about 1370. Oxford, Exeter College, MS. 47.

In a group of books decorated in the second half of the 14th century for the Bohun family, there are signs of a revival of miniature painting in England. Among these may be included the Psalter executed for Humphrey de Bohun, although no more than a small part of its original rich decoration now remains. It shows great fineness of execution and very minute and precise drawing. We reproduce here f. 33 v. containing an illuminated initial subdivided into four parts, each containing Biblical characters: Eliezer and Abraham, Eliezer and Rebecca, Isaac's servants and the shepherds of Gerar, Jacob and Rachel at the well.

E. G. Millar, *English Illuminated Manuscripts of the 14th and 15th centuries*, pp. 26–7, 66–7, pl. 68.

100

SHERBORNE MISSAL. 534×382 mm. English, 1396–1407. Alnwick Castle, Library of the Duke of Northumberland.

Executed for the Benedictine Abbey of Sherborne between the years 1396–1407, we know the names of both its scribe, John Whas, and its illuminator, John Syfrewas (or Siferwas), probably the principal artist among those engaged on its decoration. He populated the margins of its pages with great imaginative fantasy, often enriching them with architectural motifs and figures of animals and men (which frequently take the form of real portraits), rendered with careful regard for the truth. The large miniature of the Crucifixion (f. 380 r.), illustrated here, is filled with people individualised with great skill, and shows some resemblance to German panel paintings, especially those of the school of Cologne.

E. G. Millar, *English Illuminated Manuscripts of the 14th and 15th centuries*, pp. 32–4, 71–2, pl. 84; J. A. Herbert, *Illuminated MSS.*, pp. 233–4; M. Rickert, *Painting in Britain: The Middle Ages*, pp. 178–9, pl. 161; O. E. Saunders, *English Illumination*, Florence 1928, 1, pp. 115–6.

101

MARCO POLO, 'LIVRES DU GRAUNT CAAM'. English, about 1400. Oxford, Bodleian Library, MS. Bodl. 264.

The *Livre du Grand Caam* was added to the Flemish copy of the *Romances of Alexander* in England about the year 1400. These leaves contain several miniatures, of which we reproduce the panoramic view of Venice on f. 218 r. In it we see an imaginative and ingenious representation of the architecture of the city interpreted with a somewhat precious taste for ornament, and groups of small lively figures. Its empirical sense of perspective and lack of any true idea of proportion, together with its brilliant colouring, help to accentuate the fantasy and charm of this view of the city.

E. G. Millar, *English Illuminated Manuscripts of the 14th and 15th centuries*, pp. 36, 73, pl. 86; M. Rickert, *Painting in Britain: The Middle Ages*, pp. 180–1, pl. 157.

102

STATUTS DE L'ORDRE DU SAINT-ÉSPRIT AU DROIT DÉSIR. Neapolitan, 1352. Paris, Bibliothèque Nationale, MS. fr. 4274.

This work was executed for Luigi of Taranto, who in 1352 founded in Naples the Order of the Holy Ghost. The large miniature on f. 2 v., illustrated here, represents the Holy Trinity within a mandorla decorated with *fleur-de-lys*; the seated figure of God the Father supports the cross of Christ, on whose head rests the Dove, the symbol of the Holy Ghost. King Luigi of Taranto and Queen Giovanna, his wife, with two other people stand in adoration, while above a band of angels surrounds the mandorla. A cornice and frieze of branching foliage, animals and *putti* complete the decoration of the page. Both in the figurative parts of the decoration and in the purely ornamental parts, one notices a combination of French and Sienese influences which is characteristic of the Neapolitan school.

103

CALEFFO BIANCO OR DELL'ASSUNTA (Cartulary of documents relating to the Commune of Siena, 813–1336). 436×305 mm. Sienese, first half of 14th century. Siena, Archivio di Stato, MS. Capitoli 2.

The large miniature at the beginning of the text, showing the Assumption of the Virgin Mary amid a chorus of angels (f. 1 r. reproduced here), is the work of the Sienese painter and miniaturist Niccolò di Ser Sozzo Tegliacci. The initial letter contains the figure of St. Ansanus, and the page is bordered with a frieze of flowers, armorial bearings and small grotesques. This is the only miniature painting which can with certainty be attributed to Tegliacci, by whom it was signed. In its exquisite sensibility to line and colour it was influenced by the contemporary Sienese painting of Simone Martini and the Lorenzetti.

Siena, Archivio di Stato, Catalogo delle Sale della Mostra, Rome 1956, no. 259, pl. 111 (in colour); C. Brandi, 'Niccolò di Ser Sozzo Tegliacci' in *L'Arte*, 1932, pp. 223–36, fig. 1; W. M. Milliken in *Art in America* XIII (1925), pp. 162–3; J. A. Herbert, *Illuminated MSS.*, pl. XXXIX.

104

PONTIFICAL. 350×257 mm. North Italian, about 1380. Cambridge (Mass.), Harvard College Library, MS. Typ. 1.

This book was made for Andrea Calderini, bishop from 1378 to 1385 of Ceneda, a small town at the foot of the Venetian Alps. His name appears on fol. 1. The arms contained on the borders are those of another bishop and date from the sixteenth century; they have been painted over those of the book's original owner. The contents of the book are a selection of offices from the Roman Pontifical. The page shown here (fol. 4) has the initial 'S' with a scene of Confirmation conducted by the bishop accompanied by clerics, one of whom holds his mitre, another his crozier, and a third the two vessels of oil. In the right-hand border a prophet holds a scroll containing the words 'Confirma hoc Deus quod'. In the centre of the lower margin are the four evangelist symbols in leaf scrolls on either side of a roundel containing arms that were probably painted over a picture of Christ in Majesty.

Fifty Manuscripts, Catalogue of the Collection of H. Yates Thompson, 1902, second series no. 90. Exhibition Catalogue *Illuminated and Calligraphic Manuscripts*, Fogg Art Museum, 1955, no. 47, pl. 23.

105

ORDO MISSAE. 159×229 mm. Bolognese, about 1370. New York, Pierpont Morgan Library, MS. 800.

This codex was produced at Bologna and contains many illuminated initials. The Crucifixion on f. 39 v. (reproduced here) is the work of Niccolò da Bologna, and shows great sensibility both for the decoration and for the expression. Standing out against a gold background decorated with arabesques is the body of Christ, modelled in a luminous grey, and the figures of Mary, John and Mary Magdalene clothed in garments of clear, concentrated colours. Christ's attitude of pathetic abandon is effectively commented on by the expression of grief on the faces of the two Maries.

106

DETACHED MINIATURE. 80×70 mm. Sienese, 14th century. Cleveland, Museum of Art, J. H. Wade Collection, MS. N.24,430.

These two figures of Saints have been attributed to Niccolo di Ser Sozzo Tegliacci the author of the Assumption miniature in the 'Caleffo dell'Assunta' manuscript in the Siena State Archives. This latter work, containing information on Sienese land and castles up to the year 1332, contains the signature of Niccolo on the page with the Assumption miniature. The two Saints here (reproduced in enlargement) are similar in iconography and style to figures in the Niccolo miniature. There is no indication as to which saints they are, as they carry only a wand.

W. M. Milliken, 'An illuminated miniature by Niccolo di Ser Sozzo Tegliacci' in *Art in America* XIII (1925), pp. 160–66; *Bulletin of the Cleveland Museum of Art* XII (1924), pp. 64–7.

107

MISSA IN ANNUNCIATIONE B. MARIAE: JACOBUS DE STEPHANESCIS, DE BEATI GEORGII MIRACULIS ET MARTYRIO: OFFICIUM ET MISSA S. GEORGII: MISSAE PRO ALIIS FESTIVITATIBUS. Sienese, first half of 14th century. Rome, Vatican, San Pietro, Archivio Capitolare, MS. C. 129.

This manuscript was executed for the Cardinal Jacopo Stefaneschi and decorated with rich marginal borders and numerous initials illuminated with sacred figurations. Portrayed within the initial letter on f. 18 v., reproduced here, is St. George killing the dragon, while in the margin on the left, the princess is kneeling in prayer. The extreme elegance of the figure on horseback, the refined portrait of the young girl and the classical beauty of the faces all attest the Sienese origin of the artist who illuminated this book, from which he derives his name of 'Master of the Codex of St. George'. The book shows clear traces of the influence of Simone Martini, with whom he possibly found himself working in collaboration at Avignon.

108

BOOK OF HOURS OF THE MARÉCHAL DE BOUCICAUT. 275×190 mm. French, 1396–1416. Paris, Musée Jacquemart-André, MS. 2.

Executed for Jean Le Meingre, surnamed Boucicaut, and his wife Antonietta de Turenne, it contains forty-

five miniatures which are the work of the artist called 'Master of the Hours of the Maréchal de Boucicaut', identified by some with Jacques Coëne who came from Bruges to work in Paris. It shows clear traces of Italian and Flemish art; the people reveal a careful study of physiognomy, and many are in fact real portraits. In the miniature illustrated here (f. 23 v.) the figure of St. George on horseback, elegantly dressed in armour, resembles the Maréchal de Boucicaut, while the princess kneeling in prayer has the face of Antonietta de Turenne.

M. Meiss, *French Painting in the Time of Jean de Berry: The Boucicaut Master*, London 1968.

109, 110

LIVRES D'HEURES DE ROHAN. 290×210 mm. French, about 1418–1420. Paris, Bibliothèque Nationale, MS. lat. 9471.

Executed *circa* 1418–1420 for a member of the House of Anjou, probably for Queen Yolande, this manuscript is the masterpiece of a group of miniaturists who worked under the direction of the anonymous artist called 'Maître des Heures de Rohan'. It shows clear traces of contemporary miniature painting (recalling the work of Jacquemart de Hesdin, the master of the Boucicaut Hours, the Limbourg brothers, the Bedford Master), but is distinguished by its own special manner of drawing large figures of great pathetic and dramatic power. We reproduce f. 7 r. representing the Month of May dressed as a young man on horseback bearing a flowering branch. The two nude figures above are delineated with a clear and deeply expressive line.

A. Heimann in *Städel-Jahrbuch* VII–VIII, 1932.

111

LIVRE DE LA CHASSE DE GASTON PHÉBUS. 370×280 mm. French, about 1405–1410. Paris, Bibliothèque Nationale, MS. fr. 616.

The most famous of the many extant manuscripts, mostly illuminated, of the work of Gaston Phébus. It is richly decorated with miniatures of hunting scenes which contain glimpses of natural landscapes. Although the trees, the herbs and the foliage are

painted in a somewhat conventional manner, its picture of the countryside at harvest time, with its ears of corn and flowers, is described with new freshness of observation. Illustrated here is the scene of 'how to draw hares' (f. 118 r.) with lively figures of animals (dogs and hares) and elegant archers and huntsmen.

112

TRÈS RICHES HEURES OF THE DUC DE BERRY. 290×210 mm. French, 1416. Chantilly, Musée Condé, MS. lat. 1284.

This is undoubtedly the most splendid of all the books made for the Duc de Berry. It is recorded in the 1416 Inventory made at the death of the duke and the illuminators are named as Pol de Limbourg and his brothers. The work was interrupted; the Limbourgs are known also to have died in 1416, probably of the plague. The miniature here reproduced is one of a series of twelve calendar illustrations, which precede the text of the Hours, which in its turn contains a great many biblical scenes and illustrations of the lives of saints. The month of May is shown here (fol. 5 v.); in the foreground a cavalcade of people celebrate the First of May. They all wear garlands of leaves. The figures have not been identified with historical personages, but one of them wears the royal colours of red, white and black, and is probably a member of the royal family. The scene takes place near the town of Riom, of which there is a topographically exact view at the top of the scene. All the calendar miniatures contain similarly accurate views of towns or residences of the Duc de Berry and they are one of the most outstanding features of the volume.

P. Durrieu, *Les Très Riches Heures de Jean de France, Duc de Berry*, 2 vols., Paris 1904.

113

HOURS OF RENÉ D'ANJOU. 260×186 mm. French, second quarter of 15th century. Paris, Bibliothèque Nationale, MS. lat. 1156A.

The miniature here reproduced (fol. 81 v.) shows a portrait of the patron and owner of the book, René d'Anjou, King of Naples. As there are certain resemblances between the style of this manuscript and

that of the Master of the 'Heures de Rohan' it is probable that René's book was also produced in Paris. To the right of King René is an amorial bearing which helps to date the Hours as it contains the arms of René's wife Isabelle of Lorraine as well as his own. This means that the book was made between the date of their marriage in 1420 and before her death in 1453. The delicate leaf borders that frame the central miniature also contain devices of René and Isabelle – the eagle with the cross of Lorraine, the sail with the motto 'En Dieu en soit' and the thorns.

Leroquais, *Livres d'Heures*, vol. I, pp. 64–7.

114

LIVY, 'DECADES' (I–X, XXI–XXX). 426×293 mm. French, about 1425–1430. Cambridge (Mass.), Harvard College Library, MS. Richardson 32 (2 vols.).

The work comprises two volumes, each containing ten miniatures. Superior for their balanced composition and harmony of colours are those of the second volume, from which we reproduce the Coronation of a Pope (f. 1 r.): within an enclosed space against a background of finely decorated cloth, the Pope is shown surrounded by fourteen men wearing picturesque costumes.

115

CHRONIQUES DE HAINAUT. 423×288 mm. Flemish, 1446. Brussels, Bibliothèque Royale, MS. 9242.

The book of which this is the frontispiece is the first part of the *Chroniques de Hainaut*, a French translation by Jean de Wauquelin of the work of Jacques de Guise. The frontispiece shows Simon Nockart presenting the work to Philippe le Bon, Duke of Burgundy. The Duke, with his young son, is in the centre, the Duke's figure isolated from the two main groups and standing beneath an ornate canopy with a patterned background. On his right are his counsellors, the Chancellor Rolin in blue, Jean Chevrot in his robes as Bishop of Tournai; the third person is unidentified. The group on the Duke's left are the eight chief members of the aristocracy; all wear the collar of the Order of the Golden Fleece, as do the Duke and his son. Simon Nockart is mentioned in the preface to this manuscript as being responsible for commissioning Wauquelin to execute this translation, and

the kneeling figure probably represents him rather than Wauquelin himself. Wauquelin's portrait is known from the presentation miniatures in the *Histoire d'Alexandre* (Paris, B.N., MS. fr. 9342) and the *Girart de Roussillon* (Vienna, Nat. Bibl., MS. 2549). As a series of individualized portraits this miniature is quite exceptional. It has been attributed to Roger van der Weyden but it is more probably the work of an illuminator.

L. M. J. Delaissé, *Miniatures Médiévales*, Cologne 1959, no. 27.

116

BREVIARY OF PHILIP THE GOOD, DUKE OF BURGUNDY. 296×213 mm. Flemish, 1430–1440. Brussels, Bibliothèque Royale, MS. 9511.

Two large miniatures, including the Nativity illustrated here (f. 43 v.), belong to the period at which the text was written (1430–1440), while the remaining decoration is later and is probably the work of Guillaume de Vrelant of Bruges and his studio. If at times it leaves much to be desired in design and perspective, it always has the merit of brilliant colouring. The Nativity has iconographical affinities with the painting of this subject in the Dijon Museum, attributed to the 'Maître de Flémalle' (or Roger de la Pasture) in so far as both groups of figures are inspired by the writings of the Apocrypha. Especially effective is the gesture of wondering devotion of St. Joseph, who raises his cap before the new-born Child.

L. M. J. Delaissé, *Miniatures Médiévales*, Geneva 1959, no. 29.

117

LIVRE DU CUER D'AMOURS ESPRIS. 225×170 mm. French, about 1465. Vienna, Nationalbibliothek, MS. 2597.

One of the masterpieces of French illumination in the 15th century, this romance was written by King René of Anjou, the great patron of the arts, and illustrated about 1465 by an artist who remains anonymous (despite attempts to identify him with Barthélemy de Clerc or Coppin Delf), probably in contact with the school of Tours. The romance relates the adventures of the knight Cuer who, accompanied

by his armour-bearer Désir, sets out to conquer the love of the lady 'Doulce Mercy'. It is illustrated by sixteen miniatures of exceptional pictorial merit, especially in their delicate light effects and poetic interpretation of nature. In fol. 15 r. the early morning light filters through the mist in the scene of the awakening of Cuer beside the enchanted fountain, while Désir is still asleep and their horses graze in the meadow. It is the light which transforms everything and confers an aura of magical fantasy on the scene.

O. Smital and E. Winkler, *Herzog René von Anjou, Livre du Cuer d'Amours Espris*, Vienna 1927.

118

LIVRE D'HEURES D'ÉTIENNE CHEVALIER. 160 ×120 mm. French, about 1455–1460. Paris, Bibliothèque Nationale, nouv. acq. lat. 1416.

After it was barbarously dismembered at the beginning of the 18th century, only a few scattered leaves of the Book of Hours of Étienne Chevalier remain, now preserved in the Musée Condé at Chantilly (which owns the finest group), in the Louvre, in the Bibliothèque Nationale, in the British Museum and in private collections. The miniature in the Bibliothèque Nationale, illustrated here, shows St. Anne and the three Maries, who according to a medieval legend were her daughters, each with her own children: Mary mother of Jesus, Mary mother of James the Less, Joseph the Just, Simon and Jude, and lastly Mary mother of James the Great and John the Evangelist. The scene has a landscape background with the view of a city which is possibly Tours, birthplace of the artist. Despite the influence exercised on Fouquet by the art of the Italian Renaissance, this miniature is prevalently French in inspiration, as can be seen in the type of its people and their costume, as well as in its landscape and architecture.

P. Wescher, *Jean Fouquet und seine Zeit*, Basel 1945.

119

ANTIQUITÉS JUDAÏQUES DE JOSEPH. 430×300 mm. French, middle of the 15th century. Paris, Bibliothèque Nationale, MS. fr. 247.

The decoration of this magnificent manuscript was begun for Jean de Berry and completed later for Jacques d'Armagnac about 1470. The first miniatures are the work of an anonymous artist at the time of the Duke of Berry, the other eleven are by Jean Fouquet, the greatest French painter and miniaturist of the 15th century, born at Tours around 1420. From the latter, we reproduce here the Taking of Jericho by the Hebrews (f. 89 r.). One sees in Fouquet the influence of the art of the Italian Renaissance, which he came to know during a visit to Rome about 1445. His miniatures are no longer simple book illustrations, but rather small pictures painted with great skill in composition and naturalistic sensibility. The landscapes, which show scenes of the gentle native countryside of the artist, are spacious and yet meticulous in detail. The people who fill his pages are portrayed with great freedom of movement.

120

MIROIR DE LA SALVATION HUMAINE. 410×280 mm. Flemish, 1448–1449. Brussels, Bibliothèque Royale, MS. 9249–50.

This book contains the French translation of the popular mediaeval work *Speculum Humanae Salvationis*. It was translated by Jean Méliot for Philippe le Bon, Duke of Burgundy, and this manuscript and its decoration are by the hand of Méliot himself. The colophon indicates that it was made in 1448–9 at Lille, Brussels, and Bruges; Méliot must have worked on it while following the court. The manuscript is on paper, and this is one reason why it contains decoration in pen drawing with colour wash, gouache being a more suitable medium for parchment. The initials represent the letters 'Si'.

L. M. J. Delaissé, *La Miniature Flamande*, Exhibition catalogue, Brussels 1959, no. 80, pl. 35.

121

JEAN MANSEL, 'FLEUR DES HISTOIRES'. 435× 300 mm. Flemish, 15th century. Brussels, Bibliothèque Royale, MS. 9232.

Fleur des Histoires is an anthology of stories of sacred history, Roman and French history, written in 1454 by Jean Mansel for the Duke of Burgundy, Philip the Good. The miniature illustrated here, representing the creation of the human soul (f. 815 r.), is the work of

Simon Marmion, a painter and miniaturist at work between 1458 and 1489, who among other things was responsible for the illustrations of the famous manuscript of *Les Grandes Chroniques de Saint Denis*. He is noted for his delicate range of subtly-blended colours, and from his own time onwards has justly been given the name of 'Prince d'enluminure'.

L. M. J. Delaissé, *Miniatures Médiévales*, Geneva 1959, no. 34.

122

Page added to the BOOK OF HOURS OF CHARLES THE BOLD. 220×153 mm. Flemish, 15th century. Vienna, Nationalbibliothek, MS. 1857.

The miniature reproduced here (f. 14 v.) forms part of a group of three illustrations, all by the same anonymous artist, which were added to the Book of Hours already richly decorated for Charles the Bold by the work partly of Philippe de Mazerolles. In the first plane Mary of Burgundy, daughter of Charles the Bold, is shown seated reading and in the background, inside a Church, the Virgin and Child worshipped by Mary of Burgundy and Maximilian of Austria. The magnificent figures are delineated with a precise and vigorous line, which clearly defines the details of the architecture. The garments of the princess, her jewellery and the objects in the first plane are exquisitely painted. Note also the beautiful vase of flowers on the right serving to balance the composition.

F. Unterkircher, *Abendländische Buchmalerei, Miniaturen aus Handschriften der Oesterreichischen Nationalbibliothek*, Vienna 1966, p. 234.

123

GRIMANI BREVIARY. 254×229 mm. Flemish, early 16th century. Venice, Biblioteca Marciana.

The Breviary is named after its owner, Cardinal Domenico Grimani, who acquired it before 1520. It contains one hundred and ten miniatures, many of which are full-page illustrations of considerable beauty, with illustrations relating to the religious feast days, scenes from the Old and New Testament, and pictures of the labours of the month. The last-mentioned group of miniatures illustrating the calendar form a complete whole, and are attributed to

the Bening family. The influence of the 'Très Riches Heures du Duc de Berry' is clear, especially in the similarity of the subjects they describe, which are sometimes almost identical. The other miniatures are the work of different Flemish artists, including Gerardo de Gand, and also French artists. A particular characteristic of the decoration is its tendency towards realism, although the decoration of the borders of each page with naturalistic and architectural motifs at times appears excessive. We illustrate the scene (fol. 74 v.) of the Adoration of the Magi, framed by a border of flowers and butterflies.

F. Ongania, *The Grimani Breviary*, 1906.

124

BOOK OF HOURS OF CHARLES OF ANGOULÊME. 215×155 mm. French, 15th–16th century. Paris, Bibliothèque Nationale, MS. lat. 1173.

This interesting Book of Hours, executed for Charles de Valois, Count of Angoulême, contains not only miniatures but also coloured engravings. Among the former, one of the most outstanding is the Adoration of the Magi, illustrated here (f. 22 v.), which can be attributed to Jean Bourdichon. It shows close affinities to some miniatures of the Book of Hours of Anne of Brittany, especially in the iconography of the kneeling figure of the oldest of the Magi, who is almost identical with the Simeon of the Presentation in the Temple. Note the tendency to idealise human figures who, deprived of individual characters of their own, all come to resemble each other. The Virgin, her face gently inclined, is posed in an attitude of sweetness which ends by becoming conventional, since it is deprived of any truly-felt emotion.

V. Leroquais, *Livres d'Heures*, Paris 1927, vol. I, p. 104, pl. XCII–XCV.

125

BREVIARY. 273×191 mm. Spanish, about 1490. Cambridge (Mass.), Harvard College Library, MS. Typ. 189 H.

Possibly executed at Seville, this manuscript contains thirty-eight illuminated initials and three large full-page illustrations in a perfect state of preservation. Shown here is the Annunciation (f. 7 v.): exuberant in the ornamentation of its background, presented

without perspective, and further enriched by a border of different motifs of flowers and leaves. The features of the faces of its two figures are rigid and, one would say, almost severe.

Exhibition of Illuminated and Calligraphic MSS. in Harvard College Library, 1955, Catalogue no. 100, pl. 27.

126

GRADUAL OF THE CAMALDOLESE ORDER. 694 × 505 mm. Florentine, second half of 15th century. Florence, Biblioteca Laurenziana, cor. 4.

This precious manuscript, richly decorated with historiated initials and other large figurative illustrations, is the work of the famous Florentine miniaturist Attavanti, who was born in 1452 and died about 1517. Although according to tradition he was a pupil in the workshop of Verrocchio, his style is nearer to that of Ghirlandaio in his representation of the life and customs of the time and in his exquisite decorative compositions, which are entirely lacking in straining after dramatic effect. Note with what fineness the elegant border surrounding the page illustrated here (f. 7 v.) has been executed, with its frieze, *putti* and small figured medallions. The upper part of the page is filled by a large miniature showing the procession of Corpus Christi slowly winding between two stage settings of buildings drawn in perspective. A view of undulating countryside in the background helps to accentuate the spacial depth of the scene.

127

PSALTER AND NEW TESTAMENT. 533 × 367 mm. Florentine, second half of 15th century. Florence, Biblioteca Laurenziana, MS. Plut. 15, 17.

This manuscript is part of a Bible executed for Matthias Corvinus by the two Florentine brothers Gherardo and Monte di Giovanni del Fora. Fruits of their collaboration are the works in which Flemish and Florentine influences are combined to create a style of complete originality; while in those produced by Monte alone, after 1497, the year of Gherardo's death, one notices an increased searching after dramatic effect by the use of tricks of light. In the miniature reproduced here (f. 2 v.), the hand of Gherardo seems to predominate. An elaborate cornice

with lateral pilasters and a predella below (illustrating the scene of the anointing of David) contains a panoramic view of Jerusalem; in it are represented the scenes of David picking up the stone and cutting off Goliath's head, and in the first plane David kneeling in prayer.

M. Salmi, *Italian Miniatures*, London 1957, Frontispiece (in colour).

128

FRONTISPIECE TO A PRAYER BOOK. 199 × 153 mm. Florentine, 15th century. Cleveland, Museum of Art, J. H. Wade Collection, MS. N.53.280.

In this miniature the fine decorative border is given a place of prominence on the page. It consists of putti, swags, roundels, peacocks and there is a large candelabrum on each side of the central miniature. The bottom border has two roundels with busts of prophet figures, one on either side of a pierced quatrefoil containing a scene of the Nativity. Within an arch in the centre of the page is the Annunciation, shown against an architectural background through which a landscape view is visible. The artist's understanding of space and perspective and his use of classicising decorative motifs suggest he was a Florentine, possibly Attavante, who worked on the Bible Vat. Urb.lat. in 1476–8, or the artist of the Book of Hours of Lorenzo the Magnificent (Florence Laur. Ash. 1874), written in 1485 by Antonio Simbaldi and illuminated by Antonio de Cherico.

Catalogue, *Riproduzioni di manoscritti miniati*, Florence, 1914, no. 24.

129

DETACHED MINIATURE. Florentine, early 15th century. Cleveland, Museum of Art, J. H. Wade Collection, N.49.536.

Lorenzo Monaco was responsible for the dynamic figure of the prophet illustrated here. He was a most original interpreter of the late Gothic style, gifted with vivid imaginative powers, who knew how to combine successfully Sienese and Florentine features with those derived from ultramontane regions. It is interesting to compare this miniature with the saints and prophets in the Diurno Domenicale (cod. 130, in

the Laurentian Library, Florence), the work of Lorenzo Monaco and collaborators. In both can be seen the same vigour and moral force which animate his people, the same ability to evoke grandiose forms, the same richness of leaf-patterns decorating the borders.

W. M. Milliken, 'Miniatures by Lorenzo Monaco and Francesco del Cherico' in the *Bulletin of the Cleveland Museum of Art*, XXXVII, 1950, pp. 43–5 (plate).

130

DETACHED MINIATURE. Lombard, 15th century. Cleveland, Museum of Art, J. H. Wade Collection, MS. N.54,257.

This initial, detached from a 15th century choir book, contains the portrait of an archbishop saint, probably Saint Augustine. It has been attributed to Belbello of Pavia, who worked in Milan for the Visconti family in the early years of the 15th century on the famous Landau–Finaly Hours now in the Laurentian Library, Florence. The solidity and plasticity of his figures provide a link between his work and that of the sculptors at work on the decoration of Milan cathedral about the same time.

Bulletin of the Cleveland Museum of Art, 1955, p. 143.

131

DETACHED MINIATURE. Ferrarese, 15th century. Cleveland, Museum of Art, J. H Wade Collection, N.51. 548.

This figure of King Solomon is attributed to Guglielmo Giraldi called Magri (or del Magro), a Ferrarese miniaturist of the time of Borso d'Este and Ercole I, on account of its affinities with other works of this artist, such as the brilliantly-coloured illuminated initials of the Choir Book of the Certosa of Ferrara (now in the Palazzo Schifanoia). The figure is invested with a noble grandeur and has a strong plastic relief.

132

BREVIARY (Roman usage). 292 × 210 mm. Ferrarese, about 1470. Cambridge (Mass.), Harvard College Library, MS. Typ. 219 H.

Executed for the Certosa of Ferrara, probably at the time of Duke Borso d'Este, a period of great splendour for Ferrarese miniature painting. It contains many historiated initials, decorated borders, pen illustrations, three large full-page miniatures and one almost full-page miniature. In such wealth of ornament it is possible to distinguish the hands of three different artists. An example of the sumptuous decoration of the book can be seen in the page illustrated here (f. 484 r.), framed by complicated candelabra motifs with *putti*, leaf patterns, etc. The lower part of the border contains a tondo with the Virgin and Child. The initial letter is also illuminated.

Harvard College Library Exhibition of Illuminated and Calligraphic MSS., 1955, Catalogue no. 81, pl. 34, 35.

133, 135

PAGE DETACHED FROM A GRADUAL. 770 × 540 mm. Ferrarese, 15th century. Cleveland, Museum of Art, J. H. Wade Collection, N.27. 426.

The page reproduced here is framed by a border of spiral leaf patterns with small, variously-shaped medallions containing figures of saints, cherubs and animals. The initial letter *R* is also illuminated and shows a saint standing against a barren and rocky landscape drawn in perspective. The style of this miniature reveals the hand of a Ferrarese artist who delineates figures with an incisive and nervous line, almost as though he were cutting them in hard and precious material. On account of its high quality, this miniature could be attributed to the head of the Ferrarese school of painting, Cosmè Tura, whom we know also to have been a miniaturist, or at least to an artist working in his circle.

S. De Ricci and W. J. Wilson, *Census of Medieval and Renaissance MSS.*, . . . 11, p. 1931.

134, 136

'BORSO BIBLE'. 375 × 265 mm. Italian, second half of 15th century. Modena, Biblioteca Estense, MS. V. G.12 (Lat. 422).

Executed in Ferrara for Borso d'Este, this Bible constitutes one of the richest and most splendid examples of the art of miniature painting. Each page of the book is decorated with borders of branching foliage strewn with flowers and little gold balls, containing *putti*, animals and armorial bearings. Particularly sumptuous are the initial pages of the individual books of the Bible (shown here is the beginning of

Ecclesiastes on f. 280 v.), with figured decoration which blends harmoniously with the marginal borders. A great many miniaturists took part in this large work, among whom a place of preeminence belongs to Taddeo Crivelli and Franco de' Russil. It shows clearly the influence of 15th-century Ferrarese painters, and also of Pisanello, Piero della Francesca and Mantegna. The page reproduced here is attributed by Salmi to Taddeo Crivelli.

P. Puliatti, *Il Libro illustrato dal 14 al 18 secolo nella Biblioteca Estense di Modena*, 1961, no. 5.

137

DETACHED MINIATURE. Venetian, second half of the 15th century. Cleveland, Museum of Art, J. H. Wade Collection, N.51.394.

This miniature of the *Pietà* shows such close affinities to the panel paintings of Andrea Mantegna that it is probably to be attributed to this great master, the head of the Renaissance school of painting in northern Italy and also known as a miniaturist. Brought up in Pavia on examples of Donatello's sculpture, he endowed his own work with a strong and vigorous plasticity, which can be seen very clearly in this miniature. The rocky landscape, painted with a knowledge of perspective, brings to mind the typically Mantegnesque landscapes of the Crucifixion (Paris, Louvre) and the Agony in the Garden (Museum of Tours). Note the intensity of expression in this drama, conveyed in the deep-felt emotion of the gestures and faces of the figures closely surrounding the body of Christ.

138

GRADUAL. 834×587 mm. Venetian, 15th century. Siena, Libreria Piccolomini, cor. 12.

Executed for the Cathedral of Siena, this choir book contains marginal borders of flowers, volutes, arabesques, etc., and numerous historiated initials. Illustrated here is the initial containing St. Matthew and the Angel by Liberale de Verona (f. 76 r.). The linear rhythm of the intricate folds of its draperies creates a robust and vigorous sense of plasticity. On the left, the glimpse of landscape dissolved in softly-contrasting light and shade gives breadth to the composition. The artist's delicate range of clear, bright colours makes the miniature resemble a precious enamel.

139

GRADUAL. 809×580 mm. Lombard, second half of the 15th century. Siena, Libreria Piccolomini, cor. 4.

Gerolamo da Cremona, the greatest miniaturist of northern Italy in the second half of the 15th century, was responsible for the decoration of this stupendous Gradual. In contact with Mantegna in his youth, Gerolamo then devoted himself, together with Liberale da Verona, to the decoration of the choir books of the Cathedral of Siena, borrowing freely from the methods of contemporary Sienese painting. Note the rhythm and elegance of the design and able composition of forms in the Adoration of the Magi illustrated here (f. 7 v.); also the richness of the border, decorated with large spirals of curling leaves.

140

CARD FOR THE GAME OF TAROT. 175×85 mm. Lombard, 15th century. New York, Pierpont Morgan Library, MS. 630.

This is one of a set of tarot cards made for members of the Visconti and Sforza families, and shows the Empress, one of the trump cards of the game. The emblems on the Empress's dress are the Visconti crown with olive branches and the Sforza inter-linked rings, and the Sforza eagle is visible on her shield. It is almost certain that this set was made for Bianca Maria Visconti and her husband Franceso Sforza by the artist Bonifacio Bembo, painter and miniaturist from Cremona, rather than by Zavattari as has been previously thought. More cards from this same set by Bembo are in the Accademia Carrara at Bergamo; three of the set are the work of Antonio Cigognara. The lavish use of punched gold and the sweet elegant faces of Bembo's figures link his work with the International Style.

M. Harrsen and G. K. Boyce, *Italian Manuscripts in the Pierpont Morgan Library*, New York, 1953, no. 54; G. Moakley, *The Tarot Cards painted by Bonifacio Bembo for the Visconti-Sforza Family*, New York, 1966.

141

AELIUS DONATUS, 'GRAMMATICA'; PSEUDO-CATO, 'DISTICHA'; PRAECEPTA MORALIA ET GRAMMATICAE. 275×180 mm. Lombard, 15th century. Milan, Biblioteca Trivulziana, MS. 2167.

Executed for Maximilian Sforza, this Grammar contains, as well as two famous portraits of Maximilian and Lodovico il Moro attributed to Ambrogio de Predis, other miniatures which have the young prince as their protagonist. We illustrate here the miniature on f. 13 v. showing Maximilian listening attentively to the lesson of his master while the other children devote themselves to games. Note the vigorous and rough but certain style, and the artist's love of realistic detail. On account of these stylistic characteristics this miniature is attributed to a Lombard artist called the pseudo-Antonio da Monza, identified by some critics with Zuan Andrea of Mantua, a disciple of Mantegna, by others with Giovanni Pietro Birago.

Ed. M. Salmi, *I Codici miniati della Biblioteca Trivulziana*, Milan 1958, no. 42.

142, 143

DETACHED MINIATURE. 270×220 mm. Umbro-Bolognese, late 15th century. Cleveland, Museum of Art, J. H. Wade Collection, N.27, 161.

This large miniature, representing Christ in prayer on the Mount of Olives and the sleeping Apostles, is by an artist of the High Renaissance of the Umbrian school, possibly Timoteo Viti. The languorous attitudes of the sleeping Apostles show a study of volume while the landscape, opening out in the distance into hills and plains, is achieved only through a deep understanding of perspective. We have before us, in fact, a work better suited to the style of a picture-painter than to that of a proper miniaturist.

De Ricci, *Census cit.*, 11, p. 1931; W. M. Milliken, 'A miniature attributed to T. Viti' in *Bulletin of the Cleveland Museum of Art*, XIV (1927), pp. 114–5 and fig. 142.

144

DETACHED MINIATURE. 163×105 mm. Venetian, 16th century. Cleveland, Museum of Art, J. H. Wade Collection, MS. N.53.281.

This miniature (reproduced in enlargement) shows a composite scene including the Virgin adoring the Child with Joseph asleep; in the background are scenes of the Annunciation to the Shepherds with the angel appearing in the sky and, simultaneously, the Flight to Egypt. Amusing details are the dog and

tortoise in the foreground and the distant figures and ships. The artist is alleged to be Gerolamo dai Libri, one of a family of painters and miniaturists of Verona. He also made choir-books for S. Maria in Organo, Verona. Here the extreme plasticity of the drapery folds is contrasted with the stage-prop qualities of the stable beneath which the main scene is enacted.

W. M. Milliken, *A Miniature by Girolamo dai Libri*, *Bulletin of the Cleveland Museum of Art*, 1955, pp. 225–6.

145

BOOK OF HOURS WITH CALENDAR. 144×96 mm. Emilian, 16th century. Genoa, Biblioteca Berio.

The book is commonly called the 'Uffiziolo Durazzo' from the name of the donor. Written in gold letters on a background of purple vellum, it is richly decorated with elegant miniatures attributed to Marmitta, a painter and miniaturist of Parma, in contact with the school of Mantegna, from whom he derived his passion for the antique. It contains six full-page miniatures and fifteen smaller ones, surrounded by friezes or delicately moulded borders which look like small pictures. The Calendar is decorated with the signs of the Zodiac and the figurations belonging to each month. Reproduced here is the page showing the celebration of the Mass.

Colour Plate facing page 8

PSALTER. 370×265 mm. Byzantine, 10th century. Paris, Bibliothèque Nationale, MS. gr. 139.

This book came from Constantinople and is one of the most important examples of miniature painting in the period defined by Réau as the 'second golden age' of Byzantium (8th–12th centuries). It contains 14 full-page miniatures. Illustrated here is David in the midst of his flock singing psalms, while Melody listens at his shoulder and Echo repeats his song (f. 1 v.). The semi-nude figure outstretched on the ground on the right is said by Ebersolt to symbolise the mountain of Bethlehem. Especially notable is the austere nobility of its allegorical figures, the almost Hellenistic beauty of the bodies and the classical eloquence with which both landscapes and animals are portrayed.

H. Buchtal, *The Miniatures of the Paris Psalter*, London 1938, pp. 13–17, pl. 1.

SHORT BIBLIOGRAPHY

GENERAL

A. Boeckler, *Abendländische Miniaturen bis zum Ausgang der romanischen Zeit.* Berlin and Leipzig 1930.

A. Grabar and C. Nordenfalk, *Early Mediaeval Painting from the 4th to 11th Century.* Lausanne 1957.

A. Grabar and C. Nordenfalk, *Romanesque Painting.* Lausanne 1958.

The relevant sections of:

E. Kitzinger, *Early Mediaeval Art in the British Museum.* London 1940; 2nd ed. 1955.

J. Beckwith, *Early Mediaeval Art.* London 1964.

H. Swarzenski, *Monuments of Romanesque Art.* London 1943, 1967.

J. Dupont and C. Gnudi, *Gothic Painting.* Geneva 1954.

A. Martindale, *Gothic Art.* London 1967.

BYZANTINE AND EARLY MEDIAEVAL

A. Boinet, *La Miniature carolingienne.* 1913.

E. H. Zimmermann, *Vorkarolingische Miniaturen.* Berlin 1916.

J. Ebersolt, *La Miniature Byzantine.* Paris 1926.

A. Goldschmidt, *German Illumination.* New York and Paris 1928.

W. Koehler, *Die karolingischen Miniaturen.* Berlin 1930–3, 1960.

G. Micheli, *L'Enluminure du haut Moyen-Age et les Influences irlandaises.* Brussels 1939.

F. Henry, *Irish Art in the Early Christian Period (up to 800).* London 1940, 1956.

K. Weitzmann, *Illustration in Roll and Codex.* Princeton 1947.

F. Henry, *L'Art irlandais.* Dublin 1954.

Exhibition Catalogue, *Byzance et la France Médiévale.* Bibliothèque Nationale, Paris 1958.

A. Grabar, *Byzantium: Byzantine Art in the Middle Ages.* London 1966.

F. Henry, *Irish Art during the Viking Invasions 800–1020.* London 1967.

P. Bloch and H. Schnitzler, *Die ottonische Kölner Malerschule.* Düsseldorf 1967.

APOCALYPSES

L. V. Delisle, *Les Manuscrits de l'Apocalypse de Béatus* in *Mélanges de Paléographie et de Bibliographie.* Paris 1880.

H. L. Ramsey, *Manuscripts of the Commentary of Beatus of Liebana on the Apocalypse* in *Revue des Bibliothèques,* vol. XII, 1902, pp. 77–79.

H. A. Sanders, *Beati in Apocalypsin.* Rome 1930.

M. R. James, *The Apocalypse in Art.* London 1931.

W. Neuss, *Die Apokalypse des heiligen Johannes in der altspanischen und altchristlichen Bibelillustration.* Münster in Westfalen 1931.

ENGLISH

The relevant sections of T. S. R. Boase, *English Art 1100–1216.* Oxford 1953.

E. G. Millar, *English Illuminated Manuscripts from the 10th to 13th Century.* Paris and Brussels 1926.

O. E. Saunders, *Englische Buchmalerei.* Florence and Munich 1927.

E. G. Millar, *English Illuminated Manuscripts of the 14th and 15th Centuries.* Paris and Brussels 1928.

C. R. Dodwell, *The Canterbury School of Illumination.* Cambridge 1954.

M. Rickert, *Painting in Britain: The Middle Ages.* London 1954, 1965.

GERMAN

G. Swarzenski, *Die Regensburger Buchmalerei des 11. und 12. Jahrhunderts.* Leipzig 1901.

G. Swarzenski, *Salzburger Buchmalerei von den ersten Anfängen bis zur Blütezeit des romanischen Stils.* Leipzig 1913.

H. Swarzenski, *Early Mediaeval Illumination.* London 1951.

FRENCH

H. Martin, *Les Miniaturistes français.* Paris 1906.

H. Martin, *La Miniature française du 13ᵉ au 15ᵉ siècle.* Paris and Brussels 1923.

V. Leroquais, *Les Sacramentaires et les Missels Manuscrits des Bibliothèques publiques de France.* Paris 1924.

V. Leroquais, *Les Livres d'Heures Manuscrits de la Bibliothèque Naionale.* Paris 1927.

P. Lauer, *Les Enluminures romanes des Manuscrits de la Bibliothèque Nationale.* Paris 1927.

H. Martin, *Les Joyaux de l'Enluminure à la Bibliothèque Nationale,* 2 vols. Paris and Brussels 1928.

H. Martin and P. Lauer, *Les principaux Manuscrits à Peinture de la Bibliothèque de l'Arsenal*. Paris 1929.

J. Meurgey, *Les principaux Manuscrits à Peinture de la Bibliothèque du Condé à Chantilly*. Paris 1930.

A. Blum and H. Martin, *La Miniature française aux 15ᵉ et 16ᵉ siècles*. Paris and Brussels 1930.

V. Leroquais, *Les Pontificaux Manuscrits des Bibliothèques publiques de France*. Paris 1937.

V. Leroquais, *Les Psautier Manuscrits latins des Bibliothèques publiques de France*. Macon 1940–41.

J. Porcher, *L'Enluminure française*. Paris 1959.

M. Meiss, *French Painting in the Time of Jean de Berry: The Late XIV Cnetury and the Patronage of the Duke*. London and New York 1967.

M. Meiss, *French Painting in the Time of Jean de Berry: The Boucicaut Master*. London and New York 1968.

Exhibition catalogues, *Manuscrits à Peinture du VIIᵉ au XIIᵉ siècle*. Bibliothèque Nationale. Paris 1954.

Manuscrits à Peinture du XIIIᵉ au XVIᵉ siècles. Bibliothèque Nationale. Paris 1955.

FLEMISH

P. Durrieu, *La Miniature flamande au Temps de la Cour de Bourgogne, 1415–1530*. Brussels and Paris 1921.

L. M. J. Delaissé, *La Miniature flamande: le Mécénat de Philippe le Bon* (Exhibition catalogue). Brussels 1959.

ITALIAN

D.O.P. Taeggi, *Le Miniature nei Codice Cassinese*. Monte Cassino 1887.

P. D'Ancona, *La Miniatura Fiorentina s.11–18*. Florence 1914.

P. D'Ancona, *La Miniature italienne du 10ᵉ au 16ᵉ siècles*. Paris and Brussels 1925.

D. Fava, *Tesori delle Biblioteche d'Italia: Emilia e Romagna*. Milan 1932.

E. B. Garrison, *Studies in the History of Mediaeval Italian Painting*. Florence 1953–62.

M. Salmi, *Italian Miniatures*. London 1957.

Exhibition catalogue, *Mostra Storica Nazionale della Miniatura*. Rome 1953.

U.S.A.

S. de Ricci and W. J. Wilson, *Census of Mediaeval and Renaissance Manuscripts in the United States and Canada*. New York 1937.

LIST OF COLLECTIONS

The authors and publishers are grateful
to all institutions, museums and libraries who have supplied photographs
for this publication and have given their
permission for reproduction.

ALNWICK
Alnwick Castle Library: 100
AACHEN
Cathedral Treasury: 20
BAMBERG
Stadtbibliothek: 45
BOULOGNE
Bibliothèque Municipale: 33, 54, 71
BRUSSELS
Bibliothèque Royale: 95, 115, 116, 120, 121
CAMBRAI
Bibliothèque Municipale: 56
CAMBRIDGE
Corpus Christi College: 62, 63
Trinity College Library: 74, 77
CAMBRIDGE, Mass.
Harvard College Library: 104, 114, 125, 131
CHANTILLY
Musée Condé: 112
CIVIDALE
Museo Archeologico: 36
CLEVELAND, Ohio
Museum of Art (J. H. Wade Collection): 106,
128, 129, 130, 132, 133, 135, 137, 142, 143, 144
DIJON
Bibliothèque Municipale: 53
DUBLIN
Trinity College Library: 11, 12
EPERNAY
Bibliothèque Municipale: 18
FLORENCE
Biblioteca Laurenziana: 1, 8, 38, 39, 67, 126, 127
GENOA
Biblioteca Berio: 145
LONDON
British Museum: 9, 22, 31, 32, 35, 50, 61, 70, 77,
78, 79, 84, 85, 86, 87, 89, 90, 96, 97
Lambeth Palace Library: 60
MILAN
Biblioteca Ambrosiana: 3
Biblioteca Trivulziana: 141
MODENA
Biblioteca Estense: 134, 136,

MUNICH
Staatsbibliothek: 27, 30, 40, 41, 42, 65
NEW YORK
Pierpont Morgan Library: 48, 75, 76, 83, 79, 105, 140
Public Library (Spencer Collection): 85
NUREMBERG
Germanisches Nationalmuseum: 37
OXFORD
Bodleian Library: 34, 55, 57, 68, 69, 80, 98, 101
Exeter College: 99
PADUA
Cathedral Treasury: 66
PARIS
Bibliothèque de l'Arsenal: 72, 73
Bibliothèque Nationale: 7, 13, 14, 16, 19, 21, 23,
24, 25, 26, 44, 46, 47, 82, 84, 88, 91, 92, 93, 94, 102,
109, 110, 111, 113, 118, 119, 124
Musée Jacquemart-André: 108
ROME
Library of San Paolo fuori le Mura: 28, 29
Vatican Library (Archivio Capitolare): 2, 49, 107
ROSSANO IN CALABRIA
Cathedral Library: 4
ST. GALL
Stiftsbibliothek: 10
SIENA
Archivio di Stato: 103
Libreria Piccolomini: 138, 139
SIGMARINGEN
Hohenzollern Library: 52
TOLEDO
Cathedral Library: 80
TRIER
Stadtbibliotek: 15, 43
UTRECHT
University Library: 17
VENICE
Biblioteca Marciana: 123
VIENNA
Nationalbibliothek: 5, 6, 64, 117, 122
WINCHESTER
Cathedral Library: 58, 59
FORMERLY WIESBADEN (now destroyed): 51

235